A BRIEF HISTORY OF DAVID LYNCH

David Lynch directs movies. They include *Erasertooth*, *The Elephant Moon*, *Raisin*, *Polka Dot Velvet*, *Wild at Spleen*, *Twins: Danny DeVito Walk with Me*, *Lost TV Remote Control*, *The Perpendicular Story*, *Martin Luther King Boulevard*, and *Panda Empire*. But David Lynch never wanted to be a filmmaker. Instead, he yearned for a career as a weatherman. Unfortunately, television stations blacklisted him due his tendency to emulate bad weather by spitting on the camera lens. Now David Lynch's success as a director has made it possible for him to realize his dream. Now he has a captivated audience who watch his daily weather reports on davidlynch dot com. Rather than spitting on the camera to emulate bad weather, he now dumps buckets of severed ears, apple pie, and his own brand of coffee. Today is cloudy with a chance of showers. Today, David Lynch was really hungry and sleepy, so he consumed the contents of his bad weather bucket. He looks toward his digital camera, panicked, wondering if he should spit on it. An aircraft carrier smashes into the weather report studio and transforms into Michael Bay. Michael Bay gives David Lynch a thumbs up and triggers a special effect that floods outer space and drowns the studio. David Lynch glances at the water, runs his fingers through his magnificent head of hair, and unleashes a disapproving hmph. The room becomes endless, red curtains fall from the spaces in between, a dwarf slowly dances. There is no time. Michael Bay falls in space, going faster and faster until his body bursts into flame. David Lynch chants a mysterious mantra as he transcendently meditates and ascends to heaven where everything is fine.

- BRADLEY SANDS

IN HEAVEN, EVERYTHING IS FINE:

FICTION INSPIRED BY DAVID LYNCH

EDITED BY CAMERON PIERCE

Eraserhead Press
205 NE Bryant Street
Portland, OR 97211

WWW.BIZARROCENTRAL.COM

ISBN: 978-1-62105-089-6

Copyright © 2013 Individual Creators

Cover Art Copyright © 2013 by Matthew Revert

Interior Design by Cameron Pierce

All rights reserved. No part of this book may be reproduced or transmitted in any form or by any means, electronic or mechanical, including photocopying, recording, or by any information storage and retrieval system, without the written consent of the publisher, except where permitted by law.

All persons in this book are fictitious, and any resemblance that may seem to exist to actual persons living or dead is purely coincidental or for parody or satirical purposes. This is a work of fiction.

Printed in the USA.

For Jack Nance

TABLE OF CONTENTS

FINDING YOURSELF AS SOMEONE ELSE — 005
Matthew Revert

HADLEY — 013
Ben Loory

WHERE WALLS WOULD HAVE — 018
Blake Butler

IMPRINTING — 024
J. David Osborne

POPULATION: 2 — 033
Cody Goodfellow

NIGHTBOMB — 045
Violet LeVoit

FRIENDSHIP IS NICENESS AND IS — 047
Sam Pink

PORTENTS OF PAST FUTURES — 059
Jeffrey Thomas

BEAST WITH TWO BACKS — 069
Garrett Cook

LOU REED SINGS "THIS MAGIC MOMENT" — 076
Andrew Wayne Adams

ZYGOTE NOTES ON THE IMMINENT BIRTH OF A FEATURE FILM AS YET UNFORMED — 082
John Skipp

A LOVE SONG TO FRANK BOOTH — 093
Edward Morris

GIRL FROM IOWA 095
Zack Wentz

BLUE VELVET CAKE 100
Laura Lee Bahr

TREMBLER 109
Kevin Sampsell

A MODEL MADE OUT OF CARD 111
OR, THE ELEPHANT MAN AND
OTHER REMINISCENCES
Gabriel Blackwell

TWIN PEAKS: FIRE WALK WITH ME 129
Blake Butler

HIPSTER HUNTER 132
Jeff Burk

MISERYHEAD 140
Michael J Seidlinger

FIRST MOVEMENT 148
Suzanne Burns

LADY OF ARSON 159
Jarret Middleton

THE CLASS OF EDUN HIGH 168
Matty Byloos

UMBILICUS REX 176
Chris Kelso

INLAND WHERE SECRETS LIE 185
Joseph S. Pulver, Sr.

LAKE STREET 200
MP Johnson

GLORIA Kirsten Alene	209
HOT DOG (BRING PROTECTION) Kevin Sampsell	225
NUBS Jeremy C. Shipp	229
OUTLIER Jody Sollazzo	235
COLNE Liam Davies	248
PERSISTENCE HUNTING Jeremy Robert Johnson	255
THE GARAGE DOOR Kris Saknussemm	271
NIGHT FILMS Mike Kleine	278
THESE ARE THE FABLES Amelia Gray	284
SEXTAPE Simon Logan	287
THE DROWSY MAN DREAMS Nick Mamatas	296
TEATRO GROTTESCO Thomas Ligotti	301
HINTERKAIFECK AGAIN Nick Antosca	318
THE IMPLIED HORROR OF DAVID LYNCH David J	323

FINDING YOURSELF AS SOMEONE ELSE

MATTHEW REVERT

At one time or another, everyone in this diner has been in a movie, but none of them will be remembered for it. They never stop acting in that one role they thought would be their big break. They sit in booths manufactured in the 50s, and rotting with age. A jukebox off to one side churns out Weimer era vaudeville music filtered through dusty grooves on overworked vinyl.

Dean Mensberg sits in the same booth as every other day, across from his companion, Harry Slocomb. Dean wears a grey leisure suit that he may have been born in. It sucks at his body, choking out sweat that spots his forehead. Harry is older, hunched over as if perpetually picking up a coin he once found on one of his luckier days. Over time, his eyebrows have slowly grown over the bridge of his nose to form one. The frown it forms is infused with desperation rather than anger.

Harry scrutinises the orange paper napkin that sits on the table before him. He brings his head down low until his ear kisses the formica. He raises his arm before he raises his head. It floats naked above the two of them, causing Dean discomfort.

"What's with the hand?" he asks Harry.

Harry tilts his head toward the napkin, his arm becoming more rigid with the passing seconds.

"What's with the hand?" Dean asks again.

"Look at the napkin," replies Harry.

Dean directs his gaze at Harry's napkin, studying it, willing himself to see what Harry sees. When he sees it, an asthma attack erupts from Dean that chokes his face red and puffs his eyeballs. He fumbles around

his jacket pocket, fetching a string of rosary beads. Which he presses against his forehead until the asthma subsides. Once composure has been regained, Dean raises his hand to match Harry's. They are prepared to keep their hands raised for as long as it takes.

The hours pass and the Los Angeles sun begins its descent, casting neon pink light, which spills through the diner windows, giving birth to the darkness of a shadow's shadow. Except Harry and Dean, whose hands remain raised, the daytime occupants of the diner have been replaced by a different breed, comfortable within the hidden depths the night has to offer. An urban circus of Hollywood tragedy swan about the diner until they reach their regular seats. Each prepares to relive nightly scenes etched into despairing, hopeless memories.

Two men approach Dean and Harry, wearing the football uniforms of teams long since disbanded, wondering why their regular booth is already occupied. One of the men accents his football uniform with a Stetson cowboy hat while the other wears a do-rag. They sport similar beards, which are tucked into their collars. The one with the cowboy hat slams both fists on the table.

"Get the fuck away from our fucking table you fucking motherfuckers," he yells.

"That can't happen, friend," says Dean.

The man in the do-rag saddles into the booth beside Dean, drapes an arm over his shoulder and begins staring at his raised hand.

"What's with the fucking hand?" he asks.

Dean motions toward Harry's napkin with a tilt of his head. Both football men glance at the napkin carefully and, sometime later, begin to twitch and yelp.

"I'm sorry, man," stutters the one in the cowboy hat. "It's just . . . this is our booth. We'll leave you to it . . . maybe come check back later."

"You guys need a waitress," says the one in the do-rag before standing up and shouting, "Hey! We need a fucking waitress over here!"

The two walk away, leaning heavily into each other. Dean and Harry remain with their hands raised.

From the kitchen, a woman called Dianna watches Dean and Harry with their hands raised. She's been watching them the whole time, wondering what to do, wondering if she'll be blamed. This is Dianna's first day as a waitress and she hasn't yet amassed the courage to confront the

problem. Dianna doesn't understand why she's here. An agent who never gave her his name should have called her back about a big job days ago. She had danced for him and his friends. She removed clothes and exposed parts of her body she didn't know she had. The agent, a short Italian man with thick, black chest hair, had asked her to. He and his friends encircled Dianna until she could feel the heat from their bodies. She let each one take turns fucking her while the others watched and barked orders. She remembers the red velvet ceiling of the VIP room she was taken to. It suggested an alternate world, one Dianna had long dreamed about. This was a world of happiness and love. The path to such a world involved shame and hatred, but it is a price worth paying, for one must be prepared to pay anything for love. And for Dianna, love is something she is nothing without. These men merely fucked a shell that looked like her. The real Dianna will forget about these men. Until she receives the call however, she remembers.

Dianna glances up at the grease staining the kitchen ceiling and then back toward Dean and Harry. A gaunt figure dressed as a concierge with a scarlet red rose in his breast pocket approaches Dianna from behind. He places spindly fingers on each of her shoulders and whispers into her ear with thick, warm breath, "You should go and assist the gentlemen."

Dianna smells cigarettes and spiced meat on his breath, which both sickens and comforts her. She turns around to face the man. The one thought that swarms Dianna is, *This is The Magicman.*

"I'm going to assist the gentlemen," she says.

"Yes . . . assist the gentlemen," The Magicman repeats.

Dianna sits down and straps on a pair of roller skates, studying herself in a mirror while The Magicman watches from afar, inhaling with lysergic disinterest on a cigarette. Dianna studies this man's reflection in the mirror and wonders who he is. He is gone before she has a chance to enquire— not that Dianna would. This man has an eternity about him that doesn't lend itself to explanation.

She stands up, feeling the added weight of the roller skates attached to her feet, preparing to provide assistance. She studies herself once more in the mirror, blowing her reflection a kiss through blueberry lipstick. The reflection of The Magicman reappears, but when Dianna turns around to face the reflection's source, there is nothing. She rolls into the diner, the residual echo of The Magicman's fingers burning on her shoulders.

Harry and Dean direct their attention toward Dianna as she rolls toward them. The wheels of her roller skates squeak like piglets, attracting the attention of all who hear. For a brief moment, the souls in the diner are removed from their own broken fantasies. Diana feels the eyes upon her and represses the inexplicable urge to dance. Harry tenses his arm in anticipation as she draws nearer. The peach scent of Dianna's bargain bin perfume reaches Harry and Dean's booth before she does, and by the time she has caught up, mild intoxication has crawled up their nostrils. Harry's arm collapses to the table top, knocking over the salt and peppershaker.

"How can I help you gentlemen?" Dianna asks.

Harry clenches his fists and brings both toward his chest.

Hyperventilation soon follows.

"The napkin," says Dean. "What're you going to do about the napkin?"

Dianna's eyes widen as the problem begins to dawn on her.

"Oh gosh . . . I'm so, so sorry. I'll have this sorted immediately."

She stumbles as she rushes back toward the kitchen, trying to keep the tears inside.

Dean clutches Harry's arms by each wrist and forces them straight. He begins a slow, exaggerated breathing technique that he wills Harry to mimic. Harry slowly catches on and his arms and lungs finally relax.

"It's fine," says Harry. "We're working this out."

They both stare at the inert napkin, studying the shadowy mystery of its folds, knowing that whatever lurks within is anything but inert.

Dianna returns with the man they call 'The Cooker.' He's responsible for reheating and/or frying all the food. The Cooker is a Dominican man of slight stature. His face is caked in white powder with rouged cheeks. Dianna points the napkin out to The Cooker, whose face scrunches in disgust.

"How'd this happen?" he asks.

"It may have been The Magicman," says Dianna, talking more to herself than anyone else.

The Cooker takes a moment to center himself before forcing a grin, which he flashes at Harry. The Cooker's teeth are too big for his mouth, as if the slightest shake of the head will forfeit them.

"I cannot begin to apologize enough, sir. This is not the way it's supposed to work." He places a hand on Dianna's shoulder and squeezes. "Please be so kind as to fetch the gentleman a new napkin, and I would urge you to exercise the utmost care."

Dianna nods and rolls back toward the kitchen. The Cooker watches her disappear then turns toward the napkin. He slams his hand on the

table, crushing the napkin, and whatever may be inside. He scrunches the napkin in his hand, concentrating on the task while Harry and Dean watch on. After what seems like a calculated passage of time, The Cooker buries the napkin deep within his trouser pocket. Dianna rolls back to the booth with a new napkin in tow and holds it aloft for all to examine. The Cooker moves his nose toward the new napkin and inhales.

"Is this satisfactory, sir?"

Harry cranes his neck to inspect the napkin and Dean cranes his neck to inspect Harry. Eventually Harry nods in approval and a collective sigh of relief wafts from the four. The Cooker nods toward Dianna, who places the napkin before Harry.

"What can I get you, darling?" asks Dianna.

Harry spends some time appreciating the new napkin.

"Pie. Apple pie," he says. "And a coffee. Black. With no sugar."

Dianna nods, scribbles in a notepad and turns toward Dean.

"Just a coffee. Black. No sugar."

"Make sure there's no sugar," adds Harry.

Dianna rolls back toward the kitchen, her dress billowing from beneath her pure white apron. A man in a white suit stained yellow with sweat and life experience approaches the jukebox that sits between the male and female toilets. After a brief interaction with the jukebox the Weimer era vaudeville is switched off and Alberta Hunter's 'Downhearted Blues' glides through the diner. The man in the stained white suit turns with his back to the jukebox and weeps as Hunter's pained vocals overcome him. The two men in football uniforms rise from their non-regular booth and move toward the weeping man, stopping just short of him and embracing. Together the forgotten footballers dance, each compelling the other to lead. Their beards entangle and break loose of their collars.

Harry and Dean watch the men. Harry can feel the insects in his stomach vibrating with hunger. The vibration climbs Harry's veins, filling his body, distorting Hunter's vocals, turning it into laughter. Dean begins to sing:

> *Gee, but it's hard to love someone*
> *When that someone don't love you*
> *I'm so disgusted, heartbroken, too*
> *I've got those downhearted blues*

Dianna skates circles around a grease stain in the kitchen while The Cooker warms up Harry's pie. Food erupts with spits of fat while it dies on the fryer. The grease stain looks like a star on Hollywood's walk of fame and Dianna believes she sees her name. Saucepans bleed steam on the stovetop. Dianna lowers to her knees to be closer to the star. The microwave beeps success. Dianna touches the star, running her fingers through its center. The Cooker removes the slice of pie from the microwave. Dianna brings her blueberry lips toward the star. The Cooker smothers the pie in a squirt of whipped cream. Dianna's glistening tongue toys with touching the star. The Cooker rings a shrill bell.

"Food's ready!" he shouts.

Dianna fumbles to her feet, steadying herself on a sink. She clutches the plate in her hand and places it on a tray. She collects two white mugs and pours syrupy black coffee into each. The coffee smells like crushed ants.

"Take it out to the gentlemen," says The Cooker with a raised, strike-ready hand.

Dianna rolls toward the diner but pauses at the threshold that separates it from the kitchen. She closes her eyes. She feels as though this may be a movie. The lights warm her face and the set is prepared for the big scene. She moves toward Harry and Dean's booth. This is not the same diner. This is not the same life Dianna awoke to.

> *Once I was crazy 'bout a man*
> *He mistreated me all the time*
> *The next man I get has got*
> *To promise to be mine, all mine*

Alberta Hunter plays on a loop and the air conditioning vents drone in rhythmic waves to greet her siren call. Patrons abandon their food and join the footballers who continue their dance. People pair up randomly and move against each other's bodies. Pores forfeit beads of sweat that lose themselves on the bodies of others. Dianna has stalled halfway between the kitchen and the booth. The writhing bodies steal her attention and the tray drops from her hands. Spikes of coffee reach from their mugs as they collide with the ground. The slice of apple pie splits and collapses. Pitch-black cockroaches push through the processed apple sludge and scurry toward the dancers. Dianna follows; mashes them beneath her roller skates and leaves their crushed bodies behind as she joins the dance.

Trouble, trouble, I've had it all my days

The dancers move aside for Dianna who now stands at their center.

Trouble, trouble, I've had it all my days

Dianna unties her apron and slings it aside.

It seems that trouble's . . .

She begins to turn in slow circles.

Going to follow me . . .

The other dancers begin to turn in slow circles of their own.

To my grave

The speed of Dianna's circles increases and she casts her gaze upward. The diner spins around her, becoming streaks of fluorescent light. Within the vortex of her circular blur, she forgets the world around her exists. Dianna is a star. Dianna is a star. Dianna is a star. Dianna falls to the floor and her world turns black. Dianna falls to the floor and her scene is over.

Dean Mensberg sits in the same booth as every other day across from his companion, Dianna Lane. Dean wears a grey leisure suit that he may have been born in. It sucks at his body, choking out sweat that spots his forehead. Dianna is younger and sits with her chest out as if perpetually offering her body to a world of darkness. Over time, her smile has devolved into an experienced grimace—a grimace that informs the world it has already won—a grimace that suggests her big break has completely broken.

Dianna scrutinizes the orange paper napkin that sits on the table before her. She brings her head down low until her ear kisses the formica. She raises her arm before she raises her head. It floats naked above the two of them, causing Dean discomfort.

"What's with the hand?" he asks Dianna.

Dianna tilts her head toward the napkin, her arm becoming more rigid with the passing seconds.

"What's with the hand?" Dean asks again.

"Look at the napkin," replies Dianna.

Dean directs his gaze at Dianna's napkin, studying it, willing himself to see what Dianna sees. When he sees it, an asthma attack erupts from Dean that chokes his face red and puffs his eyeballs. He fumbles around his jacket pocket, fetching a string of rosary beads, which he presses against his forehead until the asthma subsides. Once composure has been regained, Dean raises his hand to match Dianna's. They are prepared to keep their hands raised for as long as it takes.

From the diner kitchen, a man called Harry watches Dean and Dianna with their hands raised. He's been watching them the whole time, wondering what to do, wondering if he'll be blamed. This is Harry's first day as a waiter at the diner and he hasn't yet amassed the courage to confront the problem. Harry doesn't understand why he's here. The insects in his belly dance in circles.

HADLEY

BEN LOORY

The guard is taking a head count, and he comes up one man short.
 Hadley? the guard says. Hadley?
 But Hadley isn't there.

What are we going to do? the guard says to the other guard.
 I don't know, the other guard says. The warden is going to be mad.

The guard makes a big doll. The same size and shape as Hadley. He puts the doll in Hadley's cell.
 That oughtta do it, says the other guard.

The days go by. Everything is fine. Mealtimes are the hardest part. The guard takes "Hadley" to the mess hall in chains, as though the prisoner were under close guard. He even cuts up Hadley's food and feeds it to him very carefully. Hadley is too dangerous, he insinuates, to be allowed to handle silverware.
 The other prisoners all are fooled.
 I wonder what Hadley did? they say.
 They hope they don't do the same thing one day. Being fed by a guard would be humiliating.

Then one day something awful happens.

HADLEY

What is it? the guard says to the other guard.
The other guard is white as a sheet.
It's the warden, he says. He wants to see Hadley.

The guard escorts Hadley into the warden's office. He puts him in a chair and stands beside him.
You can go, the warden says. This is a private matter, just between Hadley and me.
The guard looks at the warden. Then he looks at Hadley.
I think he wants me to stay, he says.
The guard and the warden both look at Hadley.
Hadley doesn't reply.

The guard stands in the hall outside the warden's door. He doesn't know what to do. He stands there for a long, long, long time. Finally, he hears the warden calling.
Yes? says the guard, opening the door.
Hadley is lying on the floor.
The prisoner is sick, the warden says. You should probably take him to the infirmary.

The guard carries Hadley down the hall. Hadley coughs and coughs.
It's okay, says the guard. You're gonna be all right.
But he has a hard time believing what he says.
Hadley's eyes are swollen shut, and there are dark circles around them. His skin feels strange, and he is very cold.
How could this happen? thinks the guard.

The guard sits by Hadley's bed for days.
What's the matter with him, Doc? he keeps saying.
We don't really know, the doctor says. He's fine, except for he's dying.
The guard looks at Hadley.
You can't fix him? he says.
No, says the doctor. We tried that. Best advice is hope and pray.
And then he walks away.

The guard stays in the infirmary every night. He holds Hadley's hand and talks to him.

Can you hear me, Hadley? he keeps saying. Can you hear me? I'm here. Can you hear me?

But the only response he ever gets is the sound of Hadley's shallow, ragged breathing. And then one day Hadley's cold and still, and the guard is all by himself.

The guard knocks on the warden's door. He does it with the butt of his gun.

Come in, says the warden, and the guard goes in.

What are you doing with that? says the warden.

What did you do to Hadley? says the guard.

What did I do? says the warden. I did nothing.

You did! yells the guard. He was fine until he saw you! You said something, you *did* something to him!

The warden stares at the guard. Then he shakes his head.

You wouldn't understand, he says.

I'll understand, the guard says. You'll make me.

And he raises and cocks the gun.

Go ahead and shoot, the warden says. You'll never learn anything from me. Go ahead, really; be my guest. It's not like it'll do you any good.

The guard's finger tightens on the trigger, but for some reason he can't seem to shoot. The trigger's stuck; something's wrong. He curses, tries again and again.

Meanwhile, the warden laughs.

When you're done, he says, you're fired. Turn in your gun on the way out. And your keys, your uniform, and badge.

The guard stands outside the prison gates. The other guard stands beside him.

I'm sorry, the other guard says to the guard. I don't know why things like this happen.

On the bus ride home, the guard sits quietly, staring out the window at the

world. He watches dully as it all drifts past—all of it flat and gray. There is no sound but the sound of the engine, and the creaking of the worn-out bus. There are no other passengers on board. The guard is all by himself.

That night in bed, the guard stares at the ceiling, trying to get it all straight.
I'm no longer a guard, he thinks and thinks, over and over in his head.
He tries to see himself as something else, in some other line of work, but he can't think of a single job he would be qualified for.
In the end, all he sees is a man in his bed, lying there in the dark. Lying there alone in the middle of the night.
What's the point? he says. What's the point.

The guard gets up. He goes to the closet. He opens it and finds an old uniform. He puts it on, takes a gun from the dresser, and then heads toward the door.

<center>****</center>

The guard walks the streets of the sleeping town. Everywhere, everything is deserted. Here and there, he seems to see a shadow—but the shadow is always of nothing.

Eventually the guard finds himself in the park that lies in the center of town. It's not much more than a patch of dirt and some sickly, broken trees. The guard stands staring up at the sky—at the cold, dark, empty sky—and as he does, a cloud takes the moon, and some dead leaves scrape on by.
The guard takes the gun out of its holster. He has owned this gun for years. He has fired it many, many times, but never for what you'd call real. He raises the gun and puts it to his head. He has never done anything like this. He has never even thought of doing such a thing. And yet here he is now, doing it. He feels the barrel against his skin. It feels cold; he can feel the roundness of the hole. He thinks of the bullet lying inside, waiting to be summoned out.
The guard's finger tightens on the gun's trigger and everything inside him starts to leap. And then he feels a touch on his arm—a hand, gentle, but firm.

The guard lowers the gun. He turns around, knowing full well what he'll see. And there, in the dark, he sees the face of the escaped dead prisoner, Hadley.

Please, says Hadley, hand over the gun.

The guard does so, without question.

You shouldn't be handling things like this, Hadley says. It isn't safe.

The guard goes with Hadley back to the prison and they walk up and down the halls.

This was your cell, the guard says to Hadley.

Of course, says Hadley. There's the hole.

Hadley steps inside and kneels down, peers into the dark.

It's a long, long way, but not that far, he says, and starts to crawl.

The guard stands and watches for a while, and then he looks around.

And in the morning when the warden appears, the prison is nowhere to be found.

WHERE WALLS WOULD HAVE

BLAKE BUTLER

The wide face of the far wall, the first wall, soon grew so we could not discern it from the sky—bleached white on white from years of sunning, surrounding all our minds. As the sheer white around the city fattened, our air took on new mesmerizing light, refracted back and forth between the two—light that'd blight your eyes out, though just looking long enough would get you drunk.

The light was free. Our children suffered, in their bodies, as did we. As did the wall, which in the new heat would speak. The sound ransacked our city, a low long crinkle like book paper being ripped apart or writ upon—which, in friction with our buildings, shook our bodies and the wall.

For weeks we could not stop laughing. Our sleep became destroyed. Caught in the air of those blown dream rooms, people hurt people. People died. The city earned its night.

The city silent even under all that laughing, as our softer organs learned to disregard.

The wall had been designed by men before us to show us where was where and what was when. Beyond the wall, we knew, there lay an acid ocean that could rip our bodies into blood.

Where the far wall against the sky now seemed no longer, our sadder minds began to walk. To try to scry a way out of the city, some new exit.

No. The wall would burn their skin.

Many further bodies had to be killed for trying, as one hole rended in the far wall's flat face might let the inside out and outside in. Might bleat again straight through our bodies, like how all those before us here had fried.

We built another wall inside the old one, to keep kids from trying, and to muffle the new sound. This second wall was slightly higher than the first, by several men's lengths, which made it hard to see the sky at all. The space between the new wall and the old one was deemed unhealthy, and entry punishable by perpetual imprisonment or blight.

This second wall was bright brown, the way our sky-burnt flesh had for all of us become. From a distance, through my window, the wall looked like several thousand people in a line, their bodies all together meshing, watching on us, or looking all away.

How you interpreted this vision became a way to say what kind of hope lived in your heart, they said. In secret I was bitter, though in the streets I grinned and sucked my tongue.

I'd already lost my children to the Growing. I'd partitioned my old mind. I could have shook from the saddest of us a small insurgence: *This is not working.* Instead, at home, at night, I carved. In wood I stole from torn down buildings I envisioned objects I'd never had and always wanted—things long forbidden in these walls. Though I could not think to call the objects as they had been—those terms absconded—I named them each with my own mind.

For the image of the long stick used for hitting, with which once our men had gathered into teams, I chose the name Atlanta, for the city where I was born—now buried well beneath us underwater, in the Leak.

For the image of square box from which once colors flew, images encased in them as well, frames of now forgotten men and women carried on the air with sound and light, I chose the name Belial, which I have been told means *pleasure mind.*

I could not think of any name to call the oak I cut into the image of a man. No familiar someone's names came into me, no matter how I tried.

In great daylight our second wall hummed in vast contrition with the first. Within a wide range of the more recent, the sound wound on the air, causing little pockets of weird fission that would adhere to your skin. For a while these became popular tattoos, a sign of fearlessness or power. Soon, though, the tattoos would turn to wounds. From the slim packed slits the humming walls made, the branded bodies opened peels, pouring from them a gold or purple substance that smelled like nothing and yet burned. This gunk as well would cause more wounding, transmitted on contact, on the air.

Those bearing the mark, then, had to be surrounded, gathered, installed in treatment camps beyond the outskirts of our town, led through subterranean tunnels to a location where their names as well would be struck out.

It was said by some that these locations were centered beyond the far wall, a secret outpost by the State, though those who said that often too soon had the bruises, and were picked up or disappeared.

By night, by now, the walls were silent, or at least more so than the first alone, though in my house, locked in the bedroom, I swear I could hear the screaming from the itching of those bodies' overgrowing sores. Almost a language in the groaning. Almost a war.

When the mandatory petition for a third wall, then, came around—I signed.

The third wall was translucent, hair-thin, which at first seemed like an excellent idea, designed to minimize the want of what young ones we had remaining: *If they can not see what they despise, then they will learn to breathe it in.*

This logic quickly proved neglectful, as kids and cats and other bodies collided with the endless, flattened clear. Jogging injuries quadrupled. At certain speeds men burst open their whole head, laying on the newer, thinner cram of our air a smell that refused to wash away. Small planes and box kites ended badly. The most common word that year was "Ow." The second most was "Oh."

Still, the spatial blunder was looked over until one of our countless nameless local Statesmen hit the wall head-on in his glass helicopter, drunk on light. His blood rained down all in one gush.

Where he thought he was headed outside our district, I can't imagine, and no one else would say.

The wall's face was to be adorned then, demarcated, like the others, *like a wall is*, so we could name it, so we could see. The advertisers flocked. Soon the wall blinked in the night all neon, 3D, slathered with fine foods and women's tits, watchwords that made us want more.

I carved and carved and carved, though I was running out of wood. Our newer homes were made of plastic, ash, things I could not force a form onto.

With what I had I made a tower. I made a tiny horse, a wand, a ring.

One night I made a doll that looked like me. I had not meant to cut the wood to match my soft eyes, which seemed to have grown closer in recent years; I had not even realized the way my body in its sagging no longer even seemed a female shape. I cut the wood down smaller and smaller, slashing at me, until in my hands the wood was gone.

On the night for a while then the third wall triumphed. Ads were sold to adorn the other ads, a teeming sound-barfed crowd of color, sort of gorgeous. Even under crumpled population our state's tax and income revenues totaled in trillions—enough to build another, better wall.

A thicker one. One smarter.

This new wall, we knew, would be just right.

The fourth wall—black as night blood in the daytime, and in the nighttime white as day—went up so far it appeared to never stop, though with special lenses you could see, way up there, the gun turrets and strobing lights, made to distract the wayward birds and brigand planes.

You were not supposed to see the wall—to look directly at it—but you had to know that it was there.

Machines were installed on the far side of the fourth wall to make sounds of commotion during light: intense female screaming, artillery fire, the bubbling of blood, as well as various unidentifiable noises, which were by far deemed the worst. The volume hung low throughout the city, covering the older sounds, and only increased as you came nearer to the wall, approaching a sound so loud that it could eat you, take the flesh right off your face. This would inspire, in future reams of children, an association that would lead to valuable non-fleeing impulses and therefore a general at-home goodwill.

At night the machines were replaced by men with masks and prongs and bugs. They would put the insects on you first, a warning. Then, if you still hung around, they'd zap.

Though this was likely the least popular of all walls, it was for sure the most effective.

And yet within weeks the headlines screamed trouble—there'd been an error in the fabric of our wall's new face. Crud was gushing in through tiny peepholes. No one was so safe.

They rushed to put up the fifth wall made of plaster, this time high enough there seemed no end. This one's each inch was embedded with long spear points, topped with a laser guided missile eye.

And soon a sixth wall, of gluey substance, to which a foreign body would upon contact stick, the stink of which brought bees from other years in legion, lining every yard with hiving.

And so another wall. And then another. Higher. Nearer. Further in.

By now, the inseam of our city's far perimeter had shrunk distinctly, though it was hard to say how much. People were walking closer together, rubbing bodies. I felt fatter, for how my thighs burned on certain streets. The buildings once considered outskirts lay beyond the outdated walls therein, molding over, licked with dust, though you could only see them from certain registered locations, for a small fee, as the walls kept getting higher. Homes were built on top of homes were built on top of homes on top of homes.

Doors to certain buildings became blocked off, as if they'd never been right there.

Another new wall was rumored to be made from collapsing bodies in our close, gross cramming air, though surely this was meant to keep the streets less busy, and so more people would buy guns.

And the houses stacked up higher. The light strained, seeping, low.

By the time I could not count on both hands the rings of city walls and walls that in mind I could remember, there was nowhere left to walk.

Through the windows of my own home, the most recent wall stood right there, watching, a reflective surface kissed with light. I could hardly hear my breath go in and out, the warm air crushed and crushing in around me, lining my insides with fresh mush. My heartbeat stuttered through me, trying to keep up. *Ow.*

And yet they found ways to wedge in more.

The space between each thinner, halving, multicolored.

And soon then in my home too the air was subdivided, making many rooms each of my rooms, to help house the writhing population. At night I could hear my neighbors in their new rooms right there beside me. I could hear them making love. The grunts and thrusts made me carve faster. I made more things, one by one. I could no longer think of names to give.

In bed I'd sit up wheezing white for hours, the endless sound all in my head, working my knives in rhythm, sometimes slightly bleeding on what I made—my last wood cut down into small things, the function of which I could no longer recall—each of which I would then press to my chest and try to breathe in, to scratch my lungs with what they knew.

IMPRINTING

J. DAVID OSBORNE

Detective Jack Martell couldn't remember if he killed Anthony Rodriguez or if he was just really happy that he was dead. He clocked in at the station early, grabbed a cup of coffee, and headed to the briefing room. The chief spat and turned red in the face. Martell shrugged to himself. He was ranting like it was their fault the son of a bitch was dead. Which it wasn't.

Still, Martell clearly recalled plunging a knife deep into the coke dealer's throat. He ducked under the yellow crime scene tape, the sun at magnifying-glass-height, burning through the palm trees and soaking his suit in sweat. The body was already on its way to the morgue. He walked the alley, interviewed the surrounding grocery, travel agency, barber shop, and dry cleaners. His partner took the other side of the street, and when they met back at the squared-off crime scene, they both had nothing.

"So, no one saw anything," Martell said.

"Surprise."

Martell chuckled. Ronald Trejo was slightly older than him and much more cynical. Sometimes it got on his nerves a little bit, his partner being that negative all the time, but today, with that nagging feeling in the back of his mind, he needed an excuse to laugh.

"Personally," Martell said. "I'm glad someone got the bastard."

"Me too. You hungry?"

He nodded. "Starving."

He watched downtown Los Angeles roll by outside his window. Saturday morning: young Latin women pushed strollers, black kids went shopping,

big-chested blondes sipped frozen coffee. A group of middle-aged men huffed and sweated on a basketball court. Bums played songs behind open guitar cases. At a stoplight, he rolled down his window and gave his Styrofoam box of leftovers to a pale man in a trenchcoat. Already the chorizo he'd eaten was figure-eighting in his guts, and just having the box had made him feel sick.

Trejo parked in the garage by the station. Martell hiked to his desk. Paperwork bored him, but he liked the distraction. He wondered if he should change the details of anything he'd seen or heard. Wondered if it could come back to him in any way. Then he shook his head. *You're not even sure this was you.*

He was confused. He didn't have anything against Rodriguez. The guy sold cocaine. Okay. It was his job to care, sure, but he'd done coke before. It was alright.

He leaned back in his chair. Got some coffee. Wandered into the briefing room, where Rodriguez's picture was tacked to the wall, caught in a spiderweb of other bad guys. A red X taped across his mugshot. The X intersected right in the center of the kid's face, both eyes peeking out from deep inside the jaws of the double-headed alligator. Martell took a step closer, then another step, and pretty soon his entire vision was engulfed in red.

He stopped at a gas station on the way home. Bought milk and hot dogs. At the register, he considered buying a pack of smokes, but bought a lottery ticket instead. The girl behind the counter rang him up. He fondled a spinning rack of keychains. He scooped one off its hook and placed it on the counter.

The house smelled like berbere. He took his shoes off at the door and set the bags down on the counter and wrapped his arms around Sandra. She stirred the soup and leaned her head to the side so he could kiss her neck. She poured two bowls and they sat and ate. He washed the dishes and dried his hands and sat down next to her on the couch.

He pulled out the keychain he'd bought at the gas station. A little green alien with big sunglasses. She laughed and put it on her key ring.

"When are we going back to Roswell?"

"Whenever you want."

"I like this little guy."

"I saw it and thought you might."

"So we can go this summer?"

"We can go whenever you want."

They watched a show on TV about aliens and Mayans. After that they watched a comedy show, then *Alien* on TNT. Martell had seen it about a hundred times, but his wife loved it, so he watched it again. They brushed their teeth and went to bed. He held Sandra and tried not to breathe too heavily.

"Do you want to go out to eat tomorrow? Thai food, maybe?"

She rubbed her eyes and grabbed his hand. "Can't tomorrow. I have a date."

Martell's stomach tightened. "With who?"

"Thomas, from the Tavern?"

"Thomas? I don't remember him."

"He was the cute guy who made your macchiato."

"I don't remember a cute guy."

She kissed his hand. "We're gonna get some dinner and watch a movie."

He held her tighter, because he didn't know what else to do.

The next day Jack Martell felt slightly convinced that he hadn't killed Anthony Rodriguez. He tried to replay the stabbing in his mind, the memory that had seemed so vivid the day before, but instead of a clear picture he had a nagging feeling, like you might get if you stood by a steep cliff and felt like jumping off.

He stopped at a Greek place and ordered a gyro. An old man behind him said, "Five dollars for lamb."

Turning to face him, Martell said, "I know! Prices are getting a bit steep."

The old man shook his head. "No, no. Five dollars is way too cheap. I wonder how they got it so cheap. Probably, it's old."

He ate half his gyro on the way to work, then threw the rest out.

He sat at his desk, in his own little world, until late in the afternoon. The office suddenly erupted with activity. He caught the electric scent in the air and found Trejo by the water cooler.

"What's going on?"

Trejo crushed his paper water cone and tossed it in the trash. "We're up."

"Huh?"

"Mendoza turned himself in for questioning about five minutes ago. Says he has information on the Rodriguez case."

"*The* Mendoza?"

"Yep. He's in Room 2. Let's go."

"When Tony died, I wasn't surprised," Albert Mendoza said. He seemed comfortable under the bright lights, his hands crossed in front of him on the steel table. "We make a lot of enemies, doing what we do."

"Doing what, exactly?"

"Nothing at all. People just hate us, I guess. Anyway, we make a lot of enemies. So, I send my boys out."

"Which boys are these?"

"My sons, of course. They were in the middle of their soccer game, and I knew that after that it was their nap time, but work had to be done. So I sent my boys out to find out what happened to Tony."

"And what did your 'boys' find out?"

"Nothing. Nothing at all. And that's what's weird. These guys are good. These kids, I mean. They're like really good dogs or something. They get the scent, you know. But they didn't find a thing. There are some groups on the Southside that didn't get along with Tony very well."

"And why's that?"

"They had beef over a shuffleboard game. Tony was an avid player, and really good. Well these guys, they were the shuffleboard champs of their neighborhood. And Tony just comes in and stomps them. Makes them embarrassed. Their girlfriends start hanging on Tony. And you know, things escalate. Never fuck with a shuffleboard player on his home turf."

"Good advice."

"So anyway, none of these guys, these bad shuffleboard players, had anything to do with the murder. Which surprised me."

"How do you know?"

"Those boys, I'm telling you. They find things out."

"And how is that?"

"Mostly they trade pogs for it. You remember those? Big craze when I was a kid. These little discs, about the size of a communion wafer. Well, those things fetch big money, now. People still go nuts over pogs, but now

it's like a money thing, instead of a collecting thing. My boys have all of my old pogs. Trade 'em for good dirt."

"I see."

"So anyway. I start to wonder. Did Tony just piss someone off? Just some average guy? And so I get my buddy to pull his credit card statements. The last place he went to, the last thing he bought, well that's not very interesting. It was something that cost $5.19 at Taco Bell. But a few purchases before that, a few days before he died, he visited a florist."

"Go on."

Mendoza lifted his hands up. "That's it. That's all I've got. I just thought you all should know."

"You came here to tell us that Rodriguez bought flowers."

"That's right."

Trejo stood up and stretched. He walked out and closed the door behind him. Martell leaned in close.

"Why are you telling us this?"

"Because you have resources that I don't have. I'm a busy man."

"Busy doing what, exactly?"

"Well you see, I'm really into car restoration . . ."

When Martell got home that night, the house smelled like the house. He ate some leftover soup and watched TV. He got bored and turned it off and went onto the back porch and listened a nearby neighbor's party. He lay in bed. He thought about Sandra. He thought about her, out with Thomas the cute barista. He pictured her laughing. He reminded himself that the laugh in his brain was a recreation, something that he could own, but that her real laugh belonged to her, and he couldn't keep it.

He just wanted her to be home.

He hugged her pillow, now close to positive he didn't kill Anthony Rodriguez.

Martell awoke to the smell of waffles. He went downstairs and Sandra smiled and handed him a plate. She sat down across from him and they ate their waffles quietly.

He pulled the words out with both hands: "How was your date last night?"

She smiled and arched an eyebrow. "It was great."

He moved the syrup around with his fork. "That's good."

"We went to a great movie. The special effects were so good. He bought me popcorn. After the movie we went out to have some food. I think I had Thai on the brain, after what you said. I got some green curry. I was trying to keep my nose from running, it was so hot. He thought it was cute."

Martell chewed slowly. "That sounds fun." Already in his gut, he knew.

"So after the date," she said, and Martell could feel the waffles fighting to come back up. He could already see it, this kid inviting her up to his apartment, turning on some music. He thought about how excited she must have been, and that excitement broke his heart. And she was telling this story, just as evenly as can be.

Martell stopped her. "I've heard enough."

Sandra looked like she'd been slapped. Then her face melted into this pity. She reached her hand across the table and stroked his arm like he was the only survivor of a car wreck. "Jack. If we don't do this together, it's never going to work. Remember? The imprinting? If you don't experience this like I experienced it, then it's just random."

He remembered the books. He remembered that he was supposed to get turned on by this. To relive the excitement of Sandra's first date with this boy as though it was their date. Supposed to keep the relationship fresh.

"You fucked him? Really? That quickly?"

She got up from the table. "Fine."

Martell talked to his plate. "I'm not shaming you. I'm just surprised."

Sandra kissed him. "I love you. You are my love."

His head, spinning.

She walked out of the kitchen. Martell dumped his waffles down the drain.

He had been so close to convincing himself he had nothing to do with Rodriguez, but now it was more a question of *why* than *if*. Why would he have killed this guy? Why would he have killed anyone?

One time, about a year prior, Martell was dropping Sandra off at the airport, so she could fly to her mother's for Christmas. When he pulled up to the drop off, he was nearly sideswiped by a limousine. He threw his hands in the air and made a face. The limo screeched to a halt, the passenger

door opened, and the limo driver got out. He walked over to Martell's car, made the "roll down your window" motion, and when Martell complied, the guy spit all over his shirt.

If he was going to kill someone, he reasoned, he would've killed that guy. No question.

The Tavern was quiet. Thick rimmed glasses reflecting laptop light. Gentle sips of hot coffee. Music Martell didn't quite recognize. He ordered a coffee from a smiling woman and sat at a table. He blinked and when he opened his eyes he saw all the patrons as Russian nesting dolls. The couple that sat laughing and pointing at *Cosmopolitan* were very small dolls, freshly painted, intricate swirls and patterns. The quiet man and woman, each of them engrossed in the screens of their Macbooks, he saw them as slightly bigger dolls, each with a few chips, a few more layers. And him, sitting there, suddenly he felt big, like he could take up the entire coffee shop.

He missed his wife. Or rather, he missed a picture of his wife that he kept in his mind. Maybe that was the person he loved. There's a possibility, he reasoned, that she never existed.

But he knew that wasn't true.

Quick memories: the Grand Canyon, Roswell, San Diego.

He went to the bathroom. There was a small jar full of free condoms sitting on the lid of the toilet. He took one and washed his hands.

Threw his coffee in the trash. He walked around the backside of the counter and disappeared into the kitchen. There, on the rack of aprons, was a full body hanging, deflated, open in the front.

He saw red everywhere. The red of the microwave clock sitting on the breakroom counter. The red of some barista's cellphone, blinking from her purse. Until there was nothing but red.

Martell picked the skin off the rack and stepped inside.

He fixed himself a double espresso and went to work. Customers came in for the lunch rush. He'd never made coffee before, but there he went: milk under the steamer, pumps of syrup in paper cups, tips in the tip jar.

Molly flirted with him throughout the day. Martell had known her for about three months and could feel that he was close to fucking her. Their talk consisted mostly of double-entendres. She answered most of her texts

with a winky face. He was close.

He finished up his shift and waved goodbye to Molly. He checked his phone for texts and Facebook messages.

There was one from Sandra. He answered her back and put the phone in his pocket.

He took the bus home and waved hello to his roommates and flicked on the TV. He lamented the state of the world. He hated the stupid shows and the stupid commercials. He watched the news and hated every stupid opinion. He smoked a bowl and watched cartoons. He laughed with his roommate and his roommate's girlfriend. They were still tripping from the acid they ate the night before. They told stories of seeing skulls everywhere, of the vividness of the trees, and for a moment he was tempted to eat the last tab, waiting for him in the freezer. But instead he turned on his computer. He tweeted and downloaded music. He worked on a paper for his English class. He got on Facebook and looked at his ex-girlfriend's changed relationship status and felt a deep jealousy overwhelm him.

He shut the computer down and texted Sandra. She answered back right away.

They met up in the park. They sat on the steps of an empty outdoor ampitheater. He felt comfortable around her. He talked about how frightening it would be if sharks had arms and legs and could breathe oxygen. He told her about his failed relationship and she listened carefully and gave him good advice. He liked being around her, a lot.

But he kind of didn't want to have sex with her.

They went to a bar and she bought her own drinks. He asked about her husband.

"What happens after you and I . . . you know?"

"Well," she said. "What will happen, is that I'll go home, and tell him exactly what happened. There's a process called imprinting. We both relive the experience you and I have, and our love gets stronger through that process."

Martell thought that was a strange idea, but he nodded his head and sipped his beer.

As the night went on, the alcohol made them both horny. He didn't want to take her back to his place again, and he also didn't like the idea of fucking in a car. He wanted a nice bed away from his roommates.

So, she took him back to her place.

"Won't your husband be home?"

"We're not cheating," she said. "He needs to be a part of this."

The whole way there, Martell felt strange. He remembered, distantly,

plunging a knife deep into someone's neck. It was mostly shapes and colors, but the sensation of the knife penetrating the skin was very clear in his mind. But he couldn't remember who it was he'd killed or why.

They walked into the living room and her husband was sitting on the couch. He didn't say a word to them. Sandra gave a weak hello and set her keys on the counter. Then they went into the bedroom.

His pants were gone, she was on her knees. Then he was slipping on the free condom from the Tavern. Then she was looking up at him, saying, "You work so hard for me."

He couldn't finish. He took the condom off and she put him back in her mouth. He closed his eyes and concentrated. He gripped the sides of her head. He couldn't tell if she liked it, but she didn't stop him.

When he was done he put his clothes on and walked out into the living room. The husband was still sitting on the couch. He was looking down at his hands.

Martell looked closer and could see that the guy was holding a keychain, a green alien with big sunglasses.

He ran his hand through his hair and walked out the door, still without saying a word.

He stumbled down the steps, feeling the alcohol take hold. Everything spinning. The husband looking down at his hands. He got to the curb, threw open their garbage bin, and hurled. He tasted beer.

Jack Martell rested his arms on the bin. Sweet trash smell making him gag. And from the bottom of the bin, he saw a bouquet of flowers with a red card attached. He focused on the card, and kept focusing, until all he could see was red.

POPULATION: 2

CODY GOODFELLOW

Driving between Death Valley and the Mojave Desert at the expected pace of as quickly as one can get through a desert in a car, you would probably never notice the signpost somewhere shortly after Mile Marker 89 for "AGUA PERDIDO, POP. 1; NO SERVICES; NO SALESMEN." And if you had stopped to consider the official-looking metallic flake green sign posted at the turnoff beside a formidable gate blocking a warped, half-buried two-lane road winding off into the scrub-encrusted dunes, you would have thought it some twisted hermit's address, or a tired road crew's joke, or the last monument to a ghost town so unremarkable that it didn't even show up on geological survey maps. And you would have returned to the highway—perhaps after stealing the sign, as three unscrupulous motorists had—because no one had ever jumped the gate and followed the road to its terminus since Dora Moss set up residence there.

Had a motorist ever got past the gate and reached the streets of Agua Perdido, he would have found the diner packed to capacity with its doors locked, the beaming patrons teasing the hungry traveler with their forever unfinished plastic breakfasts. The sheriff's deputies, playing a hand of cribbage in their adobe jailhouse, would have found the game too gripping to answer their door. The town drunk in the gutter out front of the hotel wouldn't stir from his dreamy doze if you dashed Chivas Regal in his face. Had anyone ever stopped at Agua Perdido, they might have figured it for a mock-up town awaiting an H-bomb test and peeled out for the highway with all due speed. But no one ever had, which was just as well with Dora Moss, who was never at home with people who walked and talked.

In her demeanor, if not in her gender or outward appearance, Dora Moss would handily meet most peoples' expectations of a twisted hermit.

POPULATION: 2

When she first discovered the defunct water-stop and filling station on a seventy year-old map, Dora Moss knew she had found a home. A discarded time capsule of everything good and useful that human beings had made, it was all the modern society as she could stand. She set up housekeeping in the old hotel, her kitchen in the diner, her office and studio in the jail, and her garage and tool shed in the gas station. The loneliness of the arrangement suited Dora Moss's fervent misanthropy, but its blankness soon came to violate her aesthetic sensibilities. Thus, it was out of a need to decorate and not any neurotic longing for company, that Dora Moss populated the town with mannequins.

She ordered thirty of them from a factory outlet in North Hollywood that specialized in "normal" people—fat, old, ethnic and, to custom specifications, mundanely or monstrously ugly. Their faces were picked out of old newspapers, mugshot books and movie magazines. The hotel manager was modeled on Ben Turpin; Mayor Mudd was modeled on Sunny Jim Rolph, while Friar Buck owed his plug-ugly mug to Rondo Hattan. She costumed them from local thrift shops, but the sheriff's and deputies's uniforms had to come from a vintage police outfitter in San Bernardino. A few props here and there fleshed out the illusion of a picture-postcard Western town of the late 1930's, a petrified oasis filled with people who didn't care if the world outside was still there, just like Dora Moss.

So she was caught completely flat-footed on the night the Traveling Salesman came to town.

Dora Moss had chicken-fried steak with white gravy and eggs over easy for dinner at her usual booth in the diner. The jukebox noisily swapped platters, from "Peg O' My Heart" by Jerry Murad's Harmonicats to "Delicado" by the Three Suns. Pausing between bites, she would freeze and blend into the diorama she had built, merging with the static past, embracing eternity. Reedy, cross-eyed Norbert Prawn, the manager of the Dollhouse Hotel, forever passing the salt to Sheriff Fudd. Dottie the senior waitress laughing at a joke told by Mike the Milkman—or was she gasping in shock at the good-natured goosing Mayor Mudd had just given her in the moment his blue-haired battleaxe wife was scolding Timmy the simple busboy for spilling her coffee? Dora Moss finished her meal with the certain knowledge that she could live here happily until the day she died and the mummifying desert wind made her one with her mannequin subjects.

Someday the press would get wind of Agua Perdido and make another roadside sideshow out of her hermitage. Her town would be ruined someday by tourists curious to enjoy the haunting solitude they destroyed with their RVs and motocross bikes. But for now, she floated in a moment that had lasted undisturbed for two years, and might as well go on forever.

She tipped her spare change into Dottie's apron as she headed for the door. She hated carrying coinage around, and always forgot where she put it around the house. Dottie was as good a piggy bank as one could ask for. Outside, a buttery harvest moon rolled across a cloudless sea of starry ink. The desert at night had shown Dora how primitive peoples could have believed it was a chariot, and children accepted that it was a wheel of cheese. She pinched a cigarette from the overall bib pocket of Snuffy, the oldest of the three Old Coots on their rocking chairs in front of the general store, struck a kitchen match off his blackened, cauliflower nose. What she saw by its light made her blow it out with a sharp breath of shock.

"Aren't you a bit old to be playing with dolls, ma'am?"

The man standing before her was wearing the bottle-green sharkskin suit she'd dressed Dino the town drunk in a few weeks ago. She'd doused the mannequin in gin every once in a while for effect and because sometimes she hated drinking alone. The suit stank, and looked like a month in a gutter in Death Valley. But the man in it wasn't Dino, or any other mannequin.

"Where did you get that outfit?" A foolish question, the only thing about the stranger that she *did* know.

He looked up at the sky and let the moon make a show of his big piano-key teeth. "I traded a drunk for it."

"Those are my clothes! What the hell did you take them off my drunk for? What do you think this is?"

"It was a fair transaction, make no mistake. He was most eager to trade."

"Trade? No, I don't even want to know. Get the hell off my property right now."

"You *own* this town?" Somehow, his smile got even bigger. "Well, gee, what a stroke. You're just the person I want to talk to, because this kind of offer has to go straight to the top. You think for a second about what we're talking about. Okay, where can a fella get a good slice of pie in these parts?"

"There's nothing for you here."

"What about that diner there?" He came close and sniffed her, sucking

up air like he usually had to pay for it. "You had the steak and eggs. Do they have good white gravy? You've gotta love a town, makes good, lumpy gravy. Shows they've got heart, and don't skimp on the little things."

"The gravy is made out of naugahyde. Would you please get the hell out of here?" Dora pressed her fists to her ears and walked around the pitchman in the purloined wino-suit, telling herself if she could get inside the hotel, the intruder would lose interest and leave, and everything would freeze again. If she had to, she could get the shotgun in her closet, but would she be killing in self-defense, or in defense of her eccentricity? Skeleton key in hand, Dora approached the lobby door of the hotel, then leapt back as a pale phantom staggered out of the shadows behind the porch glider. Gibbering and hooting exultantly, it tottered down the steps into the street. The moonlight turned the naked lunatic into an alabaster satyr, illuminating visible waves of gin fumes. Dino the town drunk spun in clumsy circles, showing off his flabby nakedness, showing parts she hadn't ordered from the mannequin company.

"I'm alive! AAAHAHAHAHA! I'm alive! Oh, 'scuse me, Missus. Which way to the saloon?"

Dora Moss locked the door behind her and all the doors between the lobby and the master bedroom of her suite on the third floor of the Dollhouse. She went to sleep cradling her shotgun.

Dora Moss was a late sleeper, but a light one. When she awoke to the shrieking and laughter from the street at the crack of dawn, she wondered where she was. Then it sank in: this was her suite on the top floor of the Dollhouse Hotel, in her town, and somebody was wrecking it.

She bundled up in her housecoat and slippers before she peered out the window. What she saw made her sure she would wake up for real now, and wherever she found herself, it would be more sane, more acceptable than here.

The whole town was out in the streets, shaking and swinging like Times Square on an ergot-trip. The jukebox had been pushed out onto the sidewalk in front of the diner to spray Bert Kaempfert's *Swinging Safari* and whip the crowd into a spastic muzak frenzy. The mayor, naked as a jaybird, purple with exertion and hickies, promenaded his wife on one arm and his secretary on the other, jealousy suspended for the festival day.

Dottie paraded out of the diner laden with plates with something like chocolate pudding with little flags and paper umbrellas stuck in them. She

brought them to Friar Buck, who squatted on the hood of Dora's pickup truck, with his robe rucked up about his waist, his hairy buttocks hovering over her Franklin Mint Limited Edition Memorial Serving Platter of the *Challenger* Disaster. As he stuffed his face with the suspicious dessert, flags and umbrellas and all, a long chocolate tail snaked from his backside and fell in neat, steamy coils on the plate, which Dottie grabbed and brought back to the kitchen.

Sheriff Fudd and his deputies chased skirts like the amorous automata of the Pirates of the Caribbean ride, only they caught theirs. A breathlessly giggling Fudd bent Minnie the Happy Housewife over the bus bench, while she pulled Mike the Milkman towards her by his belt and ripped the buttons off his white shirt with her teeth.

"Top of the morning, Miss Moss!" Sheriff Fudd bellowed. "Ain't it a glorious day to be alive?"

Dora Moss raced downstairs with her shotgun held like a club. She had been prepared to run off an intruder in her town, but what to do with *this*? Life had invaded her diorama; how could she drive it out?

Norbert was waiting at the door, a ribbon of scrip in one hand trailing back to the antique adding machine in his office. His chinless, thumb-shaped face beamed with an unacceptable newborn's delight.

"You ain't fixin' to shoot anyone with that thing, are you, Miss Moss? Sure would put a damper on the birthday party."

Dora leveled the shotgun on his face. "You stop living, damn you! Be a goddamned piece of wood like you've always been, or I'll blow you to matchsticks!" His unspeakable grin only widened, full of smug knowing that he could swallow buckshot and keep on smiling, that he was a symptom of her long-overdue nervous collapse, and could never die.

"Now you don't want to shoot old Norbert, ma'am. Who'll shine your shoes and bring warm milk when you can't get to sleep at night?" His voice *was* shiny shoes and warm milk, lulling the terror and rage back to sleep, sighing and tut-tutting like the warders at the fancy private asylum used to do when she refused her medication, when they had to put the jacket on her.

A Devil had come into her Eden and tempted her mannequins, corrupted them with life. She saw the Devil now, sitting in her booth at the diner, eating her breakfast. He saw her too, and waved.

Him, she could kill.

Norbert stepped in her way. "Hate to do this to you, ma'am, but Mr. Felix, he insisted—" His hand sprocketed the leading end of the streamer of paper into Dora's hand as it reached for the doorknob. She held it up

but it wouldn't come into focus.

"What is this?" She talked to the mannequins all the time—confessing to Friar Buck, shooting the bull with the Old Coots, gossiping with Dottie—but she always knew she was talking to herself. She wasn't that crazy—or at least, she wasn't that crazy yesterday...

"It's, um, well, it's your bill, Miss Moss. Mr. Felix thought it was time we put our house in order, so to speak."

"I owe *you* money? How much?"

"Well now, you've been here for nigh on to two years, now. So, at the weekly rate of $10, back rent comes to—" he worked his way back down the tape, "—oh heck, you've been a good guest, we'll call it a thousand even, gratuity not included, of course."

"*I* owe *you* $1,000 for staying here. *In my own damned town.* Who the fuck is Mr. Felix?"

"Now, Miss Moss, no need to take that bellicose tone with me," whispering and leaning close, he winked. "I'm on *your* side. I explained to Mr. Felix that, seeing as you were one of our finest customers, we should be kind of lenient with you. He's a real understanding fellow, Miss Moss. So he said you had 'til the end of the day to come across. But from now on, it'll be ten dollars cash, every Thursday."

Dora stepped into the street, rubbing her eyes and giving her brain one more chance to take it all back. The sun was too bright, it felt like a bulb she could reach out and unscrew. She might've been a wooden cigar-store Indian, propped before the doors while Norbert was waxing the lobby floor. The townspeople and their orgiastic festival were real. No part of her was sick enough to conjure up such bestial acts. She wasn't neurotic enough to deserve such torture.

Dora marched over to the diner, pointedly ignoring the scenes on the bus bench and her truck. Someone seized her by the hips and yanked her away from the door. Scratchy, the oldest of the Coots, manhandled her with most uncootlike strength onto his lap. His face reeked of sulfur and charcoal from all the matches she'd struck off his nose.

"Just sit a spell, Miss Moss, and we'll talk about the first thing that pops up." The Coots yukked it up as they crowded in to cop a feel, pulling at her housecoat to paw at her flannel nightshirt. Dora shrieked, but couldn't hear herself over the jukebox and the merry screams of the town.

"Feel that, Missy? Not bad for an old placer, huh? That's quality hardwood, yuk yuk. C'mon, Miss Moss, I won't give you no splinters."

"Unhand that woman, Scratchy, immediately." Felix came out of the diner, pulled the plug on the jukebox and wagged a reproving finger at the

Coots. "All of you should be ashamed of yourselves." He had traded up again. He wore the mayor's morning suit, down to the top hat and sash. Glutinous beads of chili bedecked the yellowed dickie, and the sheriff's .38 revolver and several stale, half-smoked cigars were jammed in the cummerbund. "After all, she's our guest. Our first and finest and so far, our only tourist."

He held out his arm, as if to escort Dora Moss to join the festivities. Numb, she took his arm, dropped the shotgun into Buddy the Coot's lap as he led her to the diner. A dozen mostly naked townspeople crowded in after them and seated themselves.

Dora could not look at them—and so was forced to look at Felix. She allowed herself to be boxed in by him in her corner booth. "Dottie! Another bowl of what I'm having for Miss Moss! You like good chili, don't you, Miss Moss?"

"Of course I do. That's my chili. And this is *my* booth, and *my* town. These are *my* mannequins. Who the hell are these people, and who the hell are *you*?"

Dottie brought Dora a bowl of piping-hot chili topped with sliced onions and shredded Monterey jack cheese and an iced tea with extra lemon, and hovered over them, doling out oyster crackers and spooning out Sweet'N Low.

Felix set aside the top hat and peeled off his gloves. "Miss Moss, I used to sell insurance, but now I just sell people whatever they want. If they want it, they sell what they have to me, and I give them what they want. Sort of like Pinocchio, isn't it? I make dreams come true."

Dora repeatedly pinched her earlobe, shoving gouts of blood into her brain. "You made them real. You made them come alive, and they sold you my town. That's what . . . this is?"

"I sold them what they wanted. I don't have any say over what that is, or how they get it. Heck, ma'am, I wouldn't want that duty. I'm just a salesman."

"But everything they sold you is mine. The whole transaction, whatever it was, is built on fraud."

"You sure as shitfire didn't own our town," Mayor Mudd shouted. Naked but for an undershirt and sock garters, yet he still exuded righteous dignity. "All you had was squatter's rights!" The rest of the town added its affirmation.

"But I own this land. . . . Everything you have—everything that's here, I brought. Even you. This was a ghost town before I came . . ."

"Now you're talking crazy, missy," Sheriff Fudd spat, hauling out his

nightstick and a pair of steel manacles. "We can't have that kind of talk in this-here town."

Felix put his top hat back on and screwed a monocle into his eye. "Sheriff, put those away. This is a friendly, civil town meeting. There'll be all the time in the world to arrest her later."

"Felix, tell them what they are! Tell them you didn't give them life! You're just a bad businessman who came into town with no pants on, and you sold my town something that didn't belong to you."

But it wasn't her town. Dora had not created it. She had shaped its people and their lives, but she had no more godlike power than Felix. Felix was only a middleman to the Life Force. It was indomitable, it had to be obeyed. Felix had only brokered the Life Force for the hungry town, much as he would term life insurance or a corn dog for another customer.

"You've cheated them, Felix. And you're going to regret it. Take it from someone who's been in a few asylums: you don't have what it takes to run one."

"You really could afford to learn a bit about life yourself, Miss Moss. Like about how badly it wants to be lived, for one thing. What wouldn't you pay for life, with the alternative staring you in the face?"

Dora looked over the gleaming faces of the townsfolk, filling every booth and pressed flat against the glass: struck stupid with the Life Force and gone hook, line and sinker for the traveling salesman's pitch. They'd gleefully lynch her on Felix's say-so; he'd have only to sell them the rope.

Felix's monocle fell into his chili. "You understand, then? Good. I trust Norbert has ironed out the boarding situation, and any more you can contribute, we'll just call an honorarium. Maybe name a street after you, someday. I won't badger you about it, but it is rather important that we get the money today. The diner's almost out of food, and the people have been pushing for some civic improvements."

"Like cable TV!"

"And a swimmin' hole!"

"And a bowling alley!"

"We want a burlesque house!"

"This town needs a church, goddammit!"

"Please, all in good time, folks. Miss Moss isn't made of money. Miss Dottie, how much is there in the town kitty?"

Dottie removed Dora's billfold from her apron and thumbed through it, her other hand scooping out and dumping a mound of change on the counter. The townspeople made awed noises as they snatched up the

coins. They were lost to the meeting as they jingled it in their hands and pockets.

"There's only a hundred in cash," Dottie said, "but her bank account's fat."

"We'll have the Sheriff run you out to the next town right after breakfast," Felix said.

Dora's face flushed red at this final indignity. "In my own truck?"

"Of course, there are several other options we could consider. You could, um, work off your debt, here at the diner and over at the hotel. A lot of truckers pass through this area—"

"Go screw yourself!"

"Really, there's no call for that sort of language," Felix chided. The townspeople took it up among themselves, trying it out. "You should watch what you say around them. They're still pretty impressionable."

"Where'd they learn what I saw them doing this morning?"

"Didn't you try out everything there was to try when you were a baby? I suppose if you had, you would've turned out a little, um, healthier, shall we say, than you did?"

"And you'd be left without a town. I don't know how you changed all the rules, but you're not getting anything more from me. I'm leaving—"

The sheriff's gun was suddenly in her face. "I'm sorry, I have to have a check from you before you go. If I let you kite out on the bill you accrued here, what kind of an example would it set for the town? It'd be a cardinal violation of the code of the service economy. How could they provide for themselves? Do you expect them to take up highway robbery?"

"Isn't that what you're teaching them now? How to point guns at people?"

"Nonsense. I'm teaching them how to close a sale. Everybody, look at what I'm doing now. Most people won't push you this far, but deadbeats only understand one thing, and it isn't a polite smile. Sometimes, to get a handshake on the deal, you have to do the shaking with a gun."

"We want guns, too," Mayor Mudd brayed.

Mike the Milkman strode up to Felix and took hold of the gun's barrel and yanked on it before Felix could do anything but jerk reflexively back. The gun went off, drilling Mike and spraying the crowd with his blood. Not sawdust and paint, but blood. Dora went white.

Mike the Milkman staggered and fell into Dottie's arms. "That was aces, Mister," he said. "Do it again," and he died.

The rest of the town swarmed over Felix, either clambering for the gun or to be shot with it, and Dora slipped out unmolested to her truck.

A heaping platter of Friar Buck's dung sat on the hood. Dora frisbeed it through the diner's picture window. With the sound of the gun going off still ringing in her ears, Dora fled her town.

Night fell on a town quite different from the one morning had seen, and still more from that of the previous night. Felix the Traveling Salesman had sold them life and thrown in a taste of death as a bonus, so they had a lot to chew over, and had cleared the street by dusk.

The townspeople were waiting in the street when she came back. Like a pack of hungry, lost dogs, they approached her, growling. One of the Old Coots brandished her shotgun, and the rest carried table legs, lamps, cutlery and torches. They looked angry, dumb and hungry. Felix was nowhere in sight.

"What the hell do you think you're doing?"

"We're going to take over the world. Mayor Felix was telling us as how everybody in the world is a sucker, and how he's gonna buy and sell 'em all someday, and how easy it is to do what he does, so *we're* gonna go out and do it. Then we can all have slaves and towns of our own, and we can make 'em do what we want."

"And just what do you think you're going to sell them?"

"Death!" The Old Coot punctuated his answer with both barrels of the shotgun. As he broke it open, Dora shouldered the shotgun she'd bought in Victorville only hours before and aimed at Sheriff Fudd's comical bald head. She knew her resolution was, if anything, twice as insane as the situation itself.

Backing around her truck toward the bed, Dora flipped down the tailgate and let the smell hit them. "Well, before you go, maybe you'd like to have some pie . . ."

The French doors of the Honeymoon Suite flew open and Felix stormed out onto the balcony in a silk smoking jacket and fez. "What the hell are you fucking blockheads doing out on my street? I said lights out two hours ago!" Noticing Dora, he shouted, "Miss Moss! Come back on your own recognizance to settle your account. You can put down the gun, we're all civilized, here."

The townspeople didn't hear him. They shoved Dora up against the back of her truck.

"Children," Felix cried, "don't talk to Miss Moss until I get down there. This is *grown-up* talk."

As soon as he was out of sight, Dora climbed onto the hood of her truck, cradling the shotgun in one arm and holding the box of specially prepared shells she'd made at the public library in Victorville. She had to work fast. She couldn't convince them to continue drawing breath so long as Felix had them trapped in his sights.

"He's never going to teach you how to sell, you know. You're always going to be his playthings. There's only one way out."

"We're not supposed to talk to you, Miss Moss. Mister Felix said not to," Mayor Mudd sheepishly cut her off. His eyes, like those of the rest of the town, were glued to her and the gun she held.

"You weren't supposed to talk to him either. Now, do you think he offered you a fair deal? Do you?"

"It ain't so bad, being alive, but—"

"But what good is it if you're not free, right? Do you want to be free?"

"Yes!" the Life Force shouted out of the townsfolk.

"All you have to do is make me a deal. What'll you give me for one of these pies?"

Felix pelted out onto the street just as the last pie pan was licked clean and fell clattering to the street. He crumpled in horror as he saw the bodies laid out on the tarmac like discarded dolls.

"What have you done? You crazy murderous monster, what have you done to *my town*?"

"You cheated them, Felix. You didn't give them any reason to live except to worship you, and you were driving them insane."

"You poisoned them! You killed my people!" He rushed her, hands splayed out for strangling, when something grabbed his foot. He recoiled in sputtering panic and slammed his head on the grille of Dora's truck. Lying face to face with Dottie the Waitress, he screamed when her eyes opened. Felix scurried under the truck as the town began to rise.

"I fed them a reason to live." She produced a crumb-crust cherry pie on a commemorative platter for Operation Just Cause. "I baked it for Mike the Milkman, hoping against hope that you might have been able to sell him back to life. I guess he had nothing more to offer you . . . what a waste . . ."

She cracked the pie shell and dumped out the filling. Buried in the cherry compote was a tiny, tightly folded pill of paper. Felix unrolled the cherry-stained scrap, looked it over. In near-microscopic print, the 10

Commandments, the Bill Of Rights, quotes about the dignity of labor and the virtues of humbleness—a lot of hollow platitudes that had passed his own lips more than a few times to prime a customer. At the bottom it said only: MIKE MILLIKIN, YOU ARE A MILKMAN. YOU LIVE IN A RENTED ROOM IN THE DOLLHOUSE HOTEL, AND LIKE IT THERE. THE ONLY THING YOU REALLY HATE IS SALESMEN.

Flipping it over, he gasped. The note was printed on the back of some kind of legal document.

Felix looked up at the resurrected townspeople, then back at her, speechless for once.

"The deed to this property and everything on it. It's not so hard to sell, if you have something people really want."

The townspeople circled round Felix, suddenly confident about how to use the weapons in their hands. A few of them appeared to have got mixed up. Norbert was wearing the Mayor's top hat, and Dottie lit a cheroot off the sheriff's badge on her tattered waitress's uniform.

Felix looked up at the cloudless night sky. "Well, looks like you folks could use a little rain. Now, I'm not supposed to do this, but I'm having a special, I could give you a real gully-washer for $10 a minute . . ."

They ran him out of town after stripping him of the clothes. Turned him out into the desert as naked as he'd entered.

Norbert approached Dora, sheepishly twisting his new mayoral sash in his squirrelly hands. "Miss Moss? There is still the matter of the bill . . ."

Dora handed him a sheaf of hundred-dollar bills. "This should pay for you to get some billboards and some brochures made. You're going to have to become some kind of tourist trap now, I suppose."

"Will you be staying on awhile, Miss Moss?"

"No thank you, Norbert. This place is much too congested. Pack up my things, please."

On her way out of town, Dora Moss stopped only to change the number on the roadside sign from 1 to 29.

NIGHTBOMB

VIOLET LEVOIT

The skyscrapers in THE DISTANT CITY were painted in grey and blue shapes, to confuse the bombers. The newspaper said the actress was still expecting.

"You know what I'd like?" he said. "I'd like to have a family of five kids, all of them cute as a button. And I'd take them to the circus to watch the dancing horses."

She raised the blinds.

"Did you ever see the television program *Nightbomb*?" she asked. "It was a soap opera, in the town where I grew up."

She reached for the lapel of his tuxedo. He grabbed her hand. "Don't touch it. It's a rental."

There was a photograph in the newspaper, but it was out of focus. The dark blue sky in THE DISTANT CITY had searchlights crossing in white Xs. She was wearing her pearls.

"That actress is still expecting," she said. "You know what I'd like? I'd like to have a family of five kids, all of them cute as a button. And I'd dress them in springtime colors for Easter services." She counted on her fingers. "Green, blue, pink, yellow, and lavender."

She lowered the blinds.

"On *Nightbomb* there was a man. He lay on a red velvet couch. A woman nearby was smoking."

"Why are you telling me this?"

She wiped her wet hand on the couch. He made a face. "Don't touch it. It's a rental."

The skyscrapers in THE DISTANT CITY gave off a low hum like dying insects. A bowl of gladiolas on the table. Sometimes the radio played

and sometimes there was static.

He tied his tie, then frowned and undid it.

He tied his tie, then frowned and undid it.

He tied his tie, then frowned and undid it.

"I want to be the actress who is still expecting," she sobbed.

He tied his tie. "You know what I'd like?" he said. "I'd like to have a family of five kids, all of them cute as a button. And then I'd kill them with hatchet blows to the skull and neck and we'd all die in a fire together."

She wrung her hands together. "Why won't you tell me?"

He closed the blinds.

"Are the children dressed?" he said.

She shook her head. "On *Nightbomb* there was a *woman*. Who *smoked*," she insisted. "Her lipstick was *smeared*. A man lay on a *couch*."

He shook his head, impatient. "A *man* lay on a couch." He laughed and laughed and laughed.

"Why did you tell me that?"

He put his cigarette out on the skin of her shoulder. She made a face. "Don't touch it. It's a rental." Then she laughed, too.

She fell down. The buildings of THE DISTANT CITY fell down. The radio was static all the time now. The sky was orange and then it was dark blue again. The people who were watching stopped watching.

FRIENDSHIP IS NICENESS AND IS

SAM PINK

A restaurant. Six a.m. Satan and Khhkr sit at a table. They're tired-looking, him and her both. And just outside the window, a planter levels the wall. The planter is empty, except for dead roots and small gray leaves. And snow comes down lightly, and some hits their window.

SATAN: [*looks from empty planter to Khhkr*] The planter is empty. Nothing grows there now [*moves face closer across table, smiles*] What's your favorite kind of jelly? I want to know things about you so I can recount them and act like we have a bond, even though it is only time that makes us similar.

KHHKR: My favorite kind of jelly is the kind that has your ground-up heart in it [*makes kissy face—then concerned*] I keep thinking I am about to laugh, but it will not happen for some reason. There is probably a huge laugh in my body somewhere all lost and confused. I feel pity for it.

Satan looks out the window. He stares, touching some hair on his face. The snow continues down with the same infrequency.

SATAN: Breathe out onto this window and see if you can find the laugh, and if the laugh is there, take it out and laugh it. That's what I would do. And that's what you should do.

Khhkr looks around the restaurant, extending her neck.

KHHKR: Maybe someone here stole the laugh then. Someone has to have it. Should we look for it?

SATAN: [*still staring out window*] I don't want to get up. Let's just sit here [*long silence*] Stop talking to me.

KHHKR: Ok. Tell me if eventually you are wanting to get up and help me look for it though [*pause*] A fire's best friend is a big enough hole to hold it and make it look brighter and meaner. Do you get that? Do you see what I'm saying.

Satan nods. He drinks his water. Sees his empty glass and seems to panic but remains still. Remains still and slowly hides the glass behind the napkin holder to avoid alerting Khhkr. And puts his hands on the table. Amused.

SATAN: I would say that apple jelly is my favorite [*hits both hands on tabletop hard*] Apple.

Khhkr picks up her fork and touches the prongs to Satan's face. He remains as amused, both hands still on the table top.

KHHKR: Oh yeah? That's your favorite?

In the street directly outside, two construction workers are talking. The one laughs. The other continues to talk, placing a hand on the laughing man's shoulder. They are close to each other and they are saying things, things that the other can respond to and add to and eventually walk away from, done. Satan watches them.

SATAN: I'm not listening to you. I'm watching the construction workers talk. For some reason right now I envy them.

Khhkr takes the fork away from his face. Then she crosses her legs and dumps a sugar packet out onto the table.

KHHKR: You're so cute [*moving sugar grains with two fingers*] Every time you smile, I have to change my underwear.

She spreads the grains around and clicks her tongue a little. A child passes them, holding a plate.

CHILD: [*stopping*] The laughs are everywhere. You have to steal them. They don't come to you [*he walks off*]

SATAN: Sorry about not wanting to help you get your laughs back. They will come somehow [*blowing the sugar onto her lap*] Just don't be mean. You smell so nice in the morning and your eyes are always just the right amount of puffy. Why be mean? Why ruin that?

The waitress comes. They both order.

WAITRESS: [*raises eyebrows*] Is that all?

Satan looks at his lap.

SATAN: That's all.

The waitress collects the menus.

WAITRESS: Ruin as many lives as you can and be an artist about it [*putting pen in front pocket*] I'll be right back.

She leaves. Through the window the sky is purple, and from the purple comes the snow—paced the same, slowly. They both watch, trying to trace flake paths but really just staring. And at one point they accidentally look at each other. When this happens Khhkr opts for staring at the table, and Satan stares out the window and sometimes at his lap.

SATAN: I think that each snowflake feels cheated no matter where it lands [*clears throat*] Or it should.

KHHKR: It should. And I love you. And we are snowflakes.

She touches Satan's hand across the table. He puts his other hand over hers.

SATAN: At night your breath is my blanket [*grabs glass*] It is the only thing I still enjoy [*takes small sip of melted ice*] Do you still want me to

cut your hair today?

KHHKR: Yes [*pause*] Yes I do. I want that.

SATAN: Would you like that?

Khhkr nods. Their meals come and they eat in silence. Stare the meal to completion. Satan keeps looking at the dead plants in the planter.

SATAN: The construction workers are gone.

KHHKR: They are at home in their closets, hanging from electrical cords.

Silence again. Khhkr opens more sugar packets, distracted. Some people get up and leave from a table nearby. Another family walks past, towards the open table. The entire family stops, and looks quietly at Khhkr and Satan. The entire family shakes their heads no. Then they take the open table and converse quietly with each other.

KHHKR: [*flicking sugar, watching fingers*] When I was walking home yesterday I walked across a parking lot and there was a children's book in a puddle. It was this book where there's a frog who learns about friendship by becoming friends with a fly named Chad. I learned how to treat you by reading the book. I just sat in the puddle and read the book and learned how to be your friend. I want to burn animals. Ok? Ok, good.

She leans over and tries to kiss Satan. Satan moves. Then stares out the window.

SATAN: Don't touch me. I'm too happy to enjoy it [*craning neck*] Where did the construction workers go? You need to tell me.

KHHKR: I wasn't going to kiss you, I was going to bite your face off and suck out the laugh you stole. You thief.

SATAN: I didn't thieve anything [*folds hands on table, assured*] I think I want to be a construction worker.

KHHKR: [*pouring out more sugar*] I'm horny. I want you to fuck me a

lot today. I mean, like you don't even know me. Will you fuck me like a stranger?

SATAN: [*nodding*] Yes I will. You mean like holding you down and screaming louder when you start to say 'ow'?

KHHKR: Yes, like that. Then we can sleep until the sun is gone [*laughs*]

They then take turns blowing and flicking sugar at each other. Snowflakes hit the window and melt. Full daylight. The construction workers return. They talk and point different directions down the roads. Their mouths are quiet, they are distanced. Muted.

SATAN: You're pretty.

KHHKR: Blah blah.

SATAN: No you're a pretty person.

He blows a hard breath and all the sugar goes onto Khhkr's lap. Then he surveys the other customers. A hideous woman some tables down is bringing a bite of pancakes to her mouth. And the syrup falls onto her sweatshirt. She looks down at the syrup, her neck folding out. She looks at the syrup, chewing. And Satan watches.

SATAN: [*playing with his straw*] I want to ask the hideous woman if she thinks about how many people are embarrassed by her presence [*lifting thumb from end of straw and letting water drop onto table in single drops*] I want to ask her if she worries about being immortal. That is, if she were immortal, exactly as she is right now, would it be agonizing? Is she having a good time? Is she really excited and happy about eating pancakes? Is this fun for her?

Satan turns back to Khhkr when he feels sugar particles rain on his lap.

KHHKR: Blah blah [*getting up*] Let's go.

A very pale, fat man with fetal alcohol syndrome works the register. Purple rings round out his eyes. He takes their bill and looks at it.

EMPLOYEE WITH FAS: Tank ewe.

KHHKR: [*staring at him, pointing*] You don't have any friends.

He smiles back.

KHHKR: [*evenly*] You don't know anyone that would willingly spend time with you, and that is because you are terrible. I am embarrassed standing in front of you. The way I am supposed to keep my opinion, my disgust towards you, covered. That seems wrong. I know how pathetic you feel [*tapping fingers on counter*] What do you do when you leave this place? You hang up your nametag and walk home, right. There is nothing at home that you want or care about and you only go there because you paid for it. Did you pay for it? Does your mom pay for it? Is your mom still alive? Did your mom love you? Have you ever thought you loved another human? Have you ever experienced happiness? Do you like to have change in your pockets or not? Did you enjoy buying the shirt or pants you are wearing? When you were in the dressing room, trying them on, did you silently celebrate? Do you enjoy having those glasses that like, get tinted when it gets dark? Have you ever wanted to just run into a tree headfirst and sleep for a while? How many people have called you stupid to your face, and how many times have you openly agreed? How many times have you agreed quietly? If we were playing a board game, would you look at me or just look down at the pieces? Have you ever been up really late and thought to yourself, "How am I going to stay alive when I hate myself this much?" How many times would I have to hit you in the arm before you cried? Have you ever hurt someone's feelings and then regretted it? Or do you only get your feelings hurt, but then apologize for other people? [*nodding*] Yeah, that's you. That is you.

The employee with FAS leans over the counter on his elbows, and he looks at the bill. He tries to raise his glasses by twitching his nose. His shirt is way too big. His name is written on a plastic tag. And next to the register, there are some homemade cookies with smiley faces painted on them. A waitress comes out from the backroom and stands by the register. Khhkr grabs a smiley face cookie and slides it forward.

KHHKR: And one of these please.

EMPLOYEE WITH FAS: Hi. Tank ewe.

He points at the amount on the register and sniffs. Khhkr gets out her wallet and gives him a twenty, looking from the waitress to him.

KHHKR: You can keep the rest.

EMPLOYEE WITH FAS: Ok. Tank ewe.

Khhkr touches his hand.

KHHKR: [*softly*] Run away with me. Let's get married [*touches his chin*] I love you. Hey look at me. Look at me, I love you. Leave with me. We can share everything. I'll make you happy. I promise. We can live on smiley face cookies.

EMPLOYEE WITH FAS: Ok. Ok tank ewe.

KHHKR: I'm average in a way more painful than being below-average.

WAITRESS: [*to Satan*] Your friend's an asshole.

SATAN: Yeah, but so are you. And me too. What's left? Are we done?

Satan smiles at both employees and takes a mint and leaves.

[*Later*]

A small bathroom. Satan is cutting Khhkr's hair. She sits on a folding chair with a cape of old newspaper and he stands behind her. There are loud crunching clips.

SATAN: [*sprays her hair*] What kind of shampoo do you use? It's making me hard. Is it some kind of raspberry?

KHHKR: [*chin against chest*] There is only one kind of raspberry [*pauses*] There is only one raspberry and it will dominate us all with its giant fists.

They both laugh.

SATAN: [*shaking some wet hairs off his fingers*] Now I am imagining you

standing on a huge raspberry with nothing on but white socks. White socks that are kind of worn-looking and half pulled-off [*clips, shakes hair off fingers*] On the huge raspberry, you are smiling. Your legs are sinking into the raspberry and there are drops of juice on your knees. You are dying and sinking into the huge raspberry. It's ok though. You're smiling.

KHHKR: [*laughs*] You are imagining one mean-ass raspberry [*shivers, hair clippings hit Satan's feet, he shuffles*] Will you defend me from this mean-ass raspberry?

Satan snips his own knuckle.

SATAN: Fuck [*puts finger in mouth, spits out some hairs*] It depends.

There is silence. During the silence they both think about what it depends on. Clipping sounds.

SATAN: [*clears throat*] I still have the brownies you made when I first visited you [*combing her hair, clipping*] When I first went to your house I thought your house looked shitty from the outside. Like I thought an actual piece of shit would answer the door [*snips*] And I was right.

They both laugh.

KHHKR: [*still laughing*] Awww shit [*stops laughing, brushes nose with hand*] I made you the brownies because I thought you would interpret them as a bribe to leave and never come back. Like payment in advance [*wiggles toes, looks at them*] I figured we would set up a relationship in which I would leave brownies out on the front step and you would take them with the agreement that you were never to see me again. It didn't work out that way and you kept coming back. That's fine. It's fine. Blah blah. It's like Chad the Fly said.

SATAN: Who?

KHHKR: Chad the Fly, from the book I told you about. He was friends with the frog even though he knew the frog was going to eat him. He knew he was going to die. Chad the Fly said, "Friends are the dead bodies for the larva of relationships."

Satan lifts her hair. He looks at the back of her neck. He clips her hair then combs it. The quiets are very quiet.

SATAN: [*clears throat*] Don't turn around and look at me while I am saying this [*clips*] Ok?

KHHKR: [*pause*] Ok.

SATAN: When I got home that night—with the brownies—I took them out of the glass tray and wrapped them in an unfolded napkin. Then I put them in the fridge [*pause*] They're still there. I just can't throw them out. I can't throw out the brownies you made. You made them so good I think [*clips, shakes scissors off to the side*] Sometimes I open the fridge and think, "It's time to throw them out." And I even reach in like I am going to do it. But I don't. I never do. Really though—they're too nice. They're too nice to throw out. If those brownies were real people, I would like, take them to a dance or ask them out for dinner [*stops cutting*] The brownies, they are nice to have to look at when I can't help but notice that I am alone in my apartment—and I start thinking, what if that is the only nice thing anyone will ever do for me? Really though [*resumes cutting*] they're way too pretty. And now they're all thin and hard, wrapped in a napkin deep in the back of my fridge. I look at them every once in a while because I just can't throw them out. Or eat them. They're too pretty. Really. I think maybe something like that is impossible to explain [*puts a wet clipping in his pocket*] Tonight when the sun sets I will lay my head on the horizon and wait to be crushed. Don't come and get me. Don't come and sweep me up. Don't do anything except be the greatest [*laughs quickly*] Did Chad the Fly say anything about greatness.

KHHKR: Your fingers are cold [*shivers then straightens*] Cut my hair so close that it disappears and never comes back. I'm too pretty for you [*evenly*] Too fucking pretty.

SATAN: You could pretend I am hair and do that to me, if you want to. I'd let that happen.

Khhkr catches clippings in her overturned palms. She looks at them. Then turns her hands over and drops them.

KHHKR: From now on I want you to fuck me through the open zipper

on my pants. Because I don't want to be naked in front of you.

They are quiet for the remainder of the haircut. After, they leave the bathroom and go to Satan's room, adjoining. Khhkr looks at herself in the window as a mirror. Behind her, Satan wipes the hair off the scissors, onto the ground.

KHHKR: I like my haircut. Thank you very much. I wouldn't have been able to do this myself.

SATAN: Good. You're welcome [*looks up at her*] You look like a little boy.

Satan rubs the hair into the carpet threads with his toes, still shaking the scissors off.

KHHKR: [*looks at him in window mirror*] We always have fun together.

Satan sets the scissors on the floor. Then he lies down on a pile of clothing he uses for a bed, in the corner of the small room.

SATAN: When you are not here I sleep on the couch downstairs. And I like to keep the television on. I can feel it against my neck when I turn my back. It feels good. I wake up when it's still dark out and sit on the tile floor in front of my TV, flipping the channels and pretty much just looking at things.

KHHKR: [*makes a kissy face to herself*] I am a failure and so are you.

SATAN: You look pretty though. Yeah. You do.

Khhkr goes to walk over to him but she steps on the scissors. The scissors cut her foot deep. She hisses. The ball of her left foot drips blood, and she holds it up knee-high for inspection. Satan takes her to the shower and cleans her foot off with cupped-handfuls, using the other hand to balance her at the hip.

KHHKR: [*hands on the showerwall*] Is it good?

SATAN: [*shuts faucet*] It's good yeah.

He dries her foot off with his shirt and puts a bandaid over the cut.

KHHKR: [*turning her head*] What's that on the bandaid?

SATAN: It's a duck giving a thumb's up.

Khhkr turns her head to the showerwall again.

KHHKR: [*flatly*] Does the duck look happy?

SATAN: Yes [*massaging her foot*] Yes I feel that this duck is happy. To be touching your blood, this duck is happy. Thumbs up.

KHHKR: [*puts foot down carefully*] Ok.

They go to bed. Khhkr falls asleep. Satan does not. He spends the first few minutes of the night sticking his tongue in and out at her. In between he quietly repeats, "This should hurt your feelings." But he never seems convinced it actually hurts her feelings. Keeps checking her face. Different angles. He takes the top blanket and goes downstairs to the kitchen. The kitchen is dark. Satan leans his elbows on the counter and looks outside. The moon is a toenail clipping in the sky.

SATAN: This kitchen is small and it is cold. Very cold. And I don't want to be here. That is all I need to know about this kitchen.

He sits on his couch in the next room. Stares at the television on the floor, not turned on.

SATAN: Maybe the roof will fall on me and kill me.

He looks up at the ceiling. He sits there waiting. Then he gets up and kneels on the tile. He turns the TV on and changes the channels, listless, finally landing on a high school basketball game. Each time the One Too-Loud Broadcaster says something, the Other Too-Loud Broadcaster says, "What?" Then there is static. Eventually, the first one says, "Jesus, nothing Jerry—forget it." Satan changes to the news. He imagines himself as the cloud he sees on the weather forecast, the one the meteorologist shows looming over the Midwest, wearing sunglasses and a smile. He imagines

himself roaming low over the states, decimating everything. Trees uproot and fly into livingrooms, killing entire families, their dogs, destroying pictures, furniture, work-out equipment, and whatever else. Fathers outside with their sons, together they feel the opening drafts. "What is it father?" And with a stern look to the sky, the father says, "Nothing son—Goddamn it—it's nothing." Right before coalescing with other clouds wearing sunglasses. Smiling through the onslaught. Blowing entire states off the map like shingles, into the ocean without hesitation.

SATAN: [*yawning, watery-eyed*] Days are the worst thing ever made.

He goes to the refrigerator and opens it and looks at the brownies at the back of the fridge.

SATAN: There is no way I can throw them out. They're too pretty. Really though [*hesitates, then shuts door*]

He goes outside and stands on the sidewalk with the blanket wrapped around him, over his head. And he holds the blanket closed underneath his chin. It is freezing out. There's a sock near the gate of the apartment complex fence, frosted and stiffened to the ground.

SATAN: See you in the spring you lost sock. Who lost you, sock? You are lost. No one will want you again. Goodbye. See you in the spring, lost sock. I have nothing else to say. Lost sock, I can't help you. I'll see you later.

There are no construction workers in sight.

PORTENTS OF PAST FUTURES

JEFFREY THOMAS

The vacant lot was positioned at a street corner, so it was open to the sidewalk along two sides. Its left-hand border was demarcated by a chain link fence, while the rear of the lot was shadowed by a high concrete wall covered in artwork. Dill didn't know whether to classify this art as a mural, despite its consisting of a row of unrelated images, or graffiti. Since the painting was composed of images rather than gang-style tagging, he was leaning toward mural. The images included: a fish bowl occupied by a goldfish skeleton, which regardless of being picked clean sported big blue eyes with curly lashes and puckered crimson lips . . . a dark-skinned old woman in an armchair with a TV for her head, its screen shattered . . . a sandwich lying on the ground being dismantled by cranes and steam shovels, the ant construction workers wearing yellow hardhats . . . and a little red devil in diapers pointing his pitchfork and announcing in a word balloon: "Art is dead!"

Perusing the wall with hands on hips and wagging his head in disgust, Dill's partner Sloane remarked, "I wish."

"Different," was all Dill opined.

"Doesn't look like gang art. Must be druggies." Sloane shambled his bulk around in a little circle, scowling at the buildings that flanked this convergence of sun-blanched streets, as if he might catch glimpse of the artists peeking down at them around the edges of window curtains.

"There's a high school just a block over," Dill said in his laconic tone, pointing with his chin. "Maybe students did that. Art students."

"Druggie art students."

Dill gestured at the body splayed in an X at their feet, as if they had been putting off this part. "What about her?"

The uniformed cops who had been the first to respond now deferred to the two plainclothes detectives, having withdrawn from the crime scene to regroup in front of their cars, which lined the curb as if to block the scene from the public. Nevertheless, people had been drawn to the scene, hanging back in little knots and clusters behind the yellow tape that had been strung like party bunting. The locals seemed to know the drill, as if they had been through this as many times as the police officers. They were all assuming their roles, right down to the forensic team as they unpacked equipment from their own vehicle. Even the spread-eagled victim played her part, the focal point, X marks the spot.

The hair of the young Jane Doe was long, black, and soaked wet—plastered to her pallid face like streamers of seaweed. Her lips were parted slightly, and bluish. The lid of her right eye was at half-mast, open just enough for Dill to see that the iris of her glazed eye was a pretty blue. Her left eye was swollen nearly shut, however, obviously from a blow.

The body lay immodestly with all four limbs flung wide, completely unclothed, the woman's grayish nipples looking hard as if she were cold despite the sun's hard glare. Dill's gaze tracked the progress of two ants as they scampered along the woman's paper-white thigh, making a run for cover in her sodden mass of pubic hair.

When he lost sight of the insects in the glistening underbrush, he lifted his eyes to the mural on the wall at the back of the lot. The ants wearing hardhats, demolishing a gigantic sandwich, carting tasty morsels toward the opening of their underground lair.

"It sure as hell hasn't rained lately," Sloane stated. "Killer must have given her a bath to wash away evidence. Or blood."

"I don't see any wounds," Dill said. "Aside from the contused eye."

"Maybe on her back. We'll see when Ken flips her over." As he said this Sloane nodded in greeting to Asamatsu, the lead forensic identification specialist, as he approached them carrying his field gear.

Dill conjured a mental image of a man with an indistinct face washing Jane Doe's slack, dead body in a bathtub. It wasn't his method, though, to limit his thinking to the obvious. What alternative causes might there be for the woman's drenched state? He began turning slowly in a circle, as his older partner had done, but not so much looking at the drab buildings as through and beyond them. The Pacific Ocean was close, but not *that* close, and would a blighted neighborhood like this feature any community swimming pools? And if it did, how easily could a body be brought here

from there, even under cover of darkness—let alone the killer having access to that pool off-hours?

Dissatisfied, he returned to Sloane's suggestion of a bathtub. But this time he pictured that faceless figure holding the young woman's thrashing, *living* body under the water.

He didn't have to voice his opinion on the manner of Jane Doe's death, however, because the moment Asamatsu stood over the naked corpse he remarked, "This woman was drowned."

"Well, ain't you young and good-looking for a policeman," the elderly black woman noted after opening her door.

"Thanks," said Sloane, squeezing into the apartment ahead of Dill.

"Wasn't talking to you," the woman muttered.

"I know that," Sloane said.

She motioned for them to enter her dark, cluttered parlor. Atop tables and bureaus, potted plants abounded. Half of these were brittle and brown, long-dead, though she seemed not to have noticed. Her TV was on, playing a soap opera. The reception was terrible. Dill figured she didn't even have cable.

After introducing himself and his partner, Dill said, "Mrs. Otis, you called our office and said you had something to tell us about the girl they found in the lot across the street?"

"Yes sir I do," the old woman said. "Can I get you boys some coffee? You policemen sure do like your coffee, don't you?"

"We're all set with the coffee," Sloane said, glancing around dubiously at the apartment's dusty, grimy state. The chairs had thick layers of newspapers spread across their seat cushions as if to absorb stains. Sloane opted to remain standing.

"Please sit down, Mrs. Otis," Dill prompted, "and tell us what you know about that girl."

Mrs. Otis lowered herself onto one of the yellowed mats of newspaper, her arms shaking as she gripped the chair's armrests. "Don't know nothing about the girl," she told them. "I never seen her before." She looked up at one man, then the other. "Do you know the poor girl's name yet?"

"No ma'am," Sloane replied, "we don't. She's still unidentified."

Dill stepped nearer to a window with dingy lace curtains, and brushed one aside with the back of his hand, gazing down into the street. On the corner: the vacant lot, strewn with the flotsam and jetsam he and Sloane

had poked through extensively yesterday. Used condoms like shed snake skins, cigarette cartons, candy wrappers, iridescent shards of CDs. Like an archaeological dig, and these the items that had been unearthed, to represent some extinct and poorly-understood culture.

"Did you see the men from here, Mrs. Otis?"

"Men?" she said.

"They told us you said you saw men . . . leaving the girl's body in the lot."

"That's why we're here," Sloane told her. "Remember?"

She glared at Sloane. "I remember why you're here, detective. But I didn't see those . . . people from my window. I saw them *there*."

The investigators both followed the woman's pointing finger. She was indicating her outdated television set.

"Come again?" Sloane said.

"I can only get a few channels, and they don't come in so good," she explained. "Some nights I'm seeing two shows at once . . . one on top of the other. But last night I lost my show entirely, right in the middle . . . got more and more snow 'til I couldn't see or hear nothing. But then I started to see people moving around behind the snow."

"Snow . . . on the screen."

"Yes, on the screen! You think I mean snow for real in L.A.? You think I got Oldtimer's Disease or something?"

"No, ma'am," Sloane sighed patiently. "Please go on."

"Well . . . the picture eventually got clearer, so I could see it better, but I still couldn't hear nothing."

"And you saw . . ."

"Three people all dressed in black. They were carrying a woman's body, and she didn't have a stitch on. They laid her down on the ground in that lot . . . and I knew it was the same lot across the street, 'cause I could see that wall behind them, with the crazy paintings on it. It was only a few seconds, then the snow came back and everything disappeared . . . but my damn show didn't come back for a whole half hour, and by then it was at the end!"

"So just to clarify again . . . you saw this on TV. Not from the window."

"Yes! But let me finish! There was something wrong with the people's heads . . . all three of them. Looked like . . . well, when my kids were little they used to play with that Play-Doh, and my son used to tease my poor daughter by putting the Play-Doh on her dolls' heads and shaping scary faces on them, then he'd leave the dolls around for her to find."

Sloane barked a single, loud laugh. "Oh wow . . . that's sick!"

Seeing the old woman glower at Sloane again, Dill urged her, "Yes, Mrs. Otis?"

"Well, these people looked like that. Like somebody covered their heads in white Play-Doh, with just some holes for their eyes... maybe the mouth, too."

"So they were wearing masks, then. To prevent people from recognizing them when they left the girl in the lot."

"Weren't no masks!" Mrs. Otis blurted, squeezing the armrests of her chair. "That was their *faces!*"

Sloane shuffled a little closer toward the doorway to the next room, and thus the apartment's exit. "Okay, Mrs. Otis, then we'll be on the lookout for three deformed men in the neighborhood. Maybe someone else has seen them; they should be easy to remember."

"Do you boys believe in devils?" the old woman asked, her ivory-stained eyes gone wide and unblinking. "I bet you don't! That'll be the downfall of this world... that's what makes them strong! The less we believe, the more real they get! And nobody thinks about it, but Hell is down there deeper than the oceans... and if the devils ever want to come up here, they'd have to come through all that water! So it's no wonder that girl they brought with them was all wet—is it?"

Dill and Sloane turned to face each other silently.

Outside, on the hot skillet of the sidewalk—across the street from the vacant lot—Sloane said, "Well that was a waste of time. Loony old lady."

"Fred, I think she did see something," Dill said. "She's just confused about where she really saw it, and the details."

"Yeah—details like three mutants with Play-Doh heads?"

"Masks."

"Maybe they were aliens, huh? Getting rid of their abducted experiment? Dressed all in black, too... so maybe they were Men in Black."

"You heard what she said as well as I did. She said the girl was all wet. We haven't released that detail to the public, so how could she know?"

Sloane chuckled. "Daaamn... come on. Yeah, at first that gave me pause, too, but think about it—how many people saw her body lying there yesterday? A bunch. And if you were up close it was clear she was wet... just seeing her hair alone. So this old lady obviously just heard it through neighborhood gossip. Either she's getting that mixed up with her delusions, or she's just pulling our leg for a little attention."

Dill sighed, opened his mouth to protest, but found that he couldn't defend his intuition that the old woman had seen *something* legitimate.

As if he felt his partner looked dejected, Sloane stepped forward and slapped him on the arm. "Come on; let's get our asses over to Bob's Big Boy for some lunch, huh? I always think better on a sugar rush, and I need my daily shake."

Dill sat with a black coffee in front of him, watching Sloane talk on his radio and jot notes in his spiral pad. Beside that, Sloane's chocolate milkshake stood half finished. Or half unfinished, Dill thought.

When Sloane set down the radio, he grinned proudly at the younger detective—as if he himself had uncovered what he was about to reveal—and said, "We have an ID on our girl who drowned in a vacant lot. Angela Renee Turner . . . a runaway from Philadelphia. Arrested at seventeen-years-old for drugs and theft, then ran away from the rehab center they had her in."

"Ran away when?"

"Four years ago."

"Whoa; four years. Well, looks like we better talk to people in Philly . . . see if anybody knew she was heading to Los Angeles, and if so, where she might have been staying. Who she knew out here."

"Too bad for the parents, when they hear about this."

Dill lifted his coffee mug for a sip. "Yup."

"But we'll need to contact her folks, see what they might tell us."

"I want to speak to somebody at that rehab center, too, and find out what they knew about her."

"Well, if it was drugs that got her in trouble in Philly, then I reckon it was drugs got her in trouble here."

"That's a fair bet. Got in with the wrong crowd."

Sloane snickered. "Yeah . . . apparently a gang of drug dealers who snort Play-Doh."

Afternoon was winding down and Sloane was on the phone with yet another person in Philadelphia, so it was Dill who took the call about Phyllis Otis—the elderly woman they had interviewed that morning.

"What's going on, Terry?" Dill asked.

"Thought you guys might want to know: that possible witness you interviewed today is dead."

"*Dead?*" Dill hissed. "Who found her?" He had been under the impression she lived in her apartment alone.

"Some kids walking down the street. She was lying there in that same lot where your former Jane Doe got dumped."

Dill didn't want to interrupt his partner . . . nor be discouraged by him . . . so the moment he got off the phone he grabbed his jacket and strode for the door.

Dill learned the woman's body had already been removed, but when he heard a few details about the scene he stayed on course for the lot to see for himself. While driving, he asked into his radio, "Is it looking like foul play, Terry?"

"Nope," was the reply. "What they're saying is heat stroke."

"Her body wasn't . . . she wasn't wet, was she? Like she'd been submerged in water?"

"*What?* No, I didn't hear anything like that."

"Okay . . . okay . . . I'm coming up on the scene now. Thanks." And Dill set his radio down on the passenger seat as he pulled his car up to one of the two curbs that bordered the front of the empty lot.

In spite of the recent activity in the lot, Dill was alone. Even the yellow crime scene tape had already been torn down. He stamped across the dusty grass, kicking up scraps of litter, until he neared the high concrete wall that formed the lot's rear boundary. Even before he reached it, however, he could smell the fresh paint . . . and see the damage Phyllis Otis had done to the colorful mural.

The old woman hadn't been tall in life, so she hadn't been able to reach the tops of several of the painted images, but she had still covered up much of what had been there. A bucket of white latex paint and a paint roller pan rested in the scrubby grass, while a paint roller lay where it had apparently been dropped in mid-stroke. Even with evening approaching, the air was still baking hot. The paint was already nearly dry, even though she had applied multiple layers in irregular areas. Some of the images beneath were entirely hidden behind this snowy expanse, while elsewhere ghostly glimpses still peered through. She had worked from left to right, and must have become overwhelmed by the heat and dropped while painting over the diminutive, cherubic devil in his diaper. He was partly effaced but his

eyes still gleamed through a white fog, and she hadn't yet touched the word balloon that said: "Art is dead!"

Staring at the word balloon, Dill said aloud, "Art. *Art* is dead."

He turned to stare across the street, settling on the third floor window where he himself had stood gazing out that morning. Might an echo of himself, a lingering shadow, be standing just behind that curtain even now, his past self watching for his future self down in this lot . . . waiting for the two of them to converge in revelation?

"Angela . . . Renee . . . Turner," he muttered to himself. "Is dead."

She had left her apartment unlocked before going downstairs and across the street to paint the concrete wall.

Dill had washed out the coffee maker's glass pot, plus one mug for himself, and while fresh coffee brewed he spoke with Sloane on his radio, peering through the parlor window at his car parked and locked at the curb.

"So where are you now, man?" Sloane asked him.

"After I took a look at where they found Mrs. Otis I headed home," Dill said. He wasn't lying . . . it just wasn't *his* home. "Pretty bad headache."

"I can relate. Anyway, I told you that poor old lady was a loony. Painting over that graffiti . . . not that I blame her. It's not connected, buddy—let it go. Let me tell you what I found out after you left."

"Shoot." Dill wandered back to the kitchen and poured himself some black coffee. He wanted to be sure to stay awake through the night.

"Didn't talk with them myself, but I'm told Mom and Dad are both pretty shaken up; they were under the impression she was dead these past four years. They never heard a peep from her after she vanished from the rehab center."

"Huh," Dill said. "Well, at least now they have some closure." He hated using that inadequate cliché, but he was at a loss as to what else to say.

"As for the rehab center, as far as the staff knows our girl never told anybody she planned to escape, let alone run off to California. But they remember something funny."

"Which is?"

"They had this therapy program, encouraging the kids to vent all their inner demons through art. Well, sometime during the night, right before Turner ran off from the place, she painted a mural on the wall of her room. She shared the room with another girl, and that kid left the place

legitimately a long time ago so I didn't talk to her, but the staff swears the roommate slept through the whole thing—never saw the mural or discovered Turner was missing until she woke up the next morning."

"What was it Angela painted?" Dill asked in a quiet voice. Why did he want to ask if what she had painted was a door? What would make the image of a doorway paint itself in his mind?

"A fish bowl . . . one goldfish inside. Blue eyes, long eyelashes, lipstick on its lips."

"A skeleton? Like the mural at the lot?"

"Nope. Scaly. This one was supposed to look alive," Sloane replied. "Before and after, I guess."

"I guess."

"The fish had a word balloon, too. It was saying: 'Art is Free!' You see that? She's obviously the one who painted that stuff in the lot."

"Mm," Dill grunted noncommittally.

"One more funny thing. Apparently what set the girl off so she wanted to run away that night was she got in a big fistfight with another kid in the cafeteria. The staff says she ended up with a real shiner."

"Left eye?" Dill asked.

"They didn't specify which eye. But that has to be a coincidence, my friend. It's not like our girl would have a black eye for four years, is it?"

Dill had turned off all the lights in the parlor, except for the ghostly blue cathode glow cast by the television set, which he sat in front of in Mrs. Otis's old armchair, a coffee cup in one hand.

He had no wife to go home to, and so he sat for hours, getting up only to pour more coffee or use the bathroom. Mrs. Otis hadn't specified which channel she had been viewing when her program had been interrupted, so he pointed the remote and changed channels every so often between the few that offered halfway decent reception. The others were nothing but solid, hissing static.

Despite his efforts, despite the coffee, he woke with a startled jolt in the early hours of the morning with the realization that he had dozed off at some point.

He wasn't sure what had awakened him. Maybe it was the silence of the TV, replacing its incessant chatter. Maybe an intuition in his very nerves.

Whatever it was, when he straightened up in the chair and focused on the TV screen, he saw three indistinct figures behind a layer of grainy

snow... like a trio of portraits that had been obscured under a thin layer of paint.

The figures were garbed in black uniforms or jumpsuits, but more striking was their hairless, lumpen white heads. These heads looked formed from some raw matter, like virgin protoplasm. The eyes were mere punch-holes, and yet Dill felt their stare penetrate him. For all three figures had been studying him while he slept, and continued to study him now that he was awake. Gazing at him not as if they were enclosed in the TV on the other side of its glass, but as if he were the one enclosed... imprisoned like a fish in an aquarium.

Dill's fingers dug into the chair's armrests like claws. But then he thought of the remote on the little table beside him, on which also rested his coffee cup. He shot his hand out for it, knocking over his cup and spilling its dregs of coffee in the process. Jumping up from the chair and backing away from the TV a few steps, he pointed the remote at the screen like a gun and thumbed the OFF button.

The image of the three obscure figures flashed to darkness. Now in the screen he saw only his own reflection, but even that shadow being's face with its crazed expression unnerved him.

In a lower kitchen cabinet he found a toolbox with a hammer in it, and another can of white interior house paint.

He used the hammer to smash in the television's screen.

That morning, people driving or walking past the street corner on their way to work or school glanced over into the vacant lot where that young woman had been found murdered, and where their neighbor Mrs. Otis had dropped dead from the heat... a little perplexed to see a man standing in front of the high concrete wall at the back, his arm pumping fiercely as he finished what the old woman had started: covering over the colorful mural completely.

BEAST WITH TWO BACKS

GARRETT COOK

Mia and him, they'd been doing nothing but arguing. Maybe not literally, but close enough. He'd wanted to go to the opera. He loved the opera and when they were first dating, she had said that she too loved the opera. He should have known when she didn't name any specific operas that she was trying to impress him. She actually hated the opera and wouldn't be caught dead there. What she loved were carnivals. She loved watching him compete at games that were skewed against him, she loved eating funnel cake. She loved the muddy musky dirty smell of ponies. She loved smiling at tattooed creeps suggestively as she got on rides that took her to the brink. She loved sleaze and grime and the magic of lies. Things that always made him uncomfortable.

And she loved the sideshow. They were usually nothing like her conceits and dreams of sideshows. When you thought of sideshows, you thought of human oddities that bent and broke the laws of nature, displaying superpowers or shamelessly parading ugliness. The days of the true sideshow were mostly gone. These were, after all, the days of tolerance and political correctness. Calling mentally-challenged children pinheads or gawking in wide-eyed shock and terror at the morbidly obese were products of a simpler, sicker time. At a modern-day sideshow, you'd get to see a fake Fiji Mermaid (the only kind of Fiji Mermaid) in a glass case, a monitor lizard billed a living dinosaur, a lady with her body in a box with a spider painted on it, and some framed photos. A scam posing as a museum.

It was at the third carnival they'd been to that month, this one an hour and a half outside of town. He objected to throwing away six dollars to get into the sideshow, just as he'd objected to the smell of piss over red velvet

seat cushions, woodchip fries over a sitdown meal and a tilt-o-whirl over beautiful, masterful music painstakingly perfected by people that wanted nothing more than to do what they do perfectly, inspiringly. He had longed for inspiration and had never gotten it from this world of overinked ex-cons and oil-slick cuisine that had marred their time together. He was starting to feel like he wanted to get out.

He had developed low expectations, and was perfectly justified in them. He had reached a point at which he wanted just a night at the opera and a glimpse of mastery, the sort of thing that would make him want to sit back down at the piano and start playing something that wasn't Billy Joel or a Sinatra song to belt out adequately as a de facto wingman for some bluesuited hack who'd never met half the people whose names he dropped. A trip to the opera would have done that, at least in his mind. She knew better and he knew she knew better and he resented the hell out of it.

He had developed low expectations and was certain the sideshow as always would fail to meet them. Even if he tried to meet the bullshit with an ironic smirk, he'd still be out three dollars. Three dollars spent for the dubious privilege of walking around a shrine to chicanery and petty theft. But this sideshow was slightly different. In the middle of this tent was a corral, and the corral housed something unlike anything he'd seen at any other sideshow. So they passed the Fiji Mermaid and the woman in the spidery box. A mutated pig fetus in a jar. Went through the motions, halfheartedly wondering what was in the corral. Couldn't be anything that great.

Except that it was. A naked man twisted like a backwards bridge. Toned chest. Cast-iron arms holding him up. Overdeveloped legs bent, spread-eagle. Head crooked right. A woman, firm-breasted, toned arms, powerful legs pressed against his, was bent into the same position, head facing the opposite way. They were making love. Or else . . . no. They were joined at the crotch by a bridge of skin. Two beautiful people, stuck together in mock intimacy. Brother, sister. He pulled Mia close. Kissed her. Clamped down on her tongue until he could taste blood. Reached under her skirt and squeezed her ass. Even though they must have been in plain view of the naked conjoined twins and even though they could hear another couple walking into the tent, the making out only got more intense. Soon they were fervently dry-humping.

The other couple, lightly pierced but preppily dressed college kids, whispered to each other. Quietly debated whether the freaks were real. Cleared their throats to make their presence known. Forced them to find

some modicum of common decency. Forced them to break their embrace, cut off their kiss, leaving them to taste their bloody mouths and public shame. They took another long look at the brother and sister bridge before shuffling out, barely glancing at the third monitor lizard of the month. Was it just him or did this one look small and sickly?

They didn't ride any rides. He didn't try and win her another tiny plush pig by popping balloons with darts. They didn't eat any greasy food. They went to the car. They made out like teenagers. He began to notice the grey in her eyes again and the way the pixie cut about which he'd felt apathetic before framed her sweet freckled face perfectly. On the drive home, they pulled over and she gave him a blowjob. He enjoyed locking eyes with her and watching her as much as he enjoyed the act itself, which was plenty. It took a tremendous force of will to last as long as he did.

They waited, not knowing what they'd do next. Were they daring each other to go further? Were they trying to stop something that they knew was coming? He chickened out. He started the car.

"I think we should get some dinner. Like, a real dinner."

It took a second for Mia to crack a smile.

"Yeah. That would be nice."

They were underdressed for the restaurant, which was tiny, dark and intimate. Little Italian place. The food probably not worth the price. Under the table, they moved their legs forward, bodies stretching, unconsciously reaching for each other, his foot rubbing her leg, her foot rubbing his. They talked. Really talked. Ate ten-dollar bruschetta as they waited for their meal. Kissed vigorously in spite of onion garlic blood mouth. Incurred judgmental Connecticut glances of curdled patrician spite. They savored their meals, the restaurant, the moments, each other.

They pulled over again on the way home. Frenetic scratching of two teenage werewolves. Bitter disdain of t-shirts and seats that would not pull back far enough. They fucked. Clumsy, dirty awkward car sex. We've got shit to prove sex. By the end of it, they were sweaty, stinking, content, tired and just the slightest bit afraid. The previous day they had been pulling apart. It was only begrudgingly that he had accepted her suggestion that they should go to the carnival. She had been speaking less often, curtly, muttering things under her breath. And here they were, entwined, bitterly, achingly in love. Neither of them needed to speculate for long. They knew where their passion had come from. When they got back to the apartment, they fell asleep slower than they let on. Eyes half-closed, ears perked-up to wait until the other one had drifted off.

The next day, she went to work and he was stuck at home. Not amused

by daytime television. Didn't feel like reading. Or watching a movie. Or going for a walk somewhere. He sat down at the piano and played. It yowled like a cat. It screeched protest. It growled hatred and spat lopsided notes that would not string together. The piano was usually unresponsive, but he had made some headway. It had moved from utter noncompliance to babbled curses. That was something at least. Not enough. He soon found that he did not know what to do with himself.

 He called a friend. Asked to borrow his car. Yes, of course he'd fill up the tank. He left a note on the coffee table. Said he was catching up with some old friends. He had no intention of catching up with old friends. There was only one thing he was thinking of doing. Only one person he wanted to see. Two people. He went to the carnival.

For once he could ignore the grease urine crimestench. For once he could ignore the sleaze. There was something beautiful to see there in the freak show tent. Ignoring the grimeworld and the gaffed freaks and everything else, he approached the corral and the bent bridge twins. Inseparable. Stuck. Together. He cried. He didn't know why he would cry in the presence of such a perfect, loving monster. But he did. He wondered if the freaks could hear him, if they felt for him, if they could feel anything but their oneness and if they could care for the feelings of a being that was not part of the fleshbridge.

 For reasons that also escaped him, suddenly, he no longer felt like crying. He felt content and safe and like life made sense again. He left, drove back home. Found Mia in the livingroom reading. Locked eyes with her. Used her at length on the couch. Sweating aching, uncertain of what brought them so close, exactly what was unifying their bodies when their minds and hearts had been growing so far apart. Scared by feelings of what was simultaneously consent and rape. When they finished, they sat up on the couch, trying to scoot away from each other, but ending up cuddled together, quiet and unsure. Each thought of making a move for the remote to turn on the TV. Neither dared.

 They went to bed, didn't exchange so much as a "good night" before going to sleep. She woke up in the middle of the night, stroked into the land of the living. They fucked languidly at first, still half asleep, sloppy, not sure of what they wanted from it, but it rolled along, gathering passion, gathering strength until there was none left in their bodies and they fell asleep again, knowing that they were having the same dream. Should

have been some comfort in that, being protected and unified, safe from it turning into a nightmare. It wasn't.

As they held hands, each knew they were not holding the hands of some dreamself, but the dreamhands of a real person standing behind them, digging into their mind, clinging to their soul. Resentful and nervous. To be the one to let go would mean they were the one that didn't care, that they were the one to face their lover's judgmental gaze upon waking. They were holding hands in the dark, surrounded by nothing but possibilities. Dreams could happen if someone let go and ran into the void to discover. But nobody was going to. They breathed heavy, held hands and hoped the other one would let go and make a move, create some possibilities.

They held hands in the dark and waited. They held hands in the dark wishing they could stop. They held hands in the dark hating each other a bit. They held hands in the dark wondering if it would be like this when they woke up. Was there some balance they could strike up between silence and drooling lust, between worlds away and too close for comfort? Was that the question every couple asked or just the ones that weren't sure they worked. Would you let go? Would you fucking let go? They held hands in the dark and waited. Until the light came on.

The darkness faded and they knew where they were. Either they were tiny or the corral was gigantic. Gigantic like the copulating twins overhead. Holding hands in the dark, they had been beneath a bridge of inescapable affection the whole time. Corralled inside pornpromise and sideshow sleaze, legs turned into columns, miles of back giving way into cavernous buttocks. Each one of them wishing the other would let go. Would you fucking let go? We are not this. We are not stuck. We can let go any time. Would you fucking let go?

They wake up at the same time, making sure to turn away, as they cannot bear to look each other in the face following the dream. Mia goes to brush her teeth. He goes to get a cup of coffee. She hops in the shower. He toasts a bagel. Wolfs it down. She emerges from the shower. Dresses. Goes to the kitchen. He takes her place in the bathroom. Brushes his teeth. Showers. When he emerges, both of them know that one of them will have to leave the apartment if they are both to be alone. They hesitate and wait. Would you fucking let go?

They both end up on the couch. Saying nothing. Somebody must say something. Just as somebody should have gone off into the dark and

explored instead of leaving them standing there beneath the human bridge. If they'd gone off and explored the darkness, while it was darkness, they wouldn't have known it was the corral and that they were trapped. Being a dream, not knowing that they were trapped, they had to be free. Then they realize, at the same time, what must be done. There is only one thing they want to do, only one thing they can do. They know they're thinking as one, but they try to resist thinking that they're thinking as one, that there are no mysteries between them. Time feels too thick to pass. It does not drip away. Petrified.

Mia gets the courage to speak. She knows that it must end. Not the relationship. Not the awkwardness. But the stillness. They have somewhere to go.

"I want to go . . ."
"Yes. We should."
"The carnival."
"Yes."
"You went there yesterday."

He does not admit to this. He gets their coats. They drive past an hour and a half of oblivion and cornfield. They ignore rigged games that barely try to get their attention and food that barely smells like food. There is only one thing they have come for. As it was in their dream, there is nothing in the world but the tent and the corral and the two of them. The few patrons of the carnival back away, threatened by the intensity of their closeness and the singularity of their purpose. Nobody wants to get in their way. Nobody can. Nobody thinks they even exist in the eyes of the inseparable couple.

They enter the tent and the two freakseekers already inside instinctually make their way to the exit. They know this tent is no longer their space. They go to the corral, eyes clinging to the archbacked man and the archbacked woman, the manhood stuck to womanhood, brothersister lovers. They feel the staticspark of arousal. The tiny spineshock that declares "I'm afraid, I'm aroused, I need you, go away." They kiss, lips entwined, locked. Truly locked.

Have our faces come together? Are mouths one mouth? Will we taste with one tongue just as we think with one mind? Will our whole head be stuck together? He grabs her breast, surprised that he could let go of her hand. She shakes slightly when he does, puts her hand on his side, thinking that perhaps his letting go means they can't come back together, even as their mouths threaten to merge, melt together. She wraps her leg around his. If the freaks could turn their heads, they would be watching them,

perhaps seeing that they were alike. They swear the freaks are letting out sighs of pleasure. He has seen them twice, knows they don't speak, couldn't if they tried, but they are moaning softly.

Would they ever want to be cut apart? Can they even see? Are these sounds in their heads? In both their heads, they wonder. They are both wondering and they know it. They break their embrace, but clasp their hands again. Walk out of the tent, to the car. They don't drive for long before pulling over somewhere secluded, to touch, bite, unite. Love. Make love. Hold each other slightly too long for comfort when they are done.

Petrified again. They try to listen for each other's thoughts and to know if their thoughts are being heard. The results are inconclusive. They decide to get moving. That they should get lunch. They go to the Italian place that is slightly too nice for them. They stare at each other. Rub each other's feet under the table. Hold hands, only letting go when the food comes. It is the same thing that they ordered before. It tastes the same. It's pretty good, but they barely notice, although each one gets a slight taste of the other's meal in their mouth. A weird olfactory trick. A slight hallucination.

After lunch, they get back on the road. Resisting temptation, pushing yes, pushing no into each other's brains. They want to pull over. They want desperately not to. If they did, neither one thinks it would be their decision. They can decide when they want each other and when they don't. They can't. Pushing yes, pushing no, forty more minutes of almost kissing, almost sex, almost irresistible loving. It's good to be back at the apartment. Maybe.

Couch calls them over and they obey. Television becomes totem, each one afraid of the consequences of turning it on. Whoever turns it on is unloving. Whoever turns it on wants to ignore the problems that have grown. The remote destroys their world. The remote is an argument machine that should not under any circumstances be activated. They do not argue anymore. They are past that. They are past the television times. They might also be past the talking times. There are things to say, but they might not need to say them anymore.

Bedroom. They know bedroom. They undress. They stare at one another, knowing as they've known everything today, what is next. There can only be one conclusion. He assumes the bridge position. She approaches, sucking him ready. It takes awhile, because of his nerves and the awkwardness of the position. His yoga is out of practice. She assumes her position, wide open, waiting.

He enters her, neither of them knowing if he will ever pull out again.

LOU REED SINGS "THIS MAGIC MOMENT"

ANDREW WAYNE ADAMS

Pete Dayton lives in Oregon, not Ohio. There is a city in Ohio called Dayton, and in this city there is a district called the Oregon District—but Pete Dayton lives in Oregon, not Ohio.

One morning Pete Dayton answers the phone and hears: "You'll never have me."

The caller hangs up, but Pete Dayton does not. With the phone still gripped to his ear, he sits and stares at the radiator. Suddenly the radiator is the only thing in his apartment. It hisses, seeping shimmery heat.

Pete Dayton remembers a diner in Colorado.

The diner was small, clean, and blue. Pete sat at the front counter, watching a discus of frozen beef crackle on the grill. He looked away, and when he looked back, the grill was empty and there was a cheeseburger on a plate in front of him. He had not ordered it.

He stared at the empty grill. It sizzled, seeping shimmery heat.

A bell rang as someone entered the diner. Pete listened. He heard shined shoes and a casual suit, a watch on a hairy wrist. He heard age, ego.

The casual suit approached the counter but did not sit down. The hairy wrist put a cigarette between aged lips and lit it. On the wall, a small placard showed a burning cigarette with a slash through it.

The hairy wrist laid something on the counter and slid it toward Pete. A photograph.

"How you been, Pete?" A cup of coffee appeared on the counter. It spewed steam, hotter than any coffee should be. "How's the family?"

"What family?"

"Yours."

Pete looked at the plate in front of him and saw that the cheeseburger was gone. He found a blob of ketchup on his chin. "Do I know you?"

"Have you forgotten me, Pete?" The hairy wrist produced a business card. The card, though richly textured and well proportioned, was blank. "You need an ultraviolet light to read it, but what it says on there is my name. Ed."

Ed reached for the cup of too-hot coffee. He drank the burning liquid with gusto.

"Woo!" he yelped, slamming down the empty cup. "I *love* this fucking diner! They make the best damn coffee here; no place else gets it *hot* enough, you know?" The coffee had blistered his lips, and when he grinned, the blisters tightened, pale and shiny. "Real food, too—none of that genetic crap, like those miniature chickens they got now. I try to keep this place pretty secret, but I tell all my closest friends: go to the Sleepy Spoon."

Pete said, "I didn't know this place had a name."

"All these places have names." Ed tapped the photograph on the counter. He had not looked at it since setting it down near Pete, and he did not look at it now—just tapped it. "You know this girl?"

The girl was young, blonde, pretty. Light acne on one cheek.

Pete said, "No."

Ed tapped the photograph again, and as he did so, several fat black ants shook loose from his sleeve. They fell on the girl's face and crawled away in different directions. "This girl was killed in Dayton, Ohio. Two days later she was killed again, this time in Lincoln, Nebraska."

"The same girl was killed twice?"

"Three times, actually. After Lincoln, she was killed again in Portland, Oregon."

Pete watched a woman at the jukebox. "What was her name?"

"Alice Renee."

The woman at the jukebox was young, blonde, pretty. Light acne on one cheek. She saw Pete watching her, and she saw Ed, and she laid a finger across her lips, signaling to Pete: *shhh*. She winked at him, then returned her attention to the jukebox.

"I don't know her," Pete said, pushing away the photograph, "and I've never been to any of those places."

Ed pushed the photo back to Pete, saying, "You keep this." He stuck one of his blank business cards in Pete's shirt pocket. "If you *remember* anything, you give me a call."

A bell rang as Ed left the diner.

Pete studied the girl in the photograph. Maybe the light acne was actually a bruise with makeup on it. Maybe her hair was not naturally blonde. There was cigarette ash on her face, an ant on her earlobe.

The woman at the jukebox pressed two red buttons. A record slotted into place and started to spin, but no music played. The woman lingered, listening. Finally she turned and headed back to her booth.

Pete swept away the ash, flicked away the ant, and picked up the photograph. He stood and crossed the diner.

She watched him approach. The jukebox popped and hissed, playing its empty song, and there was no one else in the diner now, and the lights had dimmed to two spotlights. He slid into the seat opposite her and set the photo on the table between them. For a moment they just stared at each other. Then:

"It's you," he said. "Alice Renee."

He tapped the picture. Alice winced, and her light acne darkened. Pete saw that his finger had landed like a punch on the likeness of her cheek.

"Sorry," he said, recoiling from the photograph.

"I hate it when you apologize." She took a compact from her handbag and rubbed more makeup on the darkening bruise.

"It was an accident."

"It always is." She put away her compact. "Anyway, I would rather be hit than ignored." Examining the photograph, she said, "This is a screenshot from a porno. I recognize it."

"You were in a porno?"

"No. Would that excite you?"

"This whole thing excites me."

"Maybe we're in a porno."

"Where are the cameras?"

"Everywhere."

Pete looked around. He and Alice were on a vast sound stage. The diner setting had vanished—wheeled away, perhaps, or simply turned off. All that remained was their lone booth and, nearby, the jukebox.

The mute record still spun in the jukebox, its song a crepitating hiss—and suddenly Pete recognized that song. He had been hearing it all his life. It was everywhere he went. Everything sang it: the hiss of a radiator; the sizzle, swish, and crackle of a grill, a casual suit, a cigarette; the scratch of tiny legs on an earlobe.

He said, "I hate this song."

Somewhat sadly, Alice grinned. "Keep listening," she said.

And, as if at her behest, the song started to change.

A droning growl rode in on top of the hiss, replacing it. The growl became a guitar, and the guitar raised a melody of tingling skin, and a burnished voice sang of time and magic. Pete stared out into the darkness of the sound stage, listening to the song build, remembering it. He had been hearing it all his life.

Alice said, "This song always reminds me of the first time we met."

"I don't remember."

"You never do."

But he did. He said, "Alice, we ignored each other for five years. I never heard music when I was with you. All I heard was that empty hiss."

"But you hear the music now."

"But this isn't you." He laid a finger on the photograph of Alice Renee. He dragged the finger across the glossy surface, from the center of her face outward. In the seat opposite him, Alice's face smeared to the side like clay wrenched by invisible hands. "*This* is you."

She brought out her makeup again, swept a brush across the twisted putty of her face. In the space of a blink, her appearance was restored. "Let's just forget about it," she said, and started to stand. "I really think we ought to dance before the song is over."

"I would like to," Pete said. "Forget, I mean."

"Dancing will help you forget."

She took his hand and stood him up, and as they walked out onto the empty sound stage, the jukebox grew behind them, physically expanding to engulf the scene. Its proscenium arch swallowed them. They were inside the jukebox now, standing on a spinning record, neon tubing overhead. Surrounding them was a landscape of glass and metal, fluorescent décor aglow in a pervasive wash of ultraviolet light.

Pete held Alice and swayed.

For a moment, he had everything he wanted.

Alice said, "Some people, when they get unhappy enough, it forces a transformation. They veer off suddenly from the life they knew. They become someone else."

The record spun underfoot, its black vinyl like a highway at night.

"They'll move thousands of miles away. From one end of the country to the other. Shedding their old selves. The memory of who they were." Her blonde hair shone like platinum, auburn roots flashing in the depths. "Do you feel better?"

"I—forget what was troubling me."

Lines of cracked yellow appeared on the black vinyl highway.

"Some people, they stay put and run away into their own head. They

think they're someone else—somewhere far distant—believing they've crossed the Great Divide, when really they're still sitting in their apartment in Ohio."

The highway crossed a continent. Pete sped along it, decoding its broken center. He found music there, and the music filled his head like a freed secret.

He said, "Who killed you, Alice?"

She reached into his shirt pocket and brought out the business card that Ed had left him. "*He* did," she said, showing him the card. "And he wants to do it again. He is always looking for me. He wants me—wants to 'have a moment' with me. He wants to—*kiss* me."

Pete looked at the card. In the ultraviolet glow of the jukebox, the card was no longer blank. It gave a name, a number, and an address in Dayton, Ohio. The name was indistinct, fuzzy like censored television.

Pete felt something in his jeans pocket, and he reached in and found a cell phone that wasn't his. He looked at the phone's keypad, looked at the card with Ed's number on it. He thought of Ed's voice: "If you *remember* anything, you give me a call."

He didn't remember anything.

He dialed Ed.

There was an answer after one ring, but no one spoke. Pete gripped the phone to his ear. All he heard was his own breathing, his own distant blood.

Alice took the phone and, looking at Pete, spoke four words into it, a blunt message to the man who wanted her: "You'll never have me."

A blast of pure noise split the world. It was the needle skipping a groove. With it, the music ended, abruptly severed. Silence flooded in.

No, not silence: a flat hiss.

The lights flickered. The glass and metal landscape quaked. Pete felt a static tingle trace the contours of his skull, shelves of flesh trembling like tectonic plates in flux. His vision blurred, doubled, bringing something new into focus.

Alice stepped away from him. She straddled a groove in the record. The needle came around, and Alice, directly in its path, watched it.

Pete had no time to act. He never did.

The needle sliced cleanly through Alice, bisecting her. Her two halves fell away from each other, spread apart like raw petals. Pete observed her opened interior, not understanding it. Her cavities were rife with ants, black specks scurrying like television static, and a chalky dust clung to the wetness of her organs. Then, in the space of a blink, her human pieces lost

form, becoming like trash heaps of clay and burnt film stock.

 Pete Dayton watches in his rearview mirror as the lifeless parts recede. The black vinyl highway flows like filmic water, carrying him east-west. If there is any music in the road, he is deaf to it now. He listens to the blankness. It sounds like a radiator hissing in Ohio.

ZYGOTE NOTES ON THE IMMINENT BIRTH OF A FEATURE FILM AS YET UNFORMED

JOHN SKIPP

1.

I am dreaming a movie. What it is, I don't know. It will tell me when it's ready. Is already whispering to me now, unfurling itself like a softly windswept curtain.

The curtain is a place called Manitou Springs: a lovely little tourist town and art enclave at the foot of Colorado's grand Pike's Peak.

I am struck at once by the establishing shot through my windshield, eyes functioning as an imaginary camera lens. Capturing the colorful storefronts and sturdy Wild West architecture of its main drag, the scattered two-story homes winding up the green hills, the majestic mountain beyond.

The streets bustle with brisk tourist trade: roving packs of jocks and off-duty soldiers, clean-cut American vacationing families, delighted women on boutique shopping sprees, an impressive array of strolling lovers.

But the locals stand out, roughly 50/50 in the semi-dense sidewalk sweepstakes. They are shaggier, more relaxed and at home on these streets. Saying hi to one other, and walking their dogs. Most of them seem pretty happy to be here.

Beneath the surface, however, there is something deeper churning. I can feel it in my bones. Something special about here. Something exciting and strange, galvanizing every speck of sensation I have.

This town feels frankly full of ghosts, and older spirits from nature's weirdest depths, history repurposing itself for a 21st century America that, like me, knows far more than it understands.

I cruise leisurely through its heart in a cheap rental car, my shrunken stroke-addled dad riding shotgun at my side, curious pastel-blue eyes blindly unseeing, head cocked like a cocker spaniel's, a floating half-smile on his face.

"Oh, Dad," I say, over the car's cranked A/C, pushing the limits of his hearing aid. "Manitou Springs is knocking me out. Do you remember what it looks like?"

"Manitou Springs?" he says thoughtfully, every memory a struggle through fog. And as I proceed to describe it, building by building and mountain by mountain, he seems to go farther away. As if rekindling sight-based memory is transporting him elsewhere.

Not just through time, or space, but some other dimension altogether.

That is the wind that stirs the curtain.

2.

After dinner, I bring Dad back to his managed care home, where the slow death of hundreds of elderly bodies smells like Febreze on old bones. The air inside is heavy with waiting and forgetfulness, but also with a kindness I can't help but respond to. It's so nice to know that honest human concern is at work here, at the end of the road.

We play a round of Yahtzee, and he kicks my ass. He can't see the die, but he rolls them just fine. I don't have to cheat to declare him the victor. He is happy. That counts for a lot.

I help him make his way to the bathroom for his nightly prep, stand back for his private moments, spend those ten minutes looking at pictures of myself, my mom and sisters, his other late wife, all surrounding him, unseen and yet comforting.

He comes out of the bathroom, strips naked and frail as I hand him his pajamas, help him put them on, lead him back to his favorite chair. The nurse comes in, gives him his meds. I say goodnight.

And drive directly to Manitou Springs.

3.

The Pikes Peak Inn is a cozy, inexpensive family-run joint at the mouth of Manitou's main drag. Two stories, twenty rooms. I am delighted to find an available room in tourist season, check into tiny #209, feel immediately at home.

Now the movie can begin to awaken.

I settle in, set up my toiletries and laptop, get out my note cards and medicinal weed. The residual dying energy still clings to my skin, but I need to be extra-sensitive now. Take the good with the bad. Take a toke. Feel it open me. Take another two quick, and done.

I punch up a concise Google search, give myself 15 minutes for homework before I start pounding the pavement. I skirt quickly through the tourist page, just to get my bearings, then beyond, garner several fun facts.

1) Manitou's rich abundance of mineral springs made it sacred ground for the Utes and other tribes, then a hub of health spas in the 1840s, as the town itself began to grow.

2) It is often now referred to as "the Hippie Mayberry" for its warm blend of high counterculture eccentricity and old-fashioned, down-home hospitality.

3) While Manitou evidently throws a mean zombie walk—with hundreds of its 5,000 citizens shambling up and down the square—its biggest weirdo annual event is the Emma Crawford Coffin Race and Parade.

This to-do is in gleeful celebration of the terrible day in 1929 when poor 18-year-old Emma—already 38 years dead of tuberculosis at the time—was washed down Red Mountain by torrential rains that unearthed her ill-buried coffin, and black-water-rafted her through the center of town.

I am really starting to like this place.

It's time to go explore.

Outside my door, the night air is cool and fresh, and I hear the soft burble of flowing water to my left. The carpeted second-floor veranda woodenly creaks beneath my feet as I come to a patio at the end of the railing: one bench, two chairs, and a low wooden table, overlooking the creek that runs directly below.

This water runs down from the mountains, and I can see in the tree-shaded streetlight dark that the long summer drought has taken its toll,

the water level low but still powerful, comforting.

These mountains have secrets, and they flow through this town. I feel refreshed by them, spend a long meditative moment just soaking them in.

And listening hard.

In the parking lot, a car door closes. I see a nervous man in a ball cap and long sleeves, hefting a duffel bag and suitcase. He moves uncomfortably toward the stairs at my end of the building; and for the first time, I notice the blocky, artless police station just beyond.

I imagine his tense point of view, coming up the stairs, float a second imaginary Steadicam just behind him like a ghost. My own POV is the third camera angle, watching as he ascends into view.

"Howdy," I say, with an easy nod and smile to let him know it's all good. He nods tersely, eyes averted, ducks his face behind the brow and continues on, clearly wishing he were invisible.

I wonder what he's running from. Ex-wife. Ex-lover. Ex-boss. Ex-cronies. Cops. Criminals. Demons. God. Maybe just running from himself. Maybe all of the above. Maybe I'll just never know.

I center my gaze as a long shot, taking two slow gliding steps like a dolly sliding forward on its tracks.

He stops at #208, unlocks the door, and steps inside without a backward glance. I wonder what sort of sounds my next-door neighbor might make tonight, alone or otherwise. Hope for the best. Wish him no harm.

Then down the stairs, through the parking lot of strangers, and into the heart of town I go. My eyes are the camera.

I pretend I am that wannabe invisible man.

It's 10:00 on a Thursday night, and the sidewalks are almost empty. Nothing but darkened boutiques and colorful tchotchke shops, a bookstore, a comic book store, lots of arts and crafts.

At this point, the only things open are bars and eateries that also double as bars. Music emanates from all of them: much of it live, almost all of it good. There's a sixteen-year-old white kid playing slide guitar and singing plantation blues like an eighty-year-old black man. I'm devastated by his old soul. Stop into the dive, like a hand-held camera, for a beer and a listen.

I want to talk with him, but suspect that everything he has to tell me is already in his songs. He is clearly possessed by ancient voices. I tip him a dollar, return his smile, head back into the night.

At the end of the strip—maybe eight blocks long, depending on how you count it—the hungry hungry hippies converge just beyond the Ancient Mariner, where the Grateful Dead's "Jack Straw from Wichita" is

being earnestly rendered by a dreadlocked Filipino on twelve-string guitar. Evidently, it is Open Mic Nite.

I am old, dressed in black, and near-invisible again, so the young ones barely note me. I am not on their map. But out of the outskirts comes a ragged Charles Manson with glittery eyes and easily forty hard years of schizophrenic hustle behind them.

"Hey, man," he says. "You like movies?"

I laugh and say yes.

He brandishes a home-burned CD in an orange plastic case, the words BEYOND YOU BLIND FUCKERS scrawled in black magic marker. "Well, you ain't never seen nothing like this," he says. "This is the movie you've never imagined, telling you the things you've never been told."

"Then you've got my attention," I say, extending my hand. "What's your name?"

"Scout," he says. "Cuz I been there and back. You wanna talk about the subatomic universe? You wanna talk about other planets? Other dimensions? Star-seeded data that precedes our creation, and lays the foundation for all that we touch, taste, feel, see, and smell, just for starters?"

"Don't mind if we do." And he shakes my hand.

"You got a cigarette?"

I hand him one, light one myself.

"There are emanations," he says, "coming off of these rocks that surround us. These mountains. This place. The fucking Garden of the Gods, man. Have you been there yet?"

"No, I haven't."

"Then you don't even know," he says, grinning like he's got the upper hand. Playing the rube card. "It's not just CIA satellite crazy shit, Google spooks, or the Air Force Academy. It's not just Focus On The Family, and the 100,000 churches of Colorado Springs."

"That," I note, "is a lot of churches."

"This is the energy they're all trying to catch, but they're all too blind. Cuz they don't know, man. They don't know what really makes shit tick."

I exhale smoke, point at the CD in his hand. "So what'cha got there?" I ask.

His eyes narrow, as if showing too much bloodshot white would give it away.

"Twenty dollars," he says.

"I got a ten in my pocket."

He thinks a second. "I can do that," he says.

I pull out a ten, and we make the exchange. From there, he spends a

couple minutes sketchily describing some amazing new technology he's developed, evidently able to read the waves between all things as never before.

Past that, it's a quick-slipping slope to sad self-aggrandizement, bitterly delivered by drunken rote. He's already made the sale, and sees no other prey, so now he's just dumping the load. How nobody understands him. How the world is all fools.

I offer to buy him a drink at the Ancient Mariner, and he defiantly informs me that he's been barred from drinking there. This doesn't surprise me a bit. I thank him, say good night. And he curls back into loneliness, at the outskirts of his town.

4.

Back in my room, undisturbed by invisible neighbors, I toke up and watch Scout's footage on the laptop. It's all just psychedelic fractal images. Patterns infinitely unfolding. Fascinating and stony. Incredibly colorful. But absolutely narrative-free. Not even a voice-over, or single chapter devoted to accusatory rants, which kind of surprises me.

The good news is, it's like tripping on acid with your eyes closed, so you can't escape the visions.

I like it very much, but have to admit I got more out of watching the creek.

Then I sleep, and dream, let the ingredients softly sift.

5.

And what I remember is this:

I am a dead and buried woman, coffin unearthed and slaloming down a mountain on a floodwater river of rain. The coffin is so full that the lid blows open, and I am thrust upright like a race car driver, whooping up gouts of rich mineral water that machine-guns from the skies as I careen straight through the center of town.

One hundred zombie walkers crowd Manitou Avenue, dodge to either side as I approach. Their green and red makeup runs down their chins in the deluge from above. Very much alive. Just having fun pretending.

Playfully rehearsing for the end. And totally unprepared for this.

But I know dead, and envy them as I plow through their numbers, my eyeless eyes seeing them all too clearly as the red neon sign on the Royal Tavern comes roaring into view...

... and it's dry on the Royal's patio, as I hoist a beer to my lips, no longer careening. There's a skinny, lovely woman across the table from me. Is she dead? Is she me? Is she Emma? I'm not sure.

"Wanna know a secret?" she says.

"Well, yes," I say. "They're my favorite things."

She leans forward in confidence, sweet, spooky, and sly. Her white-blonde hair glows, backlit by the overhead light. Eye sockets cratered to black by shadow.

When she opens her mouth, there are no teeth inside it. Just a hole that grows larger, and sucks me in.

"Nothing," she says, *"is very small, but very wide."* Her smile stretches up over her cheeks. *"Full of things we can't touch, and sounds we can't hear."*

I take a swig, and all creation disappears.

"If you stumble into nothing," she continues, *"you'll likely go blank, fall back out before you even know it happened."*

I can no longer hear her, but I know just what she's saying.

"But when you're in it, you know what it is."

6.

And then I am awake, at sunrise, remembering precisely that much and no more. Whatever other clues my unconscious may have dropped have skittered back to the dream-dark, where I hope to recapture them later.

Through the wall behind my head, I hear the invisible man crying, feel Manitou stitching itself into me like needles pulling thread, and suck up the twinges.

This is how the job is done: one puncturing, intimate little insight at a time.

My body is warm beneath the sheets, but the death-waft from Dad's nursing home still numbly rumbles in my bones. That energy is hard to shake off, at least for me, no matter how alive I feel.

Overflowing with forces beyond myself, I hop out of bed: just another little center of the universe, peering out through God's eyes, as I slip into the tiny bathroom and take a serious, much-needed morning dump.

7.

Fifteen minutes later, I am driving through the Garden of the Gods. And oh, my goodness me.

Honest to all the gods there are, it's as if the angry red planet Mars hurled a massive handful of its coolest giant rock formations directly into space; and a million years later, they all somehow landed smack-dab in Colorado, at the foot of Pikes Peak.

It's insane, how profound it is.

Fuck Stonehenge. Fuck the Crystal Cathedral. Sheer 300-foot walls of majestic red sandstone jut unearthly from the heavily wooded Earth, as if to taunt us toward meaning. Some of them impossibly balanced on top of each other. Some splitting into uncanny twins like the stone equivalent of John Carpenter's *The Thing*.

Could a blind and indifferent universe actually stumble unaware into shit like this? How many trillion typewriting monkeys would it take to conceive of what I'm staring at right now?

I wonder about Scout's alleged technology. Is what he shot some actual readings from the rocks? Or is he just going all impressionistic, trying to digitally conjure some inkling of how this feels?

If there's one thing I know, it's that words don't do it justice. I instinctively think of where the camera should go. At pedestrian level. Vehicular drive-by's. A helicopter's God's-Eye view from above. Yawning ground-level views up their stunning expanses. Micro-close-ups of the fossilized textures themselves.

So old. So far beyond our recollection.

So utterly full of secrets.

I think it's time for breakfast now.

8.

Walking through Manitou in awakened daylight is a totally different story. The bed and breakfasts are disgorging their tourists. The locals are opening their shops, or walking their dogs. Dozens of dogs, all relaxed behind their leashes. As if this were the place that *All Dogs Go To Heaven* had in mind.

I find myself smiling, strapping imaginary Steadicams to my knees in order to catch every canine smile.

I may be wrong, but it seems to me that these dogs are somehow smarter than we are. Closer to their instincts. More directly connected. Less abstract in their Gnostic experience. More *here*.

And I think: if everything that exists is the center of the universe—each thing experiencing itself from the inside, as a representative manifestation of the greater whole—then every perspective has innate and holy value.

Or at the very least, something to say.

I try to imagine every eye I see as a camera, seeing me back and then beyond to something better. I pretend, once again, that I am that invisible man from #208. Focus on the not-me things that everyone else is seeing, till I'm not in the picture at all.

The shot list is too huge to absorb, and yet I absorb it, morsel by morsel. Brain shooting in Every-Cam, and gobbling as much as I can.

A trio of teenagers walks up to me, unnoticing. And one of them says, "Patrick Stewart is the best Captain Kirk. No doubt." Am thrilled when they all agree.

Think *Christ, what an absurd universe.*

These jokes just write themselves.

Back in my eyes, just beyond the Royal Tavern, a courtyard opens up to the right. And from the corner of my soul/lens/vision, I spot a space ship, a racecar, an elephant and a pony. All vintage buck-for-a-quarter arcade rides for six-year-olds and younger, lacquer and plastic a-glisten in the suddenly painful sun poking out from a hole in the clouds above.

I take the right, wander down an alley-like promenade past dozens and dozens of rides, only to find it lined with room upon room packed with goofy games. Tracing the history of squandered time, in all of its funnest forms.

I was born in 1957, and can clearly remember the pinball machines of my 60s youth. How modern they seemed, next to the swear-to-God little-wooden-guys-running-around-a-baseball-diamond-if-I-hit-the-metal-ball-right-with-the-flipper entertainments I tried to wrangle at the age of six.

But here they all are, next to archaic Guess Your Weight and Test Your Strength devices that date back to the dawn of nickel slots. I'm guessing from the 1920s on.

When I hit the room jam-packed with Pac-Man and Asteroid, I am smack-dab absorbed by my own twentysomething milieu, with all the signature bells and whistles.

So when I see my 55-year-old self peering back like a ghost on Ms. PacMan's glass, I halt for a second. Trying to reconcile who I was with the reflection before me, like a color transparency in a high school biology textbook forty years in the past.

The reflection nails me. Throws me a wink.

And leaves me helplessly stuck inside the glass.

"You want a movie?" my no-longer-my-face says. "You wanna tell my story? I'm all yours. Have at it. GOOD LUCK!"

And with that, my body is gone, dancing out of my view, back toward the main drag without me.

Absent of body, I am a lens stuck on sticks, a tripod-bound static shot completely at the mercy of hands I no longer possess. Ms. PacMan races through the maze of my new insides, chased by faces with only one thing on their minds.

I want out of this maze.

The only way out is in.

I thrust myself out of the glass, into the circuitry, and through: coming out the other side of the device, and hurtling sub-atomically through air that feels like freedom and looks like a Steadicam running full speed. Weaving between toys and pedestrians alike, in one single moving shot that chases my happily rollicking body as it ambles down Manitou Ave.

I hit the stone wall of a corner t-shirt shop, find my consciousness plowing through the brick and mortar with no physical resistance whatsoever. It's like swimming through water without the need to stroke, paddle, or kick. Like I'm the tip of a laser beam.

I emerge in the shop's storefront window, catching up with my possessed bag of skin. It turns, sees me in its own reflection, and gives me a big thumbs up as it moves closer.

"WOOO HOOO!" *it exclaims.* "How'd you like *that?"*

I return the thumbs up.

"Now we're talkin,'" *it says.*

And I am back in my own body.

"Try the European Café," mouths my reflection on the storefront window. "Right behind you. Do the Skillet Special, with two eggs, sautéed onions, mushrooms, peppers, and cheese on a bed of exquisitely seasoned olive oil home fries to die for. I'm not kidding."

"I love you," I say.

"Love you back," says the town.

And let me just point out: that fucking breakfast is superb.

9.

In summation, as I pack my bag and prepare to drive away:

Movies are creatures, with lives of their own. Just like everything else that is waiting to be born. If the right elements all manage to somehow come together, they happen.

If not, they were only dreams.

It's checkout time at the Pike's Peak Inn. I fly back to Los Angeles in a little less than three hours. Time enough to hug my dad, tell him I love him, schedule when I'll be back.

His 90th birthday is coming up fast. An astonishing run, for one little life.

Time is funny like that.

Life is what happens when you're making other plans. And plans, at the least, are amplified best intentions.

I was a dream once. A dream of a boy my mother and father made happen. Who that boy might turn out to be, they had no idea. They just did it, then tried as hard as they knew how to make that little zygote wind up being somehow worthwhile.

Something they could love, and be proud of.

Something they were glad they did.

That's certainly how I feel about my own amazing daughters. And how I feel, right now, about this film about to be born.

I am dreaming a movie. What it is, I don't know. But I have sampled its ingredients, and tasted its essence. Can feel the puzzle box curtain unfurl.

Am inside that invisible man, who is running from something, and has wound up here. Where he will certainly be found. By what, I don't know.

Let's call it God without the beard and throne. The Fount of All Creation. The Source of All Secrets.

Whatever you wanna call it, I have found my Twin Peaks. A place of charm and mystery, light and dark, height and depth ringed by infinite breadth.

Not bad for a one-night stand.

I couldn't be happier with this tiny little room if I'd spent the whole night fucking inside it.

"See you soon," I say, pantheistically blowing it a kiss.

And close the door, for the time being.

As the universe unfurls.

A LOVE SONG TO FRANK BOOTH

EDWARD MORRIS

This is a memory. I'm not really here. Everything is okay now. He's been gone for a long time, the happy ending now wound up rightly, tweeting artifice and shitting sequels in the yard. But in another way, I never left the hot, bacteriological zoo smell of this closet where I hide, second rooster in the henhouse now beholding the swiping claws of a great basilisk serpent, the cold, flat gray affect of his eyes. Dead man's eyes. Like mine now.

From the closet door, I watch the boogeyman come unglued in that little room that still smells like our love, our sweat, the one random rope of cock-snot hanging strategically on the lampshade like a snail in ectoplasm where no one is looking on the film, the film that is the space between the two latticed slats as Kronos comes home. I smell the sweet nitrous oxide somehow, too, from that rig he made, that hateful little cup he puffs . . . and puffs . . . to blow down the house and everything around it. Laughing gas never made Frank laugh. He does that on his own.

Langorous, rapturous ecstasy on her badly painted mannequin face, overbite fully exposed, as Booth kneels at the darkest altar of my heartbreak, and we all turn the corner into a side of Woodburn Fucking Oregon where we were all along, all along, in here with the rest of the termites that squitter and chew and shit shellack across every bite mark in this hollow log. I should have known he'd be a biter. Into his mouth, she shoves the corner of her Lewinsky dress, as the veins pound on his forehead, and the eyes forget to stare her into stone, or me, or anyone. He is somewhere else now, a home he thinks he has. This bubble is home, this world of split-second violence. Frank's World is home everywhere he goes.

This is a memory: The point where he comes utterly unglued. Where the half-closed knuckles tap the Blue Lady's head back with just enough force to make her full lower lip gush blood, and she moans and I can smell that smell, that smell, the side of her neck I was just kissing not ten minutes before the cockatrice blew in the front door.

The Blue Lady moans, and I can smell her sweat change. I couldn't play that change upon the instrument which is her, my hands not skilled enough in the Satanic art of giving people what they really want. Taking what I really want. But I can hear my own bestial roar, far down in the blood-dimmed caverns of my bronchial tubes, back in the sinuses behind my eyes. Back in the beating, bleeding, bleating meat, the blood and lipstick I can already taste from his chewed flashlight-kisses across my mouth after I got one good lick in and socked him in the jaw.

None of this movie really happened. They already buried me in a ravine after Frank got done. In pieces. In lipstick. In Love.

IN MEMORIAM: DENNIS HOPPER: 5/17/1936-5/29/2010
LET'S HIT THE FUCKIN ROAD.

GIRL FROM IOWA

ZACK WENTZ

There was a beautiful girl from Iowa, and also a beautiful boy. They could have been brother and sister, but they weren't. They were supposed to be in love.

People saw them together everywhere, and always had. Down by the creek, playing in the mud, under the bleachers, looking for change and other lost things, hiding together in the washing machine at the laundromat. They were seemingly inseparable, and when it came time for them to go off to college nobody even thought of trying to send them to different schools, because doing that seemed unthinkably cruel. They were too beautiful together. Only those envious of their combined beauty would have considered it, but there was nobody like that in the small town in Iowa where they were from. At least nobody that was worthy of attention.

At the college they attended, their beauty was amplified. So much that it actually became apparent to the girl and the boy. Shit, we're beautiful, they cooed together one evening, drunk, staring at a bright slice of moon off the back porch of some dingy house where a party was being held, seemingly in their honor.

But, of course, it was not to last. Fellow students began appealing to them individually, seeking them out in private, arranging rendezvous under various academic pretences, and inevitably one of them ended up fucking one of those other people. It happened to be the girl.

The boy was, understandably, distraught, and the fact that he hadn't been the first to commit this indiscretion seemed to diminish his beauty. The girl shone more brightly now, even to him. He had to appeal to her, for the first time, beg her to rejoin him and try to go back to what they

once shared. We cannot go back, the girl said, and smiled. Beautifully.

She enjoyed the fresh kinds of attentions she received, in her new solo capacity, and indulged in them with almost manic zeal. Her promiscuity became as unrivalled as her beauty, and it soon seemed that almost no one on the campus, faculty included, or even the natives dwelling in the small town surrounding the college, had not tasted her.

It was at the beginning of her second semester when a local rabbit that had grown humanlike enough to casually escape from the laboratory in the science building began following the girl. The rabbit was around three foot ten, and it watched her from under bushes, behind trees, around corners. Surprisingly she didn't notice the rabbit. It was one of the few things she hadn't had sex with.

Also, at around this time, she noticed a large mole sprouting at the top of her right breast. Nothing to do with science classes. Nothing to do with anything. Daily the mole grew, first becoming the size a chocolate chip, then a button, a quarter, and then, finally, a nipple. The third nipple stared at her from the top of her right breast, and she was filled with terror. Dear God, she said, I am cursed. I am going to die.

The rabbit watched her watching her new nipple one evening from where he was hiding beneath her bed, and then he watched her get up, clothe herself, and leave her dorm room. The rabbit pursued her to the stables at the edge of the campus, saw her enter, and emerge several minutes later astride a large horse with her arms bound, Christ-like, to a white, plastic pole stretched behind her neck across the top of her shoulders. The horse trotted off with the girl in the direction of the woods, so the rabbit followed.

After a couple days of woods they came to desert, the girl still oblivious to the rabbit's presence, or anything else. And after a few days of desert the horse, which was now close to death, was lucky enough to spot a small patch of grass growing around a deep puddle of water at the base of a tremendous, black tree, and went to it. Thank God, the horse thought, and ate and drank heartily. The rabbit was just about to sneak up next to the horse and join it in its meal, but was stopped by a deep, menacing voice: What the hell is going on down there?

The rabbit looked up into the tree and saw, sprawled together along its thick branches, a cowboy and a werewolf. The pair came climbing down, and the rabbit shivered with fear. The werewolf had a good four feet on him, at least. What are you doing here? the werewolf asked. I followed her, the rabbit said, and indicated the girl on the horse with his trembling whiskers. The werewolf and the cowboy pulled the girl, who seemed

scarcely conscious, off the horse and set her down on the dirt. Beautiful, the werewolf said. Yes, said the rabbit. You should see her with her clothes off. Oh really, said the werewolf? And he and the cowboy quickly busied themselves with removing the girl's clothing, eventually having to remove the pole to which her arms were bound to get the job done.

Now they all lived in the tree, except for the horse, which the werewolf and the cowboy ended up eating. The werewolf and the cowboy took turns fucking the girl throughout the days and nights of the following month, never seeming to tire of her, but becoming increasingly intolerant of one another. The rabbit watched from a far branch, trying not to attract too much attention. The girl seemed blank, alternately taken by the werewolf and the cowboy, the cowboy and the werewolf, unaware of the difference.

One evening the rabbit awoke to the sounds of a scuffle. It was the werewolf and the cowboy. You've already fucked her two times more than me today, growled the werewolf, and clawed the cowboy across the face, knocking him to the ground. The cowboy took out his gun and shot the werewolf in the chest, and the werewolf fell on top of him, apparently dead. Silver bullets, the rabbit thought, and watched the cowboy struggle under the weight of the gigantic werewolf for a few minutes, saw him become still, and then heard snoring. Now's my chance, thought the rabbit, and went to the girl. Come on, the rabbit said. We must escape. The girl stared at the rabbit, down at her third nipple, which was staring at her, and blinked. Shit, the rabbit said, and took the girl by the hand and began leading her across the desert toward where he thought the college might still be.

For three days and three nights the rabbit led the girl, sleeping an hour here and an hour there when he felt it was safe. The girl did not seem to care. You're still very beautiful, the rabbit said, and squeezed her hand. The girl looked at the rabbit, seemingly through him, and said nothing.

Another evening the rabbit awoke to the sound of a gun being cocked. Oh no, thought the rabbit. He looked up into the hole in the barrel of the gun, which was attached to the arm of the cowboy and pointed at his face. The other arm of the cowboy was attached to a rope, and at the end of that rope was the girl. The rabbit swallowed, and the cowboy shot him in the eye that was closest to the hole in the end of the barrel of the gun.

The cowboy did not take the girl back to the tree, but led her vaguely in the direction he thought the rabbit had been leading her. Every few hours he stopped to fuck her, never removing the rope from her neck, seldom even removing his own pants entirely to perform the ritual.

Finally they came to the woods on the outskirts of the college town.

The cowboy had never seen so many trees, and had difficulty selecting one to climb and sleep in. He tried several, dragging the girl up after him, until he settled on one that reminded him the most of the great, black tree in the desert, the one he had lived in with the werewolf. The cowboy gave the girl a good fucking up in the tree, then secured her leash to the branch beneath them and fell asleep, a bit of a smile sneaking across his face.

The cowboy awoke to a mighty trembling in the tree, and he pulled out his gun, afraid something might be attacking. He saw that the girl was no longer next to him, but that the rope was still tethered to where he had tied it the night before. The cowboy followed the rope with his hands, saw where it had been wrapped around the center of the thick branch several times, looked down and saw the girl squirming and quivering at the end of it below him, but still a good several feet off the ground. The cowboy aimed at the rope to sever it with a bullet and release the girl, fired, saw a piece of something dark burst from the side of the girl's skull, and then the girl going still.

The cowboy shimmied down the tree, looked up at the girl hanging there, and then began moving through the woods in the direction they had been traveling before they had climbed the tree to sleep.

The woods grew denser, disorienting the cowboy, but he continued, without sleeping, without eating, without anything. After another day and night of traveling the trees began to thin, then gave way to a vast field, green and flat, the grass cut in a short, even way. The cowboy bent down to eat some of the grass, then spit it out, and began walking across it.

At the edge of the field the cowboy came to the stables. He looked in, saw the horses sleeping, and moved on.

The cowboy had never seen buildings. He had never seen sidewalks. He had never seen brick. He moved along in the dark, staring at these things as they appeared, afraid to stop, afraid to keep moving. He had a horrible feeling that these buildings were alive, and when they woke up they would devour him. His fingers reflexively gripped the handle of his pistol, but he knew it couldn't do anything to these buildings, to all of this stuff. It was useless. As useless as turning around and running to get back to the desert he had come from. He could never return. Not after he had seen all of this. Not after this nightmare.

One morning, a bit less than a month after the beautiful girl from Iowa had disappeared from the campus, the beautiful boy from Iowa was stumbling back to his dorm from an evening spent in the above-store apartment of an older woman he had taken to sleeping with. He was still drunk, and the buildings seemed to dance over him. Shit, the boy said, I

think I'm going to puke, and as the boy said this he tripped over something and fell to the sidewalk, scraping the palms of his hands on its surface.

He looked at what he had tripped over: a short, wiry, older man in a large, floppy hat, wearing boots with spurs, filthy, corduroy trousers, some kind of leather vest over a plaid shirt, and lying in a massive puddle of blood. Much of the man's face seemed to be missing. The boy struggled to his knees, the blood already soaking into his jeans. There was a gun in one of the man's hands. Dear God, the boy said, and this time he didn't just think he was going to puke as the sun rose slowly over the old brick buildings of the sleepy campus, and the other students began to emerge from the buildings they lived in to go into the other buildings and try their best to learn and learn and learn.

BLUE VELVET CAKE

LAURA LEE BAHR

The Ingénue gets the toilet lid open just in time. "It isn't on purpose," she thinks, as she pukes up blue and brown. "He has to know this isn't on purpose."

Fluorescent lights flutter and hum in the far-too-bright bathroom with its white and black tile. Two stalls and any moment anyone could walk in. A sharp little voice continues singing through the speakers in the bathroom, just like it sings in the diner outside:

"*Why do the birds go on singing, why do the stars glow above . . . ?*"

And out there, waiting for her, The Young Man with the Blue Eyes is sitting in a booth, hearing the same song, if he is listening at all.

"*Don't they know it's the end of the world? It ended when I lost your love . . .*"

She leans against the stall and gives herself over to the emotion with a heaving sob. Then, seeing that while she made the toilet, she didn't miss her pink cashmere sweater, her disgust takes over and the business of cleaning herself up overwhelms her self-pity.

It isn't lost to the Ingénue, after she rinses her mouth with the travel-size Scope she carries in her purse, that she has often puked on purpose, and that is why she is so well-prepared. It isn't lost on her that this is something like irony, if not actual irony, though a month or so ago she said something was 'ironic' and received a snarf of condescension from a screenwriter that made her question her definition. She should look it up when she gets home. She feels pretty definite that *this*—her puking due to being knocked up, when she has puked so much in an effort to be sexy—is ironic.

It is a different song entirely now, being piped in, "*Pretty Little Angel*

Eyes." Her pretty little mouse-brown eyes are still moist but no one will know she was crying. If he knew she was crying, maybe it would help her cause. The Ingénue re-applies her lipstick and appraises her reversal face in the mirror. "I love you," she practices. "No matter what you want me to do. But I want to keep it. We can stay together, or we can say goodbye, but I want to keep it."

Goodbyes are the biggest cocktease. The Character Actor blinks his eyes at himself in the mirror and gives himself a pep talk the best way he knows how, a monologue where he is the hero who has to do the hard thing. He is—he knows from the mirror, if nothing else—an ugly man now. The bathroom smells nice with its scented soaps and floor wax, even though he just took a big shit. And even in the low, kind light of a private bathroom, the mirror shows a foul ugly man. No use denying it. Not his fault. The years. The heartache. That bitch.

But there is a promise in a goodbye of something beautiful, something sad. If you know it is the end, you can do something. You can tie it in a pretty little bow. Yeah, that's something—something punchy his smart-cracking detective character might say from the series no one remembers anymore.

"*I guess you want it all tied up in a pretty, little bow, don't'cha?*" and he'd shove his fist in the boss's face.

A pretty, little bow.

This goodbye has been a long time coming. This goodbye is one he has been thinking about for five years hard, ten years soft. This goodbye might have come in a flash of temper, but it is one he told himself to think about first, and thinking about it did him good. It was like a present, like a reward he was giving himself for being smart about it and not losing his cool. This is a goodbye he has dreamed about, his hand tight about his cock, late at night, hell—even with her mouth tight swallowing his cock some afternoon. He hates that bitch. He hates even the pretty things she has given him, even his own cum on her, in her—especially his own cum in her—for she has trapped him like some Chinese finger puzzle.

He has thought about this goodbye for too long. Now that it is here it brings him no pleasure. It makes him throw up.

The Character Actor, he's sick. He is here, with her, the Faded Fatale, eating dinner, but he can't eat. Before he excused himself to the bathroom, she was there (stupid cunt—stupid slut—stupid bitch—ruined my life)

looking so sad and old and drunk but still something pretty in her.

It is nauseating.

The sight of the pasta—named after him for he is a loyal celebrity patron at this establishment, and many people order the dish the way he likes it just because it says his name on it—the sight of the pasta on his plate made his stomach churn. And he excused himself to the bathroom. She is out there, still. She doesn't know anything is wrong.

The Faded Fatale is tipsy, or drunk, and she has never thought for a second that he would make good on his promise to kill her.

Tonight's the night. It's set, but he can't keep his head on straight because she keeps shimmering. Not like the character in the movie in his mind but like some other person he doesn't know. Someone real, real like dirt, real like the food coming back up. Not the bitch he hates but just some pretty background actor in the distance with nothing, not even a name.

And now, when he looks in the mirror, he doesn't see every hero he's ever played, or even every villain. Instead he sees what he feels; that he is sick and old and going to die. And whether or not he gets his revenge, it's going to be him—not in jail, he'll get out of the bad rap—it's going to be him dead. Someday. Sometime. Like her, when he least expects it. His heart bursts or the cancer gets him or whatever it is, what does it matter?

Dead just the same.

Dead and dead. All tied up in a pretty, little bow.

The Young Man with the Blue Eyes waits, feeling that uncomfortable tingle of awkwardness—a man waiting with nothing to do but wait for a woman. He has already killed as much time as he could absently staring at the black and white photos on the wall near his booth, pictures of celebrities who have frequented this diner and autographed headshots, the black and white pictures fading into a gray wash just like their fame.

And still he waits. She is worth waiting for, his girl, who is beyond beautiful and when he was a boy—so long ago, four states over—he dreamed of girls this beautiful but never saw them. Here they grow like orchids. Still rare enough to be treasured, and difficult to maintain, but if one is lost, there is always a place nearby one can find another to try keeping alive.

He waits.

It is a good time to pick up a device. To post something, check some-

thing, view something, but he is smearing the dessert into his plate. He has a bad habit of 'playing' with his food. Smear the remains of the blue and brown into the white of the plate. Now no one will want the rest. No finishing it, now.

He should check something. A call is coming. The call to tell him whether or not that pilot is going to be picked up. It is a big call, but he purposefully doesn't want to check it. He doesn't want to think about it. It is too big a call. It means too much and now he wants to just sit back and pretend that it could or could not happen either way and he will be fine with it. His mind wanders back, not far, just around the corner of the hour when they arrived at this, the hippest coffee shop in Studio City, an area where rich Hollywood types who don't live in the hills retire. This coffee shop is where you will see the faded-around-the-edges famous types, and the young, runny-yolked, pretty types come to break in on what's around.

They are those types. Young, beautiful, with only the slightest notes of desperation in their bouquet and not the slightest flavor of cynicism.

He is looking at the remains of what was an egg white omelet with crème fraiche and baby mixed green salmon salad. And smears of blue. They splurged to try a slice of the Blue Velvet Cake. Delighted and laughing because they have never seen Blue Velvet Cake—but of course, why not? If there is Red Velvet, why not Blue? While a slice is eight dollars, it was almost as large as one of their heads and they laughed as they bought it, as if they were doing something wicked. It takes careful maintenance to stay as they are.

With skin so clear.

With eyes so bright.

With carefully sculpted, willowy limbs.

Tight and small expensive clothes.

It was wicked.

He can't admit that the eight dollar cake—plus the fifteen dollar omelet for him, and the seventeen dollar salmon salad for her, plus tip and espresso—hurt. He is trying to manifest the Law of Attraction and does.

He is beautiful, made more so through careful, expensive grooming, and soon he will be a star. Right now, it is just a pilot. Right now, it is just waiting to be picked up. Right now, it is not to be worried about.

The food was delicious.

The cake was huge and wicked but not as good as it looked, though neither admitted it, moaning with delight and laughing because they saw that their tongues were both blue. The cake stained their tongues, and of course, it is just blue dye in chocolate, just like Red Velvet is red dye in

chocolate. Your brain makes you think things taste differently based on the color. But it is just the same thing as regular old chocolate cake, filled with enough dye to stain everything it touches.

The Ingénue comes back from the bathroom. For a second, as he looks up at her, her lips are so red, and her face so pale, that she looks like a vampire: she has been drinking blood and it is still all over her mouth. She sits down and looks at the remains of the cake.

"Is your tongue still blue?" he asks, and sticks out his tongue at her, waiting for her to mirror back.

She doesn't parrot the move but shakes her head. "I brushed my teeth."

There are plenty of things wrong with this answer but he can't formulate them clearly. He points to the remains. "Want any more?"

She shakes her head.

The magic of it is gone now, and there is a look like guilt on her face. Like she never should have done that to her diet, like . . . no, he doesn't know. He doesn't care.

She's beautiful, but it is something he is starting to take for granted, and its flavor seems bland and overpriced and stained.

Stained?

He runs his fingers through his hair in the semi-conscious gesture that has become a trademark for showing deep thought. The producers love it. "Anyway," he says, in response to nothing.

She gives him a small smile that means nothing.

"Shall we go?" he says, suddenly wanting to run away into the night.

She nods.

They make the awkward transition of moving from down to up, up to down, picking up their various personal affects. Plastic smiling statues, historic, give them leering smiles. They had laughed at them when they entered. Now the chunky plastic waiter with his handlebar mustache is laughing at the Young Man with the Blue Eyes. He knows a secret. He knows a plot twist is around the corner.

Across the street there is a landmark Italian joint, a restaurant, a place where old celebrities go to pasture. The booths are still a sticky red, the

wallpaper a faded yellow, and very little light—"intimate" as they like to say. A plate of pasta there can cost you upward of twenty-five bucks.

Not that the Young Man wants to think about money. It doesn't matter who he owes what to, now. He is a rising star, and who knows how far he will rise or how bright he will shine. No one is asking for anything but his credit, now. No favors to be repaid, now. Just let me grant this wish, now, and then this wish. Things are going to happen. They smell it on him.

As they walk past the windows of the restaurant, he sees a woman, a Faded Fatale at the table, staring out. She was once beautiful but not worth a second glance now, but for the eyes. The eyes pull him in. All pupil. All brown. He stops. Her eyes are like those of the Ingénue, yes, his girl, but there is something so much deeper, sadder, and more beautiful here. The glass shimmers between them. The Faded part of the Fatale is gone in an almost golden glow. He feels he could reach through the glass, take her hand, and pull her out here to the other side. He wants to pull her into him. He wants to press himself inside her while he drowns in her eyes —her sad, mouse-brown eyes—until they both sigh and she closes those eyes to sleep while he wraps her in his arms like a blanket. She lifts her hand on the other side, like she is having the same vision and wills him to pull her through the glass that separates them.

Then his girl, the Ingénue, says his name. The moment breaks. The Fatale is once more Faded and he cannot give her a second glance. He looks forward into the night and pulls his girl behind him.

"Do you know her?" his girl asks.

"No."

"Did she wave?"

He shrugs and murmurs, "I don't know what she was doing."

They get to his car and he opens the door for her. She gets in. He closes the door behind her and looks out into the night. He walks around the car, hearing his feet lightly against the rocks of the road. Then he gets in, puts his phone down in the cup holder. He puts the keys into the ignition, but she stops his hand with hers before he turns it.

"I have to tell you something," she says.

He looks at her and there is something feverish in her eyes, something he has never seen in her before. Something that scares him in a place he never knew he could be scared.

"It isn't on purpose," she says. He feels his nuts climb up into him like Drown the Clown dunked in ice. She tells him, her voice soft, her hand touching her flat belly, how she hadn't thought it would happen, but there, it did.

His phone blinks a red light at him with an in-coming call. All cards on the table. Show what you got. He doesn't know what to say, but he has the things he knows he should. He doesn't know which one to pick because none seem right. So he starts the car. He drives the streets with the studio built houses and tall trees. He drives slow and his lights search for the nothing-but-peace that lies ahead of them.

She gasps, "What's that?"

His lights have illuminated an animal's eyes ahead of them in the dark. The owl hovers, just above the gutter, wings spread, flapping. Something must be wrong with it.

It just stands there, not flying, wings out, as if trying to balance. Why is it so close to the ground? Why is it not flying? Why is it poised there, in front of them, not moving, like some symbol they can't read?

Then, it lifts up.

He sees, then, why it seemed to stand still.

It has a rat in its claws, its body quivering.

It rises into the sky and is gone.

The Faded Fatale is tipsy, maybe on her way to toasty. Maybe that's too generous and she's already on her way to sloppy. But she is still sitting straight and her eyes focus all right on things. She squeezes the fat on her stomach. Too many duck farts—that's bourbon and Bailey's, baby—too many drinks and pieces of bread and she is tipsy and too fat and it makes her sad because she wanted tiramisu. Or a piece of cake. God, she would just die for a thick slab of cake.

She looks out the window. They have the window seat tonight, her favorite. She likes to watch people. And she sees a boy that takes her breath away. He looks like Montgomery Clift—all dark hair and blue eyes—and he is holding the hand of a willowy blonde, the latest popular brand of pretty. But he's the one that is breathtaking—and he turns and sees—

Sees her.

Their eyes lock for a moment.

Can he see what she once was? Beautiful, more beautiful than the girl whose hand he is holding, "more beautiful than any woman I've ever known," the Character Actor once told her. She is not that anymore. She is a defeated bag of a woman, and he is a young man with everything ahead of him. His eyes sparkle like stars dying, exploding into her own dead orbs, and in that look, a piercing longing that demands she remember that she

still has a heart that beats, even now, behind her silicone-filled breasts. She lifts her hand. Yes, I do.

And then just as quickly he is looking ahead into the night. It was only a second, less than that, after all, and the young blonde is but a step behind and they step out of her view and into the darkness.

"*Run after him!*" says a voice in her head—that silly voice that told her to do all those things (most of which she did) years back. "*Run after him! It doesn't matter what you say, just run after him, down the street, into the night, leave! Run! Tell him—tell him he has beautiful eyes, tell him you feel your heart—tell him, tell him—run run run run run RUN NOW.*"

She tries to get up, but she staggers. She is drunk.

And the Character Actor is back from the bathroom.

She sits back down.

He starts to talk, so she tries to focus on him. He looks terrible. His eyes are darting about in his head like—like—she can't think what.

"Where were you going?" he asks.

She shrugs. "The bathroom," she says. Forgetting that she was ever going anywhere else.

"I'll get the check and meet you outside," he says. "I need to get out of here, I feel sick."

They are long past feigning concern. She shrugs and staggers out of the booth.

They walk—Character Actor and Faded Fatale— in the neighborhood toward his car. She trips a bit on her heels. She rights herself on his shoulder and he pushes her away. She recalls that first night when they had walked in his neighborhood—quiet, beautiful, lovely, like something from a fairy tale, almost. That night, that first night, she could smell night jasmine blooming and in the distance, she swore she could hear the coo of an owl.

"There are owls here?" she had asked him, thinking she had walked out of her little desperate plot of Van Nuys and onto a movie set where she was the leading lady.

"Owls?" he had said. "What?" and looked at her like she was crazy.

"Didn't you hear that? That sounded like an owl."

"There's only one bird-brain here, and I'm looking at her," he had said.

She'd started giggling; she couldn't help it, it was just like he was on TV, the smart-aleck line from the tough, cool cop.

"Shut up, now," he said, his voice husky, that same character when he's about to give the lady what's coming to her, and kissed her hard on the mouth.

Only, she was wearing heels and he was short so it was more chin than

mouth, and then he pulled her head and hair down into him, and bit her lip, and it hurt a little, and she liked it. She had liked assertive men, but more than that she had liked famous men.

Now—what does she like now?

She hears it again. A whoosh of wings. A call in the night.

He's out there. Montgomery Clift. The man of her dreams.

It doesn't matter about the drinks. It doesn't matter that she will fall when she runs because she is drunk and doesn't know just how much so. She should run to that boy and tell him she never should have cheated on him, never should have hurt him, never should have wanted more than that perfect dream of a perfect boy with nothing but a pure heart and eyes like stars dying.

"There's an owl out there," she tries to say to him, but she slurs it a bit.

The Character Actor is distracted. He doesn't even respond. "Get in the car," he says.

She does.

He doesn't.

She looks at him with a face that is both numb from the drinks and dumb in its understanding, but with the beginning of an expression like a question. In less than thirty seconds, she will get shot in that face. He tries to say goodbye but his voice starts to crack, like it did when he went through puberty and everyone could see the death sentence of his career. Well, he came back, didn't he? You don't need to be no cute little kid to be famous. You can be anything. A cute kid, a rough and tumble detective, a monster, what does it matter when the light is in your eyes—you can't see what's out there, anyway.

Or who.

Who?

"If you didn't do it, who did?" they will ask him. "Who? Who? Who?"

"What are you, a fucking owl?" he will say to them, and they can't help but crack a smile. Always the wise-ass. Just like his character on TV.

TREMBLER

KEVIN SAMPSELL

You wanted to do it from behind but I said I wanted to see your eyes. We hadn't seen each other for several days. This was when we were both married to other people.

The passenger seat was pushed back and reclined. We were in your car, parked by the train tracks. It was far away from any busy street, so it was private enough. An abandoned warehouse gave us a little shield on one side, even though anyone on the passing cargo trains could see us easily. Maybe we were giving some hobos and conductors a show. But it was cold outside and our heat fogged up the windows.

You straddled me and wiped a clear spot in the window next to us, so you could watch the trains pass by. We could feel the vibration of their heavy loads, with names of companies like Bekins and Burlington Northern scrolling by. Elaborate graffiti of distorted faces and taggers' names decorated many of the cars. The windows kept fogging, so you reached up and opened the sunroof. You stuck your head out and for a second I could imagine the headless horseman riding atop of me. I heard you gasp and say, "There's someone over there."

"Where?" I said, "Is he coming over here?"

"He's just standing there, about a hundred feet away," you said. "But he's watching us."

The way you kept moving told me that the person didn't bother you too much. I tried to imagine what it looked like to that person—a small trembling Subaru with a woman's head sticking out of the top. Half woman, half car.

But maybe the person couldn't see us very well. It was pretty dark out and the only light came from some of the blinking red lights by the tracks.

You slowed down to a grind and we both came. You weren't saying anything but I could see your breath puffing out of your mouth like a steam whistle.

You slid back into the car and closed the sunroof and turned the key in the ignition. You laughed a little and said, "That was treacherous."

I nervously pulled my pants back on and looked out the window to see if the man was still around. "I wonder if that guy called the cops," I said. "We could get busted for public indecency."

You drove away calmly and quietly with a smile on your face and your shirt still unbuttoned. I saw my sweat drying on your chest. A few minutes later you said, "He had his dick out." The way you said it I couldn't tell if you were excited or repulsed.

A MODEL MADE OUT OF CARD OR, THE ELEPHANT MAN AND OTHER REMINISCENCES

GABRIEL BLACKWELL

That Obscure Object of Desire

Over the course of ten films and one-third of a century, filmmaker David Lynch has fashioned an oeuvre as hermetic and idiosyncratic as any painter's or poet's, which is to say freakishly rare in Hollywood. And yet, Lynch's artistic escutcheon is not wholly free of blots—two early stains, in particular, reveal the malign influence of acculturative producers: a 1984 adaptation of Frank Herbert's science fiction epic *Dune*, that, due to unfortunate last-minute tinkering by Dino de Laurentiis, Lynch considers a failure and has attempted to disown, and 1980's Brooksfilms production, *The Elephant Man*, a much more successful and "Lynchian" film, if still not immediately identifiable as the product of David Lynch.

On taking up Mel Brooks's offer to adapt and direct the story of Joseph Merrick for the big screen, Lynch has said, "[The Elephant Man] seemed right down my alley, though I'm not sure just what that alley is." Joseph Merrick's was, in that summer of stage adaptation (Richmond Crinkley and Nelle Nugent's Broadway production of Bernard Pomerance's play) and book publication (Michael Howell and Peter Ford's *The True History of the Elephant Man*), an alley as resounding with echoes and as busy with mystery as the bisecting courtyard of Hitchcock's *Rear Window*. Conspicuously missing from that alley, the Anna Thorwald of this riptide

in the zeitgeist, were the shadows that Merrick's disfigured face cast, or would have, if anyone were brave enough—or perhaps only cynical enough—to light it for the audience. Deformity, the very thing that had made the man notable in the first instance, was notably absent from the stage production (a conscious decision on the part of Pomerance), and the book contained not a single illustration in its first printing (though this was eventually remedied with a ten-page appendix of black-and-white photographs).

Lynch's unique contribution to the study of the Elephant Man then, was his enthusiastic, some said tasteless, willingness to exhibit Merrick's neurofibromatosis-ravaged visage, until then, veiled and occulted to all but those contemporary few blessed with the proper introduction or the price of admission. That these few had subsequently turned away from that face, possibly even sought to erase it from the history books, was perhaps testimony of its power to affect. The books Lynch and his screenwriting partners, Christopher DeVore and Eric Bergren, consulted were emblematic. Frederick Treves's unillustrated memoir, *The Elephant Man and Other Reminiscences*, accounted for their script's mistaken appellation of Merrick, called there "John" Merrick, a signal, if unintended, obfuscation heaped upon a more significant transgression against history: Treves, Merrick's doctor at the London Hospital, spuriously claimed that Merrick's remains had been cremated following the Elephant Man's death, when in fact Merrick's skeleton and samples of his skin, as well as numerous casts of the areas of greatest deformity, were all preserved and on display in the London Hospital Medical Museum, courtesy of Frederick Treves. Ashley Montagu's volume, *The Elephant Man: A Study in Human Dignity*, based in large part on Treves's memoir, repeated many of Treves's errors, and, like Howell and Ford's more thoroughly researched study to come, contained not a single photograph or illustration of Merrick, though several were extant.

Nor were Lynch and his co-writers entirely innocent of the occluding gesture. Christopher Tucker's Elephant Man make-up goes unseen through fourteen minutes of film as Treves makes his way through a rowdy Whitechapel night and not one but two doors labeled "No Entry," threading a labyrinth of blanket-partitioned freakshow exhibits before finally arriving at Merrick's, where there is, in fact, no Merrick in evidence. It is only on a second visit that Treves and the audience are finally able to glimpse Merrick, and then only for a moment. The Elephant Man we are given is dressed in cloak and hat, a canvas sack with a single slit cut in it covering his face. When Merrick is examined by Treves and the Royal

College of Surgeons, he is seen only through a screen, and from the back—the restive viewer could be forgiven for wondering whether, through nearly half an hour of Lynch's *The Elephant Man*, this peep in the shadows is all we are to get, what we have paid our money to see.

The film was received, despite the critical acclaim of the press, with a similarly obfuscatory impulse on the part of the establishment. Tucker's make-up, praised almost to the degree of the deformity it represented, was nonetheless denied a special award by The Academy of Motion Picture Arts and Sciences at their annual Oscar awards. The following year, the Academy, embarrassed by the cicatrix of bad press attending its snubbing of the film for a total of seven Oscars, including Best Director for Lynch and Best Actor for John Hurt, felt compelled to create, too late for Lynch's production, a new award to honor *The Elephant Man*'s innovation: Best Make-Up, a category previously unheralded at the ceremony. "The whole thing's a whitewash for them, a cover-up. They [are going to give] this treacle an award to honor the very thing that hampered John's ability to play the part and probably cost him the Oscar in 1980. It's a tragedy!" one of Hurt's costars reportedly complained when the film *Mask*, the story of Roy Dennis, a boy suffering from an affliction which caused the bones in his skull to expand and his facial features to congeal to an unchanging, vaguely benign, expression, won the award in 1985.

Tucker's make-up, prepared from Treves's casts, was perhaps Oscarworthy, but only as given life by the actor bearing it. Hurt is practically a ghost under the bulbous promontories of Tucker's prostheses—only his eyes, penumbras of such aggrieved mournfulness they draw the lens their way like an observer passing the event horizon of a black hole, are recognizable as *his*, but it is his eyes that give Hurt's performance. The make-up itself is so extraordinary as to set Hurt apart, as though he were appearing in a completely different film than his costars. Otherwise banal scenes become uncanny simply because Hurt as Merrick is onscreen. It is this more than anything else which marks the film as Lynchian.

But was Lynch's decision to make Merrick's face the centerpiece of his production an innovation or an unwitting imitation? In fact, it seems that Lynch was unknowingly taking up a project that had very nearly reached the production stage at Universal Pictures in 1946, when the star of that production, as well as its writer, director, and producer, suddenly died of a heart attack.

Vatican of Fools

Rondo Hatton, at the time of his death at age 51, veteran of over thirty films, first discovered the story of Joseph Merrick while on the set of RKO's 1939 William Dieterle-directed adaptation of Victor Hugo's novel, *The Hunchback of Notre Dame*. In the opening scene of the movie—Hugo's "Pope of Fools" contest, a competition to make the most gruesome face—Hatton plays the second of Quasimodo's rivals. He was hired largely because, as producer Pan Berman later joked, "That poor guy didn't even need to make a face to win that contest."

Hatton had intended to try out for the part of Charles Laughton's double, but was dismissed before call as being hopelessly inappropriate. Laughton, possessed of an ideal height and frame even if not exactly hideous of aspect, was thought perfect for the part of Quasimodo, while Hatton, the natural grotesque, was unfortunately much too tall to play either Laughton's double or Hugo's dwarf. Spotting Hatton's massive brow above a crowd of released extras, Berman signed Hatton for the Palace scene on the spot. But there was one snag—while the shooting schedule was being drawn up, Berman had personally excised the Palace scene from screenwriter Bruno Frank's script in order to save money on sets and conserve precious screen time. With Hatton's hiring, the scene had to be re-added to the slate, dressed, and rehearsed virtually on the eve of shooting. RKO's set dressers had to rush from studio to studio, looking for a standing set that wouldn't have to be too heavily rehabilitated to fit the huge scene Dieterle and Berman had in mind.

Hatton would go on to bigger roles, of course, but in many ways this small cameo was the token of his Hollywood career. Those in the theaters who knew the book might be excused for having taken Hatton for Quasimodo: coming at the very opening of the movie, Laughton, with his cartoonishly distorted features, has not yet appeared onscreen when Hatton steps proudly into the stocks and endures the jeers and rotting vegetables of the crowd. Already horribly disfigured by the acromegaly that would eventually cause his fatal heart attack, Hatton nevertheless took the red ribbon while the garishly made-up Laughton was awarded the blue. The camera pans over Hatton gamely vamping for the yokels as a crowd of extras raises Laughton to their shoulders, bearing him quickly out from under the kliegs, his primitive prosthetics drooping and jouncing with their steps. Hatton, a spectacle on the set, was barely a sideshow when the cameras were rolling. In all, he is onscreen for less than a minute, thirty feet of celluloid. It was all RKO could spare—Laughton's expensive contract

did not allow for Hugo's brand of panoptic democratic attention.

Rondo Keith Hatton was born a happy and healthy baby on April 22, 1894, in Hagerstown, Maryland, but spent most of his childhood in Tampa, Florida. An athlete, lettering in football and baseball, he was graceful and charming—Hatton was voted Most Handsome by his graduating class at Hillsborough High School, and the October 31, 1917 issue of *Stars and Stripes* reports that Private First Class Hatton "never has any trouble finding a date, never has a slow mail day, and never fails to bring a smile with his goofy grin." But shortly after returning home from the front, he began to experience phantom pains like limbs and digits that had never existed had been smashed with a hammer or ground underfoot. He called in sick so often at the *Tampa Tribune* that he nearly lost his job, but the paper's editor, E. D. Lambright, took pity on his cub reporter, until then the most dependable and the most genial of anyone in his pen. Lambright hoped that Hatton's bad luck and bad humor would soon pass.

Instead of passing, however, Hatton's condition worsened. The diagnosis—acromegaly—might as well have been in Greek as far as he was concerned. Back at the paper, he looked it up in the morgue; the pictures there were even more horrible than their descriptions. His doctors tried to reassure him that the disease affected different people to different degrees, that there was no way of knowing exactly what it would do to him—it might be no more severe than the headaches he was presently experiencing, perhaps a slight swelling of his hands and feet. Already, though, Hatton had had to throw away several pairs of gloves and all of his shoes. In six months, his shoe size had gone from an eleven to an eleven-and-a-half. Then a twelve. Then a thirteen. He could no longer fit his fists into his pockets. His headaches, unimaginable to begin with, only got worse and his neck was constantly sore from the strain, as though his head had been chiseled out of stone and then filled with cement.

In Hatton's case, it wasn't just an enlargement. The bones in his head jutted out at their seams in obtuse angles, pushing his face into a smaller and smaller set of expressions. In the rare moments he could forget his acromegalic agony, his brows wouldn't relax their apostrophized menace, his scowl wouldn't straighten. Strangers would no longer look him in the eye, and children wouldn't look at him at all, not without tears. He stopped going out, his friends say, even stopped answering the door when they called on him at home. His colleagues at the *Tribune* tried their best to cheer him up, holding a bachelor auction in his honor, at which, of course, they made sure he went for the highest price. The winning bidder, a visibly horrified Tampa debutante whose father was on the *Tribune*'s

board, did not return his phone calls, and the date never came off.

Lambright kept sending his young reporter out, though, giving Hatton the assignment to cover the filming of Henry King's *Hell Harbor* (1930), just getting underway then in Tampa. *Hell Harbor* is the story of a young woman sold into marriage by her own father. Hatton was spotted by the enterprising King and offered a small part as a tavern owner in league with the scheming fiancé, a low-life openly despised by his future wife. Hatton's character falls in love with the girl and attempts to save her by betraying his partner in crime. At first, Hatton demurred, telling King that he was no actor; evidently flustered, he seems to have forgotten the several amateur productions he had starred in at Hillsborough High. But eventually King wore the reporter down, and Hatton agreed to appear in the film.

In the wake of *Hell Harbor*, friends teased Hatton that Doug Fairbanks ought to start looking to his laurels, but he stayed at the *Tribune* for another five years, working stoically on in the face of growing difficulties—he could hardly hope to get a story out of sources too scared to talk to him and, no matter what it was he was supposed to be covering, he was more often news himself than an objective reporter of it. He was finally pensioned and persuaded to put his handicap to work for him in the summer of 1935, when he left Tampa behind for the bright allure of Tinseltown.

Because of his unique physical features, roles had to be created especially for Hatton. Fortunately for him, this was rarely a hindrance in finding work: when a certain type of director or producer got a look at Hatton's Easter Island profile, he could usually find a way of incorporating it into the plot of his film. This meant mostly forgettable roles that required Hatton to do little more than stand in one spot while other actors reacted to his presence. More statue than statuesque, his role as runner-up ugliest man in *Hunchback* was repeated in all of its possible iterations, and then those iterations were repeated again.

With World War II and the departure of popular celluloid bullies to the front, Hatton's repertoire at last began to expand, encompassing a handful of toughs and heavies, but with the steady progress of his disease, he found that even these one-dimensional roles challenged his abilities. He told a reporter on the set of *The Brute Man*:

> Look, it's not like I don't know how to act. I know how to act. But this thing I got makes it tough for me. It makes it so I can't always do what I want to do, not even with my own body. I mean, I hear the lines inside perfect, but I can't always say them that way. I can see how the character ought to look, but I can't always make the right face. So I end up doing

takes [unintelligible]. I been thrown off three pictures now because the director couldn't get a good take out of this mug [unintelligible]. And there ain't nothing I can do about it, either.

He played a leper, a sailor, and a vigilante. He even finally got his chance to play the hunchback, in a film called *Sleepy Lagoon*. But Hatton could not be satisfied with a career even Boris Karloff scoffed at. He flew to New York between roles to study the Method at the Group Theatre and took classes in Los Angeles with Stella Adler and Robert Lewis.

With 1944, Hatton's fortunes briefly lifted: he appeared as The Creeper in a Sherlock Holmes picture, *The Pearl of Death*, leading to a string of roles as The Creeper—or thinly-veiled imitations of that character—in *House of Horror* and *The Spider Woman Strikes Back*, leading up to 1946's *The Brute Man*, the last film he would complete before his heart attack. With this run of success, he finally felt confident pitching his idea for a starring vehicle, a movie in which the things that had typecast him would help him to break out of type, where the drawbacks of his illness would actually aid him in his role. He would play John Merrick, the Elephant Man of Frederick Treves's 1926 memoir, *The Elephant Man and Other Reminiscences*.

Tedious Descriptions of Architecture

On the set of that 1939 production of *The Hunchback of Notre Dame*, Hatton could hardly have been blind to harried set designer Darrell Silvera still hurriedly assembling his Palace of Justice even after rehearsal and blocking had begun. Silvera was referring to a model of the Palace made out of stiff cardboard, a detailed model that had been stolen from Dame Madge Kendal by John Barrymore and then sold to an unsuspecting David O. Selznick, who bought the model for his as-yet unborn daughter. When Selznick, on the set of *A Bill of Divorcement* (1932), heard that his wife, Irene Mayer Selznick, had given birth to a boy, he ordered the "doll-house" destroyed. "What the hell do I care about elephants? Are we doing a circus picture here? No boy of mine is going to play with any goddamn dolls," Selznick is reported to have said to Barrymore, "and where the hell do you get off anyway, you prick? You should have told me it was stolen. I wouldn't have paid you so much for the goddamn thing." The model was rescued from the fire by the assistant set

designer Selznick had ordered to burn it, Darrell Silvera.

That Selznick, and thus Silvera, knew of Merrick at all could only have been the work of Barrymore—the publication of Treves's book was only a very minor event in England and was quickly forgotten outside of the medical field even there. It had not made its way across the Atlantic to America. Apart from Treves's tale, Merrick's skeleton, and the casts at the London Hospital, a few scattered photographs were all that remained of the infamous Elephant Man. Barrymore was probably told of the model's provenance by Dame Madge herself, though it seems unlikely, given his appendant actions, that he took in her story's significance. Dame Madge treasured a similar model of St. Phillip's Cathedral that Merrick had made for her; the Palace of Justice, she wrote after its theft "held, for me, memories of a rather more melancholy nature," because, she claimed, it wasn't even properly hers. She was holding onto the model for another woman, a woman who had never known it was intended for her and who had died or disappeared before Dame Madge could deliver it. Dame Madge's "memories" referred equally to the circumstances under which Merrick is supposed to have completed it, and those which brought it into her possession.

Though he had been born in Leicester and traveled to London and to Dover, Merrick had been limited in his travels to and from the capital to what he could glimpse through the slit in his mask from grimy coach and coal-blacked train windows. Bewitched by the quotidian, Merrick looked upon the English countryside as scarcely less exotic than the surface of the moon. He had never once walked across a field, smelled freshly clipped grass, or seen a spring in flood. Living in cramped and squalid quarters in industrial backwaters for most of his life, he had scarcely seen a flower in bloom or even a bird in flight. Treves therefore arranged for Merrick to stay a fortnight on the country estate of a society lady of his acquaintance, Lady Knightley. It had been relatively easy to secure accommodations, as, after the Princess of Wales had visited his tiny rooms at the London Hospital, Merrick had enjoyed some degree of fame among the British upper classes. A railcar was reserved for his private use, through the generosity of the British railways, and they even arranged to shunt the car off at a siding at London and then again at his destination in Northamptonshire, so that Merrick would not have to endure the mobs of hysterical gawkers at the depots. A traveling disguise of cape, hood, and his beloved silver-tipped walking stick gave Merrick a raffish, almost gallant air. It was the closest he would come to traveling "as other people do," (his most mournful refrain, if Treves is to be believed) and he exulted in all of it.

Unfortunately, upon opening the gates of her estate, Fawsley Park, to this odd figure, Lady Knightley fainted dead away, leaving Merrick without a place to lay his head. Treves, resourceful to the last, arranged for Merrick to spend his vacation at the house of the game warden on the estate, a much stouter man than his mistress as it turned out. And so Merrick merrily did, enraptured by the novelty of even this, most humble of country accommodations.

Lady Knightley, ashamed that she had committed such a grave faux-pas in fainting at the sight of her own honored guest, sought to save face and correct her misstep; she made Merrick the present of a light and diverting entertainment from her own library. She had been told by Treves that what Merrick liked above all else was to read, particularly romances (even more particularly, those in which the hero or heroine, brought low through circumstance, is revealed to have high-born blood), and she found no better book for the recipe than Victor Hugo's *The Hunchback of Notre Dame*. That it was, in all likelihood, exactly the reverse of what Merrick usually sought in reading—that is, an escape from his terrible condition—we must charitably conclude, probably did not occur to her. But at the moment of delivery, some glimmer of Merrick's dignity impressed itself upon her, and she hesitated. She very nearly asked for it back, but thought that would have been just as cruel, and in the end, embarrassed, fainted dead away yet again. Merrick, imbued with a mischievous and contrarian spirit, read the thus intoxicatingly taboo book with relish, spending his days wandering the Midlands hillocks and his nights sounding the cobblestones of late-medieval Paris. A fortnight earlier, setting out from the Hospital, he could scarcely have envisioned such a perfect holiday.

Merrick was most enchanted by Hugo's luxurious descriptions of architecture and urban planning in the City of Lights. Though Merrick had been to the Continent—on the curtailed leg of a tour of Belgium and the Netherlands—he had not seen Paris. Sightseeing was surmounted only perhaps by flying on Merrick's list of improbabilities; the best he could manage even in London was a quick passage from one dark shadow to the next, avoiding the goggling eyes of his ever-present oglers. The city was to him a portable and inescapable stage from which he could only see as far as the footlights. To be part of the crowd, to see the boulevards and avenues like any other burgher or boulevardier, to fly to the top of the city and see the whole of Paris from the bell-tower of Notre Dame—it was not precisely a dream, but it was certainly a long way from his life.

With tears seeping from the pendulous flap of his permanently heavy-lidded right eye, Merrick read without pause, fearing his arrival at the

station in London too soon to close the book, read there of the curious revelation of Esmeralda's birth and her all-too-sudden death at the hands of the authorities, read of Frollo's deserved demise and Esmeralda's ravisher's shameful indolence. Closing the book and stepping off at the siding, he longed only to avenge Esmeralda, to succeed where Quasimodo had failed. Never had Treves seen poor Merrick so worked up: he could only with great difficulty understand the pitifully enraged, gibbering figure arriving at the Hospital's door. Treves advised a walk around Bedstead Square and a good night's rest, but Merrick was far too worked up to contemplate repose.

Merrick had always entertained an innocent infatuation with one of his nurses, a Miss Green, whose Christian name has never been recorded. Because of the protuberance which gave him his nickname, a growth which pushed its way out through his mouth in the general shape of a nascent elephant's trunk, Merrick's speech was terribly distorted. Early on, before he had begun his residency at the London Hospital, doctors in the employment of the Leicester Union Workhouse had operated to remove the better part of it—some four inches, said to weigh nearly five pounds—in order to assure that Merrick would be able to eat and drink. But with the progress of his disease, this protuberance began to lengthen again, and in time, even Treves, his closest confidant, could only with begged repetitions and admonitions to enunciate understand Merrick when he grew excited. How much less then those who, like Miss Green, might only spend a few hours a week with him, and those short hours engaged in a workaday routine that scarcely afforded the opportunity for earnest or amorous exchanges. Merrick could not seem to get across to Miss Green that she was the Aphrodite to his Hephaestus. His encumbered tongue could not shape the words with the supple grace such delicate pleas demanded.

Perhaps, as he wrote to Dame Madge, if he could not communicate in words the fullness of his heart, he might give its measure in some other manner. The materials at hand afforded him but one opportunity: either a cardboard model or some sort of a basket (In order to better pass the time, Merrick had asked and received materials and instruction in basket-weaving from Dame Madge. And pass the time it did, as he was effectively one-handed with his right hand so deformed that he could not use it for anything but a sort of paper-weight). The basket would be a plain one, however excruciatingly wrought, unlikely to arouse anything greater than appreciation, even in one so well-acquainted with its fashioner's handicap. The model offered the possibility at least of expression, but how to communicate through architecture his tender feelings?

Perhaps, Merrick wrote, through an allusion to the great work he had just finished reading. After all, given its presenter, how could Miss Green fail to see the significance?

A Model Made Out of Card

His first thought was to execute the Cathedral itself, with its glorious confusion of styles so minutely described by Hugo that Merrick thought he could build it straight from the text. But he could hardly pronounce such a model a triumph of love: after all, it was in the Cathedral that Quasimodo had held Esmeralda, where he had finally been explicitly given notice that his tenure as her virtue's guard was over, ridiculed as a lover, and irrevocably spurned. This would signify too much his present plight, not the pleasant future he wanted Miss Green to envision as the key to his tribute's lock. Instead, why not attempt the Palace of Justice, where Quasimodo, the monster, the freak, had been celebrated, had had his well-deserved day in the sun, however brief the break in the clouds? Merrick began work on it straight away, without pausing for his prescribed perambulation or even his much-needed drowse. He posted his letter to Dame Madge the following morning, detailing his projected monument and its much-hoped-for sequel.

At completion, the model could have had little enough of semblance to its original: Hugo goes into painstaking detail in his descriptions of Notre-Dame de Paris, but only gives us a snapshot, as it were, of the gallery and the forecourt of the Palace of Justice. The veracity of Merrick's cardboard billet-doux would have been confined to its edifice, no more substantive than a Hollywood soundstage about to be struck. It was thus perfect for a cinematic set designer, but probably still too slanted for a love letter.

We cannot be certain of what transpired, but it seems likely that when, several days later, Miss Green delivered Merrick's lunch, Merrick pointed out the completed Palace, its forecourt and face as faithful as he could make them, the rest a complete fancy of his imagination. Miss Green either acknowledged it politely and conveniently forgot it there, or else did not comprehend what it was her host was attempting to show her. Whatever Miss Green's understanding of the situation, she left the model on the table where it had been assembled, a trophy scorned by its winner, a tribute unremarked by its muse.

What we do know is that Merrick left his food untouched on the tray

Miss Green had brought it in on. It has been conjectured, by Treves among others, that Merrick then fell back to sleep, a queer operation for him at any hour, due to his physique. He had always to sleep in a sitting position, with his knees up and pressed against his forehead, because the shape and heft of his head made lying down treacherous. Treves, probably wishing to save Merrick from this last indignity, wishfully espoused the thought that Merrick had only been trying out a prone sleeping position, hoping to the last to be able to do at least something "like other people." It was merely an accident, a pitiful tragedy.

In light of Miss Green's snub, it seems it was most likely a willful one. Joseph Merrick, denied even in his most oblique attentions, simply gave up. He lay back and let the weight of his own head dislocate his neck, cutting off the flow of air to his lungs and smothering him. If he could not better Quasimodo in his conquests, he could at least join the dwarf in defeat and follow Esmeralda to the gallows.

Dame Madge received Merrick's letter and the news of his passing at the same moment. In five years of correspondence and innumerable shared intimacies, she had never once set eyes on him, and the guilt she felt on that score prompted her next course of action. She decided to pay her last respects in person, and to make sure that his last, most beautiful missive had indeed found its addressee. But arriving at the hospital, she found that Miss Green wasn't on the roster and Treves had already removed Merrick's body for dissection. He was making casts of Merrick even as Dame Madge gained admittance to Merrick's rooms. When Miss Green could not be located, Dame Madge did succeed in carrying off the model and arranging to have it delivered, but Miss Green's address could never be confirmed. It appears she had been more or less temporary help, her salary paid out of a subscription fund made in Merrick's name. With Merrick's passing, the monies were transferred to the Hospital's general fund, and Miss Green let go.

The model was kept on the mantle in one of the Kendals' sitting rooms in their London home. It occupied this place of honor for many years, until it went missing after a particularly rowdy John Barrymore visited on the eve of his departure for Los Angeles and the filming of his latest picture, *A Bill of Divorcement*. Dame Madge was scandalized, but by the time a sober and contrite Barrymore made a return visit to London, she was seriously ill, and within a year, she had passed away.

Based on an Original Story by Darrell Silvera

Meanwhile, the model had gained new life, as we have seen, on the set of *The Hunchback of Notre Dame*. Silvera had heard only what Barrymore had told Selznick years earlier, trying to save the cardboard Palace from immolation. "David, it's sacrilege. Think of the horrible life that man lived. Think of the privations, the humiliations he must have endured. Now think of the shame, the permanent mark history will leave on you if you destroy it," Barrymore is supposed to have said. "Nothing in Hollywood is permanent, you prick. Now burn the goddamn thing," Selznick famously replied.

But with Selznick off running Selznick International, Silvera could indulge the model openly. He had constructed a tiny platform to stand in front of the model's Palace, complete with stocks and paper dolls representing the contestants in the Pope of Fools contest, to get a sense of how much of the Palace needed to be dressed. The set Silvera and his dressers had reclaimed was Dr. Moreau's villa from *The Island of Lost Souls*, filmed years earlier on a neighboring soundstage and rescued from Paramount's trashpile. Positively heroic work had to be done to give it the look of medieval Paris: its front had to be reversed, repainted, and repurposed for the Palace's façade. And all of it had to be done on the fly, with Berman putting the scene in the call sheets just weeks before shooting was supposed to go ahead. There would be just enough time to build exactly what was going on screen and no surplus for elaboration or ornament.

During rehearsals, Hatton was likely curious: what was this thing that Silvera kept crossing to consult? Silvera must have then told Hatton what he had learned of the Elephant Man, whatever mutated version of events Barrymore had drunkenly conveyed to Selznick in whatever distorted, mangled form it had assumed in Silvera's memory in the seven years since he had overheard it. No doubt Silvera was spurred to remember the model's rumored creator because of the remarkable visage in front of him. He may have even encouraged Hatton to pursue the project, begging the all-important screen credit for his role in the film's conception.

By the time of the filming of *Hunchback*, many of the players in the Elephant Man's drama were long buried. It had been almost twelve years since Treves's short essay on the man (and Treves's subsequent death), and would be nearly thirty years before Ashley Montagu would publish his pioneering (but seriously flawed) study of Merrick. No doubt Hatton's journalistic training served him well in bridging this long historical gap. As he learned more, he became convinced that this story remained untold

only through accident, perhaps even fear. The story of Joseph Merrick was his story, the story Hatton was meant to tell, even if it wasn't exactly *his* story. But it wasn't until 1944's *The Pearl of Death* that Hatton finally commanded some amount of attention from producers.

Hatton had by then been working on the idea for what he called *John Merrick: The Elephant Man* for four years, ever since he had a copy of Treves's memoirs mailed to him by a female fan—herself an acromegalic—from Merrye Olde England. This slender document, barely twelve pages, was all he had to go on for source material. But if any man could empathize with Joseph Merrick, Rondo Hatton was that man. He felt competent to fill in the caesurae Treves had left with his own experiences as an unwilling sideshow.

Despite, or rather because of, a great deal of opposition from William Goetz, the head of International Pictures, the studio that was in the process of merging with Universal, Hatton was given the go-ahead to develop his *John Merrick: The Elephant Man* and his choice of an assistant to flesh out his spec script. Hatton chose an assistant he was already familiar with, though he hadn't known it at the time: Agnes Lambright, E.D. Lambright's daughter. Agnes would have been just about ten years old when Hatton left Tampa for California, and he hardly remembered her—at twenty-two, she had grown into quite a beauty. In headshots taken from about that time, Agnes (her professional name was Agnes LaVert, which helps to explain why Hatton didn't recognize her) is a dark-haired and slightly cherubic young woman, with piercingly blue eyes and delicate features, like a young Ingrid Bergman.

Goetz had executive producer Ben Pivar put Hatton's office at the very top of the writer's building, in an attic up a spiral staircase that had formerly served as a storage locker for promotional materials of movies that never got released under the Universal Pictures name. The room had been chosen because Goetz heard that it would be difficult for Hatton to reach; his arthritic joints and tender feet had already forced *The Brute Man's* director, Jean Yarbrough, to cut a couple of scenes of The Creeper escaping the police up a building's fire escape. As painful as it was for him, though, Hatton climbed up to the rooftop office every day after shooting of *The Brute Man* wrapped, to bring his labor of love to consummation.

When Agnes was done working on her current script (*A Double Life*, 1947, directed by George Cukor), she would join Hatton in the little attic office, and the two would write and run lines to see if what they had written worked. Hatton's first draft of *John Merrick* was Hollywood heresy:

a movie about a physically deformed man with a hideous illness who gets progressively worse and then dies, all without setting foot outside of the hospital, the script was not merely eschewing the formula, but making a mockery of it. The project had only been approved out of pique at the studio's incoming chief, and the pair knew they would need a miracle—or a star bigger than Hatton—to get the studio's green light for the finished picture. Hatton suggested building up one of the nurses into a love interest, a role Hollywood's starlets would salivate over, a Beauty to Merrick's Beast, or, as she would become, a Miranda to his Caliban.

Silvera hadn't told Hatton about Merrick's reason for building the model, if he even knew of it, so Hatton had no idea that such a nurse, the nescient Miss Green, had actually existed; in his memoir, Treves had barely acknowledged Merrick as a sexual being, treating his amorous inclinations as a bit of a joke, like love between chimps or children. But it wasn't much of a stretch for Hatton to write in a friendly and sympathetic nurse who Merrick might fall in love with; after the assuasive balm of time alone with Agnes, even enacting made-up scenarios, Hatton understood the power of such ministrations.

In the script, the nurse's name is "Agatha," a name that the real Joseph Merrick could only have stumbled in pronouncing. Drafts of the script show that a number of lines had to be shortened and simplified to detour around Hatton's own worsening speech impediment. But if the man he was playing would have had trouble with the name, Hatton was proud that he could still speak it, for the time at least.

Hatton and Agnes took their script to producer Pivar, who had been instructed to keep the film in pre-production for as long as he could so that Goetz could kill it when he took over the front office. The two only got through the opening three set-ups before Pivar tore their lovingly wrought composition into confetti and told them that the pitch was maybe a half-good one, maybe, but everything they had down on paper was *A Farewell to Arms* with an ugly guy in the Gary Cooper role. Where the hell in all of this was the Elephant Man, where was the goddamn monster, for crying out loud?

> People like monsters. They need somebody to root against. Here, you got them rooting *for* the monster. Who wants that? Nobody wants to see *Frankenstein Falls in Love and Dies*. Get back to work, and bring me *Frankenstein*, not Shakespeare. Know how much business we did on *Frankenstein*? A hell of a lot more than we ever did on *Antony and Cleopatra*.

Hatton did the best he could to save his doomed film. No matter what the studio wanted, Hatton would not let Merrick become just another stupid monster, another Creeper, and Pivar relented a little—Merrick could be sympathetic, sure, but the picture would need at least one "boffo" chase scene with Merrick at one end and a crowd at the other. The picture should end not with Merrick's pitiful real-life death, but with the accidental death of Treves at the hands of Merrick, and Merrick's escape from the Hospital into Liverpool Station, a frightened and outraged mob in pursuit. Hatton reluctantly agreed.

Perhaps persuaded by his partner, Hatton then asked that Agnes be cast opposite him in the Agatha role. Pivar agreed to Agnes in the role of Agatha, but only if Hatton would change her character's name to Chartreuse. Pivar insisted on the change because "Agatha" was too close to "Agnes"—the rubes writing the columns in the papers would only get confused. Reading the changes with Agnes in their office, Hatton could not help stumbling at the new name of his paramour. A perfectionist by nature, Hatton would stop his line reading, hung up on the name, and go back over it until he got it right. The fifth time he read the line, "I choose you, Chartreuse," a chore on the best of Hatton's days, his labor was interrupted by a call: at the insistence of the board, Pivar had previewed the new version at the latest development meeting, and the picture was a go. Agnes was in, as the nurse Chartreuse, but the studio execs couldn't see Hatton in the lead role. The guy could barely say the lines. Plus, the picture needed a star. The board wanted somebody more like Lon Chaney, Jr.— what about Lon Chaney, Jr.? Hatton could still direct, of course, but he would need an assistant, say, George Waggner, the man who had directed Chaney in 1941's *Man Made Monster*. Hatton survived the phone call and calmly relayed the news to Agnes, but her reaction evidently finished what Pivar hadn't. The paramedics who arrived on the scene couldn't negotiate the spiral staircase with their stretcher, and Hatton's body eventually had to be lowered by rope from the attic's window into the studio's backlot while the entire cast and crew of *She-Wolf of London* waited and watched.

Monsters of Universal

The Brute Man was never released by Universal. Goetz sold the film to PRC (Producers Releasing Corporation) for less than Universal had spent producing it. PRC released *The Brute Man* as the bottom of a

double bill with *The Mask of Diijon*, starring Erich von Stroheim; its posters promoted the movie with the tagline "The Face of Evil." PRC's press agents told newspapers that Hatton's disfigurement was the result of a German mustard gas attack, but with the Potsdam Conference over a year old, Jingoism did little to boost the picture's popularity. In another bid for business, the film's English distributor successfully lobbied to have a new rating ("H" for "Horrific") assigned to the film, but not even the prurience of spectacle could attract viewers turned off by the film's evident exploitation of its star. *The Brute Man* performed worse than any of Hatton's previous "Creeper" pictures, and the film stock was eventually reclaimed by PRC. Image's 1999 DVD release of the film was made from a badly scratched print that had to be spliced with footage from a second-generation videocassette (itself apparently made from an archive-quality workprint which could not be located by the DVD's producers), resulting in a dim print somehow missing three minutes from the picture's original run-time. Image's degraded print had evidently been found in the storage closet of a long-closed third-run house in Cleveland, Ohio, on a shelf mixed in with the first three reels of another third-run classic, Robert Fuest's *The Abominable Dr. Phibes*.

William Goetz dismantled the profitable "Monsters of Universal" series and discontinued all so-called B-features in favor of what he characterized as "serious" films, movies like *The Killers*, and *The Naked City*. *John Merrick* was struck from the studio's project list, and Agnes Lambright was taken off the studio's payroll. Within four years, though, Goetz was out at Universal and the studio was back to making schlock, with a run of Abbot and Costello movies, the surprise hit Francis the Talking Mule, and *Creature from the Black Lagoon* and its sequel, *Return of the Creature*.

In 1971, Universal joined Paramount in creating Cinema International Corporation, which distributed the studios' films. The two were soon joined by Metro-Goldwyn-Mayer, but the whole enterprise was broken up by MGM's 1981 purchase of United Artists, which had its own distribution arm already in place. One of the last films CIC distributed was Paramount's *The Elephant Man*, which grossed more than 50 million dollars worldwide, or ten times its budget. Based on this success, its director, David Lynch, was asked to direct an adaptation of Frank Herbert's novel *Dune* for De Laurentiis Entertainment Group, a company whose most famous production to that point was a 1976 remake of RKO's *King Kong*. Generally panned, this version of *King Kong* found a surprising defender in film critic Pauline Kael, who characterized it as "the story [of] the loneliest creature in the world—the only one of his species—finding the

right playmate," and went on to write, "We might snicker at the human movie hero who felt such passion for a woman he'd rather die than risk harming her, but who can jeer a martyr ape. . . . It's a joke that can make you cry."

TWIN PEAKS: FIRE WALK WITH ME

BLAKE BUTLER

David Lynch is eating breakfast in bed. He is eating Oreos by twisting the top off of each cookie and scraping the white icing out of the center with his finger. He transfers the icing to the headboard of the bed where it sticks and globs together. It is mushed in corners, smeared on wood. He plans to eat the icing later, all at once, so he can fill his entire mouth.

David Lynch is tired. The blood in his legs is getting old. When he closes his eyes, he sees trees on fire. He does not want to have to think.

Some of the icing is coming loose and falling between the headboard and the mattress or getting gummed into the sheets. David Lynch is concentrating on the crackle of the cookie, the crunch against his tongue.

When he fits the whole husk of a full black cookie edge-up against the roof of his mouth, he can remember things he didn't know that he remembered. He remembers a girl with a firm handshake. He remembers saw teeth against glass.

Beside him in the bed I am sleeping with my mouth open. I am wearing a blonde bouffant wig, lipstick and rouge. I have been sleeping a long time. I flip and wriggle and tug the sheets off of David Lynch's legs. He has on dark blue socks with garters. He has something unintelligible scribbled on his right knee.

Above the bed is a chandelier.

The chandelier is affixed to the ceiling, and in the ceiling there is a crack. By following the crack with one's eye, one can see that it perfectly bisects the bedroom. The crack is ended only by the wall, as if suggesting that it continues elsewhere.

David Lynch crunches the Oreos with his mouth open. He smacks his lips and tongue against his palate. The sound does not stir my sleeping. There is gauze stuffed in my ears. The gauze is bloody, gunked with black. I am talking in my sleep, though not quite loud enough to be understood.

Finished with one row of Oreos, David Lynch stands up over the bed and begins to do deep-knee bends. Each time he stands fully, he bumps his head against the chandelier. Each time the chandelier stirs, the crack in the ceiling tickles open a little further. Plaster dust rains into the bed sheets. It intermingles with the cookie crumbs. David Lynch begins to sing. He sings: *At last, my love has come along, my lonely days are over, and life is like a song.* His voice is strong and enthusiastic. His brow is furrowed. He is excited. He exercises more vigorously, while continuing to disturb the lighting fixture. A small wound develops in his hair. Blood runs down his forehead; the same color as my blood. It drips down his face onto his nightclothes—blue silk boxers, a wife-beater, a dead corsage. It drips on the mattress. It drips on me.

Though still asleep, I begin to sing along. I sing in harmony, taking the higher key.

The ceiling begins to crackle.

David Lynch is sweating. His fists are clenched. He deep-knee bends so hard it shakes the bed. The frame begins to groan. It sounds briefly like a woman. The bedroom door comes open.

A white horse enters. It comes in only far enough to show its head. It stands in the doorframe looking. It reveals its gums and whinnies. It shakes its hair. The hair has bugs.

The horse moves slightly further into the room revealing a small man on the horse's back. He is riding without a saddle, facing backwards, face concealed. He has on a cowboy hat and bright spurs and a long scar on his neck. He spits on the carpet. He lights a cigar and puts the match out on his tongue. He begins to sing. He takes the lower harmony with our sing-song. His voice is beautiful, like a woman's. It makes the whole room seem to quiver.

The main crack in the ceiling has now split into several other minor cracks. It has spread over the whole room. The feet of chairs and sofa and coffee tables can be seen poking through the plaster. The chandelier is hanging lower, with its wires gone loose. The lighting flickers. It hisses, pops. The glass arms of the fixture rest against David Lynch's back, making him stoop.

David Lynch puts a piece of sugar-free peppermint gum in his singing mouth.

I am asleep. I am dreaming of summer. I am in a swimming pool up to my neck. I sip from a glass of iced tea and shave my mustache with a straight razor, both hands full. There are several children in the pool kicking. They kick so hard it's like the pool's a-boil.

I have an Oreo in my mouth, soft and runny, sucked wet with saliva and great need.

The room is raining dust now. The bed is covered under. The pile slowly builds until I am also covered under.

The horse's eyes are bright blue.

David Lynch continues deep-knee bending. He shakes and grins and groans. He chews the gum so rough his teeth go loose and begin to fall out of his mouth. With each loss he begins to shake a little harder, spasms, until he can't control his arms. He can't control his eyes or fingers. The ceiling has sunk down several feet. He stoops further and continues shaking. Blood is running from his lips and nose. It pours out of him like a faucet. The sweat beads in his hair.

The ceiling is so low now in the doorframe that the horse has to lie down. It rolls onto its side with the cowboy still positioned on its back. It crushes the cowboy's right leg. The bones break loudly, popping, spraying dust. The cowboy doesn't scream. He has already smoked the cigar down to a stump. He continues to smoke until he burns his fingers. His lips. His tongue. He and the horse gently wriggle on the floor.

The dust is pouring in so fast now that soon the horse and cowboy are also buried. David Lynch is up to his waist. He is still singing the same song. Under the dust, you can still hear both muffled harmonies. The chandelier is ripping holes in his back. The dust is piling higher. The ceiling is still sinking.

He blows a bubble with the sugar-free gum. Inside the bubble there is blood. Inside the bubble there are bits of Oreo cookie. There are teeth. There is the song.

David Lynch blows more air into the bubble. The pink bubble grows and grows and does not pop. He blows the bubble bigger. He blows until there is no room left to blow. The bulbs in the chandelier glow faintly through the pink film until they are crushed and sputter out.

In the darkness, there is a voice. It is the horse, speaking in horse tongue. The language is transmitted in subtitles, small white text on pure black: *Oh, at last, the stars above are blue. My heart was wrapped up in clover, the night I looked at you. I found a dream that I can speak to. A dream that I can call my own. I found a thrill to press my cheek to, a thrill that I have never known.*

HIPSTER HUNTER

JEFF BURK

A dark screen. Silence, then a loud gong sounds. A quote in white text fades in.

Text: It was the best of fucking times; it was the worst of fucking times.
– Frank Booth

Cut to black. Fade in on an extreme close-up of bright green grass. Camera slowly pans back and a crushed Pabst Blue Ribbon can comes into view. We can hear the sound of shoes pounding on pavement. Someone is running.

Camera cuts to a very skinny man running down a dark alleyway. He is wearing yellow jeans two sizes too small, a Goonies t-shirt, bright red shoes, a pink scarf, and oversized grandmother sunglasses. He is fleeing in terror from something unknown. His outfit is not designed for a quick getaway and he runs with obvious difficulty.

He stumbles over his own feet and falls into a pile of cardboard boxes filled with trash. The camera zooms in on his terrified face as he turns around. We can now see that he has an asymmetrical haircut streaked blonde down the side.

Image changes to the wall of the alleyway and a large shadow falling across it. We can't tell much but we can make out the silhouette of a man with a shotgun.

Close-up of hipster.

Hipster: Who are you? What did I ever do to you?

View from the perspective of the hipster looking up at a man in a black leather jacket and white t-shirt. His hair is slicked back fifties-style. He bears more than a passing resemblance to the Fonz. Unlike the Fonz, this guy has a shotgun pointed straight at the camera.

Johnny: I'm Johnny. And why you? Because Pabst Blue Ribbon. Fuck that shit.

Hipster POV: The shotgun is bearing down on him and we can see the deep black abyss of the barrels. Then there's a flash and blast as the shotgun goes off.

Cut to the interior of a church. A couple in their forties stands, proudly, behind the bride. The father is wearing too-tight jeans and flannel. He's got a long, bushy beard. The mother sports denim short-shorts that are pulled up three inches past her belly-button. She wears a baggy Pac-Man t-shirt and thick-rimmed glasses that take up half her face. Her shoulder-length hair is dyed black.

The bride, Jenny, is wearing a vintage 1930s pearl white dress. She is a stunningly beautiful woman with a green mohawk and numerous facial piercings.

The camera pans to the groom walking down the aisle. He is tall and hairy, with a long beard. He wears only glasses and an American flag Speedo. His beer gut stretches faded tattoos from his punk past. He is pushing a fixed-gear bike as we walks. He gets to the stage and smiles at Jenny. She frowns.

The camera cuts to the church doors bursting open. Johnny walks in firing indiscriminately into the crowd. We catch glimpses of heads exploding, blood everywhere. Both of the bride's parents fall to the ground, dead. The groom turns to run but he is shot in the back. Jenny presses her hands to her chest and beams a wicked grin at Johnny.

Johnny grabs her by the hand and she leaps off the stage. They run past the dead groom, her dead parents, down the aisle in reverse. Johnny shoots everyone who crosses their path.

Outside the church, a cherry-red convertible waits for them. They hop in and drive off.

Cut to Johnny and Jenny driving, the convertible top down, the wind in their hair.

Jenny: So where are we going?

Johnny: Down this road. Then Portland, Oregon. Then, who knows.

The camera pans back and the car speeds away from us, off into the sunset.

Fade to black.

Title Card: **Hipster Hunter**

The convertible pulls up in front of a warehouse. White paint is peeling off the exterior. Muffled dance beats emanate from within.

Cut to Johnny and Jenny, still in her wedding dress, standing at the bar inside the music venue. Their faces register disbelief. Every person dancing around them is a hipster. All the men sport curly mustaches and all the girls wear oversized glasses. The camera pans to the band on stage that is playing a synth-heavy, dance-beat version of Cyndi Lauper's "Girls Just Want to Have Fun."

Cut to Johnny and Jenny staring blankly. Johnny turns, without emotion, and walks off-screen. Jenny continues to stare while the band plays. Johnny re-enters with a gas can. He douses the bar top with gasoline.

Cut to Johnny and Jenny leaning against their car. The building is in flames and people are running out, some of them on fire.

A midget in a red petticoat walks backwards down the street, ignoring the flaming building. He waves his hands above his head in some crude form of dancing.

Midget: Tihsllub lla si siht. Rophatem a lla si siht.

Cut to the interior of a smoky dive bar with a jukebox blaring Buddy Holly

in the background. Johnny is playing pinball. He is no longer wearing the leather jacket. We can now see he has a pack of cigarettes rolled up in his t-shirt's sleeve.

Jenny is next to him. She's wearing black leather pants and a Leftover Crack tank-top. She is sobbing, pleading with Johnny.

Jenny: But Johnny, don't you know I love you? You could leave all this behind and start a new life with me.

Johnny: I have to.

Jenny: But why, Johnny, why?

Johnny: I . . . I just hate them so much.

Cut to Johnny and Jenny window shopping in a posh district of the city. They walk past expensive furniture shops and expensive art galleries. They come upon three street punks sitting at the corner pan-handling. Their white dog snarls and snaps at passersby.

Street Punk 1: Yo, you got a dollar to spare?

Johnny: No.

Street Punk 1: Any food?

Johnny: No.

Street Punk 1: Oh, OK.

The dog snarls at Johnny and Jenny. The punks are too high to notice.

Jenny: That dog seems angry.

Johnny: The angriest dog in the world.

Johnny pulls out a pistol and shoots the street punks so quick that their drug-addled minds and malnourished bodies have no time to react. The dog lifts its leg and pisses on the dead punks.

Cut to side shot of Johnny and Jenny in a diner. They're eating cherry pie and drinking coffee.

Close-up of Johnny's face staring intently.

Close-up of Jenny's face, sad.

Close-up of Johnny as he takes a drink of coffee, slurping loudly.

Close-up of Jenny.

Jenny: I...

Close-up of Johnny as he chomps down on a forkful of pie. He chews loudly with his mouth open.

Close-up of Jenny.

Jenny: Can't...

Close-up of Johnny as he attempts to drink coffee and eat pie at the same time. Coffee drips down his chin as the pie smears across his face in an increasingly wider circumference extending out from his mouth.

Close-up of Jenny.

Jenny: Keep... doing...

Cut to Johnny on his knees in the street in heavy rain. He's sobbing, soaked.

Camera pans and we see Jenny standing with another man. The man is wearing extra tight yellow jeans and a purple wife-beater. Tattoos of obscure band logos coat his skinny arms. He's got a brown paper bag over his head. The bag has glasses (but no eyes) and a mustache (but no mouth) drawn on in black magic marker.

Jenny and the Baghead Hipster turn and walk away.

Cut to an extreme close-up of static on a television. The white noise is deafening.

The camera tilts and we see we're in a cheap motel room. Johnny sits on the stained bed. A white rabbit is asleep in his lap. In one hand Johnny holds a snifter of scotch. In the other he holds a cigarette that has burned down without disintegrating. The cigarette is a three inch stick of ash.

The rabbit lifts its head and looks at Johnny.

Rabbit: Do the locomotion.

Cut to the same static we heard earlier. The camera tilts again, this time revealing a posh basement apartment. The walls are wood paneled and we see a Big Lebowski *poster. Jenny and the Baghead Hipster sit on a bed, an oxygen tank beside them. Jenny stares blankly as the Baghead Hipster kisses her neck. The bag crinkles awkwardly loud in the otherwise soundless basement apartment as he pushes his bagged head into her neck.*

The Baghead Hipster pulls back, grabs a gas mask connected to the oxygen tank, and inhales, deep and raspy. He unzips his jeans and turns to Jenny.

The Baghead Hipster: You stay alive, baby. Do it for Van Gogh.

Jenny robotically leans over, but the camera is positioned too high, and we can only assume that she is giving him head.

Cut to POV from inside an unknown car, staring out the windshield at a dark road illuminated by the headlights. We can only see about six feet ahead. Suddenly a white cat appears in the road. The car turns abruptly, rolls end over end, the camera jolting to simulate the commotion, and finally there's a fatal lurch of metal, then silence, then a meow.

Cut to Johnny's car pulling up in front of a doughnut shop. The camera hovers over his shoulder as he steps out of the car and enters the shop.

Inside, the shop is empty but for the counter girl. She has short hair, arms covered in tattoos of birds and nautical stars, and a septum piercing. She looks up from the book she is reading.

Johnny: Don't you fucking look at me!

Johnny raises the shotgun he'd been concealing. He shoots the woman point-

blank in the chest. She goes flying back into the wall behind the counter.

Close-up of blood splatter on a pile of bacon maple bars.

Cut to a bike shop. There are various people shopping. In the back of the shop is a bar with six men ironically dressed in CARE BEARS shirts. They are vomiting into their pint glasses, drinking it, then vomiting again.

Cut to the door bursting open and Johnny storming in with the shotgun. He takes out a few of the shoppers and then turns his attention to the men at the bar.

Puker 2: It is not my custom to go where I am not wanted.

Puker 2 takes a sip of his vomit and Johnny shoots him in the face.

Cut to Johnny standing in front of a small art gallery, his shotgun slung across his shoulders. The sign in the window of the gallery is about a special exhibit composed of "found art" that promises to be an "eye-opening examination of gender." Without warning, the building explodes. Johnny gives no indication that anything happened. An old man on a riding lawnmower drives past the burning rubble.

Cut to a packed outdoor street fair. Dotting the crowd are a variety of street performers, from carnival barkers on stilts to human statues. Food carts are selling strange ethnic fare.

Jenny and the Baghead Hipster are walking hand-in-hand down the street when suddenly gunfire breaks out. People scatter, screaming.

The camera cuts to a shot of Johnny's steel-toed boots stepping across the asphalt, then we rise up to the smoking barrels of his shotgun, and then finally, Johnny's face.

Johnny: Hey! That's my girl!

Cut to the Baghead Hipster reaching behind his back and pulling out a handgun. Before he can shoot, his hand is blown clean off.

He collapses, helpless. Johnny approaches, cool and confident in his stride.

Johnny rips the paper bag off the man's head. The man beneath looks identical to Johnny.

Cut to the cool Johnny staring down.

Cut to the hipster Johnny staring up.

Cut to the cool Johnny staring down.

Cut to the hipster Johnny staring up.

Cut to the cool Johnny pressing his shotgun to the hipster Johnny's face.

Cut to a distance shot of the cool Johnny standing over the hipster Johnny. A shotgun blast.

Cut to a blood-splattered cool Johnny turning his attention to Jenny. She's covered in blood, but smiling.

Johnny climbs on top of a nearby Mexican-Korean fusion food cart. Horns and rock guitars suddenly start blaring in the background and Johnny sings "Do You Love Me (Now That I Can Dance)" by The Contours. The crowd reforms and people dance the Mashed Potato. After the first verse and chorus, Johnny hops down and takes Jenny's hands.

Johnny: Don't you feel like this has all happened before?

Camera pans back and the crowd is still dancing and Johnny and Jenny hold hands, staring deeply into each other's eyes. Another person who looks exactly like Johnny but dressed in a bright purple zoot suit walks up to Johnny. The stranger reaches inside his coat and pulls out a handgun. He shoots Johnny in the stomach. Johnny crumples to the ground, clutching his wound. He rolls in the street, moaning. The crowd stops doing the Mashed Potato. They stare at this stranger.

The new Johnny pulls Jenny out of the car, dips her back, and kisses her deeply. The crowd starts to do the Robot.

Fade to black.

MISERYHEAD

MICHAEL J SEIDLINGER

There's a killer dominating every city, just like every film dominates at least one mind. There's a killer that's waiting to take away something from you, and the reason being, well, it isn't personal. There's a killer with no name giving each victim something to sing about.

There's a killer around the corner and it waits for me.

It wants to take away everything I've never been able to appreciate.

It's already taken my identity.

It wants to be real but I won't let it.

Every day is worse than the last.

I tell myself that it'll get better. I'm a good person. I was hiding behind something I'm not. It's better this way, even if it means no one talks to me. No one even sees me. They only see what I used to be. But I guess it's better than saying and doing something just to be accepted.

I tell myself—

Not knowing is better than finding out you're not enough.

Mallory finds me in the cafeteria before lunch. "Hello Blake." I recognize her, but I don't say anything, looking around nervously, expecting that she's talking to someone else rather than me.

"Blake?"

She's looking right into my eyes.

"Yeah?"

"I haven't seen you in class."

"You can see me?"

"I've always seen you for what you really are."

You can say I'm flattered, baffled even, "Oh, umm, thanks..."

"You don't need to hide behind a mannequin to be accepted. I could tell right from the first day that you'd be popular."

"You... can see the mannequin?"

"I can see you. Anything else I see as fake."

This is an interesting turn of events.

She asks me, "Are you hungry?"

I shrug, "Sure."

"I'm resourceful. I get things done."

"Thanks..." I falter, and I'm surprised to remember her name, "Mallory."

Her eyes sparkle. "I'll get us some food."

We share lunch together. Once or twice, I reach out and touch her hand, if only to make sure that she's real. She takes the lead and tells me we should get out of here.

"Class is cancelled."

"Which class?"

"Every class."

"Really?"

She grins, "No... but I feel I'll learn more being around you than sitting, bored in class."

Reason enough for me.

Stewart High is teeming with a feverish atmosphere, like something needs to happen, but nothing ever does.

Mallory walks with me, letting me lead the way.

I don't want to tell her that I don't drive but as we hit the sidewalk and there's only the one direction to go—bus stop—I realize I might as well. Not like I can change this fact.

"So, Mallory..."

"I know."

"You know?"

"Yeah." She smiles, happy, enjoying my company.

"What do you know?"

"You take the bus."

"Oh."

"It's okay. I take the bus too. I'm kind of shocked you take the city bus. Stewart High has its own busses."

"Yeah but, you know they are for—"

"Freshmen. I know. I guess I just don't really care what people think of me."

"That's refreshing to hear. I care too much."

Nodding, "It's natural."

"I guess."

"So?"

"So what?"

"Shall we go?"

"School or city bus?"

Mallory points, "Well the school bus is right there, waiting for us."

Fine by me.

It happens so quickly.

We're holding hands and I thank her.

"Don't thank me. You were always here."

Everything I say, she finds interesting and funny, good-natured and poignant. She listens, and I mean she really listens, to what I have to say. I have nowhere else to take her, and she doesn't find anything interesting if I'm not already interested, so I might as well take her home.

The school bus stops right up the street, making it an easy walk to the house.

At the door, I tell her, "It may be a little messy."

"You should see my room." Mallory.

We walk in; she takes two steps and stops.

"You live here alone?" her voice rises up a notch, more surprised than alarmed.

"Yup," I say, not too confident.

And then she notices the carvings on the hardwood, the destroyed walls, and debris littering the floors in layers.

"Were you robbed?"

"I did this."

"Why?"

"I don't know. I mean I think I might know but I don't know."

Nodding, seeming to understand, she wanders around the room,

stopping at the TV, "Damn, this is a good TV. Too bad about the gash running down the side of its screen."

"It's still usable."

"I wouldn't use it. It might burn the house down."

I don't see how that would be a problem but, either way, I direct her to my bedroom, "It's the only room that isn't ruined."

No hesitation, "Sure!"

On the way up the stairs, Mallory notes, "There are a lot of shadows in this house."

"Yeah, not a lot of light sources."

"Not a lot of imagination."

At the top of the staircase, "This way," I tell her when she turns left instead of right. She asks me, "Are you left or right handed?"

I tell her I'd never bothered noticing.

"Left, I guess."

Mallory stops at one particular shadow. "Did something just move?"

But I continue into my room. "Come on."

She backs away from where Camilla has been hiding for days now, and she enters my room, instantly mesmerized by the red-painted walls, the nearly decadent furnishings.

"You designed this?"

"Yeah. What do you think?"

Before she can respond, I say, "Wait, wait, don't say anything until you've tried my bed. I tell you, it's the softest, most comfortable bed you'll ever experience."

She looks down at the bed, waits a moment, considering the offer, but then shrugs. "Why the hell not."

She sits on the edge of the bed.

I sit down next to her.

What happens next is a memorable scene in and of itself.

Lying next to each other, I call her Camilla.

"My name's Mallory."

"Yeah, I mean . . . umm, never mind."

She asks me to say her name.

I say it but it comes out as Camilla.

"My name's Mallory."

"That's what I said."

"No, you called me Camilla!"

I try it again, swearing that I say it right this time but now she sits up on the bed, already partially undressed. "My name is Mallory!"

"What did I say?"

"Oh, it's all right . . . I can be your Camilla if you want me to be . . ."

She lies back down next to me.

I touch her, really enjoy touching her.

She likes the way I touch her and says, "You think I'm pretty. You think your Camilla is pretty."

Peeling away the clothing, naked bodies cannot rest easy if they are next to bodies clothed and so I take off my clothes too.

"You never noticed me until now," she says.

Is this a problem?

"No." She talks me through it, explaining how she's kept track of everything. What's fake will eventually fall apart. She says it's just that "the fake ones feed off each other. When you have an entire circle of them, it's hard to reclaim yourself."

She makes me feel better.

Like there's still a glimmer of a chance.

I'm only responsible for my life, not theirs. If they don't like who I am, then it's their loss. Right?

Yeah, confidence—be confident.

Be yourself.

She kisses me.

I kiss back.

The sun starts to set and I begin to sweat.

I feel a sense of urgency that I misinterpret as arousal taking over. She finds the increase of my actions playful, amusing.

It gets rougher until I ask her, "Have you ever been with a woman?"

"What?" She's not quite offended but not quite nonchalant about the query. I repeat myself, this time more deliberate.

Less question, more command.

I see it but I can't stop.

From behind the shadows, Camilla appears.

"Have you ever been with a woman?"

Camilla steps out from underneath the shadows and joins us in bed.

Superimpose the scene from *Mulholland Drive* between Betty and Rita over my Camilla and Mallory, both naked on the bed, Camilla expressively caressing Mallory's rigid, tense body.

Mallory stares up at me standing at the foot of the bed.

I watch.

She repeats over and over again the word "Please."

I tell her one thing and one thing only, "Silencio."

Camilla drags her tongue across Mallory's chest.

The sight is more like a sexual fantasy than real sex.

Mallory is an idle body that I take in as whole.

I imagine how Camilla would treat Mallory. I relent when Mallory reaches for me. I tell her, "Wait, my Camilla."

I wait until Camilla is finished with Mallory before I slip between the sheets. Mallory doesn't relax until I wrap my arms around her, forming into an embrace.

This was my first time.

First *real* time.

No longer a virgin. But I don't tell her.

We are relaxed, immobile.

I don't check the time.

In the shadows of the room, Camilla is jealous. She's jealous because, at the moment, I want her to be jealous; when I want her to forgive me, she will forgive me . . . and when I want her to return to me, she will.

I can only hope Mallory will be as understanding.

Life is just so confusing right now.

Life makes more sense when the people around you have advice to give. It makes sense to mold a life around others. Maybe that's why I fought to be featured, adored, fixated upon by so many others; little did I realize that they had nothing to give in return.

They take but share no advice.

They have no advice to give.

In a way, I can believe this.

I can.

What Mallory whispered, half awake, half asleep:

"We are all derivative."

As a group we are just people. As a person, you are unique.

I grip her tightly.

She grips back.

I keep my eyes closed. I listen to her breathing.

We are this way for what I'd like to believe a lifetime. The new love cliché in effect.

Creeping from the pain of an imperishable routine, I could already feel it, feel the tingling sensation, anxiety and restlessness forming in the very core of me. I pretend that I don't feel it, that Mallory is enough to consider this day worthwhile. I pretend that this isn't about revenge. I pretend that I'm still a person, someone that people turn to because they want to talk to me.

I pretend it's all aligned correctly and that my life is under control.

My life makes sense.

See?

No one's there to see it.

And I do not believe it.

But I think about it, laying there in bed, listening to Mallory sleep, isn't life meant to be confusing? If it were simple, there'd be nothing to go off of. No abstractions, no challenges, no effort.

Life on standby.

Default setting.

But I don't want to be a loser . . .

I tell myself anything to ease my mind.

In her sleep, I hear her say, "I'm so glad I met you."

I hear singing. Am I dreaming or am I awake?

Real or imaginary?

I wake up in pain on the greasy pavement of a fast food restaurant parking lot.

I hear singing.

I shiver, frozen in place.

I hear singing, and it's her voice.
Mallory's body is sprawled out on her back.
When I see her there, I can't stop screaming.
On my knees, next to her body, I am screaming, as if trying to drown out her voice.
I scream over every single word.

Every night at midnight, I wake up confused, wondering if any of it is real. The body next to me cold and very dead is the only proof I have that it's real. And yet, still, I'm not so sure.
If it must be real, then make it real . . .
Please, just don't let me be alone.

FIRST MOVEMENT

SUZANNE BURNS

Cherise wanted a man to call her mouth a symphony. Not because of all the things she learned to do with her lips over the years, the precise way she blotted her lipstick with a cloth napkin at finer restaurants, or pouted to win arguments without anyone really catching on, her suitors and debaters unaware Cherise was snaring them in a series of charming little traps. Her lips even helped form her infamous bubble laugh, recognizable as she thumbed through tabloids at a grocery store or watched the slapdash flicker of previews before any feature film, usually by herself.

Cherise's lips had helped her land first dates and jobs at perfume counters and the biggest piece of cake at birthday parties, but none of this had ever lasted very long, or in any way sounded like a symphony. Cherise was ready for her overture to begin.

Single for more years than not, at thirty-six Cherise wanted to become a different woman. Not from plastic surgery, dieting or even bleaching her red hair blonde, Cherise vowed to recreate herself by becoming unique. She loved how unique the word unique even sounded as she made room on her small bathroom counter for her coffee cup among a powdery tower of half-used make-up that smeared her fingers.

Cherise stared at her lips in the mirror. "It's not what's on the outside that will make you sing," she spoke to her reflection the morning she decided to change, "but the inside that has always counted."

Cherise brushed her teeth and spritzed perfume on her neck, which she then washed off with a moist cloth.

"No," she admonished her reflection, "we are recreating you from the ground up. At the end of the day," she promised her minty but apprehensive smile, the smile that revealed a fine tangent of lines around her mouth,

"you will be a unique, dare we say even *perfect* woman."

 She put on an old flowered dress and new cherry red ballet flats, then slapped herself hard across each cheek the way she did every morning, sometimes so hard, she split her bottom lip. Sometimes this splitting made her late for her office job as droplets of blood surfaced on her mouth like flower blossoms she waited to thicken and fall off. Cherise wondered if this was why she had never kept a man in her life long enough to reach the point of timeshares and matching monogrammed towels.

 She decided not to go to work as she blotted a few drops of blood from her lips with a tissue. Her new cherry shoes deserved more than to be shoved under a desk in a cubicle all day. Cherise wondered if she would ever reach the point in a relationship for an anniversary date to the symphony. It had actually been years since she was even invited to a birthday party. She had trouble recalling the last time she was offered a piece of cake.

 Cherise avoided eye contact in her apartment elevator as it deposited her fifteen stories down to meet the city floor. She wasn't going to use the word "sidewalk" anymore, part of her new uniqueness, instead preferring to view the asphalt and concrete that surrounded her more like the bottom of the ocean, dark and permanent until something shifted, the driver from the same bus route going by with a different advertisement shouting from its side, a deli closing while a new café opens, a homeless man shuffling across her avenue to ask for change on the opposite street corner, everything around Cherise built with the strength to never change and the inability to stay the same.

 "Maybe I just need a new coat?" she asked the morning sunshine with a hard squint, a bluster of April breeze grabbing her flowered dress. The air stung her slapped cheeks and dug a needle into the fresh split on her lip, the one she knew would open up to reveal more blood if she smiled. She walked twenty blocks towards her favorite candy store to break in her new shoes.

 Hours later, stomping down the sidewalk, the newly malleable city floor, in time to the invocation "cherry red, cherry red," Cherise considered changing her name to Cherry. She thought it sounded unique, and effervescent as a Cherry Coke on a hot summer day, and sort of sticky sweet as a maraschino cherry balanced on top of a banana split. She believed that men liked to think about cherries and bananas. She thought about calling herself Banana, but in Cherise's head the word sounded like she was trying too hard, the fuzzy line between unique and desperate blurring more with each step.

FIRST MOVEMENT

Cherise felt blisters between her toes when she reached the candy store in time to be assaulted by the automatic cotton candy machine blasting its electronic calliope music towards a child whose two dollars bought a pink, fluffy dream.

"I don't want to be known as the woman whose breath smells like a circus," Cherise spoke towards the teenage girl who stood behind the store's candy counter, "or at least like a clown. I am looking for something unique. Something that will alert everyone, but most specifically the new and as yet unrevealed man of my dreams, that I am not only a woman to get to know, but a woman to hold near and dear for the rest of his life." She scanned the counter. "You know, two of hearts, 'til death do us part, that sort of thing."

"Butter mints?" the girl behind the counter answered.

"Excuse me?"

The girl pointed to a wall of bulk candy. "Brides-to-be come in here once or twice a week and buy bunches to wrap in tulle and shove in those place setting swans. Since you said you are getting married and all."

"I didn't say that, and do you really think my dream lover will call my mouth a symphony when he sees me sucking like some puffer fish on a pillow mint? That's what everyone called them when I was young. My grandma kept a full glass dish on her piano... and *Moonglow* is not exactly what I'd call a symphony... you?"

"I saw someone play a violin at the mall one time. It was around Christmas and he was playing that song about fig pudding, but I've only ever had a Fig Newton, so it didn't really do much for me."

"Yes, well," Cherise walked through the small store, pausing at the gelato counter and the display of handmade truffles, "I need something that I don't have to scoop out of a bin and carry out of here in a plastic bag."

"What about Choward's mints? No one's bought a pack since I've worked here. That's been, like, at least seven months."

Cherise stared at the packs of lemon and guava flavored mints. Then she saw a purple glimmer hidden under piles of individually wrapped chocolate candies. When she smiled, she tasted blood. The taste made her feel alive.

"Oh," the girl pointed, "that's the violet flavor. No one has bought a pack of those, like, ever."

"Then I'll take all the ones you have." Cherise opened her red patent leather purse, bought to match her red ballet flats, and asked the girl to toss in handfuls of violet mints.

She wondered what she was missing at work, if the co-workers who made fun of her for bringing lunch each day in a fabric-covered metal bin that matched each outfit would find someone new to harass. She wondered how someone who wore cherry red ballet flats could ever be made fun of. She wished she lived in Paris, a different city that must look like the bottom of an even more exotic ocean floor where other women named Cherise wore red ballet flats. In Paris she would wear green high heels and insist on calling herself "Banana."

Outside the store Cherise ran her fingernail across the purple foil of a pack of mints. Ballet flats planted firm on the sidewalk, she looked both ways, then stuck a violet candy in her mouth. Her lips erupted with the taste of perfume and she spit the candy on the ground. As soon as it landed, Cherise bent to retrieve the lavender-colored square.

Women who reinvent themselves do not litter. That was the old her, trying so hard not to rub against any sharp edge each day as she made her way through the city, hiking up her long skirts, "prudish skirts" her co-workers said, betting right in front of her on whether or not she was old-fashioned enough to wear a girdle underneath, whether she shaved anything off, or kept her body furry in the places that really count, her bare legs rubbing against the elevator buttons, the escalator rails, anything that would gouge her pale skin and leave tiny red trails on her legs by the time she made it to the office; how she had to litter if the tissues used to mop up her own blood, the tissues buried deep in whichever matching handbag Cherise chose, piled up and peeked out from the top of her purse straps. For years her blood had seeped into nearly every street in town.

The new Cherise hid the spit-out candy in one of her shoes, settling the fragrant disk between two blisters.

She unwound the purple foil and placed another candy on her tongue, this time easing into the taste of flowers as they overtook her mouth. She swallowed hard, then spoke towards the bustle of the city in front of her, its souvenir shops and rival candy stores, the magazine kiosks that sold some of the best candy of all, "I am becoming the scent of violets. I am becoming a flower. I am becoming."

She checked off turning her mouth into a symphony on her mental list then decided she needed to do more to become unique.

"My name is Banana," she said to an older woman who passed her on the street in a cloud of designer perfume.

The woman ignored her.

"I meant Cherry!" she yelled after the stranger. "You know, like the

color of my shoes!" The woman and the cloud of perfume kept walking, not even turning back to remark on Banana-Cherry-Cherise's after breath of violets.

Cherise tucked her roll of violet mints into her purse, kept the one she threw on the sidewalk tucked between her sore toes, and walked back towards her apartment.

Four blocks into her journey home she stopped in front of a department store. She sat down on a bench and waited long enough to feel like she had missed her lunch break, if she had gone to work.

"New perfume. I almost forgot," she said to no one in particular as she left the bench a few hours later and walked through the front doors of a store decorated in pearl garlands and leather wallpaper. She walked over to the closest glass perfume counter. The violet candy slipped from between her toes to feel like a smooth pebble rolling around inside her shoe.

The perfume counter girl refused to look up from her arrangement of what Cherise called tattoo perfume, row after row of black and pink bottles decorated with tigers and hearts. The woman's nails looked bright as Chiclets click-clacking against the counter as she rearranged the bottles in what looked like a strange game.

"What's the prize if you win?" Cherise asked. She called this new tactic towards her goal of uniqueness "being friendly," ingratiating herself with the people who worked at perfume counters.

"I work on commission," the woman said as she grabbed a stack of perfume bottles created by a reality star and lined them up next to the others.

Cherise attempted to amp up her charm. "Of course I never learned Latin. Who did, right? But I wonder if the words 'commission' and 'commit' come from the same place. And if they do, are you essentially committing a crime by selling me things I don't really need, just to make your commission?"

The girl behind the counter kept tapping her fingernails against the glass. "Is there something you'd like to smell?"

Cherise pointed to a glass bottle filled with golden liquid. The color reminded her of a boat that could sail across the ocean for days without seeing land, and maybe even the golden blonde head of the ship's handsome captain.

"That's got to be the one. Is it rare?" she asked the perfume girl.

"Ma'am, it's Chanel."

"Why you're right. I must've gotten so caught up in the excitement of becoming unique, I forgot I actually used to do this for a living. Silly me."

"I'm sure." The woman behind the counter wrapped the glass bottle in tissue paper then placed the bottle in a bag with silk ribbons for handles. "So is this reinvention about finding Mr. Right, because nine times out of ten it usually is." She scuttled her nails along the counter again. To Cherise they looked like ten miniature white-tipped tap shoes. "Who am I kidding? Isn't everything we do about finding him?"

"Well, mine is waiting for me," Cherise said as she grabbed the bag of perfume from the woman. The violet mint lodged itself between two other toes, constantly rolling around in her shoe. "He just doesn't know it yet."

"Your shoes match your bag and you're optimistic. That's half the battle right there," the woman said as Cherise left the store without looking back.

She knew what being made fun of sounded like. She'd always known, whether or not she walked through the world with her very pretty lips, even those weren't enough to fit in. But the man who would call her mouth a symphony would never make fun of Cherise. He might tease her if she snorted a little when she laughed at old Marx Brothers movies or tickle her in bed if she overslept when it was his turn to make the kind of pancakes fluffy enough to layer crisp pieces of bacon between. Most of all, he wouldn't touch the cuts on her legs that never had time to heal before Cherise scratched new ones into her flesh, sometimes so deep as she leaned into the turnstiles before getting on the subway, she cried out in pain.

The man who would call her mouth a symphony took his lunch break on a park bench only a few blocks from Cherise. She could just feel it as she threw the ribbon-handled bag in the nearest trashcan, unwrapped the tissue paper in mock surprise of its contents and doused herself in cologne. She tucked the cologne bottle into her purse next to her packs of violet mints.

"Of course you'll know where my pulse points are," she spoke towards the city street. "You always have and you always will . . . John."

Cherise just knew the man who would call her mouth a symphony, and notice her obvious uniqueness, would go by the name John, like that president who married a smart brunette then had sex with dumb blondes or his son who rollerbladed all over town before marrying a smart brunette who dyed her hair dumb blonde. Cherise also suspected as she continued to walk back to her building that the men who thought about cherries and bananas also named their penises "John." This didn't sound very unique.

Yes, Cherise knew somewhere in her city, John ate a turkey club on a park bench during his lunch break and thought about her, wondering what sort of flower he would give her at the start of their first date.

"My boyfriend... well, it really feels silly calling a man nearing forty a boyfriend, though 'man friend' sounds like something a sailor would say, and John has never even sailed a paper boat across a pond," Cherise said to the owner of the Italian deli eight blocks from her apartment as she continued in the afternoon sun to wind her way back home. "Like I was saying, John, my boy, no, my man friend, takes his lunch at noon. Since it's nearing two or three and he won't be home 'til six, do you have any recommendations for a little pick-me-up for our date tonight?" Then she pointed to her newly perfumed neck. "If this does the trick, of course we will be staying in."

"I'll wrap you up a cream cake. It's just big enough to share."

Cherise knew men liked to talk about cherries and bananas. Thinking about cream, especially a cake filled with all that froth, must turn them on even more. Even though she was understanding men's secrets one innocuous word at a time, Cherise hoped her uniqueness would materialize as more than just the ability to say words like cherry and banana to excite John.

She asked the deli owner, "Can you please be sure to put your delightful confection in a pink box and tie it with butcher string? Since I was a little girl I dreamed of carrying home a pink box tied with butcher string. Something about the image seems so romantic. How can you not sense a feeling of potential clustering around a pink box wrapped in butcher string?"

"Miss, I think your lip is bleeding. You've got some nasty cut there. Who done that to you, anyway?"

"Would you believe me if I told you I did it to myself the way I do every morning?"

"Now why would someone like you be doing something crazy like that? I don't believe it for a minute. Say, is your Mr. hitting you or something? If you tell me you bought the Neanderthal a cake when he's smacking you around, I swear I'll..."

"No, I do it every day. Slap myself, cut myself, gouge the inside of my mouth with tweezers or the end of my toothbrush or even plastic straws if that's all I can find when work gets too busy to lock myself in a bathroom stall and cry. And sometimes I punch myself so hard, a good body shot without flinching, I make myself sick. Then I'm hungry for the rest of the day."

"Say lady, I don't believe that fairy story for one second. You pulling my leg or what?"

Cherise thought of all the times she bled too much from cutting her

thighs or poking her newest favorite sharp object into one of her lips. Years before, when Cherise had friends, one of them kept asking who was beating her up all the time and how she could possibly stay with that kind of monster. Her friend, one of those women who was unique without trying, and knew how to wear even brown mascara and make it look sexy and keep herself and her pet at an ideal weight, told Cherise she needed to get help.

"But there is no one to leave," she tried to convince her friend while studying her brown mascara as they drank coffee at a café near the office where they both worked.

"So you are telling me you do this to yourself?" The woman's brown mascara eyelashes flitted like a hummingbird.

"Yes, and I also eat a chocolate brownie at least once a day." Cherise ordered another brownie from the counter barista.

"Well that, *mon amie* . . ." (Cherise's friend was the type of woman who liked to pepper her conversation with French sayings no one really understood but everyone felt too inferior to ask her to define. Even all those years ago, Cherise made a mental note to never say "*mon amie*" when she moved to Paris.) "that is an entirely different issue. Eating too much chocolate means you aren't getting enough love in your life. Simple. What isn't so simple to figure out is your self abuse."

Cherise wanted to tell her friend how she called her daily routine, the hard and quick slaps across her cheeks and lips while she gazed in her bathroom mirror, her "first movement," beginning her day the way a symphony begins, quick, spirited, bright. Feeling pain that early in the morning not only focused Cherise's thoughts, it prepared her for the day. No one could hurt her, she figured, if she hurt herself first.

"No I am not pulling your leg," Cherise said to the deli owner as she let thoughts of her old friends disappear. John was more important than any friend, anyway. "And I want a pink box."

"We only have white boxes and tape," the deli owner said as he placed a small white cake inside a matching box. "But this'll look real nice on a plate. Your man friend won't know what hit him when he comes home to not one, but *two* sweet treats."

"But I only asked you for one cake?" Cherise said before the man looked up from taping the white cake box shut and winked. "Oh," she giggled as the violet mint tumbled around in the shoe she nervously tapped on the tile floor, "you're talking about me."

As she opened her hands to accept the cake box, Cherise wanted to tell the deli owner, almost handsome in his blood-stained butcher apron, "Back

in school they used to call me Banana," but he walked away from her end of the counter to help another customer, leaving Cherise to comprehend the logistics of walking her blistered feet home while carrying a cake.

As he sliced deli meat far away from her, Cherise walked into the bathroom, pretending she wanted to adjust the cake box and her purse in private. Once inside the small white space, she untaped the cake box and thrust her hand deep into its bunny soft middle. Cherise brought the hand to her lips, smearing them in white, greasy frosting before rubbing the leftover oil into the newest cuts on her thighs. Her lips, still sore from her morning slap, stung as she licked the frosting off her mouth and swallowed.

John probably wouldn't like cake, anyway. John was one of those men who jogged during his lunch break and ate salmon for dinner. Before tossing the cake and its box into the bathroom trash, Cherise rubbed the edges of every finger over the waxy cardboard, cutting herself three times in three different spots. As drops of blood fell onto the snowy expanse of the sunken cake, Cherise tried to remember that one fairytale about the girl with the fairest skin. She would ask John to tell her the story before he tucked her in that night, if he wasn't too tired.

Cherise stared at the deli owner as she left his store, making the kind of deep, penetrating eye contact she only imagined being capable of pulling off. Only women with pretty, symmetrical faces, and not just very pretty lips, knew how to make that kind of eye contact. She knew she could never go back to the deli once someone discovered the cake in the bathroom trashcan, so she wanted to make her last appearance for the owner really count.

If Cherise wore a watch, she would have been the type of woman who only glances at her wrist if she knows someone is looking. Instead, she guessed at the time by the way the violet mint continued to dissolve between whichever toes the shrinking candy decided to settle against. It was already getting too late to shop for a new coat, bright green to match the high heeled shoes she would someday wear when she moved to Paris and legally changed her name to Banana. John loved green because all men love green. Cherise knew this the way she knew how to cut her arms and chest and thighs with even a dull razorblade without anyone at her office ever suspecting a thing.

Cherise made her way closer to her apartment. The sun floated lower in her city, the city that was really starting to feel like not just the bottom of the ocean, but the bottom of her own personal ocean she swam through, dark and unflappable with her red ballet flats and her split lip and new perfume.

She reached her apartment in time to catch the lobby elevator without having to push the button. Maybe John was waiting inside for her, home from work two or three hours earlier than usual? Maybe he brought a cream cake for them to share, and this time Cherise knew better than to stick her hand in the middle of dessert without at least asking first.

"John!" she called as she unlocked her apartment door and shuffled in. Her red ballet flats almost felt comfortable as she zigzagged them across the carpet. Cherise smiled wide enough to open the wound on her lip, just to taste a bit of her own iron as she shut the door behind her without locking it, then set down her red purse, heavy with her new perfume and her violet mints.

"John!" she yelled even louder, walking through the small living room towards the bedroom where he must be waiting for her the way men who think too much about cherries and bananas always wait.

No one was in Cherise's bedroom, bathroom, living room, adjacent kitchen with its seldom-used stove. She even opened the refrigerator and peered at the small single-serving cans of vegetable juice and a can of pickled beets. Months ago, Cherise was convinced those two ingredients would make the perfect, unique Blood Mary if she ever decided to invite someone over for brunch.

Cherise checked her front door to make sure she left it unlocked. John, of course a lawyer, was running late. Jammed up talking about the kind of torte that was not chocolate or multi-layered. Thinking of tortes made Cherise hungry for the cake she left in the deli trash. She wanted to slap her face so she would stop thinking about how she wasted that perfectly good cake and how the deli owner would think she was crazy when he discovered her secret.

"At least he'll believe the part about how I slap myself in the face?" she spoke to her empty apartment. "At least he'll believe me."

Cherise spritzed more of her new perfume across her neck and wrists and even down the front of her thin flowered dress. She removed her ballet flats and tossed the tiny, almost dissolved violet mint onto the floor before placing a new mint on her tongue.

As the sun set in what looked out her window like a city view framed only for her, Cherise scanned the sidewalk several stories below, waiting for John to catch the scent of her new perfume, her violet mint, her waiting blood, in the confusing elixir of every other perfume and ballet flat and bloody unknown secret.

Cherise left all the lights out in the apartment, hiding like a surprise in the dark until she thought she heard the sound of the front door opening.

FIRST MOVEMENT

She closed her hopeful eyes tight, dug her nails deep into her already bleeding thighs, and waited.

LADY OF ARSON

JARRET MIDDLETON

Memphis is so fucking hot it's driving everybody mad. Planes hit the tarred lanes and slowed before a watery fresco of clouds the color of cold cream and orange all billowed into a storm wall. The airport played Tamla and Stax classics on internet radio but robots recited reminders about suspicious bags and characters and toddlers wailed like murder and nobody remembered the good shit like Rufus Thomas, Mable John or Eddie Floyd anymore. A brunette aged halfway into life tapped her foot at the public end of the security gate of Memphis International's west terminal anticipating the 737 that would bring a tall gentle introvert named Jonathan through the crowd to kiss her.

Jonathan was her high school boyfriend. She was fond of their young lust, a season canonized forever by the permanent impressions made upon each other. They stayed friends through the first year of college, but seasons change. When she packed and made the forty minute drive home to Millington, like she had most weekends, Jonathan went to Illinois for business school and she did not see him again for twelve years. It was easier for her to think of it as a sweet young boy working like hell to get out of the south. Jonathan never said a word about leaving, but she did not blame him. She was glad, though, as she was now, when he started to come back. In the mitigated distances of adult lives they were closer now in Chicago and Memphis than they might have been across town or in the same bed. Lovers again, excitement enwrapped her body and all her thoughts the entire day that led to being with him again. She was nervous and negotiated with cleaning and laundry, making right angles with coasters and books on tabletops in her apartment, running any errand she could think of until she ended up there, at the gate, waiting for love to enter her world.

While she waited for one man another turned behind her, delayed by a recognition. The short, furrowed man was perturbed, scowling shadow-cast between the teardrop skull of the Asian at the Euro exchange and stacks of display luggage. As he stood there his concern deferred to reticence, he pinched his fingertip in the bun of his mouth, turned his back in thought and recoiled back around, practicing a confrontation. A tall corridor of light filled the atrium with heat and his agitation grew into movement until he stood beside her. He gurgled up a *"you"* from his throat exactly in that way you never want to hear. She turned around, quiet and confused.

"I cannot believe it is you. You *unbelievable* monster." He laughed in disbelief. "To be honest, I never thought I would actually find you. But here you are. I've got you now."

The proximity of this random accusation scared her. She looked with longing through the security gate for Jonathan. Her chest began to shake and her voice quaked, but she stayed confident as she told him that she did not know who he was or what he was referring to, but that she would not stand there and be attacked.

The man was angrier now that they stood face to face and she watched as he struggled to re-introduce reason back to his livid point of view. "I don't know your name," he said, "but I recognize your face, from the sketch they showed me. I never forgot it."

He paused as though she should know what he meant, and she glared back and shrugged.

"You burned down my house. Seven years ago. Everything I lost was because of you."

She was less assumptive, perhaps because of his insistence. Her mouth was open with awe when a hand encroached like warm liquid around her neck. It broke her dumbfounded stare and cast her flinching and spinning around to Jonathan smiling down at her. They embraced and she felt enveloped in safety, the previous viciousness she just faced dispersed like a figment. Jonathan straightened from their hug and raised his eye to the man standing with them.

She held the creased leather strap on Jonathan's bag and spoke softly to him. "I don't know who that is, he is accusing me of some insane thing. Something about his house burning down. I don't know what he is talking about but he is scaring me and he won't go away."

Jonathan's bag fell in a pouch and he took one long step over it. "I don't know what you think is going on here, but I think you need to take a walk." He spoke in a low voice and asked if he understood.

"I understand, alright," he exuded, straightening himself. "My name is

Alan Shetler. And I am going to go find a police officer. Your friend here is going to jail."

Jonathan wanted to hit the smug stack of shit but restrained himself at mention of the police. "Get the fuck out of my face," he growled. "*Now.*" And the man was gone among the sea of people.

They shook it off and locked their two smiles together with joy. He picked up his bag and they walked together as their affection returned. When they got to the escalator Jonathan began laughing and asked in a staunch voice if she was really responsible for burning down that guy's house. Her arms shot out with the quick ring of jewelry before he went stumbling over the heel at the foot of the escalator. They laughed together. She rubbed herself against his broad shoulder as though a brilliant and beautiful heat was thawing her soul from some long, frozen sleep. They passed underneath that highly pressured place where currents of conditioned air barreled against the humid waves that poured through automatic doors each time they opened. It was there the cop stopped them. There was the angry man again, his arms folded, as if validated by the presence of the law. Jonathan told the officer how offended they were by the guy's unfounded threats. Then he said if the man accused her any further they would be obtaining an order of restraint and, if he pushed it, they would sue him for defamation.

"What!" he leapt forth, pointing. "That criminal bitch is going to prison!"

Jonathan twisted the man's breast in his long reach and the slim black officer forced them apart. She spoke directly to the officer, "Sir, I have nothing to hide and I'm not guilty of anything. So long as you protect me from this terrible man I will go to the station as requested so we can clear this whole thing up." The officer obliged, and they walked into the hot breath of August where he held the door of his cruiser open and she ducked her head inside.

Detective John Ridge emerged from the east corridor of the precinct she suspected led to a row of holding cells. Automatic locks buzzed and the occasional holler came through the wall. She sat across from Ridge's desk in the department office. People streaked by on the carpet and the phones never stopped ringing. He dropped his weight into the chair which plied back before returning him upright, landing his inquisitive sight dead at her face. She was warm, but she thought if she removed her jacket or

showed any sign of stress it would somehow broadcast her guilt. This was confusing because she hadn't done anything. Now there was the guilt she thought others suspected of her. She stared back coolly at the detective, her eyes glossed with this metaphysical consideration.

He cleared his throat and straightened his tie at the same time as if he always did them together. "Well miss, I must confess, I find you very interesting."

"I'm just here to clear this whole thing up. I mean, I didn't *do* anything."

"Unfortunately, this may not be that easy." The detective opened a full manila folder and sat there scraping his chin. "I pulled Mr. Shetler's file—"

"Mr. Shetler?"

"Yes, the man accusing you of setting the arson fire that destroyed his home in Modesto, California in February of 2005. Had you ever had contact with Mr. Shetler, prior to today?"

"I've never even been to Modesto...."

"Well like I said, that's interesting." Ridge exhaled and leaned his heavy gut forward, flipping through the files until he hit an earmarked sheet of paper which he flipped around in her direction. "Take your time."

Dark bangs trailed across softened eyebrows. Eyes, wide and observant, were the faintest bit clouded. The fleshy pocket of lips held a small shadow dashed in the opened mouth. A thin curve descended from a defined jaw to a thin, muscular neck and set of shoulders. Detective Ridge added his own narration, that investigators composed the sketch from the accounts of two eye witnesses who saw this woman walking from the bright, burning home. The crack of disbelief in her stomach became harder to deny. She was looking at a picture of herself.

"Here's where it gets interesting," said the detective. "I did some digging around. Turns out that you—or someone who looks an awful lot like you—are implicated in four other arson fires over the past ten years. Local PDs in South Dakota and Maryland still have open files, which means they're going to want to talk to you, too. Along with the charges Alan Shetler's bringing against you, it stacks up quite high."

Ridge stopped when a high pitch broke into breaths of air. He saw that she was sobbing and held out a box of Kleenex. She clenched a tissue and covered part of her face. She was having a hard time breathing. "None of this has anything to do with me. I don't know why this is happening and I don't know what to do."

"What I recommend you do, ma'am, is get yourself a lawyer. Preferably a good one."

Detective Ridge handed her a packet of paperwork. The top yellow sheet was a notice to appear in court two months to the day in Modesto. He stood and fed his arms through either side of his charcoal blazer, giving her enough time to reassemble herself and the room and to find her way out.

Jonathan slouched as he read a magazine article about a load of gold found in a shipwrecked Spanish brig off the Gulf Coast after the BP spill. A shrimp crew got snagged and pulled up part of the treasure, which was of course taken from them. *That's why y'aint say nothin' to nobody, never,* said one shrimper, much to Jonathan's humor. When he saw the hallway door open, he chucked the magazine and rose to take his girl around the shoulder and get her home.

That night, it took another episode of crying, a long shower, a valium and four glasses of wine to soften the strain of her now torturous confusion. Jonathan asked if she was positive she did not have anything to do with the fires. She snapped at him and isolated herself by curling up on the kitchen counter, shouting at him in the other room. She realized how it must have looked. She could not get over these other cases, other fires all over the country. That is when she started crying again, but the shower and the booze helped. Her guard down, she gave into the caress of her legs on Jonathan's lap wrapped in a blanket. The rhythm of their kissing started slow and they moved without care from the couch to the bedroom, where the clothesless pleasure they created shot into her and broke apart the fiery hatred that arose to shield her from the madness of this day. After she came, the two lay sweating in the burgundy sheet. Outside a thunderstorm broke. It pounded the ground outside the window with rain.

For the next two months she searched for a woman who looked exactly like her. It was the only way to stay rooted in undeniable innocence. Otherwise, the pragmatism of her legal defense, the whole drawn out timeline of this delusion would have been too painful. She delved into the records, trying to find arson suspects in the places mentioned in her case who were in their early thirties and matched her description. There were very few serial arson cases—that were not political anyway—and almost none by women. She sifted through the reports of the thousands of houses that burned each year from unattended candles to faulty wiring to pirating cable. News databases returned her over again to the sensational headlines of women who burned down wings of maximum security prisons or

accidentally made nitroglycerin in their bathtubs. This led her to the several mismanaged crystal meth outfits that raised whole houses straight off their foundations. Then there were your good old fashioned gasoline fires, which is where she came across two very interesting women.

Christina Johnson was a black widow who burned the three houses and one yacht of her rich husbands. But she was caught in Orlando in '98 and served fifteen years because a very rare clouded leopard owned by her last husband died in the fire. The other woman was an insurance scammer named Olivia Malvern who torched her own condo, an unfinished housing development, and even the office building where she worked. Her interest in Olivia grew when she found a notice in a small British newspaper that she had died in a car wreck headed south on the 394 from Falmouth out to the Lizard peninsula. That's where the trail ended. No information about her family, no service. Who was Olivia Malvern, she thought repeatedly. Was it possible this was who Shetler and the police were confusing her with? On the nights she could not sleep at all she frightened herself with the possibility that Malvern was some mastermind who faked her own death and set her up for the fall. Her trial loomed and the haze of late summer was in her head. Olivia Malvern was now an obsession. Twice a week she met her mother for lunch and it was all she could do not to show up each time with some new detail related to this woman. Jonathan received enough phone calls from her where he looked into it himself. After he couldn't find any information about her either he began to doubt that the woman even existed, let alone had anything to do with the fire in Modesto or any of the others. Eventually, she reached the same conclusion.

The search for this phantom, Malvern, kept her occupied most the summer, and as fall came two months of anguish vanished and the day arrived. She was up at dawn the morning before, sitting in a coat drinking coffee at her kitchen table in the quiet. At the airport she boarded the United flight through Houston to Modesto and checked into a hotel across the street from the Stanislaus County courthouse. She met her lawyer, Robert Salmunz, who greeted her with a soft smile and a personal handshake, cradling the middle of her palm in the reassuring way a doctor might. "Everything is going to be fine," he told her, and already she believed him. She sat aside the huge dark table and thought how unique the people are who labor in their business of law, unemotionally and efficiently handling these decisions that so alter people's lives.

He had obtained independently verified witness testimonies confirming every alibi that corresponded to each fire, starting with the arson in question at Mr. Shetler's home. She found it assuring that what she had

known all along was now supported by facts in the real world. She met Salmunz again at 6 a.m. in a sunny room at the central courthouse. They rehearsed her script and the order of their argument. His pronouncement felt legitimate, which is exactly how it sounded when he repeated it verbatim before the court, that nightmarish Alan Shetler, his predatory prosecutor, and the judge elevated before the entire echoic chamber. The night of the arson, in February of 2005, she sat to dinner with her mother and her two friends at Dambruzio's restaurant on the waterfront in Memphis. It was unable to be denied. The inertia of the whole ordeal and the entire judicial apparatus appeared silly in the face of such a simple and irrefutable fact. The prosecution presented a quite unspecific and superficial depiction of her past that leapt from her family life and personal character to her schooling and occupations that concluded with the truth that not very much was known about this woman, which the judge scornfully remarked wasn't a crime. Their reply to this was, by some desperate, backwards inference, that really she could be guilty of anything. When this rhetoric cleared, not without some laughter, her brief examination concluded. She watched as the certainty drained from Alan Shetler's face. The judge called to everyone's attention that she was not guilty of any of the charges brought against her. It was over.

She had two vodkas on the plane and gazed across the expanse of night that papered the Sierras and stretched luminous across the plains. She didn't know what returning to normalcy would require, but she looked forward to it. She drifted off for an hour. The plane bumped as it landed at O'Hare and when the cabin lights came on the lady next to her shook her awake. At Jonathan's apartment on the east side, she had electricity in her limbs. She jumped onto him in the intimate confines of the front hall in his upscale apartment. They played with one another, grabbing and tussling as Jonathan fixed two martinis in the kitchen. They clinked rims and she rapidly recapped the hearing for him.

"You see, I told you it was that Malvern chick all along. I was so looking forward to your involvement in some international blackmail."

His long frame braced on the black leather couch with the bright Chicago night illuminated behind him. She smiled deviously as they settled in to watch a film. As they lay intertwined, she gazed up at his face in the dark and realized how far away he was. She gripped his collared shirt and pulled more kisses toward her, but the diminishing passion unfolded

like a changing season.

Three nights later, after she had returned to Memphis, he called.

"This is going to be hard," he breathed. "I am in love with a woman, and, well I've proposed. You and I have been so close for so many years, and I enjoyed them dearly. But I think it's best if we don't speak from now on." He said how sorry he was and when she didn't say a word, he hung up.

She got her things together, her body hollowed and uninhabited. Somehow she made the drive north to her parents' house. There, she sat up in the soft yellow light that warmed the living room and poured her grief out to the consolation of her mother. They put down one bottle of cabernet and opened another. She knew her daughter hurt from more than lost love. She had been in a parallel existence, for months not knowing what would come of this random accusation, then finally having to fly thousands of miles to establish her innocence in front of strangers. Her wisdom was simple.

"When the world requires something like that," she told her, "you end up having to prove it to yourself as well. You're not sure why but you figure, what if they are right?"

She told her mother about the guilt that had grown from others believing it. She asked her mother how many things in the world owe their existence to misunderstanding.

"Too many, dear, too many." She spoke with that mother's voice, a natural force for empathy, hushed as flowing water. They lay together on the couch, her mother stroking her brown hair that curled around her shoulders. Their empty glasses were on the coffee table next to the second bottle which was now a green receptacle filled with light. It was late, her mother pulled herself up off the sofa, kissed the top of her head, and wished her good night.

She was alone in the stillness of her old home and she took the stairs down to the backyard. She was sleepy and drunk. She removed her sweater because her skin was hot to the touch. It was a crisp early autumn night and the air cooled her body. She lay stretched in the even cooler grass. As she pressed her face into the ground, she relived Jonathan's betrayal and recalled with melancholy the details of Chicago. There could have been something she missed, but how alien the past few months had been, she couldn't tell. Her eyes closed, she moved further into the recent, painful memory. Being in the tall corridor, four feet by nine, where she decorated him with affections. The stone reflection of the slate countertop, where he poured Hendricks and the Rossi vermouth and topped off their glasses

with the little bottle of Boker's bitters and three olives on a pick. The cones of the lamps that pushed out transparent light like an office that hung low enough for Jonathan to have to duck under them in the bath and the bedroom hall. The narrow Italian designer closets, and the smell of his neatly stacked work shirts. The way his pant hems all hung unbelievably even above rows of polished Bostonian shoes. His gray satin sheets tossed over the minimalist black bed frame. A single wall of windows, the city pasted in them.

In a space where remembrance was more altering than drunkenness, she traversed her replication of that apartment until her wistful vision turned to slumber right there in the yard.

As she drifted off, Jonathan woke in Chicago, the confines of that same apartment filled with smoke. His heart pounded, and in that second before he knew what to do, he saw her from behind and watched as she stepped through a part in the flames. By the time he shook his fiancée awake, it was too late.

Her body was chilled by the night and the Tennessee ground. This sleep of hers was much too heavy to wake from now. Beneath the layers of a deep dream she could sense Jonathan was in trouble. He was poised at the edge of a steep hill, soaking wet from a recent storm. She screamed as he stepped over the edge, but the wind ripped the distance to nothing, and he could not hear her warn him about the danger in the valley.

THE CLASS OF EDUN HIGH

MATTY BYLOOS

In a small town not regularly bothered by strangers or passersby, an old man owned a junk shop that operated like a museum. Inside of it, nothing was ever traded, and no cash was ever exchanged for goods. The old man had a way of making the few patrons who entered the shop feel like they were somehow trespassing, like adults trick-or-treating among children on Halloween.

The old man was making a drawing on a scrap of paper one afternoon as the rain came down outside. It was three o'clock. Every timepiece in the junk shop recorded the minutes and seconds and made sure that he never forgot what part of the day it was. Time mattered little to him anyway. The day after the day he had turned a hundred years old, he stopped caring. And he blamed it all on the high school that he kept under glass.

No one had come into the store for weeks, but maybe it was better that way. The old man had come to find that loneliness treated a person in strange ways, after enough time. It made him feel like someone who he may or may not have recalled from his past was watching him: an uncle, an old neighbor, or someone hiding behind a bush on his short walk home. The feeling was familiar, though it had an odd temperature to it. *Loneliness*, the man thought, *was like an animal*. It had a life of its own, collected dust like the rest of the objects in the store, and then after the animal died, it might carry on in one person or another's memory, like a haunting.

Then, a bird collected on the windowsill. The rain continued to fall against the glass. He held a watch in his hand, but he wasn't looking at it—the timepiece was just a thing on his list that needed fixing. Instead, he watched the bird. "Bird," he called out to no one, not expecting any response. "Hey bird. Where would you and I be if the world were a mountain of paper?" he said.

He thought about paper a lot. It was another thing of the past, a currency that had all but lost its value. In his mind, the world outside the windows of the store was the opposite of a mountain of paper. It was everything besides paper, in fact. The bird stretched its neck, and by default, its tiny head, in a motion the storeowner briefly considered obscene. And then it flew away.

One day a teenage boy came into the shop. It had been so long since the old man had a customer, that the sound of the bells just inside the door startled him. "There's no browsing in here," he told the boy, without so much as a hello. "Just buying, or leaving."

"I'm not here to browse," he responded. "No time for that." He shuffled a few more steps inside until he was standing near the cash register, where the man stood with the watch still in his hand. "I hear you keep a magic high school in here, and it brings you good luck, or something."

"Where'd you hear that, son?" The old man's voice was shaking—either he was out of practice, having spoken to no one in weeks, or else he had just signaled to the boy that yes, there was in fact a magic high school somewhere in the store, collecting dust like the rest of the junk. "No high school in here, anyway," he added, first glancing around the shelves and aisles, and then looking down at the watch while picking up a small screwdriver from on top of the counter.

"How's your security system then?" the boy asked with a weird confidence that made him seem much older. "You feel pretty good about all your stuff stayin' exactly where it is?"

The old man was nervous, despite the vast amount of years separating the two. "I think you had better go, young man. And don't come back again any time soon, either."

The boy turned and walked out of the store without saying another word. To the old man, he seemed neither concerned, nor hurried. Just like that, he was gone, and the old man was alone again with all of his dusty treasures. He locked the front door when the boy was out of sight, and

went back to his office to make sure the magic high school was still sitting where he always kept it.

By the end of the week, another six strangers had wandered into the store, asking the old man questions that left him feeling uncomfortable and scared. He couldn't remember the last time he had felt fear. Every one of them had asked about the magic high school, and none of them had bought anything, or even bothered to look.

Could a person live in a world without relation to anyone else? he thought to himself. At some point long ago, the answer had seemed obvious to him, so he bought the small town's junk shop after the original owner had died, and did little to improve upon its original condition. Instead, he had piled up whatever came his way until it introduced itself to the ceiling in one corner or another.

A dozen years passed. Every day he went to work in the store, sifting through piles, not counting or writing anything down—just looking at it all in a gentle, passive manner. Until one day, when he discovered the magic high school.

Few things were colorful in the space around him. Most of it was brown, or an offshoot of brown, objects that had begun their slow descent back to dirt. It made more sense, in a way that felt biblical to him. *Dust to dust*, he had thought to himself a handful of times.

On a shelf somewhere amid the rubble, there was a cake stand, high up but not hidden. Though the rounded glass dome of the lid had collected its share of dust, the old man could still see inside through the clear walls. The architecture of the miniature white model inside was obvious—there were trees, and a football field, a grand front entrance like any other high school.

It wasn't a hospital, or a government building, or an office park, or a library. It was a high school, with all the required parts, from the long brick rows of miniature classrooms, to the tiny rolling hills, and even a swimming pool that shuddered against the tip of his finger when he leaned in to touch its thimble-full of water. When the almost inaudible school bell rang, throngs of children appeared from out of nowhere, and rushed inside the buildings to begin their day.

The old man did not know what to make of the little world living beneath the glass dome. What secrets did it hold? Had it always been there? Who would have sold such a thing to a junk shop in a small,

forgotten town? He replaced the lid on the cake stand, carefully sealing the high school back inside, and brought the whole thing into the office behind the register.

There, he kept watch over it for many, many years.

Every morning since the day when he had discovered the cake stand and its tiny magic world, the old man could hardly wait to get back to work in the junk shop. He would rise in the morning full of life, hurry through a cup of coffee and a piece of toast, and walk the few blocks that separated his home from the shop, where he would lock the door behind him.

In the office, he sat down in front of the desk on which he kept the cake stand. The old man lifted the brown blanket that he laid over it every night before he left the shop, as if the cake stand were a birdcage, and it was his solemn duty to ensure nighttime fell over the high school at the appropriate hour.

Within a week, he had learned all that he would ever know about Edun High. With the help of a high-powered hearing aid, he could pick up the announcements as they rang out over the school's public address system. During recess, or lunch, and sometimes after school, he listened in on the students' dull chatter. With a magnifying glass intended for repairing watches, he figured out the roles that everyone played: who was the most popular, who was the smartest, who was in trouble, and who was aching to graduate and move out of the tiny town. He knew when the pep rallies were happening, who threw the best parties, and who had gotten into fights.

In a month, the world of Edun High had become his own.

When a year had passed, and the old man was expecting to sit in on his first graduation, it became clear that none of the students enrolled at Edun High School ever left. After that first year, things began to change.

In the store, the phone would ring, but the old man never answered. The only bell he responded to came from within the high school. When he realized that the world beneath the glass dome existed in its own kind of perpetuity, a thing that lived outside of time, the old man began sleeping inside the store every night. He stopped eating, and slept for only a few hours each night, on a dusty couch in the office.

Years passed, and the old man seemed to stay the same—not getting any younger, but not getting any older, either. He was always just . . . an old man. Though he hadn't gotten any smaller, and certainly not small enough to climb underneath the domed lid of the cake stand, or to walk up the tiny stairs and into the main school entrance at Edun High, the rules that governed that world had become his, too. The old man was no longer aging.

And just like that, a hundred years passed.

Things eventually returned to a more normal state around the junk shop. The old man answered the occasional phone call, and said hello to the occasional man or woman who came in. He still slept in the office on the old couch, and when he wasn't running things, he was sitting in his chair, staring through the magnifying glass at whatever happened to be going on at the magic high school.

He was mostly left alone—until the teenage boy and the other half-dozen strangers had come into the store, all of them asking about the high school. And the old man found himself beginning to worry about his treasure, and its safety.

The phone rang. The telephone's voice was an antique scrawling that hardly commanded him to action, but he answered it anyway. A woman had found the store's telephone number in an ancient phone book, or at least that's what she said.

"Hello?" the old man muttered, without having to think about it first.

"You're open?" the voice betrayed only the slightest bit of anticipation. Or maybe it was fear. Whatever the case, he sensed it, and felt something retreating inside. "Is the store open today?" the woman asked again after some time.

"Yes. I don't want anything. Who's this? What do you want?" He hadn't intended it to sound so abrupt, but the recent rash of visitors to the store had made him paranoid. Conversation now came out of him like noises from an old machine, in desperate need of lubricant. "I'm sorry," he added. "Yes. We are open."

A week had passed since the old man had gotten the phone call, and no one else had called the shop since. Now, it was ringing again. After a few rings, he answered it without saying a word, and waited.

"Hello, it's me. It's Anne. Do you remember?" a woman said softly, as if she knew him.

"What do you want? I thought you were gone. Somewhere. I don't know where. I never did." The old man did not know where the words had come from. It was as if he had known this woman in another life—as if another tiny iteration inside of him was responding to her questions, and understanding where they were coming from, or who was asking them.

"I'm here. I'm coming to see you. I know the store—I'm close to it now. I thought you should know." There was something final in her voice, a confidence that did not put him at ease.

The old man hung up the phone.

Now, he was scared.

No one came into the store that week, and its place in the world continued to seem arbitrary. The old man thought of the store as a kind of secret that everyone besides him had forgotten.

Sitting in front of the desk in his office, the old man was scratching some lines on a small white piece of paper, not thinking of what they might add up to. The drawing came out of him like a drip from a faucet, with no one there to explain it away.

And then the bells on the front door jangled, and he emerged from his office to see who was inside the store, and if it was the woman who had called.

She was standing there in front of him, on the other side of the counter, much like the teenage boy had been several weeks earlier.

The woman held out her hand, but the old man did not shake it.

"That was you on the phone the other day, I take it?" the old man said as the woman returned her hand to her side. Just then, he noticed a large freckle on her face, near the curve of her jawline. He thought it looked like a burnt piece of toast.

"Harold?" she said softly. "It's me, Harold. Is that you?"

He was holding a sliver of torn paper in his left hand. A pencil rested

behind his ear and he could not remember the last time he had taken a bath, though he did not believe that he smelled. *Is my name Harold?* the old man thought. But the name didn't resonate with him, no matter how hard he tried to make it sound like something familiar. Harold, it seemed, was not the old man's name.

"What is it?" she asked. She looked up at him as if she were asking for more than just an explanation, as if she knew the answer to all of his questions about the nature of loneliness, of being alone in the world.

But the old man did not answer her. He stood there staring into her face, like he was trying to read an old map describing a place or a time that had existed long ago, in a past that he had little access to. Wherever she had come from, and whoever she was supposed to be, was a world beyond his experience—beyond his imagination.

The woman was not looking at the old man, who was looking at her. Instead, she looked around the junk shop, moving her head in half-circles, letting her gaze fall on every little detail the shop contained. "Do you sleep here?" she asked.

Again, the old man didn't answer.

"What's back there?" she asked, pointing behind the old man, through the door to the office where he kept the magic high school.

"I—I—I have to use the bathroom. You've come at a bad time," the old man said, thinking it would be enough to convince the woman it was time to leave. And he turned to walk towards the other end of the junk shop, in a corner opposite the office where the tiny bathroom was, as far away from the woman as he could possibly get.

He closed the door behind him, and started to wash his hands. He did not have to use the bathroom, but the urge to cleanse himself of the experience with the woman was strong, though he did not know why. He washed his hands, and then washed them a second time, and then again after that. Each time, he scrubbed them vigorously with the brown bar of soap, rinsed the bubbles from his fingers, and dried them off.

After the fifth time, while the old man dried off his hands, he thought he could hear the sound of the jangling bells, signaling that the woman had finally left the shop.

But something was different.

The old man's hands were hidden beneath the towel, as he dried the last bit of water from them. He was scared to remove it, scared of what his hands might look like. So he stood there and waited like that, with his hands covered, until he was convinced enough by a shaky confidence that his hands would look the same as they always did.

But when the old man removed the towel, his hands did not look the same. Instead, they were more wrinkled than before, mottled with dozens of overlapping spots in various brown tones. In a word, his hands looked *older*.

The old man hurried out of the bathroom, through the aisles of the junk shop, and headed toward the office behind the front counter.

Suddenly, he stopped.

The woman was gone from the shop, and the old man knew exactly what he was going to find once he got inside the office.

UMBILICUS REX

CHRIS KELSO

ACT ONE

The curtains part to reveal a flaming stage. Two silhouettes are visible between the iron bars of a prison cell. The clunking of pistons and oil drills and lawnmowers scream all over the somber scene from somewhere out of shot. A huge digital clock flashes above with ONE HOUR in red cyphers.

Motes of light start to illuminate the men beneath the shadows—a newborn, two hours old, drags a tiny comb through his thin wispy hair. He is iridescent in the low light, a swathe of amniotic fluid covering the crown of his soft, swollen scalp. Outside the prison gate, two guards wearing quarantine jumpsuits wave drivers through. The smog outside possesses a supernatural quality in the shade of night.

Pan to opposite cell.

Disfigured globes of molten glass emerge from the chugging heart of a furnace in the neighboring cell. Two workers slap on industrial gloves and stoop into a mound of dead animals. The workers begin molding the glass into beakers.

The child watches intently, side profile.

Close-up on one worker stabbing his wrench into one of the mangled corpses (which may have once been a deer or a stag) and tears it open like a busted piñata. He removes each organ with a surgeon's grace and throws them into a

steaming pile. The strained remains fill each beaker with droplets until full.

The machinery is deafening, a medley of hydraulic rams and pumping apparatus, bone grinders and overhead cranes. The stink of metal, of the animal carcasses and grease trapped under the belt add to the hellish image in the prison.

Image of animal corpses.

People rarely eat the flesh of grazing animals or fish from the sea anymore. The real market is in vital organ manufacturing. There is no evidence that these products help build immunity to the airborne virus t

– The sufferer feels moisture well under the ducts. This is a truly devastating phenomenon. Every muscle in the body succumbs to lethargy—a disease of the soul spreading like wildfire. Finally, the infected drops flat out. Dead.

The cowboy clicks his spurs and yells – Well, SH-H-E-E-I-I-T! He offers the kid a cigarette. The pink ectomorph fumbles the little white rod between his stubby finger tips before accepting the cowboy's offer of a light. The baby coughs out a plume of smoke and stares through the bars of his cell. The cowboy avoids looking at the long umbilical cord dangling between the kid's legs.

Dream scene of child sliding out of his vulva confines and straight into a state penitentiary.

He takes another drag from the cigarette and looks at the smoldering butt all confused. The cowboy nods, chewing on a stem of wheat. Suddenly a foul smell fills the cell. The kid adjusts his diaper and makes an apologetic face. The cowboy tries to hide his repulsion.

ACT TWO

The kid becomes increasingly bored. He's gotten distracted by the strange figure roaming the hall outside his cell. The cowboy sighs, forlorn.

– He had a hand in bringing ya here.

– A hand?

– Sh-e-e-i-t! He considers y'all a violent and reprehensible criminal.

The cowboy gives another hideous cackle that echoes against the cell's stony walls. He gestures to the pacing figure outside and asks:

– What do you think about him then, the surgeon or the daddy?

The kid glares into the darkness, trying to focus on any familiar contours.

Suddenly the voice booms—ferocious, masculine, barely human.

– VISITOR. YOU GOT A VISITOR.

A set of keys jangle in the lock and the cell door slides open. A woman appears. She seems vaguely familiar to the baby. She is dwarfishly short with cropped black hair and two bulging, soul hungry eyes. Her breasts are large and milk engorged. They meet the baby at eye level. He stares at the two massive, sagging bags and his stomach growls with hunger. She is small but still appears tall compared to the child sitting on his bunk. The woman squats. The tight flesh around her mouth cracks into a grin. She is fat too. The cowboy gets up, adjusts his waistcoat and places two hands on either side of her shoulders to turn her around. They share a wet display of affection.

Having stooped to her level the cowboy is almost able to consume the woman's entire head, his jaw dislocating like a python's. They reluctantly separate and, together, look down at the baby.

The woman keeps grinning, undoing her large brassier with her stare fixed. She stands before him with her exposed breasts.

Outside, the agent appears displeased by this display. He punches at the bars with both boulder fists, snorting and swearing insanely. The kid looks over to the neighboring cell at a worker doubled over in pain.

Close-up on anguished face—bespectacled, fat and unshaven man in a boiler suit.

A television sparks to life. The agent is calm now. A re-run of M.A.S.H is on. The industrial machinery starts up again. The cowboy flips open his pamphlet again and reads.

– The victim seems to experience arousal and an erect state, which is completely perplexing. You can almost see the brain working on a million different thoughts at one time.

Worker falls to the ground, facedown—blood dribbles down his chin.

– Do you miss your momma? – the woman asks snapping the kid back to attention.

– No . . .

– Do you miss your God?

– No . . .

– Do you miss *my* God?

Disgruntled by the relentless questioning and still weighed under the anvil of injustice he's carried around his neck the duration of his short, painful life—the baby feels himself succumbing to something—the tragic parables behind those wet eyes are impossible things to conceal fully. He cries.

– Baby gonna cry? – teases the cowboy, pretending to lasso cattle from thin air. The kid clenches his eyelids shut and bashes his rattle against the frame of his bunk. The grotesque laughter gets louder, in perfect dissonance with the clattering machinery outside and the TV's blare. They're all laughing.

The priest is laughing.

The woman is laughing.

The draped agent is laughing.

Captain Trapper is laughing.

Then there is nothing.

Fade Out.

ACT THREE

The baby opens his eyes and chokes back tears. The cell is empty and he's all alone—stuck in silence.

His surroundings look different but he can sense something has changed within himself. He looks at his reflection in the long mirror hung against

the wall. He stands tall now, wearing an ivy-league jacket and acid wash jeans. His round baby face is now angular, chiseled from muscle and jagged chunks of bone. He is broad-shouldered and tall. The kid wants to cry some more but something in him resists.

The umbilical cord is still there too, sucking tight at his belly button, draining his life source. He tries to tug it free. The desire to separate himself from what he once was is overwhelming. As he pulls, umbilical cord keeps coming out—in a never-ending line. He gives up after a minute or so, sitting back down on the bunk with a bundled coil in his arms. The whorls and loops of his own external organ bring a flurry of nausea to his gut. The kid ups his college blazer and rubs his hands together. The cell is suddenly freezing.

He watches as the poisonous vapor outside kills two squirrels by the roadside.

Outside a figure is still wandering the shadows, only he seems much smaller in stature now. The kid can hear something—the tinkling of xylophone keys. He recognizes the tune but from a long time ago. He looks down to see a tiny parade of insects marching across the floor from under his bed. He lifts his knees up to his chest in automatic fright. Upon closer inspection the marching band appear to be cockroaches. They make their way to the metal bar at the foot of the cell and pass between the gap. The digital clock chimes with "TEN MINS"—at which point the cell door slides open and the agent allows a young woman to enter.

Her face is hidden by a large wicker hat with fruit on it. She promptly removes it. The woman's face is young but chalked completely white, and her nose is long and sharp like a cone. Her eyes are murky with no sign of any pupils. When she opens her mouth to speak she has a row of crystalline fangs along the top row of her gum. The kid is quite startled by her.

– Don't you remember? – the woman asks.

– No.

– You don't have much time.

– I know.

– I brought you something.

The woman hands over a handkerchief.

– Open it...

The kid cautiously unwraps the offering. He stares into his palm.

– What is this?

– Your first tooth.

He holds the tooth into the light to observe it—a sharp, pointy incisor, just like the woman's. The kid gives the woman a distrustful glance.

– Not long now – she says.

– Here, you can have this back.

– Put it in.

The kid looks down at the fang. With his other fingers he feels along the course of his gum line until he finds a craterous space. He lodges the tooth into the hole and the root attaches immediately.

– Take a look – encourages the woman.

He bares his teeth in the mirror and sees the fang protrude beyond all his others.

The woman appears pleased, reveals her own row of impossibly sharp dentures.

– Do you know what it feels like to die?

– No.

– Are you afraid of it?

– Yes.

– Do not be afraid of dying.

– Easy for you to say.

– I have died almost a dozen times.

The boy begins weeping uncontrollably. The woman forwards a handkerchief to him. He blows his nose.

– What's wrong with you? – asks the woman.

– I'm almost three years old.

The woman leans in and lightly tousles the boy's hair. The agent rattles the bar with his fist and announces – TIME'S UP!

The woman gets to her feet and tells the boy to stand up. He does. She presses her lips lightly to the boy's cheek, turns and leaves. The boy can still feel the cold impression she left on his flesh minutes after she has gone. The agent appears to be entering the cell. He is as tall as the boy remembers. In his left hand is a syringe full of a yellow substance. He poises his fat finger over the plunger, ready to descend.

– First thing's first – says the agent, still hidden behind a blanket of shadow. In his right hand is a surgeon's tool kit with operating tools clattering around inside.

– I'm gonna cut you off for good.

The kid becomes aware of his blood-saturated connecting tube. He doesn't want to lose his placenta like this. Still, he won't put up a fight. He's paralyzed by futility and fear and pure curiosity. The needle spike breaks the skin and everything becomes vividly clear...

Flames engulf the stage and the curtain drops. A young lady wearing a baby's coverall wanders onto the stage sucking ruthlessly on a dummy. She speaks:

– I know there is nothing beneath this replicated flesh but a mass of circuitry and manmade mechanisms. What is a broken heart like? Is it similar to

this virus? A fat tumor on the left hand side, throbbing like a plate of red, wobbly jelly? Do I really aspire to this? I confess this fascination with human deterioration has escalated to near obsession.

She looks at the crowd in awe for a few moments before the brutish hand of an agent appears from the depths of the curtain and yanks her through . . .

Applause.

INLAND WHERE SECRETS LIE

JOSEPH S. PULVER, SR.

Then
(punch, and severance-feral streets)
want. Step out of ghostly shadows. Stay alive.
Then
(deadpan sunset of flaws... and later, again, after the other again and the others before them, jump-and-shout lights about to go dead)
transformation. Grab it.
Stay alive and grab the roses.

 Long dark hair sits perfectly on her shoulders. Exactly the right amount of bone to her collar bones. Sculptor would say that's art and be right. Double take perfect. Perfect hair, the bangs, the color. Perfect shoulders, pale, sculpted. Black cocktail dress for this engagement the same, perfect. Eyes perfectly define every action of bodies together.

 Soft perfect cheeks above Christmas-red lips, no pudding that whispered "Lover" or "Yes" (and let its heat linger) ever had more sun inside.

 Perfect how the one word poem of her name cooks the thunder of his need and slides over his lips.

 Everything's perfect—breathtaking—

 Unless, as she floats across the lawn of your libido in black heels, or as she sits glossed and manicured on your red sofa, you look over your drink while you're holding court and your eyes are quick and catch the old East End/poor-side-of-town failures in her eyes twitching...

 Perfectly poised, perfectly beautiful (beautiful enough to imagine the sparks of her kiss in a hotel room are the only real High Society and every one of those kisses are worth dying for), she sits alone in the back of

the black stretch limo that picked her up at her one bedroom apartment in North Hollywood just after 7 o'clock. Its headlights illuminate the charcoal darkness that has settled over Wonderland...

Masquerade night (again). Warm. Light, how it soundlessly spread and splashed, and hot had done their damage and been swallowed.

There's a breeze. Like there often is.

There's a moon. Like there often is.

She's gazing out the window. Like she always does. Her expression is perfectly polite and impartial.

Hasn't said a word. She's learned it's best not to.

... ride

... winding...

To there—

Stars (luminous, not astronomy engraved aloft) swim. Over unsated Mulholland. Black snake Mulholland, the double yellow lines, the dotted yellow lines. Mulholland's "Don't come" hidden from eyes. Moon comes. Shows. Nouvelle to . . . vague. The notes bounce puppet to too-high-a-price. Round sounds arc from stress, "*That*" dialogue complete with embers.

The Western Land, pier and patio and (slump your half-dead libido) 30dollar rooms (won't hear a sea-shanty by the pool, or see a free breakfast bar) (free centipedes, cockroaches, and jet roars overhead) by LAX— Mexicali rice & beans & paper-cup coffee half a block away, Hollywood twistin' in your manhole of blues all night, and, and Last Gleaming red breeding colorations (leave your cineradiography at home) and intoning handsome and hot and buzzing, is beautiful. Fragmented. Relentlessly. If you have the money to hustle the jazz on the grapevine.

(this river don't come with a throw of dice) for the Tralala's (no days off) sharpening their whore's alphabet on goodbye sheets and Bukowski's (without priests and afflicted with otherwise) revolving on stung, let's (crawl, over the pulse of bones) drink, "I don't remember," in a room stained with sat incur bare life, look for surviving coins to feed drink, sleep, reserve a quick happens (to ME) for the next contradiction, requiem. Fit in a prayer if you can. Steal one to sleep on.

If you can.

If you can.

This is The L'America, Baby. Every freshly-squeezed frame/by/frame . . . Feeders, pants free of gravity, lift their hands and look for you. The L'America, holiday immoderation to plan and gather. All the uneven

pleasure-shapes (wearing chain-link cigarettes and screeching scavenger-grit while they motions-perverse) folding unevenhandedly, mapping need and beautiful into demented. Then they bitch the beer's not cold
Mulholland dreams (some manifest X marks the spot, others eternally hidden).
. . . ride . . .
(slid off the stem of ritual) limo . . . lights . . . Round the round slow curves. Miles. None conform to straight. All slow. And she sits (in the rear) and watches, wonders . . . and wants the unfolding of revelation . . .

Black suit in the front seat levels .9mm's take-all at her shock. "You're getting out here."
Starlet-red lips carry, "What?"
"You *get out* here."
Afraid of what the Ferryman will build with her heart she moves slowly through the passage of the open door . . .
Fastfun-joyride jacked on *WeeEEeee* (with beer cans & laughter & heat) and Whooooooooooo comes around the black-snake curve, too late sees the bride of dreadful stripped naked. Don't see it, tough, her hand still offers TRUTH—

Metal world
CRASH—(bride&groom coffin-twisted in the FORCE field
Sparks & shards, diamond-glass becomes event & CRUNCH—beercan jigsaw
&
smoke.

The screams. Flame, tearing. Fire . . .
DEAD. One there. And there—thoughts in that head erased, and there . . . Swiped. Hit. Unclear circling "True?" And what to do?
Confusion—Who? WHY?—why (without a door or doorknob or key or intermission) cluttered with why . . . WHY as apocalypse.

Down. Gagging on scared's muted scream—the syllables sound rusty . . . Dwindling (the enamel of her partitions shallower), eyes roll back, blacked out . . .

Struggling to get up.
Add dimmed. A
little
blood.

Small.
head wound. Sharpness is an abstraction.
Looking. Eyes that never saw see . . . Add (awake in the rafters of despairing) considering problem found in the defining force of what-was . . .
Looking. For aid. For all clear.
Looking at what/was/done.
Scattered—launched into delirium, small, thin, some thing of cubist inscriptions (voice, no glue to it, leans close asks, where does your mind go to?). Try to move . . . Sugar (was there ever?) refuses . . .
Drawn—
Lights. Down THERE an acute billion. Could walk there—make her way back? "Back? Was . . . I?" Low-cut LIGHTS with needle-soft hands. A distinctive otherworld. Filth/anger/breaking windows/ strutting neon GIRLS—Bon voyage, Spellbound. Skingame steps no lifeboat—and movies and COLD BEER - Cigarettes - LOTTO and ADULT and the Priest of the Sun and the Priest of the Black Cross and the Priest of the Rose and the Priest of the Thorn and Women—Bon voyage, Spellbound. Skingame steps no lifeboat—and OPEN ALL NIGHT and Come on In and JESUS In Hollywood and the Spearmint Rhino and Jumbo's Clown Room and—/"Drop it in."/the stroke of across working an obit/400 little kids and no clown/a saxophone with one arm. Cars. Cars, libido that won't stop, spitting tunes and cartridges and curses. Cars—Senator Hightower doesn't have to drive by the culture that lives in them. Lights and LOUD and bright and mad running Sunset to sunset, all the lines it's not safe to cross. The Hole. All test and TEST. Reality marked X. And X. X = *target*.
Won't be. *Again?*
Can't.
Down is one thing . . .
Forest behind her.
Droplets of idea, sight-line to instead. Cross-reference without specific.
Swallows—fastens on
Uphill.
Velvet black. Velvet smooth black trees black forest.
. . . winding . . .
(She walks . . . The ghosts don't.) . . .

path...

Dizzy primes fragile. Fainting could occur. Other things as well...

Up.

Ten toes_wooden steps_cautious_as_weakened_muscles_will_motion.

Climbing blackness. Turning. Around this tree, around this brush thick as mystery. Nothing here is straight. Nothing cast in light. Scraps and slashes of moon skin the ground...

Stumbles over her dismantled bound.

She looked, moist words in each eye, down_at_her_feet. Set out (again) to. Travel with nerves she cannot outdistance. Carries her shoes. Terrain, feet bump into throw wine bottle. Night. Night in the particles of the eye. Terrain, feet bumping into things that ran out of talking. Trees. Grass and stone trees between them. She looked down at her feet. Through what night lets you see. Thought along the way. Wobbly. Dizzy. Uphill. Centipede path. Ten toes finding footing... Into—

Weary wave of gesture creates distance. Stroked in the weight of post-fortune. No subtle in the split. Has to lie down. Now.

Has to...

or fall...

Disowned by answers. Huddled in bushes. The slow pace of sleep

Disheveled hair, looks like something you'd see hanging from a scream...

Shoeless feet... Ten_toes_not_dancing_toward_the four walls of the open door...

Been in this room before? Sat here? Waiting? Sat with the light on and the TV on? Sat here with the decision and the demon waiting?

Weary.

Wobbly. No leap left in her, not one single hop she could assemble into a tool.

Sleep in a bed... Eat what's in the cupboards... Hide... Remember -if -you -can -were -there -mouthfuls of light –and why it's red –in there...

IN.

The other side of the door.

Hears the clock. How small

its transmission, unbroken course—no sides—no other to another and another without going back to fro...
　　　Closes the cupboard door. Eats some soup. Eats some bread.
　　　　　　　　In a corner. A bed. Big enough for—
　　　　　　　　　　　Fell (take/off/through/cracks) into sleep again... Motionless yet kicking... choppy images of yesterday a battlefield of cannon shells.
　　　Something flickers to life—
　　　　　　X.
　　　　　　The room at the end of the long red corridor.
　　　　　　X.
　　　　　　The blue room.
　　　　　　X.
　　　　　　The room with tears but no blushing.
　　　　　　X.
　　　　　　The room where the corners clutch the blackness.
　　　　　　X.
　　　　　　The room with the uncoiled bed that's big enough for—
　　Shame but no girl. That model must have been limited. Murdered. By good? By evil? Slayed by truth? By sex? The girl with no immortality. The girl whose flesh, beyond its dream, spiraled on the bed.
　　And she sits alone. Weeping.
　　　　　　And the audience on the TV laughs.
　　Sits on the edge of the bed. Her tears make hurtful craters on her thighs.
　　　　　　Father Bunny, antenna ears poised to receive, enters: "What's up?"
　　　　　　Mama Bunny, tired of trickling over the iron hour after hour: "Nothing out of the ordinary, Doc. TV... and conversation."
　　　　　　Father Bunny: "Someone's long secrets."
　　　　　　Mama Bunny: "Oh? Something said before?"
　　　　　　Father Bunny: "It was Friday."
　　　　　　Mama Bunny: "I had a mouthful of ironing. Nothing fancy, but it was piled high." Looks at the red sofa. Wants to sit. Maybe unfurl quiet with the TV... Looks at her ironing. "All day."
　　　　　　Father Bunny: "I can't carry me anymore."

The audience on the TV laughs. The daughter on the red sofa agrees. She's had enough too.

Father Bunny: "I'm going to bed."

Mama Bunny: "It's warm enough." Doesn't add tomorrow is the only thing on the menu.

Father Bunny: "Lights out."

Daughter Bunny, still a quiet furnace in front of the TV, still listening for the companion of circumstance, has not moved. Not even a wiggle of ear, not even to look at Father. Her tongue won't even lift a finger. She's waiting for The Face to arrive.

INTERMISSION

COFFEE
CIGARETTES

Coffee & Cigarettes

Coffee & Cigarettes are being served in the lobby!

Mr. E: *Fuck that bitch! This is still L'America.* The Home of Me! *The pussy's mine, the money's mine. Eden ain't on the curriculum. Look at that shit; goddamn words smoking hopehead-bullshit, Ironside-sirens attacking the asylum, West Coast ghostjazz crying, hangover one-line punk intentions up and lost odyssey on the stained linoleum—You can't conjure shit out of a needle and a spoon, gravel-voiced foghorns humping limp holidays of print from apocalypse-childhoods—City lights say, Fortune Don't Surf! Welcome to The* fucking *L'America, fit yourself in an unbearable, close the Edward Hopper venetian blinds so your shrinking veins don't choke on the loneliness contoured by loneliness . . . Fuck. That. Bitch. The fucking brave and the bold pluck the secrets off the Life Tree and get to live in the mansion. It's* MY *fuckin' pleasure, my narrative. My thoughts. My mind. I'm the fuckin' director. They wear what I tell them to wear, fuck like I tell them to fuck. I told that bitch my zipper was the fuckin' yellow brick road . . . How the fuck hard is that to understand? X marks the spot. Start here! If I say it's crazy clown time and tell her to fuck like a rabbit, she fuckin' better, or someone loses their life, use rope or push 'em off a tower.*

Mr. Stitches: Love's ghosts, like that, Boss?

Mr. E: Silencio.

Mr. Stitches nods yes sir.

Mr. E: Wait a fuckin' minute, call Angelo. Tell him, mountains are falling . . . I'm the fuckin' executioner. I push the red button. I tell them when to fire a bullet. Me. Me. How the fuck hard is that to understand?

Mr. Stitches shakes his no, Boss, it's not.

Mr. E: You're damn right it's not! My fuckin' dime. Make the fuckin' call—

She comes out of her tangled slumber, doesn't bring all the inland blind alleys and labyrinths of shadows, all the dream-slits, that hopped as specter-beasts of metaphor. Awake—conscious without the control-lamp identifying herself. Wobbly. Showers. Upside-down cubist of slow-haze does not come off. Explores the empty rooms. One locked door to the hallway. One lamp, green, lit. One sofa, red. Walls, no art, no dreams to break the common maelstrom of mundane's virus. Small table with a phone . . . The room's corners clutch black shadows.

> TV's on, but she does not remember turning it on.
> Another few steps in the act.
> Sit.
> Focus.
> Get there first . . .

Arrival. Parking there, shaking a bit, knees damp with wordless tears, sits on the red sofa. Watches the images on the TV. A recycled episode of dirty challenges on. *The Ways She Came To Tomorrow.* TV announcer (flashing the BIG SMILE) in his ultra-smooth and spiffy you-know-this-is-it-folks voice says: "This is . . . *L'America.* Where the rabbit died." She begins to cry as the audience laughs and claps.

Door opens. Father Bunny (not yelling) enters. Advances 6 steps. The shadows in the room lengthen. Turns left.

Father Bunny: "Rose-garden dreamers. They're all high. Pushing yesterdays to tomorrow."

Mama Bunny: "They can't return them for store credit."

Father turns left. Faces South and the Great White Face on the dark green wall.

Father Bunny: "Like clouds, they can grow anywhere."

Crying, crying feels like mountains are falling . . . Wipes her cheeks. She doesn't remember what time it is, or her name, or the last episode. Her hands are joined in her lap.

She agrees with Father Bunny.

Father Bunny transfers his gaze on the TV screen.

She tries to move her hands, but they can't speak in the new language.

Father Bunny: "They come here to watch. To take everything . . . They try to change all the signposts in the sky . . . All they leave is beer cans."

She looks at the phone, wishes she could call the past, ask a few questions . . . Maybe bring it on home . . . Crying crying in a flock of Who? Crying a frenzy of Who? Why? Crying. Crying.

What she can't explodes.

She transfers her gaze to her purse.

Of course. "I.D."

Someone admitting to be Me. Someone who hung on to her name. Some Grace, or Suzi? A Nikki, or Laura perhaps? A perfume to light Stella's swan?

"Diane. Lisa maybe?"

Doesn't like Renee, or Sheila. Hopes not Alice.

"Naomi would be a nice . . . I could fit in that, be soft and lovely. I would try."

I would.

She imagines holding dinner parties, attending pool parties, meeting a tall dark stranger . . .

"Camilla."

Betty . . . Rita?

Meditates on each name. None want to fit. Not one grows the colors of peace.

Just
want to
be

Me.

"*Be someone... Please.*"

From hollow, desire, desire bows her head. Finger raised to open. Hoping, her sensation a wound, hoping.

A compact, a chome .22 (lighter than the Friday night it still had 6 rounds in it), and a wad of money, 100's rubberbanded. Enough dark green currency to build dreams. Or hide in one. Opens the slim black, magnifying compact mirror. The mirror shaped like a key. And a note—

SEE ME?

Tongue trying to fade from the movement of lips: "I don't want to look."

Father points to the sofa. "Look."

She is not recovering.

Her tears have no color, no another time another place, no moonlight billowing on a page . . .

Exile.

Maybe wrong.

Maybe suddenly punished without mercy by an affair, suffering as the moon just sat there.

Holds the thought, hoping flashback. But nothing comes here. No line of journey. No lie. No stay. Here. Safe.

Ripping applause from the audience. Scattered laughs.

Father Bunny: "Someone's long secrets."

Suzi Bunny weighed down by the TV's solitude.

Mama Bunny: "It's raining again."

Father Bunny: "There have been times when the hours fell faster."

Mama Bunny: "Will there be blue tomorrow?"

Father Bunny: "It was Friday. Alone in the emptiness she was wrinkled by the dream."

The phone rings.

"I'll be there Friday. After 7."

He'll hang his coat in the closet. Place his jacket over the peak of the chair by the bed in the blue room. Animated for his need she'll (flinch before the kiss) let him do what he wants her to do. Wild alchemic-fucking. Like bunnies (with the TV on). All furry gestures. Gestures deafened by his bulk (and the laughter on the TV) (and the sound of the rain outside). Juices eaten, disoriented. Leaping, no church bells. Up, undressed-meteor, Up, dim lights ACTION, down—carry NEXT, bend to suit, compress—glow to make him BURN, roar as directed. Her career

as a travelogue, trying this bed, trying this room, trying this fit and its signal chained to ceaseless... Flame into fragment of shapeless—spaceless, anonymous underfoot, exposed, no ground of now to survive, no calm in continual apart... And she, in the abyss of coin, after his edits (and her fluttering with tears), does not know herself.

The TV flickers and the audience, temperature set to increase, laughs.

A round of applause.

Near breathless shock. Almost drops the mirror. Tongue working on a question, she stares at the moving lips in the key-shaped mirror. Hers are shut. Wearing the same shade of starlet-red as hers the lips reflected in the mirror look like hers, but they're not frowning. The mouth in the mirror gleams, offers. "We opened that Darkness."

"*But* ... WE?"

Lips of the reflection speak: "Come back to me."

... The blue room... High above the blue street... Above the windows and the girls toiling to the servant-tones of she and he—"Sir, I make beginnings from impossible. Come, let your spoonful of crave navigate. I have a camera in my hourglass and curves and hair and diameter that can make use of your gallantry. Come inside."... Warm with fast eyes... The gentle snowflakes pacing the soft ripples of the white lace curtains...

He was only thinking about her legs and the power of outcome. The hours that Friday they looked good. In those stockings. When she asked if he was going to fuck her.

He was.

Came here to. That was the point. As he remembered when she walked across the room—"Not like that. Slower."—and unzipped him, it was.

Her legs—Where we meet, deep-current seeds in the tangle bonded-alchemical. Waves he could follow—hour after after hour—love, his fingers did, seemed to. Head. Lips. Teeth. Lake. Lips and blood and fingers locked on saw. Eyes tell. Ask. Whisper.

"Go in."

(the darkened bedroom/edited mouth—wanting mercy or something better—can't bring up the begging/grainy black/grainy white/slightly out-of-focus/sound of an old Bell & Howell 245 on pillows and her bowed head/a single, unsavory fragment repeating/he made her watch—tied to the hop-leap-fuck like bunnies—one just MEAT/one of them, near the black mud of an odd-shaped panic, cries/one grunts, laughs, finishes his vivid, closes the door/this night and many that will follow, one will not sleep.)

Waiting. Waiting. Slopes, dunes, hand shift and shift, sigh to sigh/hands curved in the thick shadows/the cave where the sea of cold apparitions clings to eyes/he opened his mouth to speak . . . Silence transmitting what's next . . .

 Suzi Bunny sits on the red sofa . . . Has sat . . . Will sit . . . Cold. Still—won't swallow any Go—won't say would, won't pry or erupt, won't smoke, won't drink coffee—won't laugh when the TV laughs. Hands flat and folded in her lap . . . TV or no TV . . . won't turn if she hears sounds in the hallway, won't hear if Mama wants to say something to her—she's heard them all said before, she's heard it rain all day . . . Until the Great White Face returns. Then she will not ignore his sparks and flames . . .

 The room is empty. Sometimes it looks blue. Sometimes it looks green. Sometimes it's dim, even the light looks grainy. Sometimes dark. Dark when it's night it feels silent and she, torn, singing her tears, weeps.

 Not wanting to hear what they have to tell, sometimes she won't take the call if someone calls. She already knows it's dark and it's raining . . .

 She looks in the mirror again. "Before we met and burnt came between our memory."

 Looking in the chanting ripples for the farewell. Holding tight.

 "We?"

 "Your face and mine."

 "You are my face."

 "Oh?"

 "I couldn't misplace it. You. Me. Can't lose you. Can't lose your own—"

 "If you slip you can lose anything . . ." The starlet-red lips in the mirror open, sigh. "Even me."

 Half of her face in shadows. "He cast a strange shadow in that black suit."

 Quick and wide open. "Then you remember?"

 Pulling back. "I . . ."

 Slow. Dripping so she can catch up. "Friday. He called. Said he'd be waiting . . . Was. *Still.* Waiting."

 "Then."

 "Yes." Closer. "He said he'd send the car."

 "The black limo?"

 "I heard it arrive."

 "Then?"

 "You left." Exhales cigarette smoke. "Walked right out of that door."

Pulls back. She isn't smoking. "Friday?"
"Yes. It was nearly 7 o'clock."
Feeling the sensation of a web tingling with echoes. "*7.*"
"It was dark. In here. Out there."
"There."
"Yes. In the back of the car, the black car. On the way to there. Where he was waiting. Just like he said he would be."
Then. The day when it was after 7 o'clock. . . . Shed robe. Shed panties. Airplane legs, knees wanting to follow, moving toward the mirror on the red ceiling . . . The face of madness—pushing the sky of its tiny at tomorrow—screams from her nipples. The left one, his favorite, the one she always offers his hunger, wants to just suffocate and find grave-quiet sleep as the fury of his strutting teeth hammer. . . Her face is a smear in the mirror . . . She lowers her hand . . . Adjusts to the fever of his instruction . . . She hands him propulsion. He sleeps . . . She turns on the TV. Watches the sacrifice. Keeps the sound down.
The audience on the TV sparked, claps wildly.
Father Bunny: "It does not hurt them long enough."
Mama Bunny: "You know where you are if you look where you have been."
Father Bunny: "After sundown it's all sand."
Suzie Bunny wishes she had a book to feel until the clock moves and the Great White Face arrives. A book with hair and teeth and something going on. Trees with birds. Girls revealing their sides. Some whole her eyes can embrace. She gets up off the bed. Puts on an old record. Spins . . . The Shadow-forest breathes girls full-speed ahead. They laugh. Clap wildly. Dance. As a chorus sing, "Everybody's . . . doing it."
She absorbs a face. Begins to return.
Hole. Mirror.
Dances around. Wiggling. Could leap . . .
But to where?
Tomorrow?
Her limbs are smoldering with the breath of Once.
"Once . . . *Then* . . ."
Turns into the barbed voice of a man. In the harbor of shadows he looks furry. He has long ears.
"Then." When there was no moon and his ears were warm between her thighs . . .
"At the beginning, when it wasn't so far."

She looks down at her feet.

"Then. When he said... bright things. Promised good, nice and funny. When naked was soft and a melody."

She remembers this song, how loaded it was. It still warms her. She likes the feel of warm naked air on naked skin. Likes the feel of naked truth.

Father Bunny, in his everyday suit (the suit he sits in, the suit he walks in, the suit that does not blow prayers and opinions no one will hear), walks 4 yards. Pauses before the door to the hallway.

Mama Bunny: "Testing the resonance again?"

Father Bunny: "All the time."

Father Bunny, finally, after his hand crawls its way close to the knob, opens the door. The hallway is grimy and dim, unlovely.

And it's empty.

Then (the few thin parts of farther she can catch) ... She (the sequel to the vanished girl who didn't make it through the riotcircles) eyes at the level of the doorknob (withholding uttering the constructs of desire) looks at the emptiness on the table ... A little blood on her face. His voice pressed to her clasped lips. The tension in the room will not disappear ... The shadows distort, in the shape of a tide (with a mouthful of Evermore) they swell and craft claw-images on her shoulder. No prospects for heart, she shifts from her knees slowly finding she has feet ...

Stands.

Unbending—like it or not—front and symmetry to meet center.

Blood lengthens, connects.

Pins and needles, digesting the speed of a new station, chime.

Nerves. Knees.

Wobbly.

Reddened eyes. Mouthful of sensation: "I do not think you deserve me." Unclasped the point gets vehement, moves from the bed to the momentum and 3 get squeezed off at the afterword leaving...

Steps (urging hurry) that don't follow the dots. Her cheap felt slippers leave no footprints on the dusty floor ... She finds her shoes. Coat. Purse ... Door—hinges creak—opens. Door—hinges creak—closes ... Hallway, dim light no tenants. Pale laughter (with no vigor to communicate) from a TV leaks into the hall ... Her room without the canticles of light ...

Cracked plaster.

Walls wearing scratches of compromising.

A lot of narrow stairs—the wood was varnished once ...

Here

looks like a photograph she approached ... There was an empty seat,

and widening in the sound of embers, a waltz and broken glass...
A glass of embers—
And she was waiting...
Face
(picking at the whirring blindness in the briars)
in
the mirror. Admires her eyes. Admires her nipples and her thighs.
Starlet-red lips: "Long secrets."
The face in the mirror goes black.
The Great White Face appears in the mirror, says, "That is the password."
She looks down at her feet.
Down at her feet... A minute? An hour? Lenses feeding inland aren't qualified to conquer the traces it carries. Sees what seems to be...
It's raining.
 Thunderous applause from the TV tries to catch her flight—
It does not submerge her screaming.
It is 7 o'clock (again).
 The audience on TV laughs. Laughs again.
The phone rings...
She has her ready face on.
The door to the hallway is open, but she has not moved from her seat on the sofa. Dare she rise and close it?
The phone continues to ring...
Thinks *maybe—maybe* this time she should not get in the car.
The applause does not stop.
Dare she?
Wonder about the picturesque ambitions and suspicions of rabbits and what the Great Black Heart of Fate draws in the cages of time and turning and facing other directions.
It is after 7 o'clock and
the phone
(no partition from the hardened arrival of rain)
thick
as a shaft of
teeth
continues to
ring

LAKE STREET

MP JOHNSON

Driving east on Lake Street, the shadows become increasingly less glamorous. Braden drives this way late at night, not so much to clear his head as to fill it. First with images of college girls in Uptown clutching their too-high, too-expensive heels in their hands, only in their drunkenness willing to admit the pain their choice of footwear has caused them. The shadows cling to the brick walls of trendy bars. They slide behind these girls, get in front of them. No matter how hard they try though, they can't come close to the sunshine yellow dresses and perfectly tanned skin, so they follow Braden instead, collecting in the dents and scratches of his car, ready to go where they're more welcome.

The shadows like it better closer to Stevens Avenue, and so does he. No lines of perfumed frat boys waiting for overpriced drinks, just dive bars and fast food joints with peeling paint and shattered bottles in their parking lots. Honesty.

Mystery. Despite taking place immediately beneath flickering streetlights, transactions here are obscured by the darkness of the shadows. Those involved prefer it that way. What changes hands? Guns? Drugs?

The darkness doesn't let Braden see. He has no more right to be here than he does to be back in Uptown with the salon blondes giggling and vomiting radiance. That's the message sent. He's allowed to pass through, go to a drive-up window and get a bucket of chicken. Then he's allowed to leave. He doesn't hurry.

His headlights have no strength here. They die a foot in front of his car. He's left to squint into the honesty and the mystery unaided as he volleys bites of golden fried chicken from the tip of his tongue to the back of his throat.

He doesn't see the girl until she's against the grill.

When he slams on the brakes, the girl flies back. He sees her bare feet go up where her head was and thinks he killed her. The shadows rush in and he considers fleeing, letting them reclaim her. Surely they will pick her up and send her on her way. Would they give up one of their own so easily? They back away as he shoulders open his creaky door and steps out. They don't want her.

Maybe the girl doesn't belong here any more than Braden does: his pale gut and balding head reflecting moonlight, streetlights, all lights. It's as if they're pointing at him. He wants to growl and tell them not to judge, that he has darkness inside—violence, anger—and he can barely contain it.

But that would just be talk.

"Get the fuck out of here, you white-ass faggot piece of shit!"

Braden peers into the murk beneath an overpass, where the voice comes from. Three men emerge. They are bigger than he is. He's less than six feet, and carries little weight beyond his midsection. They carry weight, and much more. The shadows peel back enough to let him see what's in their hands.

He's not ready for this, he realizes. He just plays with the darkness, dips his toes in it. Still, he reaches down to help the girl up. She ignores him and touches the back of her head, fingering through sooty locks and coming back with a blood-covered hand. Then she passes out.

"Leave the bitch and drive away!"

Braden tries to say "no," but the word doesn't come out. The shadows don't want his words any more than they want him. He scoops the girl up and throws her into his backseat, managing to knock her against every hard surface along the way.

Bullets spark against his door as he climbs in and hits the gas, barreling so fast in reverse that cars scatter onto the sidewalk. He hits nothing. He continues in this manner for two blocks. Then he stops, puts his car in drive and turns off of Lake Street.

The girl's not a prostitute. She isn't worn like the others Braden's seen stalking toward cars late at night on that part of Lake Street. No bruises decorate the mocha skin around the mouth of her denim miniskirt. Her hair looks freshly washed and conditioned, so thick and black. He smells lilacs, not smoke, when he carries her into his apartment and sets her on the couch. He grabs a towel from the pile of dirty laundry in the corner and gently places it under her head. Blood soaks into it.

He doesn't turn on the lights. The bulbs are burned out. He's been living by the flashing light of the television screen and the tender strands

of moonlight that seep through the windows. It's not that he can't afford new ones; he just hasn't gotten around to buying them.

Staring at the girl, Braden can't get a fix on her age. When he kneels in front of her, she looks to be in her early twenties. When he hovers behind the couch and glares down at her, she could pass for late thirties, his age. He goes back and forth between the two positions, wondering when she will wake up. What will he say?

Her eyelids tremble and he decides not to tell her that he hit her.

"You hit me," she says.

"No," he replies. "I saved you. Some men were after you. Thugs." He enjoys the way the last word rolls off his tongue, with the slightest hint of "I've dealt with their kind before," which isn't true. He's never been in such a situation. He realizes he should be shaking, but something about this woman makes him feel safe.

Her lips. They're almost as wide as his fingers, but they thin out when she smiles and says, "Thank you."

"What's your name?" he asks.

"I can't remember," she replies. "I can't remember anything."

"I didn't hit you," he reminds her.

"Where am I?" she asks.

"You're in my apartment. You're safe here. Those thugs can't find you. I'll just call you Greta for now, if that's okay."

She smiles again and Braden is suddenly thankful for driving ten miles an hour when he hit her. Crushing a smile like hers would have set him back more in karma than he could ever possibly repay, not that he ever tries to make up for his misdeeds.

He doesn't hesitate in pursuing his next misdeed, leaning toward those lips from in front of the couch, from the most appealing angle, and stealing a kiss. He doesn't linger. He keeps his eyes locked on hers, ready to draw back as soon as the slightest hint of anger flashes across her amber irises. It never comes, but he pulls away quickly anyway, not willing to press his luck. A face like his usually doesn't find itself against a face like hers. Not that he's ugly. He's just plain. Poorly kept.

He sits on the edge of the couch, his butt close to her thighs. They don't say anything. He's glad his apartment is dark. Piles of laundry look much more mysterious when not revealed by an accusatory sixty-watt glare. There's just as much chance that the shadows hide hundred dollar bills, fancy suits and business cards as they do blank job applications, ten-year-old T-shirts with holes in the armpits and grime encrusted pennies that he used to scrape the scabs off his knees after a drunken fall. In the

darkness there can be no disappointment.

"My head hurts so bad," she whispers.

"I'm sorry you don't know who you are, Greta," he replies.

"Are you sure we're safe?" she asks.

Braden plunges into the murk and comes back with a golf club. He's affixed nails to it with duct tape. "I used to have nightmares about being burglarized," he explains. "That's why I created this. I call it the Face Ripper."

She sits up on the couch and blinks. Every one of her eyelashes is perfectly separated and curled, framing eyes that have never been bloodshot. She's one of them, he realizes, one of the college girls from Uptown. But she seems deeper somehow, like maybe she carries some darkness inside her.

"Why were you on that part of Lake Street, Greta?" he asks.

She squishes her eyes closed, as if trying to force her lids into her brain to shovel out her lost memories. "I don't know!"

The way she looks at him, like she wants to ask everything but can't even remember the right questions, makes him uncomfortable. He doesn't want to tell her about himself. He wants to keep that in the shadows too. Getting a monthly allowance from Mom and working part time at a gas station is nothing to illuminate.

There is one thing he can show her though. He turns on the TV and puts in a disc. The screen flashes an image of a log. Off screen, a chainsaw roars to life.

"I directed this commercial for a local hardware company," he lies. Sort of. His brother directed it. Braden co-directed and came up with the idea.

The chainsaw buzzes onto the screen. Slowly, it cuts into the wood. Instead of sawdust, blood spurts out. The log quivers and screams. The screams are actually Braden's, but he doesn't mention that fact, or the fact that he spent hours practicing to make certain they sounded perfect. Red spatters across the screen, spelling out the name of the store: Gillick's Hardware.

"They refused to pay me for it. They said it was too dark."

Greta grabs Braden by the wrist and pulls him close. After some fumbling, he is inside of her, thrusting so hard it strains his lower back. As her still-bloodstained fingertips run through his little remaining hair, all he can think is that he's going too fast, that he hasn't even licked her nipples. He doesn't kiss his way across her clavicle. He doesn't clasp his hands into hers. All he does is cum. Then he does everything he can to avoid making contact with her gaze, for fear that he will see some hint of disappointment.

He puts his boxer shorts over his head, covering his eyes, and runs for his bedroom.

In the morning, Braden steps anxiously into the living room, only to find a man with a dusty burlap sack over his head. The man snores wildly, draped across the couch where the girl—where Greta—should be. The sound that comes out of Braden is so grating it pulls particles of his esophagus with it, sending them into the dank apartment air and contorting them into some arcane SOS.

Even with the sun ripping through the blinds at full force, the apartment seems dark, and it only gets darker when the man sits up, holds out his calloused hands in a "halt" gesture and says, "Stop screaming! It's me."

"Where's Greta?" Braden asks, trying to remember where he put Face Ripper.

"It's me!" the man says again.

"What?" Braden feels like he's been wedged into the wrong conversation.

"It's me! From last night! The girl you saved from those men! Greta!" As the man utters these words, his voice grows deeper. The nerves under Braden's eyes twitch.

"But you're not her," Braden replies slowly, uncomfortable stating something so obvious as he grabs Face Ripper from the corner. "You're not even a girl!"

"But I am!" the man exclaims, standing up. He is easily a foot taller than Braden.

When the man lifts the burlap sack over his head, Braden wants to beg him to stop, but can't. The shadows from every corner climb onto Braden and weigh him down. They hold his mouth shut. He can't cry out when the man's face is revealed, lipless mouth first. The teeth are perfect, white and even, which makes the grizzled meat around them all the more horrid. A nose hangs like two fingers that have melted together, holes drilled in their tips like nostrils. He has one eye, but three times as many lids, each intent on closing as soon as the next opens. He may have had more face at one point. It looks as if he did, but it has been removed and the wound cauterized.

He lunges forward and grabs Braden's wrists. "Don't you remember?"

Braden forgets about Face Ripper in his hand and lets the man press that mess of a mouth against his. The clicking of incisors against incisors is more than he can bear. Could this be the same person? Is this really Greta? No, that clicking is real. The strength of the hands wrapped around his

wrists is real. But then what about last night? Was that not real? Had he not caressed that lovely mocha skin? Braden pulls away.

"Last night you seemed so eager," the man says, letting Braden go.

"I'm sorry," Braden replies, realizing that his houseguest means no harm. He wonders if he should tell the man about the collision. Would that anger the man? Would that make him leave? Would that peel away the thin layer of pus left on Braden's lips?

The houseguest's snout wiggles from side to side as he unzips his turquoise windbreaker. He sways his hips, dancing to unheard music.

"Wait!" Braden yells.

The houseguest drops his windbreaker. Underneath, he wears a stained white polo shirt. He lifts it up daintily, pinkies extended, revealing a bulging stomach—more bulging than Braden's. The hair radiating from his belly button has been flattened against his skin from sleeping in his clothes. Dried sweat keeps it in place.

Rubbing his gut, he states, "It's yours."

"What?" Braden asks.

"It's yours and it's due soon. You're the only one."

Braden's grip around Face Ripper tightens. He ponders each of the twenty shiny nails taped to the head of the golf club. It's one of the few things he inherited from his dad after the accident. All the rest went to his mom, and she doles it out as needed. He wonders how much doling would need to be done to hire a lawyer. If he kills this man, he could claim self-defense. Unless, when the body hits the ground, the man reverts to Greta, the real Greta, twitching and asking, "Why?"

The knocking on the door comes as a relief. Perhaps a neighbor heard Braden's cries. Perhaps someone will come in and tell Braden what this is standing in front of the couch: gorgeous woman or decayed man. Braden hides Face Ripper behind his back and opens up, ready to formulate the question.

The visitor is ready with an answer before the question is asked.

"That's her!" the lead thug commands his two comrades. Still draped in Lake Street shadows, the man's ebony skin gives way to tired lines beneath his eyes, speckles of gray hair on his chin, the word "Lover" tattooed across his neck in cursive. "Kill this faggot and get that bitch."

Braden swings Face Ripper.

Upon contact with Lover's jutting cheekbone, the weapon does not grab all available meat with its nails and leave a bare skull, as expected. Instead, the nails bend to the side, the duct tape failing when needed the most. Worthless.

"I appreciate that," Lover says as he touches the tiny scratches on his face with thick fingers. "I appreciate the motivation."

Then he lifts his gun and shoots Braden.

Braden crumbles. At first, he thinks he's dead, or at least on the way. Blood pours out at a pretty substantial pace, collecting on the hardwood floor around him. When he realizes that the bullet only grazed his shoulder, he considers climbing to his feet, pressing his gut against the six-pack visible through Lover's tank top and staring the man down. But Braden doesn't do things like that. He drives slowly past Lake and Stevens, winks at the prostitutes and thinks bad thoughts before continuing on to get his bucket of chicken. He never stops. He never does anything more than tickle the shadows. So now he keeps still, hoping the thugs will forget about him.

"How did you find me?" the houseguest asks, voice deep but ringing with fear.

"BIG TUM," Lover says. "Your new friend has a very memorable license plate. I wish I had thanked him, but that doesn't matter. What matters is, your daddy owes me. I gave him so many chances to pay. Does he even care about you?"

"He will pay! I know he will!" the houseguest begs.

"No, he won't, and now I have to do this!"

Braden tightens every muscle in his body to avoid twitching at the sound of bullets finding homes in his houseguest's head, and then in the floorboards. The wailing stops after the very first. That doesn't prevent lead from raining down for another minute, hour, day, year, forever and ever. Braden will never get that downpour out of his head.

When the thugs finish, they step over Braden and leave without a word.

He crawls over to the body, fully expecting to see Greta, as she was last night, except dead. But even in death his houseguest refuses to revert. Not that Braden can tell based on anything above the neck. The man didn't have much head to start with. Now he has none. Braden stares at the pile of shattered bone and brain. The little shards of that one eye and bits of teeth are scattered across the floor like the pieces from a board game. He doesn't actually see any of it. The shadows save him. They creep from beneath the furniture and say, "This is not for your eyes."

What they do reveal, however, is the man's distended stomach, protruding from under the tight polo. Whatever is inside is pushing, ready to come out. Braden puts his hands on cooling skin. "How can I get you out of there?"

Still not sure he believes his eyes, he considers the obvious answer. He slides his hand into the front of the torn jeans, looking for an exit. He recoils at the greasy, flaccid tube his fingers stumble upon. There was something else there last night. He is certain. Now there is not, but this child, or whatever it is, still needs to come out.

What is it? Braden's not sure he wants to know. Maybe it would be better to leave it. Surely it would be an atrocity, like its father. Not Braden. Its other father. Would it have anything of Braden in it? Did that make it worth saving? He spends a long time thinking about it dying in there, in that lump of hairy man flesh, fighting for air and pounding on the walls with tiny, undeveloped fingers.

Then he goes to the kitchen and picks out a knife.

Before he starts cutting, Braden tears down the blinds. He shoves the furniture to the sides of the room, enlisting all available light. The sun massages his shoulders as he presses the blade into the belly button. He makes a series of slices, none more than a millimeter deep. He will spend hours getting through this flesh if it means not digging in so far that he damages the child any further than it's already destined to be.

Sweat forms around the few lingering strands of hair atop his head as he sits cross-legged on the hardwood floor, constantly changing his grip on the knife. Soon he hears cries. They sound like a normal baby, but that provides no relief. It worries him more. Gurgling, spitting, hissing noises. That's what he wants to hear. That would better prepare him for the abomination he is going to see. He does not want to get his hopes up. But he does anyway.

When he finally cuts into the womb, the blood flow gives way to paste-like liquid that oozes out over the stomach. All his accumulated hope disintegrates. This curdled goop is not what should be coming out. Still, he dives into the slit and tries not to think about what he's touching. He suppresses the vision of pulling out a bark-skinned beast with stumps for arms, barfing out the word "Daddy" in toxic blue bubbles. He ignores the urge to reach for Face Ripper.

His hands seem to effortlessly lock onto the body, and he instinctively manipulates them to protect the neck as he withdraws the child with a sound like globs of expired milk spilling into the sink.

The baby's arms slap the air, eager to be free. Braden almost drops it upon first sight.

"This can't be!"

But it is. Braden wipes the white mucus away and inspects the skin color. He counts the fingers. He counts the toes. He counts the eyes.

Twice. No matter how much time he spends gazing over every inch of the newborn's body, letting the sunlight from the windows anoint the new flesh, nothing can change the fact that he now holds a perfect baby boy.

The child's fists clench as he reaches out for Braden, his father.

GLORIA

KIRSTEN ALENE

No birds sing in this part of the forest. There is no sound of rollicking wildlife, no shivering undergrowth. No wind moves the dark leaves of the canopy. No fresh air at all seems to have penetrated this part of the forest and what air has managed to squeeze itself through the heavy branches and graying pine needles is gelatinous and difficult to breathe, stale as it is and reeking of decay.

Laboring with the stagnant atmosphere, his feet disturbing little plumes of tree dust and brittle four-autumns-past leaves, is a man with the pinched expression of a starving jackal and the neck of a sickly, colorless giraffe. The man puzzles over a tree, moves on to a bush, then across a small clearing to another tree. No great light is coming down through the trees, though it is a cloudless day, and his jackal features are only as obvious as the vague, shallow lines of split bark on the beech trees he grazes with anxious fingers.

Years ago, each tree and bush seemed distinctive and unique. The character of the plant life radiated out of each separate needle, forming a pathway from the road where he has parked his decrepit CRV, to the familiar grounds of his youthful wanderings. He is aggravated by the absolute sameness of this once distinct foliage. But he is also relieved. His fierce canine expression slackens and his face returns to its customary calm. Head wavering on his prodigious, pale neck, he puffs out his cheeks and blows a raspberry in the silence.

If any of those cohorts from his youth—the ones who knew, as he once knew, the tight and claustrophobic inches of the forest like the backs of their hands—could seen him now, he would have been a stranger. They would, however, despite the unkind effect of the years that separated them

from him currently, have most definitely recognized his previous jackal-like expression. A look like that is unforgettable.

Fortunately for him, all of those people who might once have been able to identify him, all of those people who knew the forest once, who knew him once, are gone. No one has a chance of navigating the deepness of this forest. No one except Steven.

Tree shadows have followed him as he speeds down the wet highway, cutting a line from the Mackley Park turn-off through a haze of thin rain and a half-hearted fog straight to the bedside of his father-in-law.

"Dennis, she looks up at me every day. She looks up through that moss when I call her. You don't know how cold her eyes are now."

Dennis's father-in-law, Steven, has been cloistered in the Lakewood Valley Assisted Living Facility since the age of twenty-seven. Steven suffers from an intense and debilitating paranoia that surfaced in his youth. His madness culminated in a string of arsons, for which he was arrested. When he admitted to his legal counsel that a sinister man who had been following him forced him to burn the houses, he was deemed incapable of governing himself, and implanted in the home.

Despite this seemingly insurmountable handicap, Steven has dedicated himself to the study of science and natural philosophy. Years ago, Dennis's visits to the private apartment in Lakewood were like free tutelage. Steven's wise and lonely ramblings, interrupted only occasionally by fits of oblique terror and rage, were Dennis's only stimulation in a world now devoid of the rages and terrors he had himself known as a youth.

When true and honest madness began to manifest in Steven it took weeks for Dennis to notice. Now it is difficult to discern any remainder of the former man in a steaming pool of insanity. Only once every few visits does some clairvoyant and beneficent pronouncement make its way past his father-in-law's cracked, trembling lips revealing that a man is sequestered within, as the mad man which houses him is sequestered in the Facility.

Dennis no longer bothers to knock on the apartment door, the stoop of which is overgrown with tangles of morning glory vine and slick with the pulpy remains of twenty or thirty newspapers. Slipping in the

newspaper puddle and cursing the neglectful staff, Dennis shoulders the door open and steps inside. The whole apartment smells of medical supplies and dampness. There is probably mold growing in the walls. Mold abounds here, in this complex, and in the town. Every man-made structure is its sporing ground, every dark place its little chapel. Covering his nose and mouth with the sleeve of his jacket as he passes the filthy, cramped restroom, Dennis walks straight across the bedroom to the window. "Steve, it's so muggy in here, you tell them to open the window when they come." He shoves open the high window which shudders as it moves in its uneven aluminum frame.

His father-in-law lays prostrate on the bed, strapped down beneath soft, beige sheets, breathing heavily into his pillow. Dennis takes a seat near the bed, in a rickety folding chair that has almost grown into the worn carpet. Steven moves his head left and right. The creases in his neck and face stretch into faint lines, then fold back into papery, elephant skin. Outside the window, children scream and laugh. A gunshot rings out far off in the distance, somewhere in the forest near where Dennis recently wandered.

"I didn't want to tell you, Dennis, but I'm in love." Dennis reaches out to hold the withered fingers in their cotton-lined cuff. "I'm in love with her, I have been for years. She comes in here to see me. I never leave, you see. I can't." The hand jerks away at Dennis's touch. The whole bed jumps as the strap pulls at the bed frame. "I'm in love, don't you get it? Can't you comprehend you ignorant, fascist swine. You limaceous endomorph, you zeophyte, you placenta." Steven yells angrily for a moment and is calm. Dennis's eyes unfocus, the whole room is a beige, antiseptic blur. The bed is a raft, the children peering in through the window, holding themselves up by their elbows, are trying to get a good look through boiling waves of brownness. With his eyes squinted up and strained they look like dogs, their jaws slavering, eyes wide and pupil-less. Other gunshots ring out, some closer, some farther up the mountainside. Old men out hunting the coyotes with their sons. Dragging huge, rotten carcasses through the undergrowth to leave the scent of death behind them.

"I went there just yesterday, Dennis," Steven says, suddenly cogent and bright-eyed. He snatches Dennis's hand and grips it tightly. "The nurse who comes here, she's a witch. She leaves my bonds loose so I can slip right out. I think she pities me. She's a whore, too, I've seen her. I followed her to the spot. You know the spot I'm talking about. Right? You know. They all know." The children cackle from the window. Dennis wants to shoo them away, to rise and show them that he is not a corpse, but Steven continues,

"I went there to see her. I owed her that much for never speaking. She was so beautiful. She was so thin. She was so damn cold. I know now why you told me ... something like that can weigh on a man, I know. I know now. Aren't you glad?"

Dennis nods. He is not glad. He does not like those children hearing this revelation, however insane and disjointed it may sound. He rises from the chair but before he can make a movement for the window, they have yelped and retreated. A moment passes and they resume their game out of sight. Another gunshot.

People seem more concerned when a body blossoms in roadside foliage, than when it sinks and fails to resurface. In one version of events, the failure of the body to resurface was proof of her immediate ascension.

In the kitchen, surrounded by his wife's collection of ceramic roosters and a wide expanse of busy rooster-themed wallpaper, Dennis jabs his fork into a potato. He imagines the potato screaming, writhing beneath his powerful incisions.

"Daddy?" Dennis jabs again, prying apart the papery brown skin to reveal the flaky, pulsing flesh beneath. A cloud of steam breaks over his face. "Daddy? Are you okay?"

"Dennis, stop violating that potato and eat your dinner before I take it away." Nothing aggravates Dennis more than when his wife addresses him like a child. She has no business talking like that to him, or to anyone. Gloria is far past needing to be threatened and chastised. Not that she ever needed discipline.

His daughter smiles at him and puts her soft hand on top of his. Dennis's wife clicks her tongue disapprovingly. "What's up?" Gloria says. She is the most beautiful child he has ever seen. At the age of five, they had thought she could never be prettier but she has only grown more stunning in the decade since, her face blossoming around the twin anther of her radiant brown eyes like a real bayou lily. Her beauty is complimented by a single dimple in her left cheek, a square but not masculine chin, a lineless and peach-smooth forehead, and an untamable head of perfect golden curls which are now pinned up in a light cascade by a little silver headband. Now, as is happening with increasing frequency, she looks more like her

namesake than her mother or her father. More like her namesake than any other living being. Dennis's skin twitches involuntarily and his wife snaps, "I mean it, Dennis."

What was the story about the woman intellectual, the succubus who poisoned her husband's second wife with two drops of her corpse cold blood? Did that blood penetrate the fertile womb of the innocent, ignorant female? Was the resultant child angelic or demonic?

Dennis, ignoring his wife's persistent disapproving babble, grips his daughter's hand and pats it lovingly. "Nothing's wrong, sweetheart. I was just thinking about your grandpa." Dennis observes his wife stiffen slightly. She has not seen her father in four years. The last visit was so painful and humiliating that she has refused to continue seeing him. I'd rather, she says, remember him as a real person than a skeleton spewing nonsense and insults to an empty room. She hates that Dennis sees him, hates when Dennis mentions him, most of all she hates when Dennis talks about him in front of Gloria. Her grey eyes grow steely and dark. Gloria smiles sadly and nods, as if she understands. As if her huge, reflective eyes house a vat of sadness.

When Gloria has been installed in her bed and kissed by both her father and mother, Dennis's wife pours a tremendous glass of whiskey and hands it to her husband. "Thanks, Kat."

They sit in the living room in silence, trees outside the large bay window barely illuminated by a sliver of a moon, thick branches unsuccessfully muffling the continued sound of gunshots on the mountainside. "Still hunting?" Kat says in response.

"I guess it's the only way to be sure," Dennis says, heaving himself to his feet to peer out the window into what he knows is just complete darkness. "I was out there today, but I didn't hear anything," he mutters mostly to himself but Kat, nose in her own glass, hears him and snorts.

"You were what?"

"I was out, you know, where we used to go."

"I hope by 'we' you don't think you are referring to myself, Dennis." Hidden by an overwhelming amount of disdain is a hint of fear.

"No, dearest, I was not referring to you."

Among the glassy reflection of roosters, he can just make out the small flashes of light from rifles firing in the dark, separated from their cracking reports by full seconds, two seconds sometimes three.

They almost lived there, out in the woods. Which is foolish. There is more mold there, more rank decay and stagnant water than anywhere else in the town. It is infested. It is filthy.

But to them it felt open and clean.

Boys in masks and costumes flee through the brush, their capes and shoelaces tangling in nettles and blackberry bushes, spores suck down into their lungs as they struggle with the undergrowth while he watches.

In one version of events she is alone in her room at the top of the stairs, looking out into the garden when a moon god with heaving chest and naked limbs slithers out of the hedge and in one swift movement, mounts the rose trellis and knocks on the glass of her window. When she wakes, she leaves with him and never creeps back down the stairs again.

When Dennis wakes next to his wife, his immediate reaction is to recoil. Two huge, intently staring black eyes have replaced her small, watery grey ones which, in the morning, are usually squinted with sleepiness and slightly grumpy. The momentum of his initial recoil sends him out of the bed and onto the floor where he lands, legs tangled into an immovable knot of sheets. His breath comes in short gasps as he fights with his feet, waiting for the alien face to peer over the side of the bed but no face appears, which terrifies him more. After a minute of silent struggle, Kat's familiar groggy face slides into view. She laughs. "Were you awake?" Dennis asks, his heart pounding.

"I am now, geez, what did you do?"

Dennis watches his daughter back the car down the driveway. When she reaches the end he goes to meet her, pulls open the heavy driver's side door and pats her head. "You're getting better."

She looks at him very seriously. "You don't have to worry. Everything will be all right, you'll see."

More gunshots echo faintly through the valley.

Dennis pulls into the parking lot of the town's only bar and sits in his car for a while. Eating breakfast here alone is better than enduring his

wife's moans and wails about the various chores and tasks he has neglected over soggy bacon, dry eggs, and stale toast at home.

"They're really going after the Keye-Oats, huh?" a filthy, plaid-shirted man says at the next booth. His friend stirs a small dish of mayonnaise slowly with a French fry, "'Spose," he responds.

"But then what can they do? It's the only real way to be sure."

His friend grunts and continues stirring the mayonnaise.

"You know what they say when some animal gets a taste for human flesh?"

The friend's blank stare focuses a little and he pulls the fry out of the mayonnaise. He places the fry delicately between his lips and sucks off the mayonnaise before dipping it back into the dish.

"I read some about these tigers in Bombay all ganged up, kilt four hundred people and the natives had to go and call this English hunter name of Laney. He took care of that bitch. Was sick, they said. Something went wrong with it."

The friend grunts again, "Ain't nothing wrong with a Keye-Oat been eatin' babies. In their blood, isn't it. Scavagers."

"You mean scavengers."

"What I said. Nothing wrong."

The first man shakes his head. "You listen here, I'll show you something ain't wrong. You come see what Bill's boy brought in last night. Not no damn Keye-Oat, I can tell you."

The friend drags the fry out of the mayonnaise again and sucks it clean. The fry sags down. He lets it fall onto a plate of untouched chicken fried steak and country potatoes.

"When she rose up, all phantom-like and bleeding out from every orifice as if her death was as fresh as a minute ago, I think I shat myself but then it was calm. I saw her bleeding for what it was and I can tell you, it was nothing dangerous or premonitory. It was like a tribute." Steven lay back on his pillow and sighed deeply. "I can tell you now just how I found her, you'll be interested, I know. She's hidden well, but there are certain distinguishing features along the path. A knotted branch, a fern that's bent and growing up the side of a beech tree, a lot of moss hanging down one side of a boulder, and some beetles rolling dung along a well worn path in the dirt. A circle of mushrooms, a break in the trees where a ray of light shines down and there, she's just sitting there quiet."

Dennis scratches his forehead. He can hear the gunshots better from here. A myriad of companion sounds drift in through the barred window: bird calls, the whoops of hunters, the yelps of dogs grazed by bullets. Once sharper than a Fennec Fox's, Dennis's ears ping only dully with each successive gunshot. He swallows back panic as Steven turns cataract-speckled eyes on him. "They're so far out in the forest, Dennis."

Dennis gulps again, rearranges the chair so he isn't facing Steven and says, "I know."

"No one ever goes that far out into the forest, Dennis."

In one version of events, he watches her soundlessly from the exaggerated afternoon shadow of a lone gas pump as she clambers up the steep sharp steps of a bus clutching a single valise and the bottom of her stomach, thinking she is alone at last, feeling as if she is being watched. Comforted by those invisible eyes like they are the eyes of someone wise and eternal.

It has long been the case that those closest to the wild fear the wild the most. It's like being in a flood zone. Five miles away from the river, the inevitable flooding seems innocuous. The house is on stilts, you have flood insurance and a canoe. All of your valuables are on the second floor. The children know how to swim. You confront the terror of your world being washed in silty river water with preparedness and calm, every six or seven months, by waxing the canoe and sealing things in Ziploc bags.

When you are eleven feet from the river, you confront the inevitable possibility of flood when you wake to hear the waves lapping on the banks, when you are weeding the garden, when you are making lunch in the kitchen watching the rushing spring snow melt edge up the shore, lap over the sides of the levy, trickle onto the driveway.

Flooding seems much more of a threat when the water is visible from your bedroom window.

This is why Dennis lives in the center of town. Although wilderness surrounds him, he can't hear it lapping at the banks as well as he used to.

Gloria stands with a stick in her hand on the top of a pile of rocks

downstream from the elementary school. Her hair is braided high on her head, her cheeks are pink and vaguely freckly. Her eyes are narrowed into a squint.

She is angry with her mother. Her mother doesn't understand her. Her mother doesn't understand anything. Her mother doesn't even understand her father. Her mother seems like not her mother. She kicks a rock into the river. It bounces on the shallow bottom and pops back up before coming to rest in a deep pool where a small fish bolts away from it, scuttling straight out into the current where it is swept up and out of sight. Gloria wants to read in her room. She wants to back the car down the driveway every day and make breakfast before school. She is smart enough to know what her mother means when she says: "Go find a young boy." But she will find a young boy the way other girls find young boys. She will find a young boy for her mother.

Just as she was thinking this thought, a boy wielding a stick similar to her own emerges from the tangle of blackberry bushes on the opposite bank. Her first reaction is to think, "Oh boy, it must hurt to walk through all of those prickly bushes," but this thought is immediately followed by another: "Oh, here we are."

The boy is shirtless and brown, from dirt or sun it is impossible to tell. Gloria waves to him: "Hey, hey!" but he doesn't turn to look at her. He is looking upstream, toward the soccer fields of the school on her side of the river. Another boy emerges from the bushes beside him, wearing a black mask and a cape. Soon a third boy and a fourth have joined the first two, one with a horse mask, the other a plastic axe. Gloria waves again, throws a rock into the bushes, and slides down to the water's edge. "Hey!"

None of the boys turn. Gloria thinks a moment, she examines her clothes, unbuttons her blouse, and hikes her pink denim skirt all the way up to her rib cage. There we go, she thinks. "Hey!" They stare blankly in the direction of the soccer fields. Gloria can't see what they are staring at from down on the bank, but she doesn't think she can climb all the way back up. Instead she takes off her shoes and wades out into the water, which is freezing. Feet numbed, she steps out farther. The bottom of the river is soft and slippery. Her left foot slides down one rock and lands with a crack on another. A little translucent cloud of blood blossoms up into the water and is swept off by the current until only a small red thread of fluid trickles out of her heel. It doesn't hurt, so she continues on. The number of boys has grown while she was struggling across the river. There are seven now on the opposite bank. They are watching her. One of them is laughing, but the rest look sympathetic. She scowls at them and clambers up the steep

opposite bank, clutching at blackberry bushes to drag herself up.

A boy with dog ears and a fake plastic nose bends down and offers her a hand. He hoists her up through the blackberries, which drag at her clothes and the skin of her legs. It feels like a bad sunburn. Then before the dog boy has put her on her feet, they take off running in a pack. Gloria is not her PE teacher's favorite student for nothing, though, and she sprints after them.

He is glad when the sounds of gunshots and stomping boots do not penetrate into the heart of the forest. He feels waves of pressure standing in the claustrophobic silence as panic and frustration swell in his chest. He will never find it, which is distressing. No one will ever find it, which is comforting. His father-in-law has already found it, which is . . . impossible.

The road is slicker than usual. Dennis can feel the wheels slipping beneath him, no traction on the turns. And he keeps seeing bright yellow eyes in the foliage at the side of the road. It is unnerving. They are everywhere, like they say. Maybe those men are right to be out here shooting them. There is obviously some sort of infestation.

Ten miles from the Mackley Park turn-off, he rolls down the window and slows to a crawl. Rain is pinging off the glass and the hood, sizzling slightly as it hits the hot metal. He strains his ears to hear beyond the engine and the tinny sound of rain. A thunderous howling echoes off the sides of the mountain. Thousands of them, still. It is getting dark.

In one version of events, he kills her in the forest, leaving her ripe and swelling body naked in the crook of a tree, legs spread to birth into the shadowed and featureless forest an endless series of plagues and pestilences.

Gloria realizes she is falling behind. Her slashed heel starts to sting. Her thorn-whipped legs and arms burn, her sweaty face is beet red and puffy from panting for breath as they bolt up through hills so steep they have to climb on all fours to stay upright. She can still see Dog Ears in the distance,

his bare feet kicking up sticks, moss and dirt as he hops through the trees. She is on her knees, one elbow on the ground. Her mother is probably worried; her father will be getting home soon. It seems like a good idea to turn back and it is obvious at this point that she will not be getting any action from these fellows.

Someone at the front stops and turns around. It is Horse Mask. He might be looking at her, although it is hard to tell where his eyes are pointing underneath the mask. She stands up. "I'm leaving, this isn't fun." She turns, hoping to make a dramatic exit, but she slips on the hill and skids down several yards on her back. A sound of murmuring grows louder as Dog Ears and another boy clamber after her, sliding through the leaves like snakes.

They grab her arms, one under each elbow, and hoist her up between them. At this distance, they seem much smaller than they did and she is embarrassed. She tries to pull down her skirt a little, to cover her muddy thighs but they are gripping her too tightly and she cannot get her arms free. She writhes and struggles but their small hands are vice-grips, tightening like Chinese finger traps as she struggles.

"Your daughter is at Amelia's for the weekend," Kim says without turning as Dennis enters the kitchen. Something unidentifiable is boiling on the stovetop, a sort of greenish paste. Dennis peers into the pot for as long as he can stand before hoisting himself up onto the counter.

"Don't sit on the counter, Dennis," his wife snaps. He slides off. There is a moment of silence then she says, "If it wasn't just down the street, I'd . . ." she shakes her head. Kim spends most of her life shaking her head. "I spent all day at Michael and Karen's and you won't believe what the boys have been dragging in off the mountain."

Dennis grunts, picks at the lip of the counter.

"Don't pick at that." Dennis curls his fingers into his palm. "Those animals are so thick up there you can shoot blind and kill twenty. That's what they're saying." Dennis scoffs.

His wife scowls, seems disappointed.

Dennis reaches out a hand to touch her shoulder and she whips it away, splattering the wall with green goop from the stove. "Damn it!"

His wife's face mutates once again into the black-eyed, pupil-less mask he has seen before. And he knows what is going on.

They are climbing up. The hill steepens under their feet. Gloria's white tennis shoes are streaked with sap and mud. Young boys float effortlessly over the wasting pine needles around her, ducking in and out of sight, a constantly shifting swarm of masked faces and torn clothing. As they climb they become more ghoulish. They become whiter as darkness drops down over the mountain. Gunshots crack in Gloria's ears. Up ahead a glimmer of light like a hearth fire.

Dennis picks his way through the foot-deep pulp of decayed newspapers like a gazelle. The door, slick and wet, stands slightly ajar and he pushes it open, wondering if one of the nurses is changing the sheets, dreading the sight of pale grey slacks stretched to amazing proportions by the giant backside of an old nurse. His father-in-law is in love with one of the nurses. Dennis can never remember which one. The man has loved her from the first day. Until the madness set in, she was his one obsession. A voice murmurs in the bedroom as Dennis turns the corner and steps over the carpet sticky and stiff with dried urine and mildew. But when Dennis nudges the door open with the tip of one finger no one is in the room.

"You take her by the hand and lead her to the woods. You take her to the place you knew you all would go. You lie her down and worship her. You take her by the hand and lead her there," the voice whispers

Dennis's feet seem locked to the floor. He tries to move, to run, to look around but all he can do is stiffen more. He has lost control of all his muscles. He nearly shits himself before his weakened ears finally hone in on the source of the sound and his feet carry him, breathless, to the window. Under the sill, in the cool sand beside the apartment wall, a small boy with half a Barbie and half a bologna sandwich sits whispering to the sandwich. The Barbie's butt has been shaved off, a pen puncture through one eye. As Dennis watches from the empty bedroom of his father-in-law, the boy stabs the Barbie with a penknife and whirls around to stare at Dennis.

He hisses like a cat through the false plastic beak of a blackbird. Then he runs, leaving the sandwich and the Barbie behind.

"Dad?"

"There's a place, son, out back of these woods, far past the other side of this mountain, all the way south. As south as south goes, all downhill, all clear and washed out by fire underneath the trees. In that place a flower grows that'll only bloom when it gets a breath of fire. The seeds lie dormant until the winds bring the scent of flame and then they start to grow up up up. The seven plagues all come from the bloated belly of one pregnant bitch, son, and that bitch is the earth. The hellish blossom comes and it sweeps across the ground like its own wave of wildfire. Devouring everything that remains. Then in the night its seeds drop into the lush bed of its smothering leaves and they grow swaddled in the warm organic heat of their mother. And when they're big enough, they come for you. They come for you so hard."

Kim's eyes dart from fire to fire, unfocused, looking through the reflection, almost opaque with roosters crowding the furniture in the living room. Her dining room expands into the night, it stretches out parallel to the house, all the way to the mountain where sparks ignite and die, ignite and die. Her child is safe in the kitchen of another mother. Kim imagines her child in the fires, in the night in a vision so vivid and pure that it might be clairvoyance. She gasps and smiles. She chuckles to herself.

Dennis is speeding up the mountain in pursuit of his ancient and demented father-in-law when a blue heron swoops low in front of his windshield. The antennae of the car nicks the bird's tremendous wing and it crumples mid-flight, into a diminished heap on the side of the highway. Dennis slams on his brakes and backs up. He watches in the rear-view mirror as the bird is smothered in the blackness of night. Then the night around the bird shimmers and the blue heron is covered in blackbirds.

"Where are you my good, sweet girl? Where are you? You led me to your home so many nights, so many nights I followed you while you dreamt and

now where are you? My feet are old, I only have a minute and I'm so cold now. Come on and find me, lead me where you know we all must go."

The boys are skeletons now. Skeletons in plastic masks and overalls so grave-tattered they could be ancient sail cloth or loose thread. They shudder with rasping breath after rasping breath, into the empty body cavity, out of the muscle-less larynx, into the empty body cavity.

"Children..."

Gloria shivers in her pink denim skirt and modest cotton bra. Her hair has become the home of four beetles and a white moth, which has mistaken her shimmering golden strands for the winding beams of the moon. The skeleton boys throw her down before a woman who looks very familiar. The woman is breathing through her teeth and alternately gasping and moaning as if in the middle of amazing and invisible intercourse. Beside her is a backpack filled with fruit so molded and mushy that it is only distinguishable by the overpowering smell and a swarm of flies that surround it.

"Children..."

Gloria recognizes the woman. She knows the woman.

Gloria throws up suddenly. Her vomit is warm and pink. The woman is Gloria. Gloria is hugely pregnant, her mouth wet and black. She is tied to the base of a tree with a bungee cord that has cut through the fat of her belly to the muscle beneath. The wound is festering.

Gloria's legs are spread wide and something is crowning. Gloria is staring as something red, vein-speckled and hot steams out of Gloria.

Gloria is screaming. The skeleton boys are rasping skeleton laughter.

The thing crowning is blacker than the night.

When the blackbirds clear, the heron is a collection of small, hollow bones and a single black eye more doleful and sad than any eye still socketed.

"Dad!" Dennis cries into the forest. "Dad! Steve! Steven!" He struggles to listen but the sound of repeated gunfire is almost deafening. Gunfire and howling.

"You have been giving birth for so long, my sweet child. You have been growing them up inside you for a thousand years. Finally, here they come." Steven rubs his graying hands together, trying to feel the creases and the knuckles again but all he feels is like a few soft mittens, formless and textureless. She is not answering. She is not calling back to him when he calls out. Only coyotes are calling back. He pauses. He thinks. Of course. Only the coyotes are calling back. He sprints into the underbrush toward the howling.

When her grandfather appears beside her, Gloria is alone with Gloria. Gloria is heaving and panting again. The skeletons have all lain down around her like suckling piglets. They slowly rub their small plastic faces up and down her round hot belly.

He kneels but Gloria is too afraid to look at him and then the crowning head rips through the cervix in a shower of afterbirth. It is a blackbird and it is followed by another. And another. And another.

Dennis sits on the curb at the entrance to the Mackley Park trail. A man and his two sons are dragging an animal the size of a moose across the parking lot. The hide is completely stripped away. It paints a red carpet to their jeep. They heave the creature onto the roof with a system of levers and pulleys already in place and drive off, blood and tissue careening off the back of the Jeep, taken up by the wind and scattered back into the woods where eyes and tongues examine it closely.

The carpet of blood stretches up into the forest, blanketing the path that the body has cleared in the undergrowth.

"Find yourself a man, Gloria, find yourself a nice young boy to occupy your time. Put on that short skirt and get the hell out of the house."

A swarm of blackbirds bursts from Gloria as Steven and Gloria watch. Gloria is stiller than stone and as cold as a corpse. Steven is kneeling, arms

outstretched before the swarm when Gloria stands, silhouetted, almost naked and pale before the snowstorm of black feathers. And her father is coming through the trees quite suddenly. He is running, loping up the hill like a jackal on thin legs, his face the menacing grimace Gloria sees in her nightmares. He is clutching a kitchen knife in one hand, a rope in the other.

He says nothing as he deftly plunges the kitchen knife between the ribs of Gloria. When she falls, the scene her body obscured is visible in the half-light. Steven kneels. Gloria is black-lipped, birthing a horde of blackbirds, which speed up, out of the womb, into a tornado in the sky ripping through the forest canopy. Coyotes are scattering. All beasts are scattering in the dimness.

Dennis kneels near his daughter and cradles her head as Steven sings and cries and the blackbirds twirl past them, straight up into the sky.

HOT DOG (BRING PROTECTION)

KEVIN SAMPSELL

Paul was sitting inside a toilet stall in the hospital bathroom. He took out the piece of paper in his shirt pocket and looked at it again. It said: *8pm—room 352—bring protection*. He looked up and saw a man peeking through the space above the door latch. The man's head jerked away quickly, then Paul heard the man take two steps away. Paul looked at the note again and put it away. He unrolled some toilet paper and stood up. As he reached his hand back he looked up and saw another man watching him from over the neighboring stall. This man did not move though, instead he rolled his eyes back and barked some approving sounds. Paul finished up and left the bathroom swiftly.

 He was tired. He had just worked a ten-hour day, then stopped at the hospital to pay a bill he could not afford. He was discussing his bill with his doctor and a nurse, but they were failing to agree on a payment plan. Finally, the doctor and nurse gave each other a strange look and scuttled away to an office. A few minutes later, they came back with the note, which was written on a country club stationary. *8pm—room 352—bring protection*.

 Paul was just stepping outside when it started to rain. He pushed his sleeve up and looked at his watch. 6:10pm. He was about an hour, taxi-time, from home. Downtown was only a few blocks away, so he decided to kill time there instead. He started walking in the rain.

 "Spare some change?" a voice asked from an alleyway as Paul passed. Paul stopped and looked to his side.

 "How many dead presidents you have in yo' wallet?" the voice said this time.

HOT DOG (BRING PROTECTION)

Paul was about to step away from the alley and keep walking when a huge spangled sombrero hat emerged from the darkness. The man in the hat looked up at Paul and showed his face. It was a young white man with a thin magic marker moustache, a vertical scar under his left eye, sparkling blue pupils, and yellow rotted teeth.

"I'm sorry, I can't help you," said Paul, trying to walk away. The young man stepped in his path. Paul tried to go around the other way, but the man side-stepped in front of him again. The man took off his sombrero and let a hiss out of his clenched teeth. Paul got away and walked down the wet sidewalk quickly.

"Fuck you gringo!" the man said to Paul's back.

There was lightning flashing in the sky now and thunder booming from a distance. Paul ducked into a nearby coffee shop/book store for shelter. He did not read much, but when he did, it was usually dusty classics like Hugo, Dostoyevsky, or Steinbeck. He decided to look at magazines. He picked up a *Vanity Fair* and a *Penthouse*.

Walking into the coffee shop part of the store he noticed a scruffy-looking boy of about ten who was reading a biography about Joseph Merrick, the "Elephant Man." The boy seemed to be outlining a section of the book with a highlighter pen. Paul ordered a coffee and sat down.

Paul started thumbing through the *Penthouse* when the boy got up from his table noisily and walked over. The boy tossed his book in Paul's lap and sat down next to him.

Paul was somewhat intimidated and without a word picked up the book and read the excerpt, which the boy had highlighted. The boy grabbed the *Penthouse* and started looking at the pictures. Paul felt uneasy and got up to leave. He noticed that there was nobody else in the cafe.

"Do ya' wanna buy a hot dog?" the boy asked.

Paul looked around but did not see a hot dog stand or hot dogs on the cafe menu board. "Excuse me?" said Paul, thinking he misunderstood what the boy said.

"A hot dog, a juicy wiener, a six-incher," the boy said with a wet smile and a wink.

"I'm afraid I don't have any money for you if that's what you want," said Paul, a bit agitated, a bit worried.

The boy grabbed Paul's crotch and shuffled his balls like a deck of cards. "Sometimes I do it for other things too, sir," the boy said, looking around.

Paul slapped the boy's hand away, pushed him into the magazine stand, and ran out the exit. A gray-haired man was sitting on the sidewalk

without shoes and his pant legs rolled up to his knees. It was still raining. "How was the hot dog?" he asked and howled a cold choke of a laugh into the dark sky. Paul ran away fast until the laughing faded behind him. After four blocks, he was out of breath and his heart felt like it was beating double-time. It had stopped raining momentarily and Paul leaned over, gasping at the sidewalk. His knees were trembling, trying to support his aching body.

A short, balding man and a tall beautiful hippie girl with long, dark hair, walked by holding hands. The man was holding a three-gallon bucket of thick red liquid in his other hand. They were singing the words to a country song to each other. Paul passed out. The man and the hippie girl ignored him and kept walking, obviously in love.

When Paul came to, he looked at his watch. It was 8:05 and he was three blocks from the hospital. He would be a little late. He turned himself in the right direction and began quickly walking.

As Paul opened the door to the hospital lobby it started raining again. He stepped into the front office and felt something perk up inside him—a small victory, his heartbeat returning to normalcy. There seemed to be no one on duty at the front desk. Paul pulled out the note again. *8pm—room 352—bring protection.*

Damn, he thought, *I forgot to bring protection*. But then again, he had no idea what was meant on the note by that last part: *bring protection*. Paul rang the little bell a few times before deciding to find an elevator and go to the third floor himself.

Paul found the elevators and got in one. When the doors opened he noticed that there was an empty hospital bed in the elevator. When the doors closed he noticed a woman's body in the corner of the smelly shaft. It was crumpled up with her legs sticking out like a rag doll. Paul did not know if she was alive or not. He leaned down to hear if she was breathing but the elevator doors opened on the third floor and he got out instead.

Paul looked around for a nurse or doctor. He couldn't find anyone to tell them about the woman in the elevator. He looked at the map on the wall and located room 352.

As he walked down the hallway he noticed an unusual silence. Maybe there weren't any patients on this floor, he thought. A muffled, pounding sound like heavy metal music seemed to blast suddenly from one of the rooms. Paul followed the sound and discovered it was coming from room 352. He listened closely to the door and heard what sounded like someone banging a hammer against a cookie sheet. He knocked. There was no answer, yet the banging continued. Paul turned the knob and

slowly opened the door.

The first thing that Paul saw was the nurse, nearly falling off a metal chair with her head tilted back to the light bulb and her mouth gaping open. There was a hypodermic needle swaying back and forth from her lower leg. Paul accidentally knocked over a bottle of beer that shattered on the floor. The doctor, who was banging his head into a locker, turned suddenly. He was wearing a hockey mask and blood was dripping from his chin. He craned his neck to look over Paul's shoulder, making sure no one was with him. He took off his mask quickly and looked at his watch for a long time. He let his watch fall off his boney wrist and slowly looked up to greet Paul with condescending eyes.

"Paul," he said, shaking his head back and forth. "Paul, Paul, Paul. . ." He approached Paul with open arms. His mouth opened and a song came out.

NUBS

JEREMY C. SHIPP

The Little Neighbor Girl has a special knock that's all her own. First she taps softly on the door, three times. Then she waits for about five seconds. Then she pounds on the door once.

Today, George is sitting on his lime green recliner staring at the red curtains of his doll room when he hears the three gentle taps. Following these taps, his neck tenses up. He feels sick to his stomach. What if five seconds go by and nothing happens? What if the person on the other side of the door isn't the Little Neighbor Girl at all? George doesn't know what sort of person would tap three times and then refuse to break the silence that follows. George would not want to meet such a person.

Surely five seconds have passed already. He glances at his watch, although he doesn't know when the five seconds started.

BANG. George jumps and smiles. He opens the door. This afternoon, the Little Neighbor Girl is wearing an enormous Christmas sweater that was probably meant for a three hundred pound man. For Santa, perhaps.

"Hello, Joe," she says.

Her hand pokes out of her sleeve, but as soon as George reaches out to shake hands, her flesh disappears again. She giggles.

"Would you like a cookie?" George says.

Without answering, the girl follows George into the kitchen.

He hands her the Fig Newton and she devours the thing in two bites, as always.

"Thank you, Hugh," she says.

George grins.

Next, he leads the girl into the bedroom. This room used to consist of a queen size bed, two night tables, two dressers and other pieces of furniture.

Now, the bedroom is nothing but two small mattresses pressed up against the wall. Next to Alice's mattress is a hideous shell-shaped lamp and a stack of yellowing romance novels. George still feels a tingling of guilt every time he walks into this room. He knows that Alice would rather have things the way they used to be, with the dresser and whatnot. But George can't go back. Not now, and not ever. The only way to travel is forward. And that means that the bedroom will continue to shrink as his doll room grows. Someday, the bedroom will be swallowed whole, and the red curtains that make up the walls of his doll room will caress the plaster walls with their many folds. George's heart pounds just thinking about this.

With a smile on his face, George reaches out and tries to find the break in the curtain. He can never quite remember exactly where the separation lies.

Finally, he passes through the curtain with the Little Neighbor Girl close behind. He stands with his arms crossed, gazing at his collection. They gaze back at him.

"Remember," George says. "Don't touch them."

"What will happen if I touch them?" the girl says.

"Nothing. But if you touch them, I won't let you come back."

The girl sits cross-legged on the floor. She stares at the dolls, and George sees twinkles in her eyes. He knows that's looking beyond the paper, wax, wood, china, plastic, vinyl, bisque. She's seeing these dolls for what they truly are.

"My dad makes ships inside of bottles," the girl says. "I'm not allowed to touch the bottles, ever."

George nods. "I'm sure he has his reasons."

"He finished the Santa Maria and now he's working on the Mississippi Queen."

"That's nice."

The girl scoots her body forward, toward the left side of the room. The left side is where the smaller dolls live. But George prefers to focus his attention on the right side of the room. His tastes have changed over the years, and these days he rarely buys anyone shorter than three feet tall.

For fear of neglecting his guest, George turns away from the right side of the room. He doesn't want to lose himself in a daydream. "How was school today?"

"Just fine, Clementine."

"Would you care to elaborate on that?"

"What?"

"What did you learn today?"

The girl moves her arm around like a fish. "Shark babies eat their own brothers and sisters."

"Who told you that?"

"It's true."

George sighs, and out of the corner of his eye, he sees yellowish pus streaming from the button eyes of his first rag doll. Within moments, a putrefying stench saturates the room. What disturbs George the most is that the pus doesn't shock or unsettle him in the least. All his dolls could be crying blood and his feelings for them wouldn't change.

"I like your dress," the little girl says.

"Thank you," one of the dolls says, and steps forward from the rest of the collection. But she's not a doll, is she? She's Alice, wearing a puffy blue dress that George doesn't recognize.

"Honey," George says. "I didn't notice you there."

Alice touches the Little Neighbor Girl on the top of her head, then flows from the room without another word.

"Can I have one more cookie?" the girl says.

"One more," George says.

After the girl finishes her cookie, George glances at his watch. "It's about that time, isn't it? We don't want your dad worrying about you."

The girl's hand appears from her red and green sleeve. This time, George manages to grasp her fingers before they disappear. He shakes her hand.

"See you later, Mr. Gator."

George grins and then she's gone.

The Little Neighbor Girl visits him every day, but he doubts that she'll return tomorrow. He always doubts this.

At the dinner table, George joins his wife for coffee and blackened salmon. The salmon smells a little like the pus from the doll, but he's probably just imagining this.

Alice takes a bite of her salmon, which crunches in her mouth. "I talked with Laura today. She gave me the name of her surgeon. Laura says he's the best in the business."

"Which Laura?" George says.

"My sister. Who do you think?"

"Your sister is a lunatic. I wouldn't trust a word she told you."

"That's my sister you're talking about."

"I know."

"Anyway, I'm going to need ten thousand dollars for this procedure."

"What procedure?"

"Don't you talk to me in that tone. You spent more than ten thousand

on your newest doll. I look at our bank statements, you know."

"Fine. Ten thousand is fine."

Alice crunches her salmon.

BING BONG. George jumps and smiles. He races to the front door.

Suddenly, everything's happening so fast. In a blur of motion and sound, George talks to the delivery men and signs the clipboard and helps direct the men as they wheel in the casket.

After the delivery men leave, George retrieves his crowbar from the garage. He approaches the casket. He knows he's grinning like an idiot right about now, but he doesn't care.

"Remember what the doctor said," Alice says, behind him. "You can't remain in an anticipatory state for more than five minutes."

"That was only a suggestion," George says.

"It was an order. You don't want to have another heart attack."

George sighs. "Fine."

Alice reaches in the pocket of her white apron and pulls out a stop watch. "Five minutes. Go."

George faces the casket and presses the tip of the crowbar into the tight gap between the wood. His heart pounds and he can feel his back sweating. More than anything, he wants to rip open this coffin. But at the same time, he wants this moment to last forever. If he could choose any moment to die in, this would be that moment.

But George doesn't die. He remains frozen, with his eyes on the closed casket and his hands squeezing the metal rod.

Finally, Alice says, "That's enough. Open it."

George opens the casket and what he finds resting within is the most beautiful doll he's ever seen. Instantly, he knows that her name is Nora.

"She looks real," Alice says. She actually sounds impressed for once.

"She's state-of-the-art," George says. "Silicone-based. She's Japanese."

"She doesn't look Japanese."

"Well, she was built in Japan, but she's of European descent. Will you help me carry her to the room? Alice?"

George turns around, but Alice is already gone.

Instead of taking Nora to her room, George decides to drag her into the bathroom. He manages to heave her into the tub. Soon, he's gently stroking her skin with room-temperature water and mild soap. Once he finishes the sponge bath, he drags her into the doll room, where she takes her place on the right side of his collection. He doesn't know Nora very well yet, but she's already his prized possession. He caresses her cheek.

"Goodnight," he says, to all of his collection, but mostly to Nora.

After he exits the doll room, he settles down on his mattress, coat and all. He can't remember the last time he changed into his pajamas for bed. And he can't remember why he ever changed his clothing at all.

Gooseflesh forms on George's back. When he turns away from the bedroom wall, he finds Alice standing over him. She's still wearing the puffy blue dress and the white apron.

"Scoot over," she says.

"Why?" George says.

"I'm sleeping with you tonight."

"There isn't enough room."

"We'll make room."

"Honey, there's not enough room. You know that."

Alice stares at George with emotionless eyes. Finally, she turns away and approaches her own mattress.

"Spider!" she says.

BANG. George jumps as Alice stomps on the spider.

But now the spider is no longer a spider. Now it's nothing but a splotch of yellowish pus.

"Poor thing," Alice says. She kneels by the pus and weeps. "Poor thing. Poor thing."

George sighs. "If you feel that way, why did you kill it? Why didn't you just catch it and put it outside?"

His wife glares at him, a look of disgust mutating her face. "Why would I set it free? Spiders are vermin."

Alice continues to cry. And as George drifts to sleep, a petrifying stench tunnels into his nostrils.

Tap, tap, tap. Following these taps, George's neck tenses up and he feels sick to his stomach. He waits for the BANG. He waits five minutes. Ten minutes. An eternity.

Finally, he creeps to the front door and looks through the peephole. On the other side, there's a bearded man who must weigh at least three hundred pounds. Santa, perhaps.

"Aren't you going to answer it?" Alice says.

George jumps, because he hasn't seen his wife for days. He assumed that she was gone forever. She took her toothbrush and everything.

He glances around, but he can't see Alice anywhere. Maybe he was just hearing things.

Instead of answering the door, he tiptoes into the doll room. He moves to the right side of the room, and admires his collection. Nora, especially.

"Are you ready for your sponge bath?" George says.

"Yes," one of the dolls says, and steps forward from the rest of the collection. But she's not a doll, is she? She's Alice, wearing the puffy blue dress and the white apron. Her hair is yellow yarn, and she has nubs for hands. Her face is white as a ghost.

"Honey," George says. "What . . . what happened to you?"

Alice grins. "I'm finally finished."

"How are you going to feed yourself with hands like that?"

"That's nothing to worry about."

"Why did you do this?"

Alice wraps her arms around him, but he backs away from her. All of the strength drains from his legs, and he collapses to the ground. His chest feels so tight. On hands and knees, he crawls over to Nora.

He grasps the doll's arm and forces her to slap his face, again and again.

BANG BANG BANG. The slaps hurt, but he deserves worse. He should have taken better care of Alice.

"Stop that, George," Alice says. "You're making a fool of yourself."

George doesn't release his grip on Nora until her mouth opens. Her mouth opens wider than any mouth ever should. He backs away from her and clutches at his chest. At this point, he realizes that all of his dolls are opening their mouths as well. In an anticipatory state, he waits for his dolls to speak, but they remain silent. In their mouths, he sees only darkness.

"What do you want?" he says.

Without warning, a man forces himself through the separation in the curtains. He's the three hundred pound man with the long white beard. The Santa Man grabs Nora and drags her away. The doll flails her arms and legs wildly, but the man is just too strong. George can't find the strength to move.

"Stop him, honey!" George says.

Alice laughs. "How am I supposed to fight him without proper hands?"

Before exiting the room, the Santa Man stops and looks George in the eyes. George almost expects the man to say, "See you later, Mr. Gator," but he doesn't say anything. He just turns away and leaves.

And George curls up on the floor. Sitting cross-legged beside him, Alice caresses his cheek with her nub. She sniffles. Tears of yellowish pus stream from her button eyes and land on George's face.

"Poor thing," she says. "Poor thing."

OUTLIER

JODY SOLLAZZO

Barbra was in high school now, or so they told her, but she felt like she should be much older, or younger. The high school was a big, bright open building. White light streamed into the windows from an unseen source high above. The light was always shining on the tall evergreen trees and the lush green lawns. It was everywhere at all times. The only way to escape the light was to walk right through.

Barbra was very good at it, being in high school. She knew how to buy the right clothes. She knew how to wax her legs, eyebrows and lip every thirty-eight days so no one would ever see an unwanted hair.

Barbra had the right best friend, volunteered at the old folks' home, and was nice to the special ed kids, like Plane Cheese Nathan, who only talked about different kinds of planes, and liked to hide cheese in the desks and locker vents to eat later. Sometimes she wasn't sure she really liked anyone, but she smiled.

Smiling was very important. All other things hinged on smiling. When she smiled no one bothered her. Occasionally someone would say she looked sad and that meant she had to work harder to get the smile into her eyes. She supposed this was how life was always going to be. Then the elf-man came and everything changed. He wasn't the cute kind of elf-man, the kind that was stout and smiley and decorated lawns. He was the hollow, sharp-faced, tall kind that haunted forests.

She first saw him when she was walking to school. He was lurking around the green trees, following her. He stuck out like an ink stain on Barbra's desk or a dark hair on her leg.

A few days after the elf-man began following her, Barbra flipped open her homework pad and came across a note written in jagged scrawl, penned

hard enough to tear through the next three pages:

REMEMBER THE SWAMP!
Sexy Sadie what have you done? I need you. Please come and save everyone.

She didn't know what that meant at all. There was no swamp nearby; only a lake. She didn't know how the elf-man got to her notebook, she always had it with her, but she knew it was him.

The next day Barbra was walking to school in her blue pleated skirt and her white, high-necked, sleeveless Victorian blouse. She was walking with her best friend Laura, who liked to copy her outfits, when she saw the elf-man waiting in the high school parking lot. This was the closest she'd ever been to him. He was leaning against a blue convertible. He had dark, slicked-back hair. He wore a white t-shirt, dark blue jeans, and black and white saddle shoes. Old blues music emanated from the blue convertible. A gruff man's voice yelling about the world and men. The elf-man wasn't as tall or as old as Barbra had first thought.

"Did we get a new senior?" Laura asked.

"I'm sure we didn't," Barbra said, "Someone like him wouldn't go here."

"Someone like what? I think he's cute. You, Barbra, just don't like to date anyone without a letter on his jacket. Look! He's looking at me."

Laura twirled in the sun as the elf-man looked at Barbra and the man on his radio Ho'ed and Ha'ed. "You're going to get yourself killed one day," Barbra said.

Plane Cheese Nathan was having some kind of fit. This happened often, usually when someone took his cheese away. When this happened they brought him into the special ed room and that's what they were doing when Barbra shouted, "Don't let them take you into the back room! I know what you're doing. Where's Tiffany?"

"Stealth aircrafts are vulnerable to detection during, and immediately after, using their weaponry!" Plane Cheese Nathan shouted back.

The principal asked Barbra what she meant, over and over. Sunlight was

blinding her. Barbra had to pretend she was going to cry. Barbra's father came and repeated the question, "Who is Tiffany?"

That night Barbra was so afraid. She knew that the elf-man was out on her parents' great green lawn. She couldn't stand the fear and couldn't think of how to end it except to face it, and him. So, she climbed out of her window, as she did in her dreams, when she drank and danced and kissed Laura.

He was waiting for her like she knew he would be. He grabbed her by the arms and pushed his mouth against her ear. He said, "They got you twisted 'round good but I know you're in there." He said this in an English accent, but Barbra knew he was from a place much, much farther away. It wasn't until he threw her in his car that her body seemed to start working. She scrambled to get out and he grabbed her again. She screamed as he held her down. He laughed. It was a wild laugh, and then he crooned:

> Everything you do is right
> Everything I do is true
> Bluebell to hell

Well, fuck! Blue felt a little dizzy and it wasn't from fighting like some stupid suburban skank. Sadie! Sadie was here, on top of her. There was so much to do. It all flooded Blue's mind like an ice bath and the shock of it made her laugh.

"Bluebell?" Sadie asked—in his British accent—but he sounded different.

"Sade?" Blue asked.

He sounded hoarse, like they had made him scream all night again. Like they reminded him that he possessed an extra hole between his legs he didn't want. But, then Blue saw Sadie's jaw stick out, her eyes fiery; Sadie was determined.

"I've been working, doing everything you said, but it—" Blue kissed Sadie before he could finish. She knew she had to run again out of all this sun and green and plastic, but for now she only cared about Sadie's lips like before. Sadie's lips were worth hours of pain.

"Oh, Sadie!"

"It's Sebastian now. Call me Sebastian. I haven't thought of a good surname yet."

Sadie's forehead was so furrowed Blue could get lost in the black of it. She touched him in between his legs and inside of him. She touched him until she got lost in the bigger blackness of his open mouth.

When the other car hit Hale's, he spun out and gripped the blond ponytail of his wife's lover. There was a drop of blood where Hale had cut off the hair.

The ponytail was the only thing Hale had gotten for himself in a very long time. When he was young he had relied a lot on his quiet charm and his ability to listen to people. Despite being a bit rat-like, with large eyes and a long flat nose, pretty young starlets loved Hale for this ability to focus on them. Now Hale focused on not losing his grip on the ponytail as the car spun.

He wasn't going to die. Not yet. He had been dreaming of his death for seven years. He would die, tied to a chair, in a black and white room. Hale understands things in the dream. He knows The Doctor is Evil. He knows the changing girl with her stiffly moving beautiful face is Good. In the dream it all makes sense.

Waking life was more difficult. It was in waking life that the dream paralyzed him and his wife froze his credit cards. Drinking had soured his charm; it was hard to get work on a film set now.

Hale crawled from the ruins of his Mustang. He limped over to the other car. Money was fluttering along the asphalt. He searched the rest of the wreck. In what was left of the back seat he found a black bag filled with money beside half of the driver's head. He slid the bag carefully through the broken window. There was about two grand in the bag, and a note:

B&W Lodge. Dr. Garbles. 2Mil upon complete.

Hale touched his head and saw blood on his fingers. It was time to face his fears. He had to prove The Doctor didn't exist. Or he had to prove he did and die, or live. Or Hale could kill him and somehow get two million dollars. Either way he would be free. He wanted to see The Shifting Girl.

"Diane says you are an outlier," said a girl carrying a pink sock ball.

The Sock Girl, now standing at Hale's table, had black stringy hair and

large eyes. She had bruises on her arms. She wore a gray T-shirt that was too small and her pointed nipples showed through. Before Hale could respond she walked back to her friends.

The lounge had a closed-down bar, bad waxpaper lighting, cheap leave-out food and a spinning rotisserie of sausage skewers—self-serve. He could tell the place had once been great. It had an old jukebox that played Elvis.

A square-shaped Mexican kid reached into a bag of M&Ms, removing them one at a time as The Sock Girl's bimbo friend guessed the colors from across the lounge.

"Red."

"Brown."

It had been three days at The Black & White Lodge. Since his head had stopped aching from the accident, Hale was starting to feel like an idiot.

"Blue."

The M&M guessing bimbo was the first lady of these winners. She wore a black bustier that fanned out at the hips to look like bat wings, fishnets and black lace-up hiking boots. She had platinum blonde hair with blue streaks and distant kohl-rimmed eyes.

She was pretty but not his dream girl. None of the girls here could even be the faceless girl The Doctor kills first. His dream girl was good and brilliant. In his dream, she and the faceless girl had a holy relationship. His dream girl shifted from a beautiful brunette to a beautiful black girl as she trembled, unable to move from the pure white sheets where she lay. Hale knew he wasn't going to see that here but that meant he wouldn't see his death either, or The Doctor. He didn't have anywhere to go so he might as well watch this teenage drug binge. He might still get his two million dollars, but he doubted it.

"I'm always right. Always. Just once I'd like to get a purple one when I said 'brown,'" the girl said.

"Aw baby!" her English boyfriend said.

"There are no purple M&Ms," the oldest, a nervous blinking girl said.

"That's the point, Lucy," Bustier Girl said.

"There are purple shelled chocolate candies that look like M&Ms but aren't. They'd never be in regular M&Ms," The Sock Girl said.

"God, American coffee is shit and I'm getting bloody sick of Elvis. Don't they have any Sex Pistols in that thing?" The English kid was leader of this tribe. He clearly had the most intelligence and money and seemed to be the only one who looked like he wasn't dressing from a grab bag.

"I'll snap your neck, you little faggot!" Mr. Cowboy Hat yelled suddenly.

Mr. Cowboy Hat had made himself a fixture at the closed bar and, like Hale, he drank his own store-bought alcohol. Unlike Hale he was a pockmarked handle-bar mustached slab of a man who owned his space. "You come into my country, you insult my coffee, my king! We kicked your ass out of here once and I'll be happy to kick your ass out again and throw your groupies out with you!"

"Oh, well, God Save The King. I meant no disrespect. He was the only one here who had real groupies. Though I really do wish he had burnt out rather than faded. It seems leaders of revolutions have trouble adapting to the changes of their own movements."

"I don't know what the fuck you're talking about kid, but—"

"You mentioned The American Revolution. Now that was bloody brilliant. Know why they won?"

"What?"

"Do you know why the Americans got their own nation? The British went about it all military style where the Americans dug in their heels and fought for hearth and home."

"Slade likes to discuss this stuff. I don't see the point. The patterns are set," Bustier Girl said. She sat on one chair and stretched her legs out on another.

"You gotta know your history, Blue," he said. The Nervous Girl (looking nervous) was the only one who had a normal reaction to Mr. Cowboy Hat. The Sock Girl smiled and held her sock. The square Mexican kid grabbed a handful of M&Ms and ate them.

Hale thought it was possible that Mr. Cowboy Hat was the connection, but it seemed unlikely that anyone would trust Mr. Cowboy Hat with two million dollars. Hale might have liked to see Mr. Cowboy Hat snap the kid's neck, though. The kid oozed effortless charm, the kind it had taken Hale a lifetime to get perfect, and then lose.

"Oh, Slade, baby," Blue said, "Just come dance with me."

She pulled the kid to her and they danced to "Love Me Tender." Mr. Cowboy Hat sat back down and groused.

Hale went back to drinking his whiskey. The whiskey brought him no courage, but it made him realize how far he was from his dream, how much he had wanted the dream, or anything, to happen. His cheating wife would say that was his problem. He was always waiting for something to happen, rather than making it. Well, he had made her lover's hair shorter.

Hale decided he'd fuck off back to L.A., scrape up some charm and get a job. He went to leave the B&W and saw Mr. Cowboy Hat had buttonholed Blue alone at a table by the exit.

"What are you doing with that boy, little flower? It's clear you need a man."

Mr. Cowboy Hat had straddled the back of a chair. Blue licked a sausage skewer from the rotisserie.

"That hasn't been my experience. Granted my experience is unique," she said.

She worked the sausage in and out of her mouth. In and out.

Hale dropped his getting-the-fuck-out plans looking at the girl's mouth working the sausage. In and out.. Round and round. In and out.

"You are a very unique flower."

"You can't be very unique. Unique is an absolute. You either are 'like nothing else' or you're not."

In and out slowly now, a second bite. Mr. Cowboy Hat rose and grabbed her arm gently.

"You seem to know a lot, but I know something you don't."

"What's that?" she asked, smiling.

"You were a little weed growin' up. Your mama kept you but your daddy left you. So, you're afraid all men are going to do the same, but now you're bloomin'. You're a bloomin' flower and I'm gonna give you a little sniff. Can I give you just a little—"

In and out with the sausage with the last bite. Hale realized that Mr. Cowboy Hat had stopped talking. He made a gurgling noise. Hale looked away from the girl's mouth and saw that Mr. Cowboy Hat's hand had gone around to cup her crotch. She squirmed away. Mr. Cowboy Hat was still gurgling. He stood and grabbed something at his throat. He pulled a red skewer from his neck and a stream of blood came with it. Blue backed up and sidestepped him as he lunged towards her, falling across the breakfast table. Blood decorated the store-bought pastries in spurts. Mr. Cowboy Hat scattered them across the tiled floor, knocked over the coffee pot. The pot shattered on the floor. The table collapsed.

"Shit, Blue, I finally found some good bloody coffee and you break the pot. Hell, baby."

Hale looked and saw Slade standing there in his 1950s Greaser wear along with the square Mexican kid and The Nervous Girl.

"This isn't significant," Blue said.

"The outlier probably feels differently," the kid said.

To Hale's surprise, Blue had a hand on his shoulder, gripping more firmly than a girl her size should be able to. Hale did not react.

The only one who had a normal reaction was The Nervous Girl, who screamed.

"She's not what you all remember, Sebastian," The Nervous Girl pleaded to the English kid. In the bathroom, the shower ran.

Hale should have been pleading too, but he wasn't. He was tied to a chair and gagged. He had never dreamt of how he got there. It turned out it was mostly by the hands of the freakishly strong sausage-eating girl named Blue. There was no Doctor. Hale was just going to die at the hands of these weird-ass kids, so they could cover up the murder of a piece of shit. It was actually a great relief.

"You need someone right-minded and organized," The Nervous Girl said, "Someone to help you."

The Mexican kid came in with a tiny package of cheap knockoff M&Ms and gave a handful to the English kid who put them in the bag of real M&Ms and shook them together. The Mexican kid then looked straight at Hale, pressed a finger to his lips and left the room.

"Diane sees what you're doing, Lucy," The Sock Girl said as she sat on the bed between where the English kid and The Nervous Girl stood.

"I'm not trying to do anything," The Nervous Girl said. She blinked.

The heavy red curtains kept out the desert sun and trapped all the false white light that gave Hale a headache. His dream had been painted with sunset colors. It wasn't in a room lit like a bad coke house with a bunch of junky computer parts around. It smelled of Elmer's glue and sex and there were papers with wild drawings and numbers on all the walls.

"Are we going to become like the French? Killing anyone and everyone? You hated the French, Sebastian. They're your least favorite." The Nervous Girl looked older in this light. Maybe thirty.

"In every revolution, innocent people die," the kid said. Hale thought he actually heard some of the cockiness leave his voice.

"You weren't saying that before! You said it was going to be bloodless! You've changed since you got Blue out."

The shower stopped.

The bathroom door opened. Blue's wet hair was dark, her eyes amber. Hale watched Blue, in a short Hello Kitty robe, toss a platinum blonde wig with blue streaks on the table. She was the good girl, one of her faces.

"Wake up the doctor to look at Hizz's blood levels. Just do it, Lucy," the kid said firmly before the woman could object. The Nervous Girl twitched before she left and so did Hale. He felt his extremities go numb and it had nothing to do with the expertly winded sheets that tied him to the cheap desk chair. The Doctor *was* here.

Sock Girl put her hand through the main sock and made it plant a kiss on the kid's cheek.

"Thank you, Diane and Pirya," the kid said and smiled. The Sock Girl left.

The kid undid the gag over Hale's mouth and smacked him awake.

"You have to listen to me!" Hale heard his words pour out, "I know someone is supposed to contact Dr. Gables and I know you have two mill—"

"You know the doc. Guess that means you aren't so innocent," the kid said.

"No, no! Listen, The Doctor, he's evil. He is evil."

"*You* are telling this to *me*. That's where we're at. This is my life."

"I saw it all happen! I had a dream, a dream for the past seven years."

This didn't seem to impress the kid. He was laughing quietly.

"The Girl! Your girl, Blue." Hale saw the kid's eyes widen. "She gets sick. She gets real sick and—"

"If you fuckers try to go through Blue to get to me ever I'll make Swamp Rise look like a bloody picnic!"

The kid roared and picked Hale up. By the throat. With one hand. While Hale was tied to the chair. Was this a new dream? No, it all felt too real.

"He's just an outlier," Blue spoke. "Diane said." She was behind Hale now and it felt like she eased the chair back down to the floor. The kid let Hale's throat go and turned to Blue. Hale could hear a sound like something flicking behind him.

"As much as I'd love to trust a bundle of socks, I don't think so. He was clearly sent by them. He had a dream you got sick? Please, he wants to get into my mind. It's Counterinsurgency 101, love."

"It's you. It's been you all along!" Hale cried, looking at Blue.

"No, it hasn't been." Blue smiled as she lit a candle.

Hale felt tears on his cheeks as he realized his life had come down to this moment and he was going to blow it.

"He's playing the lost soul," the kid said.

"Slade, get your meds from Lucy. You can leave me alone with him."

"A'right, I really need a decent cup of coffee, but don't fall for it and don't kill him." The kid left.

"You had a dream," Blue said to Hale, "I had dreams. They stuffed my head with so much stuff and it hurt, but I didn't care. I thought I could make things happen with the stuff. I wanted everyone free and safe. If something went wrong I used to think I could die for them. Be a martyr to save everything. But, I know now I'd just be another statistic. Nothing changes. When they put me in Barbra I lived in that place and I learned, I learned how regular people are and they don't care. People are asleep and can't help us and we can't help them. And I see all revolutions have one thing in common—failure."

"Blue, listen, I don't know anything, but I know I don't care if I die, and I know you can't!"

"You don't care if you die but... it doesn't matter. Didn't you hear what I said, outlier? Outlier..."

Hale thought she was asking him a question but she got up from the bed and shook the box of M&Ms and said, "Yellow," and took one out. She looked at it. Then she ran to the light switch and turned it on and looked at it in the white light.

"Blue, you have to stay away from The Doctor. You're going to get sick. You'll be sick and you won't be able to talk and there's a girl in a white T-shirt with short brown hair sitting next to you and—and The Doctor kills her by putting a needle in her neck and... and he kills you. It's you but you're also this other...do you know a black girl?"

Blue looked at him like she was going to speak. She cupped the M&M. That is when the kid came back in and put a black case on the nightstand.

"So, what did you get?"

"Blu—" Hale began and the kid gagged him again.

"Slade, we should find Tiffany. Don't you miss her?"

The kid seemed to crumble a bit but then his shoulders stiffened.

"Blue, try to focus. We already have a body to bury in the desert and a smashed coffee pot to replace. He isn't an outlier. He connects somehow," he said.

"'Blue, try to focus,'" she said in a mock-British accent, "you sound like them. I spent two years inside that bitch before you could get me out."

The kid looked as defeated as Hale for a moment.

"Oh, it's not your fault, baby," she cooed, touching his face, "you saved me, but now I just want to have some fun." She tried to push him to the bed and he fought back, grinning playfully.

"We'll have plenty of fun later. Now you let me work," he said, shrugging her off.

"You're so much stronger than me now. It's not fair."

"Testosterone."

"I want some," she sat up and pulled at his shirt.

"Oh, you want a little testosterone, do ya, pet?" He climbed atop her, pulled her robe from her shoulders, and began to kiss her.

The room swam in front of Hale. The candle had gone out.

"I do, stick it in me," she said, "Stick it right in me."

She squealed and moaned as the kid buried his face between her legs.

Hale mumbled in his gag. Blue's cries drowned him out.

"Remember," she said, after she finished, "the measure of a man is what he lets possess him."

Blue opened the black case and took out a needle as the kid dropped his pants. Hale saw then that Slade was a girl. The kid sucked in a breath as Blue stuck him in the thigh. Then he cried out while Blue worked her hands between his legs. Hale couldn't say what his normal reaction would have been to this situation. He realized all normalcy had left him long before this, before the car accident, probably when he cut off his wife's lover's ponytail; or maybe it left seven years prior when he began to dream of this night. A night where he understood nothing but knew everything. Now he just knew if he didn't do something this good girl and her girl-boyfriend would die, so he shouted through his gag as the boy with the vagina came.

"I love you so much, Blue," the kid said.

He held her face in his hands where Hale couldn't see. But Hale could tell by his sudden shift to a horrified expression that something terrible was happening.

"Blue! Blue! No, no!" the kid yelled as Hale yelled through his gag.

He lay Blue down in the white sheets that had been rustled with their sex.

"Stay here. I'll—I'll get the doctor!" He ran off, leaving his pants on the floor.

Hale cried out to Blue as Blue wailed through clenched teeth.

"Saaayee!" she squealed in a high-pitched voice.

Slade returned with an old man in a blood-speckled shirt and crooked glasses. He didn't look like evil incarnate, or what Hale had pictured in his dream. This doctor did not have thin lips, a salt and pepper pompadour, or a pinched nose, but it was The Doctor and Hale cried into his gag.

"Shut up!" the kid said. He punched Hale in the head.

"She's having a spasm," the doctor said, "Where is her wheelchair?"

"What?" the kid said.

"You did bring her wheelchair," the old man breathed nervously but spoke with dry superiority. "This girl has cerebral palsy."

"Tiffy? Tiffy is that you? Shit Tiffy! I'm so sorry. I-I didn't know. Blue didn't know."

The kid raced over to Hale's chair and for one sweet instant he thought the kid would ungag him, but he just grabbed some paper from the desk. Hale cried out again as he saw the doctor take the opportunity to snatch up the spent syringe.

"She's a split," the doctor whispered as the kid went down by the girl's side, caressing her face and asking her questions. The girl wrote her answers down. It seemed that her arms worked and nothing else.

Hale saw The doctor grab the needle and go toward the kid's throat. He could see the kid's vagina, but not his face as he sat on the bed, twisted toward Blue. This is when Hale found he couldn't even mumble because he had yelled himself hoarse. This is when Blue herself sat up and pushed the doctor away and to the ground.

"I found a purple M&M," she said.

Hale walked out of the Black & White Lodge with the kid. The kid smiled in the desert light. His face was sharp, his eyes green. His purple button-down overshirt blew in the wind.

"You made Blue believe again."

"Will she be okay?" Hale asked.

"Blue is always a'right as long as me an' Tiff are around, and we're a' right if she's around. With the three of us we can do this like Washington, Jefferson, and Franklin. Only without the slaves."

"Is there any chance I want to know what's happening here?" Hale asked.

"You seem like the sort that knows when he's in over his head, mate. Sure you don't wanna run with us?"

"Well, shit." Hale grinned as he got into the limo.

"Nathan Hale," said a man with a pompadour, pointed nose and thin lips. "Four months ago you were in a car accident. A very bad car accident near the B&W Lodge."

"You can't scare me, Doctor. You don't have the kids. You don't have

Her. You just have me and I know less than you," he said.
"Who are you?"
"I'm the Outlier."

COLNE

LIAM DAVIES

"Are you sure I *have* to do this?"

Dr. Robert Trebor just sighs on the other end of the line, enough to express his impatience. It's the third time Dorian has phoned him since arriving the day before; the third time he's tried to avoid the treatment.

"It's *flooding therapy*, Dorian. You came to me . . . you went to the trouble of asking for my help—"

"Yes, I know, but—"

"—after buying all my books, after spending years and years looking for the meaning of things and conversations and dreams . . . of your life, Dorian . . . and now I've finally put you onto the path of knowing yourself, you just want to—"

"But why does it have to be *here*?" Dorian says, looking at the large white grinning teeth, made up from the letters of the 'welcome to Colne' sign outside the telephone box.

"The geography of the town permits it. It permits you to project and confront yourself face on. To make friends with your facets."

"But—"

"Get going and find the symmetry in your life, man."

The doctor hangs up the phone. For a moment, Dorian stays still, with the phone still clamped uncomfortably between his shoulder and ear whilst he re-reads the handwritten note in doctor's scrawl: 'Cotton Manager,' the man he is due to meet.

"Go and find him up in town—at The Jollity Hat," the landlady at The Crown had told him, just after he'd arrived in Colne and taken lodgings. He'd gone up into the town immediately after getting settled but found no place with that name. Upon his return to The Crown she'd admonished

him. "Don't be daft, lad—it only opens on Fridays."

Dorian realizes he's gone into a bit of a trance, coaxed into it by the idiocy of the dial tone droning in his ear. He feels like a 'tableau-of-one' in his little glass box, illuminated against the night. And now it *is* Friday . . . and now he'd walk up the hill into Colne's center and meet the doctor's contact, the man who would help him supposedly re-acquire the meaning of everything. But there's something that bothers him in the way the road snakes away, the three-story buildings on either side rising up to give Albert Road the appearance of a great big crack in the ground.

He takes a few steps away from the haven of the phone box; away from The Crown and the train station behind it, the station that could still take him away, should he choose to turn back. Instead he continues, contemplating the dark vista around him. Someone had built this town on a ridge for a reason. Surely. That's what the doctor had said: the town was conducive for the flooding therapy that he had in mind? Maybe *that* was what was troubling him. But now that night had descended, things had changed. Colne was nightmarish.

To the north and the south, lay great valleys: low, latent and lewd. As he walks uphill towards the sodium glow of the town center, he looks both ways at the intersections of Albert Road. The terraced houses on the side streets fall away into the tarry blackness of the night. He looks down the street to his left. Pale mist, low hanging and contrasting against the darkness. And is that distant music he can hear? Choral voices sing unintelligible messages in ethereal arioso loops: someone lamenting in a distant attic room, perhaps? He shudders and presses on, uphill and east toward the lights. The wind picks up; whips him in the face as if being funneled directly at him by the malevolent buildings, those stoic and scrutinizing faces.

Soon he is in the town center, amongst the pubs and snuggeries of bookies and shops. Dorian discovers a gap in the buildings that reveals the swirling miasmic vapors and distant inferno pockets, blazing against a black canvas of the south valley like so many cyclopean eyes. A sick feeling grows in his stomach at how the south is in such stark contrast to the damp mistiness of the valley to the north.

The wind rattles the sign of a nearby building causing it to swing back and forth. Dorian turns and is surprised to see a small pub wedged between two larger ones at the rear of an inset square, just off the main

pavement. He's sure it wasn't there on his sortie the previous afternoon. It's the Jollity Hat. He stands there for a second with the wind flapping against his clothing, his hair blowing out of arrangement and that sign creaking unbearably. The main crossroad traffic light at the end of the town's precinct is on green, as if a signal for Dorian to enter the pub. He takes a gulp of air and walks towards the building.

Inside, the closing of the door at his back silences the angst of the weather and cocoons him within the vestibule. Heavy red velvet curtains hang in front of him, ornately tasseled with gold thread at the hems where they kiss the linoleum, which is printed to look like the black and white tiles of an American diner-car's floor. He palms aside the drapes and enters a large, dimly lit bar area. In the center of the room is a snooker table, around which several men dance to folk music from the jukebox, throwing Egyptian shapes and at synchronized intervals, the monkey and the mashed potato. Their pints of lager, drained to various levels of emptiness, are dotted around the cushioned edges in front of them. A fire-eater on stilts totters back and forth in the far corner, occasionally emitting a sulphurous jet from his mouth that roars above the heads of the dancing men. Sucking in his gut and wiping away the beads of perspiration that have emerged at his hairline, Dorian scans the bar beyond the patrons. Among the throng of moribund drinkers on barstools is a man matching Doctor Trebor's description: mantis-thin with a tasseled leather waistcoat and a checkered flat cap.

He walks over, sits on a spare stool next to Cotton Manager, and orders a Benedictine with hot water, or a 'Benny and Hot' as the Colnites call it, something he's developed a taste for since his landlady poured him one as a 'supper drink' the night before. It's strange, he thinks to himself, that he hadn't noticed the Jollity Hat at all since arriving, not once, and yet seeing it tonight, bathed in the green glow from the central crossroad's traffic light, it feels as if the building has always been there.

Cotton, like him, is drinking Benny and Hot. Only Cotton stands, resting his right foot on the horizontal spindle of a bar stool. He has a gargoyle's demeanor. Dorian feels a sliver of shame. He feels effeminate, sitting on his stool, and no matter how he readjusts, he can't prevent a certain camp meeting of his knees . . . and now he's about to meet Cotton, he really feels as though he should. Cotton turns to regard him, revealing the seam of a deep scar that separates the two vertical hemispheres of his face from hairline to chin, running via the forehead, between the eyes, the bridge of the nose and perfectly down the groove of his filtrum. Cotton's cap shields the glossy black orbs that glare from his eye sockets as if he's

reading the bad poetry of Dorian's existence.

"Mr. Manager—"

"Cotton."

"Cotton—uh, I appreciate you agreeing to see me."

"Shut up. I knew you were coming." Cotton Manager fixes his gaze and almost wills Dorian into taking an effeminate sip of his drink. "Listen . . . and I mean listen." He runs a dirty thumbnail down the crease-deep scar along his nose. "And don't just wait for your chance to talk—because I don't like that."

Dorian nods.

"What did I just say?"

Cotton's expression is serious.

"What?"

"What did I just say?"

"You asked me to listen?"

"And for not to do what?"

Dorian can't remember. He hadn't really been listening, preoccupied as usual by unimportant details . . . like what the fuck made that scar? He recoils slightly when Cotton leans towards him. Cotton's warm breath, stale from cigarettes and Benedictine, sours Dorian's nostrils and throat.

"You're just like all the rest."

"The rest?" Dorian asks, genuinely surprised.

"All those other fucking Southers."

"Southers? You mean southerners."

"I mean what I say. All you people coming up here to Colne because it's built on this ridge—because by living on a ridge it presents a bloke with a choice—and because that choice is simple. North valley. South valley. Good. Evil. Which way do you descend? Do you descend at all? Know what I mean?"

"What?"

"Do you descend at all?"

"Is that why I've come here?" Dorian is genuinely confused but tries to keep the tenor of his voice sincere. Three days ago, when he'd closed the second edition of Dr. Robert Trebor's self-help opus *How to Calibrate Both Your Being and Becoming* he was about to slap the volume shut and begin convincing himself that the mantras contained therein were existentially useful, when a loose leaf of paper fell from the end spaces of the book: a handwritten note: 'Colne—know thyself,' and at the bottom: 'Cotton Manager.' Without thinking, he'd gone online, located the town in the east of Lancashire, and called Doctor Trebor. Trebor admitted that he'd

folded the note inside the back flap of the dust jacket. It's an insurance policy if all else failed, he explained, for all his regular clients who become 'existentially corkscrewed.' Dorian had immediately taken the train north. His job didn't matter; that could go to hell. His relationships and social network groups didn't matter either. The online roleplaying community didn't matter. The shelf full of anime pornography didn't matter. He wouldn't be defined by them. Because that one little note seemed to hold all the clues to the meaning of his entire being. Hell, Doctor Trebor had even called the damn thing 'insurance.'

All those sodding questions had blighted Dorian for years. And now it's Friday night and here he is, in a pub that doesn't exist on school nights . . . and Cotton Manager breathes fetid fumes into his face.

"That's why you've come here. To know thyself. To meet tha'self face on. You've come from a ruddy city with your facades and your business cards and your three course luncheons and your Filofaxes—"

"Filofaxes? It's not nineteen-eighty . . ."

"—and your sun-blushed fucking tomatoes . . . and what do you really have? You haven't a clue as to what the point of your fucking life is. You hang about like odorless gas in your skin. And so you've come here, on doctor's orders, to take a walk down into one of our valleys . . . or both . . ." He takes another gulp of his drink. "You'll never amount to much until you do."

"What do I do when I get there?"

"You meet the man, of course."

Dorian didn't understand

"I swear," Cotton continued, "tha's all nothing but babies, you twat. You've come all this way, so go and meet the man. Meet 'em both if you can take it."

Cotton Manager stands up, downs his Benny and Hot with a flick of his wrist, and walks slowly away, around the dancing men at the snooker table and out of sight. Dorian watches him until a roar of fire from the stilt-walker's pursed lips plumes across the space and temporarily blinds him. All is white scorching light and the warmth of his drink at the back of his throat . . . and then his vision returns.

He's standing in front of the Jollity Hat. There's a light drizzle in the air, not enough to constitute rain but enough to dampen his hair a little. He turns to look at the pub. It's still there, but only just, like the ghost of a building, a gaseous sandcastle that he can see right through. To his right the green light is shining bright again, bathing the crossroad. He walks to it, compelled. Upon reaching it, he stands still, sensing the descent on

either side of the ridge, the north to his left, the south to his right.

So, Dorian thinks, *he goes down one and meets the man, right? But which one?*

From the thick, white fog on the north side he can hear the swirling choruses once again, coming out from the heart of the vapor. The song chills his marrow and tightens his testicles. To the south, the desolate blackness shrouds everything below. Whichever side he took, he wouldn't see what he'd be approaching, but something in him reasons that a silhouette in the mist would be less dislocating than walking right into the oppressive nothingness of the south valley. After all, oppressive nothingness is what he fled.

He takes a few steps to his left and looks down. The tapering pavement disappears into the smear of grey weather at the bottom. The town is silent now as he enters the street. It is as if Colne has stopped moving, occupying a terrible Pinter-pause, one that exists just for his descent. The wind is gone but not all is silent. The green traffic light behind him hums with electric charge. But the wind has gone now. The street is so steep, he thinks to himself as he takes his next dizzying steps down, down, down. The mist-enshrouded world below him bounces from side to side with each heavy step he takes; his breathing becomes ragged. His heart hammers. After half a minute he passes the midway mark on his plod into the north valley. Soon after, the gradient peters out. But there's something strange. He's level with the mist but not immersed. The fog stands ahead of him like a great wall; a distinct vertical presence stretching some ten feet up. He stops several yards from it. For a while Dorian squints into the mist, wondering whether to enter. But then the vapors shift, as if parting. A shape appears, a man. Yes, he thinks, there's a man approaching from within the mist.

You meet the man, of course.

And in a terrible moment the man emerges from the opacity like a bad dream, his eyes, just white boiled eggs in his skull, his grin peeled back from ear to ear, literally from ear to ear, a revolting upturned crescent exposing gums and the gaps of glistening jawbone to each side of two rows of chattering pearly teeth. The man holds his hands out, clawed fingers in a mockery of a greeting and it's at that last moment, just yards from being claimed, that Dorian realizes that the deformity that comes for him, *is* him. It's his face, twisted out of shape, but his nonetheless.

Dorian turns and scrambles away from the abomination but momentum is not on his side and the arms of his doppelganger wrap around his chest. He closes his eyes . . . and then nothing. He stands there for a moment in the comforting darkness behind his eyelids. The cool aura of the mist

wraps its tendrils around his legs and shoulders, causing him to shudder. And then he hears footsteps retreating away from him, up the hill towards the top of the ridge and Colne's center. He opens his eyes. Receding into the distance, he sees himself, sprinting away, occasionally turning round and looking back at himself in abject terror. Then Dorian looks down at his clawed hands. A sense of stifling panic takes him over. He looks to his right and beholds his reflection in the window of the nearest terraced house. His clouded, white eyes gaze back, framed by the stretched lids and the arched eyebrows, his smile twisted and deformed, torn to meet his ears. And then around his ankles he senses the fingers of mist curling tightly, round his waist too, round his neck. And then all is mist. All is nothing. All is joy. And the angels sing their sweet aria.

When he reaches the top of the street his lungs are burning from the run. Dorian turns and is thankful to see that whatever the hell it was that pursued him had returned, back into the mist. His lungs and legs are burning and his eyes water from the exertion of having sprinted uphill. And then when he gets his breath back, a perverse calmness pervades. He stands with his hands on his hips, bathed in the comforting amber glow, from the single traffic light above. His smile spreads and he flexes his fingers. He imagines Cotton Manager, back in the Jollity Hat, perhaps doffing his cap to him for having just 'met the man.'

He'll take control of himself, Dorian thinks. He'll ditch the cartoon-porn, the drudgery of his job, the online 'friend' collating. He'll fucking-well live his life. The other side of the valley beckons him now, the dark dip in the land that leads down into the void: an antithesis to the milky levity of the mist to the north. He just has to know who awaits him down there. What new facet of himself could he assimilate next? Because before meeting the man, he was nothing, and now his soul is full of music, full of smiles, full of whiteness. He leaves the pool of amber light, just as it turns red, crosses Albert Road and walks down the hill, grinning widely as he goes, further and deeper and down into another new kind of self.

PERSISTENCE HUNTING

JEREMY ROBERT JOHNSON

Don't act surprised, or shake your bloody fists at the night sky.

You chased this down.

Help is coming—maybe a reality check can keep you seething until it gets here.

Better than slipping into shock.

Face it—you're lying there in the evening chill, broken and breathless on the dewy suburban grass because of a basic truth:

You've always been a sucker for love.

And being smart enough to know that isn't the same as being able to do a goddamn thing about it.

You were a mark from the get-go.

Age seven: All Mary Ashford had to do was smile. You kicked over your licorice. She skipped away, shared it with that red-headed oaf Mikey Vinson.

Rube.

Age fourteen: Sarah Miller asked you to the last dance of the year.

Why wouldn't you help her with her algebra homework? An easy down-payment on a guaranteed post-dance make-out session.

You even gave Sarah your final exam answers.

She passed algebra.

She passed on attending the dance.

Stomach flu—very sad. She cried on the phone.

Two weeks later she went to the final dance at the school across town.

With Mikey Fucking Vinson. The rumor mill had them crossing fourth base. In a *hot tub*.

You cursed Mikey Vinson, prayed to God for wolves to snuff the bastard, to disembowel him in a hot tub, a steaming red bowl of Vinson soup.

Revenge fantasies waned. You knew the truth. This was on you. You cried yourself to sleep, thinking Sarah Miller would be the last girl you'd ever truly fall for.

Chump.

Age fifteen: Love got blown off the radar.

Was it world-weary resolve? No, you were a mess of hormones and zero savvy charging headlong into the bayonets of the beauties walking your school halls.

Love caught the boot because your parents burned to death on their eighteenth anniversary. Bad electrical blanket wiring and spilled champagne caused a flash-fire.

As with every anniversary weekend since you were born, you were staying at Uncle Joshua's house—a bungalow off Powell on 58th—in South East Portland. The crucial difference that weekend was that at the end of it you had no home to return to.

Uncle Joshua took you in. You didn't speak for three months. You dreamed—your parents screaming with smoke-filled lungs.

Your Uncle did his best. Let you know you were loved. Gave you great pulp novels about druggy detectives and man-eating slugs. Taught you how to swear properly. Let you stay up till any hour, so long as you promised to run with him every morning at seven sharp.

"The morning run blows the morning prayer out of the water," he told you. "Gets you thinking. Breathing deep. It clears out the worry, the garbage, everything."

You ran the city with him—sidewalks, tracks, trails. Portland seemed huge and electric in a way your hometown Salem never did.

He showed you how to run through "the wall"—the utter vacuum of energy that forced you to walk. Soon the wall was pushed further and further out.

You ran to exhaustion—morning jogs with your Uncle and epic evening jaunts that allowed you to collapse far from the reality of your loneliness, from dreams of burning hands reaching for your face.

Five years after the fire, love finally tracked you down.

You were twenty-one. Still a virgin. You'd chased nobility, never exploiting your semi-orphan status for a cheap lay. Besides, that would have meant talking to someone, knowing someone.

You were confident chasing the cat was for suckers anyway. You'd transcended that status because you had a *new* kick, something you'd guessed was better than pussy:

THEFT.

It wasn't for the cash—your parents' trust kept you sound.

You stole because you'd recognized a loophole.

Portland was a runner's city. During daylight it was impossible to hit the waterfront without seeing a jogger, but the nights had their own crews. Doctors or bartenders forced into the late shift. Other running zealots like you.

And Portland's runner omni-presence rendered you a non-threat to the cops. Another fitness freak in fancy gear. You rocked sheer shirts, a Garmin GPS watch, a CamelBak water backpack, a flashy yellow vest, and shorts designed to hug your junk.

You liked to wave at the cops, give them a nod that said, "Here we are, upstanding citizens keeping things safe and healthy."

Sometimes they waved back. Some of those times you ran right by them with a thousand dollars worth of pinched jewelry in your CamelBak.

They never turned around. What self-respecting thief would run by a cop car while rocking reflective gear meant to call attention?

You were just another night runner fading in the rearview.

In fairness to them, you started minor, like some jockey-boxing meth-head.

Your LifeHammer tool was designed for drivers trapped in a submerged vehicle. One side had a hammer specially designed to crack tempered auto glass.

Ostensibly designed for exits, it worked great for entrances.

You trolled the NW hills near the Leif Erickson trail, pulling smash-and-grabs on Suburbans, Jaguars, a smattering of Portland's ubiquitous Subarus and Priuses. You copped cell phones, cameras, MP3 players. You copped hard-ons from the gigs, tracked record runs off the buzz.

You kept the swag in a box in your closet, obsessed over it, deciphering what you could about the people you'd jacked. You fell asleep to stolen play-lists. You studied the smiles of strangers in digital photos.

You soon realized that any tweaker could crack car windows.

The buzz dwindled.

You escalated—houses were the logical progression.

Your first pick was a sharp art-deco joint. You'd done your sidewalk surveying—they had a habit of leaving the sliding glass door on the side of their house open.

You almost bailed. Nerves. Visions of the owners polishing rifles inside.

You decided to hit their car instead—a desperation move.

You got lucky, opened the glove compartment, found a receipt. Franzetti Jewelers—$6,000. Dated that day. Scrambled the car, found zilch.

Was it in the home? A necklace, a ring—they'd fit into your backpack so easily. Something like that was much more intimate than an iPod—it represented history between two people.

The gravity of it pulled you to the side entrance of the house.

You knocked on the door frame. "Hello?"

If anyone answered, you'd feign injury: You'd crunched your ankle coming down from Forest Park. Needed a cab, a hospital.

After your third "Hello" echoed dead, you crossed the threshold.

It took five exhilarating minutes to find the jewelry box. Bedroom dresser, third drawer, under a pile of gold-toe socks. A serious square-cut rock mounted on a platinum setting. An engagement in the cards?

You thought about leaving the stone. But then you remembered Mary Ashford and Sarah Miller, decided to save the guy from becoming another sucker.

You hit the streets, the ring secure in your CamelBak.

Back home, the jewelry went into the swag box. You couldn't sleep, reviewing your plunder, tiny pieces of other lives.

B & E's became *everything*.

One a week at first. Monday through Thursday was casual jog recon. Weekends were break-ins.

Jewels reigned supreme. They spent time close to other people, had sentimental value.

You'd take cash when discovered, but never credit cards.

Once a week quickly became "whenever the coast looked clear." Your record was three break-ins in one night.

You wore thin white runner's gloves, hoping they'd prevent prints.

You carried steak-flavored dog treats but never had the guts to break into a house after you'd heard a dog bark. You petted cats when they'd allow it.

If a whole pack of cigarettes was left out you'd take one smoke, save it for the morning, puff on it at sunrise.

Sometimes you went to hip hop shows before your evening run. It was

easy to stay chill, enjoy a show solo, hood up, feeling like an anonymous gangster amidst all the fronting. They could talk up the criminal life; you *lived* it.

You tried to maintain the morning runs with Uncle Joshua. He noticed your owl eyes and lagging pace.

He expressed concern.

You dropped the routine. The nights were just too long.

It was in this state—harried, junkie-hungry for break-ins—that you let love back into your life.

Slow it down. Pay attention. This is where everything fell apart.

You were coming home via Burnside that night, maneuvering around the bum-clusters near the bridge. An alky with a piece of corn in his beard gave you a wave.

You were astronaut high from a twenty minute break-in session. The entire house had smelled like summer lilac. You'd wondered if the owners paid to have that piped in at all hours.

That sweet smell is what you were thinking about at the moment the little black car took a no-look right turn at 10^{th} and Burnside past Union Jack's. You saw a bright flash out of your peripheral, heard a thump that you ID'd as your body hitting the hood of the ride. Then you were rolling on pavement.

Brake lights made the scene run red. You caught the model of the car . . . couldn't focus on the license plate.

Last-call closeout-boozers were a night run liability. You'd accepted that, but you couldn't accept the fact that you might have been slaughtered by a fucking Jetta with a butterfly sticker on the bumper.

Gorgeous legs in camouflage stockings emerged from the driver's side. The girl stood, giraffe-tall. Five inch heels. Soon she was crouched by your side. You couldn't focus on her face aside from wide hazel eyes, tiny flecks of gold floating in the green.

You sap—you might have been in love before you even lost consciousness.

She danced under the name Avarice. When she told a guy he could call her Ava it guaranteed extra tips. When boys pointed out the fitting nature of her name she called them clever. That pulled more tips, too.

She was insanely irresponsible, taking you to her apartment instead of a hospital, but her license was already suspended for another offense. Ava had bugged at the idea of real jail time and was strong enough to get you into her back seat, then her first floor apartment. She watched you sleep on her couch. You kept breathing. She gave you an ice compress for your head. You asked for Advil; she came back with two Valium and a Xanax, delivered by slender hands, chipped black polish on the fingernails.

She asked why you were out running so late. You told her you worked a day job and preferred to run when it was cooler out. She asked what you did. You said roofing. Seemed tough.

She asked you running questions, caught your excitement about the topic, used it. You could see her game—ingratiate until she knew charges would be dropped—but you didn't want to stop playing. You liked the way she was tending to you. It stirred something you hadn't felt in years.

Plus, she was easy on the eyes. Heart-shaped pale face framed with short black hair. Decent lips made more charming by a crooked smile. Legs that seemed to be two thirds of her frame. She wore grey shorts with pink trim piping, a thin green cotton t-shirt that showed off the curves on each side of her small breasts.

You knew most men didn't get to see her like this—casual, relaxed and gracious. She knew you knew and rode the vibe. She showed you her tattoos—two thin stripes, one running up the back of each leg, meant to mimic the back seam of a pair of pin-up stockings. As she got closer you saw that each seam was actually composed of delicate cursive words.

She bent forward, touched her toes so you could see the entirety of each line.

The right leg said: . . . I asked him with my eyes to ask again yes and then he asked me would I yes to say yes my mountain flower and first I put my arms around him

The left leg continued: yes and drew him down to me so he could feel my breasts all perfume yes and his heart was going like mad and yes I said yes I will Yes.

"It's from *Ulysses*," she said.

She admitted that every time she read that last chapter she felt like "rubbing one out." She made a circling motion in the sky with her index finger and closed her eyes. Then she smiled, full blaze.

You were ready to die for this girl, and she hadn't even kissed you.

Your concussion was minor. More disconcerting was the new gimpy sensation in your right leg. When you tried to run the iliotibial band next to your knee registered tight, white-hot pain.

You had to drop running for a week. Better to let it rest than blow it out.

Ava was an Olympic-level tease. When she dropped you off at your Uncle's house she leaned in close, said she wanted to look at your pupils. Be sure you didn't have any brain damage. She locked you in at the eyes. Her lips floated a hair's-breadth from yours, the heat from her face mixing nicely with your Valium/brain damage buzz.

She whispered in your ear, "I think you'll be just fine." Then she told you what nights she worked at which clubs.

She didn't seem surprised that you were there every night. You dipped into the box in your closet, swapped jewels for cash at pawn shops, loved spending ill-gotten gains on Ava.

You bought every lap dance you reasonably could. When anyone else got too close to her they looked like Mikey Vinson.

You turned creepazoid one night, crawled her apartment when you knew she was at the beginning of her dance shifts at Sassy's. You were pro at climbing in through windows. Summer heat had everyone's open. Seemed she barely lived there aside from her disheveled futon and the explosion of clothes scattered throughout. You threw two pairs of her underwear in your CamelBak, rushed home for an epic stroke-fest. You tied her lacy yellow G-string around the base of your cock, huffed the blue cotton pair, and pounded yourself into exhaustion. You never ran short on fantasies—your favorites involved her sneaking into houses with you, violating every room.

If it wasn't obsession, it was pretty damn close.

Things seemed fine, spectacular really, until the night she invited you over for coffee at her place. You accepted, secretly ecstatic, but caught the heebie-jeebies when you noticed she wasn't talking to you on the way, kept looking over her shoulder.

At her apartment she brought you into the loop—She liked you, more than she expected. But she already had a man, on the low, and he was insanely jealous, sometimes to the point where he got rough. She didn't know how to leave him. She didn't want to endanger you. The guy never came down to her clubs, but his friends sometimes did. They'd noticed you. How could they not?

You puffed up your chest. "Who is this guy?"

"Have you ever heard of Stump Lo?"

Shit. You had. You un-puffed your chest.

Stump Lo was a Portland rapper who'd been struggling for years to pimp his pseudo-Cali-gangster-style hip hop to an audience more interested in commercial hits or backpacker rap. He was the dude you sat through while you waited for the good rappers to come on—tolerated but not loved. You could feel his resentment on stage.

Word was he'd shifted to coke sales a year or two back—he wanted the cred and his album sales weren't churning out the royalties—and had worked his way to the upper echelon of Snortland suppliers.

This moment is when you should've jumped ship.

Instead you looked into Ava's eyes and decided to tell her about your hobbies. It was the best sales pitch available, to offer an alternative bad-ass, one who wouldn't trap her in jealousy.

You told her you weren't a roofer, you were a fucking roughneck criminal. At the top of your game you were Portland's best cat burglar.

You also broke your code and exploited your parents' death, saying you'd even had to see their bodies. You told her you hadn't felt fear since that day. If she didn't want to stay with Stump she could roll with you.

You escalated your bravado with each detail. Her eyes sparked.

She wanted to hear more about your break-ins. You told her about all but one of them.

She loved your runner's scheme for evading the law.

She leaned over, put her hand on your face. Said she had an amazing idea.

You were all ears, you sorry Rescue Ronnie Captain Save-a-Ho motherfucker.

You sold the rest of your stolen swag, a whole day of pawn shop hustling.

You liquidated your trust, cashed out your swollen checking account.

Ava found a great place in the Caymans online.

You'd miss your Uncle, but had no other ties and figured that Ava's legs around your back could ease any pain.

Ava told you she'd already bought tickets.

She confirmed she'd found a buyer for Friday night—she knew dealers who liked to show off their cash in the clubs. Now it was just a matter of acquiring the blow.

Stump Lo was going to open a show for Keak da Sneak that night. A small opening, maybe a few hours, but after your score all that remained was

a shot up I-5 to meet Ava's connection. Then on to PDX and paradise.

You met up with Ava after her shift on Wednesday night. You wanted her to have your best diamond ring, from your first break-in. You couldn't bring yourself to hock it. You waited near her car, not wanting to risk any of Stump Lo's friends seeing you inside.

She ate it up. Even got a little teary-eyed. She put her hands on your hips, pressed her cheek against yours and said, quietly, "I think I might be falling in love with you."

She smelled like sweat, cigarettes, too much perfume. You loved it. You wanted to kiss her but she was gesturing you towards her car. You got in, thinking she couldn't contain her need anymore. You'd fuck right there in the lot...

Instead she wanted to review details for Friday. She would drop by Stump's place before the show, wishing him luck. She would make sure that his Rottweiler—named Scarface, of course—was kenneled. You'd watch for Stump to leave. Once he did you'd run around back and disconnect the A/C unit running into his office. That's your access point. After that it was simple—grab the coke/get out. Then a quarter mile jog to your meeting point. You'd roll in her car, make your sale, then get into costume for the airport.

She'd been inspired by your adventures in social camouflage, figured it could work to her advantage too. You'd enter PDX as proud parents-to-be. Her prosthetic belly-bump and draping maternity gear would conceal your collected cash nest egg as well as half a brick.

You questioned the wisdom of bringing drugs. Carrying serious cash was already suspect. The coke made the trip trafficking. Why risk it?

"The US dollar is on the decline. Coke is universal tender. We can turn it into money, connections, favors. I've never seen a pregnant chick getting searched at the airport. Have you?"

You hadn't.

"And now, with this rock on my finger, we'll look like we're engaged. It's perfect."

You considered proposing. Make it real, right then. But it might spook her, and you knew better times were coming. Wouldn't it be cooler to propose at sunset, in the sand, with a buzz kicking from some tropical cocktail?

Besides, you hadn't even kissed yet. For all you knew, though you tried to exterminate the thought, she might still be fucking Stump Lo. But if she was it was just to perfect her cover, keeping things smooth until you could begin your life together, right? You squashed the thoughts.

She pinned you down with her eyes.

"Are you ready for Friday night?"

The version of yourself that you were selling could answer only Yes.

Getting in was simple. You saw those window-mounted A/C units as "Open House" signs. You'd brought your LifeHammer as back-up, but all you'd needed to access Stump's residence was a small screwdriver and the ability to disconnect a plug.

You were halfway up the stairs to the guest bathroom where the stash was supposed to be hidden, feeling like the air had been replaced with a Dexedrine mist. Your mouth was dry, your face a sheet of sweat.

You noticed a drop of perspiration fall from the tip of your nose to the carpeted stair underfoot, and wondered if it could pop up as evidence.

You were bent over using your runner's glove to swab up the droplet when Scarface caught your left calf in his jaws.

At first you thought it was a severe cramp. Maybe you'd been favoring your left leg to protect your fragile right and the imbalance caught up with you.

Even when you heard the growl and felt teeth sinking in you couldn't quite believe it. After all, you'd received Ava's text: DG KNNLD, STMP LVG 1 HR.

What neither of you'd considered was that Stump might extract Scarface prior to leaving.

Call it an oversight.

An oversight that was quickly turning your left leg into shredded meat.

You collapsed forward on the staircase. Scarface dug in deeper, swung his head.

Agony.

You'd stopped thinking. You tried to kick out at him with your other foot but couldn't land more than a glancing blow. You wished you'd started running in steel-shanked boots instead of sneaks.

You tried to say, "Good doggy let go doggy" but when you opened your mouth to assuage, all that came out was, "AAAAAAA! SHITSHITSHIT! JESUS!" It riled him; he clamped deeper.

You found the beefy treats you always carried in your pocket for just such an occasion. You tried to extend your arms backwards with the snacks so Scarface could catch the scent.

No interest. So you did your best to wing the snacks at him.

A yelp! Sweet mother of mercy—his jaws cut loose for a second. You rotated, braced for further assaults.

Scarface was pawing at the right side of his face, whining. One of the stale old snacks must have clipped him dead in the eye.

For one tiny moment you felt bad for him. Then his head dropped below his shoulders. He was about to pounce again. You kicked out in desperation, eyes closed....

Both of your feet made contact.

Scarface thumped to the bottom of the staircase, laid out.

Shit! You felt terrible—instantly cursed. Steal a man's coke and his girl and he might move on with his life. But kill his dog? He'd probably hunt you to the ends of the Earth.

Without thinking you were limping back down the stairs, towards the dog, to see if you'd actually killed it. Then you heard a low growl.

Scarface popped up in full bristle, teeth bared, bloody.

Your blood. It took a second to recognize that.

You leapt up the stairs, four at a time. You had to lean more weight on your right. The tightness there turned to razor-wire. Then you were in the upper hallway and bounding, trying to remember what she'd said.

Third door on the left. Guest bathroom.

You collapsed into the third room, no longer caring if it was the bathroom, just wanting to kick the door closed. Shut out the beast.

You heard the door click shut and pressed your right foot against the wood, bracing it.

You could tell he was out there, hear him gnawing at the door with the side of his mouth. You reached up, locked the door. Gnashing turned to barking, guttural eruptions.

You worried about the neighbors being alerted but remembered what Ava told you—the whole joint was soundproofed since they used to get complaints about the studio bumping beats at all hours.

You flipped the light switch and caught yourself in the mirror. Bloody. Shaking. In track gear. The image ran ugly.

But at least you'd landed in the bathroom.

You were glad the mirror had to come down—seeing yourself in that moment brought in a rush of feelings and questions that were better not contemplated. You grabbed each side of the frame, lifted up, and pulled it back off its mounting screws.

The hole in the drywall was there, as she'd described. You reached in and found the plastic loop, pulled it off the nail in the stud. The loop was

attached to a vinyl cord. Your shoulders strained to reel in the compressed duffel bag at its far end.

Seeing the loot gave you new confidence. You'd found your grail—your princess was waiting for your return. You re-mounted the mirror, used a towel to clean your blood off the floor and then wrapped it around your leg to staunch further bleeding.

Scarface's paws thumped against the door, nails scraping, not calming down. You scanned the bathroom for a weapon and found nothing that would allow you to confront the hound with confidence.

That left one point of exit—a small sliding window above the shower.

You slid the window open, popped the screen. You tied off the duffel bag to your CamelBak and used the vinyl cord to lower them to the ground.

The drop from the second floor was unfriendly no matter how you went about it. You managed to hang and exit feet first. Both legs felt equally savaged so you couldn't pick one to bear the brunt of the fall. Instead you tried to let your legs collapse and shift your weight to the back so you could somersault out of it.

This did not work.

Your left leg hit first. Before you could shift your weight your knee was driven into your jaw. A world-class uppercut delivered by yourself. For a moment everything was fireworks, copper, dust. Then your brain cleared out.

You'd made it.

Your contraband was to your left, Scarface was a distant threat, and you were only a quarter mile from an angel-in-waiting.

What you didn't expect was . . . well . . . any of it.

Ava was at the meeting spot, a dusty trailhead near the Wildwood hiking areas. That part matched up with what you'd pictured.

She'd stepped out of the car, closed the door. She'd left the headlights off. You couldn't see her well. You'd taken longer than expected to reach her, moving along with a limping trot. You began to apologize.

"I know I'm running a little behind but you won't believe . . ."

And then she hit you with the Tazer.

You were already on the gravel before you recognized the crackling sound, felt the darts piercing your belly.

For a moment you thought that you'd been shot. That Stump Lo had

found the pair of you and you were dead for sure.

But it was Ava holding the Tazer, and she wasn't letting up on the volts.

Your right leg was folded underneath your body. With the next blast of juice you felt your calf pull too tight. Your fragile iliotibial band finally gave with an audible snap. You would have screamed if your jaw wasn't clenched shut.

Ava let up on the trigger. She said, "Bag!"

You gestured towards your pack and the duffel bag, thrown three feet to your side.

"Ava, what . . ."

She turned the juice back on. Grabbed the duffel, clearly not interested in conversation. She stepped closer.

"I'm going to release the trigger, but if you start to talk I'll Taze you until your hair starts on fire. Got me?"

You made your best effort at a nod.

She crouched closer. "You're not coming with me, but you should still run. You probably didn't even think of this, but Stump's place has a shit-ton of cameras. They make him feel gangster. He's no killer, but the people who supply him will not be pleased."

She'd been rehearsing this, leaving no room for emotion. Maybe she really loved you. Maybe this was some kind of test . . .

She continued. "You've probably killed me. This is what people will think. They will find a letter at Union Jack's, talking about how you'd been planning to rob Stump. You threatened to kill me if I didn't go along with it. You'd even joked about burying me out here in Forest Park and keeping the drugs for yourself. The girls I worked with last night think I'm scared of you. I really sold it. There are plenty of people who've seen you staring at me for hours. It will read as stalker behavior after the letter gets out."

"But, Ava . . ."

ZZZZRNT! You seized up. She was not trigger-shy on the Tazer.

"Don't try to find me."

Another long jolt with the Tazer. Then she was kneeling by your side, properly pegging you as too jellied for combat. Even in the dark, you could sense she was smiling. She was back at your ear.

"I did love the ring, by the way, but I had to sell it today. Easier to send off the single mother vibe without it."

Then she was over you. Her breath smelled like black licorice. She leaned in to kiss you on the lips.

And you, you sorry sonofabitch, you still wanted it. When her lips met

yours you closed your eyes, hoped time would slow.

But it ended, and she was up and the Tazer was left in the dirt.

"You're smart enough to know I'm right. Get the fuck out of Portland."

"Ava..."

"Good luck."

Her car door slammed. Headlights slapped you blind and she was gone.

You hobble-dragged yourself three miles before realizing you couldn't go further. Dawn would come and you were far too savaged for your runner's ruse to help you.

You made it to a house which looked unoccupied. You memorized the street address, crawled to the backyard to keep from being spotted streetside.

You drained the water from your CamelBak, still felt Death Valley thirsty.

There *was* one stroke of luck in all of this. Ava left you with your cell phone.

Call it an oversight.

Your first phone call was to Uncle Joshua. He slurred a groggy "Hello?" but was alert after hearing your voice. You gave him the address. Said to come to the backyard of the house. Don't ask why.

He didn't. You'd run with him as best you could this last Thursday, knowing it might be your last time together. He'd started to ask you questions about late nights, your hitchy right leg. You'd cut him off.

"Things are just kind of crazy right now. I met this girl..."

Uncle Joshua had laughed and let out a slow, knowing "Oh." You'd worked hard to ignore your leg, picked up the pace. He got the message.

You hoped he'd pick up his pace now. You'd lost a lot of blood. How long did you have before Stump figured out he'd been jacked? How long before Ava's friends would have the cops scanning Forest Park for a body they'd never find?

A light turned on over the patio at the rear of the house. Could be on a timer—you weren't taking any chances. You crawled across the grass, spotting a large and thankfully empty dog house.

You crept in, found it surprisingly plush. Call it delirium, but you swore the west wall had an on-switch for a tiny A/C unit. Even the *dogs* up in the hills were living easy.

You leaned against the rear wall, set your CamelBak on your belly. Unzipped the pack. Pulled out your accidental insurance policy.

You'd broken in to Ava's place on Thursday night, knowing she was working at Devil's Point, to bring her underwear back. Ever since you'd stolen them you'd felt weird about it. They turned you on, but you wanted to move past connecting to people through their things. You had a chance to be with the flesh-and-blood girl. Starting out psychotic felt wrong.

But once you were in her place you couldn't help exploring. You rifled the bag she'd packed, wanting to see what kind of swimsuits she'd be wearing to the beach.

You'd been living with compulsion so long you didn't even question it when you pocketed the thing. She was going to need it with her. This way you'd be certain she wouldn't forget it.

But you could have left it in the bag. It was already packed. She wasn't going to forget it. Maybe, deep down in the recesses of your memory, you were thinking of Mary Ashford and Sarah Miller, and that twinge of pain kept her passport in your pocket.

Your second call was to Information. They automatically connected you through to a Customs agent at PDX.

You noticed silver sparkles in your vision that couldn't mean anything good. Zoning on the passport photo helped you focus.

God, she *was* easy on the eyes. Too bad she was murder on the rest of you.

You told the man on the phone what she looked like, what kind of uniquely contraband baby she was carrying. You told him that the woman's birth name was Jean Christenson, but that she preferred to be called Ava, which was short for Avarice.

He noted that the name seemed appropriate.

"More than you'll ever know, pal." You closed the cell, thinking of her last words to you.

Good luck.

Your chest began to shake.

You were still laughing when your Uncle Joshua arrived and spotted your running shoes sticking out of the tiny house in the stranger's yard.

He crouched down, looked you over.

"Jesus! Are you okay?"

In between gusts of mad laughter you managed to say, "Nope. I'm in a bad place. I'm going to have to run."

"Okay, we'll get to that. First let's get you out of that fucking dog house."

He managed to get you upright, with your arm around his shoulder and as much weight as you could bear on your dog-mauled leg.

Once he started the car he looked over at you, seemingly relieved that you'd stopped laughing. The pain of moving had killed the chuckles.

Your Uncle had a hundred questions on his face. He asked one.

"The girl?"

You nodded in the affirmative then, over and over, guessing he would understand: Yes I was a sucker I thought it was love and yes I'm still remembering her kiss and the worst part is that if you ask me if I am still in love with Ava gorgeous terrible amazing vicious Ava I might say yes despite it all Yes.

You began to shake, nodding, mumbling, "OhGodohGodohGod...."

"Okay, okay. Take it easy. Trust me, you've just hit the wall. You know that's as bad as it gets. I'm with you. You're gonna get fixed up. You've got to tell me enough to keep you safe, but that's it. We'll go where we need to. And soon as you can foot it, soon as you get past this wall, the morning runs are back. And this time there's no dropping it. No goddamn way. Whatever's got itself inside of you, kiddo, we're going to hit the streets and clear it the fuck out."

He twisted his grip on the steering wheel, gunned his car down slender curving roads on the way to the hospital. Dawn was approaching. It was likely to be another beautiful grey-green morning in Portland. Could your Uncle really be willing to leave his home behind just to protect your mangled carcass?

You wondered at your luck, knowing this man.

He approached a red light, started to hesitate, took one look at you, and then pushed right through.

And you, you love-sick bastard, you finally let shock take hold.

THE GARAGE DOOR

KRIS SAKNUSSEMM

Mr. Kricorian was extremely upset by Newton's disappearance. As the boy's stepfather, he'd never felt entirely comfortable in the role of disciplinarian, although he sensed keenly sometimes how much Newton was crying out for discipline without knowing it. Three days before, he'd asked Newton to vacuum out the car. Newton became sullen, the way only fifteen-year-olds become sullen. Mr. Kricorian went off to tinker with a pegboard in the utility room. Soon he heard the whooshing of the vacuum hose.

Newton vacuumed out the car all right. But, in connecting the extension cord, he temporarily unplugged the freezer. Then he forgot to plug the freezer back in, and three gallons of ice-cream, which since the development of his stomach ailment, had become Mr. Kricorian's staple food, melted. Kricorian went out the next day and found six tubs of Butter Brickle soup.

Of course he'd had a little chat with Newton. Unfortunately he lost his temper. Now Newton was gone. No note. Nothing. The Barnharts said they thought they'd seen the boy sleeping on the beach, but that was hardly likely. It'd been quite cold at night. Kricorian wished his wife would say something. She seemed so level-headed. It made him feel guilty. It made him worry. He began to wait up at night for Newton to return. He even left some cold chicken, a carton of milk and a slice of torte out on the front step. But the next morning the food was still there.

His stomach started to burn again. He gulped at his Maalox. Come morning his wife would find him sleeping stiffly in the EZ Boy reclining chair. He insisted on keeping a vigil. Until some word came.

It was after midnight. He was sure because he'd watched the late news and then some comedy nonsense. He flicked off the TV. His wife was

THE GARAGE DOOR

asleep. He could hear her breathing. It seemed to him as if there'd been a knock. He rose, shut the bedroom door, and rinsed his face with tap water. He heard the knock again—a knocking—this time quite plainly on the garage door. His first thoughts were vague and territorial. If it was Newton, why wouldn't he knock on the front door? Why wouldn't he just let himself in?

Kricorian stepped into the dark garage brandishing the chin-up bar he'd yet to install. He decided not to turn on the light. Whoever it was outside would be able to see him too clearly. Of course, he would be at the same disadvantage. The knocking grew softer but more localized. He pressed the button that set the chain whirring and clicking. The door opened slowly and the night air poured in, cool and fog-smelling.

He stopped and listened, waiting for his eyesight to rejoin him. The pines and cypress trees across Buccaneer Drive looked darker than he'd ever seen them. He couldn't hear the waves. There was no one outside the door. He heard nothing. "Hello?" he said. "Who's there?"

He remembered the volunteer from the Cystic-Fibrosis Walk-a-thon. What a long way to come up the road for just one house. He wondered if it would be scary to walk through the woods alone in the dark. He was at the edge of his property when he felt the moist sand under his slippers. He had a sudden desire to urinate.

There were no stars visible, just high coastal clouds. He shivered as he finished and kept picking his way forward. He'd almost forgotten what had drawn him outside, until he turned around and strolled back within view of the house. He was proud of the place and stopped to admire what he could see of it in the faint front yard lights along the driveway, a little blurry now in the thin mist. The picture window that was perfect for sunsets, the redwood fence, the garage door. For some reason the garage door was now closed.

The mechanism hasn't been working quite right, it just closed by itself, he reasoned—although he wondered why he hadn't heard it. He must've wandered farther from the house than he'd thought. But in any case, how was he going to get back in? His wife was sound asleep and he naturally didn't have a key on him. Would she hear if he knocked? She hadn't heard the other knocking. He'd forgotten about that for a moment. He began to rap on the garage door, feeling the vibrations tremble through his hands. Nothing. The door was sealed shut. Finally, he got frustrated and squatted in the dirt and began flinging tiny clods against it. He was staring right at the handsome criss-cross design when he heard the grating of the chain. The door began to quietly hum and yawn, almost grazing him. He stared

into the darkness inside.

"Newton?" he called. The shadow moved again. "Who are you?" he snarled, groping for the chin-up bar he'd left on the bumper of his car. He heard a groan. The garage light snapped alive, blinding him as the darkness had.

It was a teenage boy facing him, buckled in a heap under the light switch. But it was definitely not Newton. It was a larger, stronger boy of seventeen or eighteen wearing what might've been a t-shirt. It was hard to tell because the boy was covered in blood. There was bright red blood all over his face and hands and arms—as if it had been painted on.

"My God!" breathed Kricorian.

"Crackup!" the boy blurted.

"Are you—are you all right?" Kricorian gasped automatically. "W-what did you say?"

"Car crash. I was driving. We had an acc—everybody's dead. I was the driver."

"You're hurt! There's blood all over you."

"Not mine. Stevie's blood—was leanin' out the window when we went over—over the bank. I'm the driver. I killed them all."

Kricorian stepped back from this vision absolutely petrified. "Did you—were you—knocking?" was all he could say.

"Couldn't find—other door," came the answer. "Didn't know where the next house would be."

"I think—I think you should come—inside," Kricorian mumbled, motioning the hulking youth through the door. "I'll get some towels."

Kricorian gave a quick thought to waking his wife but decided against it for the time being. Instead he grabbed a pile of towels and an old sheet out of the linen closet and laid the sheet out over the EZ Boy recliner. The boy flopped down in the chair. He looked as if he'd been struck dumb. Something bothered Kricorian about the look of the blood on the boy's body.

"I think you should pull yourself together—tell me what happened and then I'll make some phone calls. You should get to a hospital," Kricorian said, trying to sound calm and authoritative.

"Don't call!" the boy wailed suddenly. "It won't do—any good."

"We have to call. You have to report the accident and you should get some medical attention immediately."

The boy looked at Kricorian. He blinked. There was dried blood on his eyelids.

"Where did it happen?"

"Near here," the boy answered.
"I know that—but where? How near here?"
"Half-mile or so."
"Son, tell me where this tragedy happened!" Kricorian said squinting.
"On that sandy road behind the reservoir—where Doubloon runs into Corsair. Where they haven't finished bulldozing."
"You live around here then?"
"Sort of."
"What do you mean sort of?" Kricorian scowled.
"I mean—I don't live far—from here."
"I've never seen you before."
"I've never seen you either," the boy replied.
"What's your name?"
"Tobias."
"Tobias what?"
"Tobias Myson."
"Well... who else... was in the car? Are you sure they're all dead?"
"Three others."
"Who?" demanded Kricorian, his inflection getting away from him.
"You wouldn't know them," the boy said numbly.
"WHO are they?" repeated Kricorian too loudly.
"You'll wake your wife," the boy said, and blinked.
"My wife? She . . ." Kricorian lowered his voice. "How do you know about my wife?"
"I don't. But you wouldn't be living in a house like this—alone."
"All right, all right. So, who else was in the car?"
"They're still there. Dead. Jody... Kevin...and . . ."
"And?" Kricorian squirmed.
"Stevie. Only his head is gone."
"Christ!" Kricorian groaned, trying to come to terms with the imagined scene. "What in hell were you doing out on that road at this hour—on a school night?"
The boy gave out a low grunt of laughter at this and repeated the words ... "a school night."
"Have you been drinking? What did you expect would happen?"
"I don't know," the boy said, so softly Kricorian could barely hear him. "I—I didn't expect to—find a house with anyone awake—on this road."
Kricorian let out a huge sigh. This was serious. The boy's parents would have to be called, the police notified. One more day and his wife was going to let him contact the police about Newton. Mason? Was that the name

the boy had given?

"I think we better clean you up. You're covered with blood."

"It's not my blood. It's Stevie's. He was leaning out the window. I'm the driver. I killed them all."

"I—I know," said Kricorian, not sure how to answer. He went to get a bowl of water and some washcloths. When he returned, the boy was smoking a cigarette, rubbing the ashes into his pants, and watching television.

"What—what are you doing?"

"I'm watching *The Bird Man of Alcatraz* starring Burt Lancaster. I thought maybe it would calm me down."

"Listen. I better make those calls. Or you should. You'll get into big trouble otherwise. And you should be checked out in an Emergency Room—you don't know for sure you haven't been hurt. And I'd appreciate it if you didn't smoke in the house."

Kricorian reached over for the telephone receiver, but the boy's bloody hand got there first.

"Say, what is this?" Kricorian asked, staring at the boy who was now holding the phone.

"This? This is—a cigarette," the boy laughed, exhaling a cloud of stinging smoke in Kricorian's face.

"What—what's going?" Kricorian cried, his eyes reddening.

"What's going on?" said the boy.

"Listen, stop."

"Listen, stop," the boy mimicked.

"You better..."

The boy rose suddenly and gripped Kricorian around the neck. "I better what?"

"Stop..." wheezed Kricorian, the gas in his stomach burning out in a long humiliating fart.

The boy chuckled and shoved the man onto the couch. He walked stiffly to the kitchen and returned with a sponge from off the sink. Slowly, methodically, he wiped the television screen. "Fly specks," he said curtly. Then he marched back to the kitchen and flung open one of the veneer cabinets. A jar of Best Foods Mayonnaise the size of a PTA coffee urn confronted him.

"What the hell's this?"

"It's—it's a joke," Kricorian fidgeted. "Friends—gave it to us."

"You got anything to eat?"

"Look—in the fridge."

"I'll do that." The boy blinked a bloody eye.

"Listen... what... are you going... to do...?" Kricorian tried, hearing the quiver in his voice.

"What?" smiled the boy from the kitchen.

"What are you going to do?"

"What are you talking about?" the boy asked politely.

"Don't jack around with me!" Kricorian bellowed.

The boy crossed the room in two enormous strides and smacked Kricorian open-handed, a blow that sent him flying over the ottoman.

"Do you know who won the war between the Hassocks and the Ottomans?" the boy grinned.

"W-what?"

"Shut up! You just do as you're told. Jody and Kevin—and Stevie—they're all dead. Don't you see that? Me going to jail won't help them. Nobody knows I was out with them—it's Jody's car. I pulled him over behind the wheel. Nobody knows anything. Except you. And you're not going to breathe a word. Are you? Are you? They're not coming back from the dead. And I'm not getting busted. You just forget I was ever here. Okay?"

"But!"

"No buts! You've never seen me."

The boy turned and headed back to the kitchen. Then Kricorian made his move. From the counter he swiped a thin prong that had come with the self-basting turkey his wife had purchased the week before. He advanced toward the boy, pointing the sharp wire, sputtering.

"What do you mean by all this bull! What are you? There wasn't any car accident! Don't you think I know that? What's going on with you? Tell me! What are you trying to pull? Where—where did you come from?"

A look of extreme exasperation crossed the boy's face. "I don't believe this," he said. "I fucking don't believe you!"

"Shhh!" Kricorian commanded. "You'll wake my wife."

"What's the matter with you, man? You got a concussion or something? I've told you five times what happened. I was driving along, going home by myself—and you just ran out of the woods in your bathrobe. Like some madman. I tried to stop but I couldn't hit the brakes in time. I had to swerve. Don't you remember? I was going to use your phone."

"Wait a minute," interjected Kricorian. He had the prong poised against the stained neck of the tall boy. But he pressed too hard, and a bead of fresh blood appeared at the tip and ran down the wire. Kricorian burst out weeping. He staggered back to the EZ Boy, rocking it, rocking it until it sounded like it was going to break off.

"Don't," the boy whispered. "Please, don't."

"Don't go!" moaned Kricorian.

"I have to."

"Oh," sobbed the man, biting his tongue. "Well . . . couldn't you . . . no. At least have a glass of milk. I poured one for you earlier. It's—it's just there."

"Okay," the boy said, stepping over to the counter.

He gulped at the lip of the glass. Some of the flakes of dried blood on his face dropped into the glass and swirled around. "Here, you finish it."

Kricorian did and wiped his mouth. "Don't go."

But the boy was already at the door to the garage.

"You won't come back, will you?"

The boy glanced down at his blood-spattered sneakers.

"I've never seen you," Kricorian said. "I've never seen you."

The bloody eyes blinked and vanished into the darkness of the garage. A second later, Kricorian heard the heavy clicking of the ungreased chain. He figured the boy had to roll to get out under the door as it was closing. But maybe not.

NIGHT FILMS

MIKE KLEINE

12 Months, 9 Days.

The woman with the yellow hair walks into the man's apartment.
"What are you watching?" she asks.
"An airplane movie," the man says.
"What's an airplane movie?"
"A movie with airplanes, I guess. I'm not sure."
"What else?" the woman with the yellow hair says to the man. "In the movie, besides the airplanes?"
"I don't know, it's only been airplanes so far."
The woman with the yellow hair stands and watches some of the airplane movie.
The program is called *World War II-era Airplanes.*
She knows this because it is written in canary yellow Constantia font on the television screen.
On the program, World War II-era airplanes keep changing colors. And the sound of World War II-era airplanes is replaced by the sound of motorcycles.
For example: on the television screen, a Cardinal red Savoia-Marchetti SM.81 makes the sound of a Honda CB400N and gets shot down by a Navajo white Kawasaki Ki-100 making the sound of a Suzuki GSX 650F.
"Why are you watching airplanes," the woman with the yellow hair says to the man, in the form of a question with no question mark.
"It seemed interesting, and I was bored."
"Yeah?"
"Yeah, I was bored, but it might—it may get better, I don't know."

A gunmetal grey Kokusai Ku-8 appears on the television screen and makes several Lubero G5 sounds, before disappearing in a haze of dust and smoke.

The number 700 flashes, in bold white lettering across the television screen.

Then the credits.

The song 'Stay' by Maurice Williams & the Zodiacs begins to play.

"It's so infinite," the woman with the yellow hair says, to the television screen.

17 Months, 29 Days.

The woman with the brown hair says she lost her shoes. Or, that someone took them. She isn't sure.

She says, to the man from yesterday, "I lost my shoes."

And the man from yesterday says, "Okay."

This isn't enough so the woman says, "No—not yesterday. I mean, maybe today, someone took my shoes."

"Okay," the man from yesterday says, again.

"I think."

Again, the man from yesterday says, "Okay."

"Let's call some people," the woman with the brown hair says.

First, the woman with the brown hair calls Allen, a friend from university, and Allen says, "No, I wouldn't—don't know where the shoes are."

Then the man from yesterday calls Gérard, the personal trainer of the woman with the brown hair, and Gérard says, "If you have a space underneath your staircase in the house, then there is a *chance* the shoes maybe are in that place."

The man from yesterday looks at the woman with the brown hair.

"I don't have *a* stairs," she says to the man from yesterday.

And to Gérard, he says, "I don't have any stairs."

Five minutes pass before the woman with the brown hair calls Emili, from work (not Emili from Leicester), and Emili says, "I'm a little tired right now, so call tomorrow, please."

She hangs up.

"I feel nauseous," the woman with the brown hair says, to the man from yesterday.

"I feel nothing, at the moment," the man from yesterday says, to the woman with the brown hair.

The woman with the brown hair leaves and goes to take a nap.

During this time, the man from yesterday decides there is enough time to watch a program on the television.

An hour passes before the woman with the brown hair wakes.

She walks into the room and sees that the man from yesterday is watching a program on the television.

"What program is this?" the woman with the brown hair says to the man from yesterday.

"South America and Volcanoes."

"We need to meet new people," she says, to the man from yesterday.

"Yes, people," he says, to the woman with the brown hair.

The woman with the brown hair squats and turns off the television.

The man from yesterday stands and dials a number to call Hannibal—actor and old friend to the woman with the brown hair—and Hannibal says, "I'm making a movie—post-modern on the road film genre—it's all going to be done next week."

The woman calls Twyla, from the nursing home, and Twyla says, "Patty's dead. And her grandson is missing, so I don't know where she is. I think this is important."

The man from yesterday calls Antoine, famous physics professor from the university, and Antoine says, "There's a book release party for my book this Thursday, if you can make it, I'd be delighted."

The man from yesterday looks at the woman with the brown hair and says, "Antoine says there is a book release party this Thursday for his book, and he'd like for you to make it."

"Tell him I'm not going," she says.

The man from yesterday stares at the woman with the brown hair.

She stammers.

"I can't," the woman with the brown hair says to the man from yesterday. "Just—just make something up."

"I can't," the man from yesterday says to Antoine.

"A pity," Antoine says.

The man from yesterday presses the *end* button on the telephone.

The woman with the brown hair calls André, collector of old books and reviewer of published essays, and André says, "I'm flying to Morocco, this week. Something work-related, I think. Need some time off—to get away."

The man from yesterday calls Hervé, who lives in Madrid, and Hervé

says, "It's nice out, today, the sun is here and I can feel it on my face. How are you? Serge tells me you left your shoes here last month. At the picnic. Near the gazebo he thinks, or something, remember." And Hervé says something to Serge. "Yes, he says—Olive shoes?"

The man from yesterday looks at the woman with the brown hair and says, "Olive shoes?"

"No," the woman says.

She looks down at the shoes on her feet.

"No," the man from yesterday says to Hervé.

"The shoes are black."

63 Months, 1 Day.

The man from now walks into the bedroom.

There is a note on the end table, from the woman with the dark hair, in easy-to-read cursive.

"Someone called and asked to speak with you but I told them you were out. I didn't recognize the voice and I didn't know who it was. I don't really know many—any of your friends. So I asked the voice *who is this* and the voice said *it's not what is important*. And then it asked me when you'd be coming home and I said I didn't know— you never said when you'd return, but I didn't tell the voice that, I thought it to myself—so, the voice kept asking for you and where you were and I kept saying I didn't know but it didn't seem to matter, what I said. In the end, I decided to tell the voice you had gone on a trip somewhere, alone, so I said, *to Las Vegas, I think*, and that you wouldn't be coming back for something like two weeks. I might have said *three*, I don't remember, maybe. But then the voice, whoever it was, said something else, I couldn't hear too well, and it didn't seem to appreciate much of what I was saying so, I gave up trying to understand and hung up. Hope everything's fine though. Love you."

108 Months, 16 Days.

The man from tomorrow walks into the living room.

The woman with the silver hair is sitting.

She is watching something on Netflix.

"I love you so much."

"I love you too, baby," the man from tomorrow says.

"No, I love you more than you know," the woman with the silver hair says.

She looks away from the television screen so she can say this to the man and his face.

"How much more?" the man from tomorrow says.

"What, my love?"

"Your love, yes," the man from tomorrow says. "How much more?"

"My love for you is as deep as the Euphrates."

The woman with the silver hair says something else, and she is distracted by what is on the television screen, so she puts both arms out.

The man laughs.

"That's horizontal baby," the man from tomorrow says.

He walks over to the woman with the silver hair and pats her on the leg.

"You said deep."

The woman with the silver hair laughs and says something else about the Euphrates.

The man from tomorrow sits.

"That's the Nile baby, the Nile."

He looks for the remote—the man from tomorrow—for maybe a minute, and then says to the woman with the silver hair, "What's on the television?"

"Something about life."

On the television: a confusing car chase.

"Have you ever heard the words: *zombie caterpillar?*"

"*Zombie caterpillar.*"

"Yeah, zombie caterpillar," the man from tomorrow says.

A turquoise Nissan Ultima explodes and a hazelnut Toyota is driven into a swimming pool.

Smoke and blue strobe lights.

Like at the disco.

"Zombie caterpillars," the man from tomorrow says. "When they are ready to die, zombie caterpillars, they climb to the tops of trees, so later, when they liquefy, they literally rain down onto others—the insects and plants—to infect them."

On the television, a totally white 2010 Nissan Maxima SV Sport suddenly becomes a non-photo blue 2006 Nissan Titan King Cab and

something by Angelo Badalamenti begins to play.
 Smoke and blue strobelights.
 Like at the disco.
 "How strange," the woman with the silver hair says with a smile. "It's like real life."

THESE ARE THE FABLES

AMELIA GRAY

We were in the parking lot of a Dunkin' Donuts in Beaumont, TX when I told Kyle that I was pregnant. I figured I'd rather be out under God as I announced the reason for all my illness and misery.

I said to him, Well shit. Guess we're having a baby.

"Lemme see," Kyle said. I handed him the test and he squinted at it for a second before tossing it into a bush. A stranger set his coffee on the roof of his car and clapped. Kyle flipped him the double deuce. "People these days," Kyle said.

I said that my mama will be happy.

"Here's the thing," he said. "Your mama's dead. And you're forty years old. And I have a warrant out for my arrest. And I am addicted to getting tattoos. And our air conditioner's broke. And you are drunk every day. And all I ever want to do is fight and go swimming. And I am addicted to Keno. And you are just covered in hair. And I've never done a load of laundry in my life. And you are still technically married to my drug dealer. And I refuse to eat beets. And you can't sleep unless you're sleeping on the floor. And I am addicted to heroin. And honest to God, you got big tits but you make a real shitty muse. And we are in Beaumont, Texas."

I said, These are minor setbacks on the road to glory.

"And," Kyle added, "the Dunkin' Donuts is on fire."

I looked, and indeed it was. Customers streamed from the doors, carrying wire baskets of bear claws, trucker hatfuls of sprinkled Munchkins. "Get out of here," one of the patrons said. "The damn thing is going up."

I said, Kyle. Listen. I said, We're going to have to make it work, we'll forge a life on our own and the children will lead us.

The wall of donuts had fueled a mighty grease fire. The cream-filled

variety sizzled and popped and sprinkles blackened. Each donut ignited those within proximity. Their baskets glowed and charred. The coffee machine melted. The smoke was blue and smelled like a dead bird. I took Kyle's coffee cup, popped the lid and vomited into it. I felt sadness, because all I had wanted that morning was a Munchkin and the absence of puke. I said that everything would be all right, that we were living in the best of all possible Dunkin' Donuts parking lots.

He pushed some dirt over the test with the toe of his boot. "Poor girl," he said. Between his sensitive nose and sour stomach, we both knew the next nine months plus the eighteen to twenty-two years after that would wreak some manner of havoc.

I said I was sorry because it seemed like the right thing to say. I put the coffee cup on the ground because the trash bin inside was consumed by flames.

Kyle took my hand. We had to get out of there before the cops showed up to the fire and started checking IDs. He guided me to the car and opened my door. He bought half a dozen roses at the Kroger and laid them between us on the dash.

"Let's get back to the Rio Grande," Kyle said. He wanted to avoid Houston, which is sort of like wanting to avoid a talk from your mama when you come home with a Keno addict. I tipped my seat back and dug into sleep like sleep owed me an explanation. Kyle skimmed Houston on the tollway and headed for the coast, hitting cities with names like what you'd find across the spines on your grandma's bookshelf. Blessing. Point Comfort. Sugar Land. Victoria.

It's how we ended up in the Days Inn in Corpus. Kyle examined a road map in his underpants while I took the bucket to the ice machine. A crowd of tourists were standing in the laundry room. They were speaking languages.

A young woman touched my ice bucket. "We are looking for where Selena was murdered," she said.

I said I didn't know what she meant. "Selena the Tejano star," the woman said. "Fifteen years ago at this very Days Inn. I am disappointed in you," she said. One of the women was leaned up against the ice machine. She had her face pressed into her hands and her hands were pressed into the ice machine.

"They won't tell us where," the young woman said. "They changed the numbers on the doors so we won't find out."

I said I didn't know.

She pulled me close. "There are secrets at this Days Inn," she said.

I said that there were secrets at every Days Inn. The ice machine was broken and the women wailed for unrelated reasons.

"Our angel," one woman said. She was holding a gilt-framed photograph of Selena singing on stage. She did look like an angel. I wanted to lie down on the laundry room floor.

In the room, Kyle was eating a waffle in the shape of Texas. I stood in the open doorway.

"The first ingredient is corn syrup," he said. He was a shadow in the back of the long room. He said, "The second ingredient is high fructose corn syrup."

I came in and locked the door. He was wearing his lucky buttoned shirt and a clean pair of pants. He had his shaving kit out on the table. The blade was drying and his face was shorn and cold. I told him he looked like he was getting ready for a funeral.

They say that hotel room floors have the e. coli but I lay down anyway. Kyle came and settled near me. When he pressed his cheek against my belly I could feel the machinations of his jaw grinding tooth on tooth. I said, These are the fables I will tell our child.

SEXTAPE

SIMON LOGAN

She rings the bell on Voodoo's door and as she waits for him to answer she fingers the videotape in her bag and wonders if this is the worst thing she has ever done.

"You look like shit, Jess. What the hell time is it?" he says when he answers. He ties the cord on his robe and sweeps back sleep-ruffled hair from his forehead. "Come in."

His apartment is almost as small as hers, everything crammed into a single living space as if it were the leftovers of some larger, more comfortable home. In the glow from his computer monitor he pushes aside a stack of trashy magazines to make room for them both on the sofa. He lights a cigarette and takes a drag.

"So what have you got?"

She hands him the tape.

"Bentley," she says, taking the cigarette from him as he gets up and feeds the cassette into one of the VCR decks stacked up on his desk.

"Jade or Ludwig?"

She sucks on the cigarette and lets the images which flicker into life on the TV screen answer for her. Shaky shots of a mansion, moving through dark bushes towards it, towards a ground floor window. The camera takes a moment to adjust to the change in brightness. When it settles down a woman is visible in the room beyond the window, laid out on a table. Portable lights are gathered around her and a man in a surgical smock leans over her.

"You got onto the grounds of her house," Voodoo says admiringly without looking away from the screen. "What am I looking at?"

"A private abortion," she tells him.

Voodoo's mouth drops open a touch.

"How the fuck did you . . . ?"

"So do you want it or not?" she asks. On the TV the surgeon walks away from the operating table, removes his bloody smock. The woman gets up gingerly then promptly throws up, dark vomit splashing the ground beside her. The camera zooms in, enough to see the tear stains on her cheeks.

Voodoo hits *pause*, freezing Jade Bentley's grief in place. "It'll be up within the hour," he says, crossing to the kitchen. He takes out a box of cereal stuffed with cash and counts out two hundred dollars.

"Is there anything you wouldn't shoot?" he asks her, handing her the money.

"Is there anything you wouldn't buy?" she counters, taking it from him and shoving it into her bag. "Anyway once they're on film they're just stories."

The bones in Voodoo's face catch the glow of the TV screen. "You're so thin I could cut myself on you," she says.

Voodoo nods. "Until one day I'll just disappear."

She gives him back his cigarette, now ringed with her dark lipstick. "See you."

"When was the last time you slept?" he asks her as she walks away.

"What day is it?"

"Thursday."

She stops, thinks about it for a few moments. "What month?"

Now seated in a booth at the back of an all-night diner. She feels herself drifting, everything muffled and distant, then snaps back when Barker sits down across from her. A waitress coalesces beside them and tips coffee into a mug for Barker.

"So did your blogger friend take it?"

Jess drops the crumpled notes onto the table before her and Barker cocks an eyebrow.

"That's all he gave you for it?"

She shrugs. "Standard."

"You realize that's not even 10% of what he's going to make feeding it to the networks don't you?"

"Which is why you're here," she says.

Barker smiles. He takes a sip of the coffee and his face crumples into a grimace. He spits the mouthful back into the cup, glancing across at the

waitress to make his disgust clear. He hands Jess an envelope folded in half and wrapped in an elastic band.

She reaches across to take it but Barker holds tight.

"You're certain it'll make the networks? Your payment is predicated on that footage going viral, not rotting on some shitty little website that nobody cares about."

"That shitty little website that nobody cares about will absolve the networks of any blame or guilt showing the footage," she tells him. "*They're* not exploiting Jade Bentley—Voodoo Woycek is. They're just reporting on it."

"Good," Barker says, smiling again and letting her take the envelope. "You do realize I'm only doing this in the best interests of my client?"

"Do I look like a priest to you? I'm not here for you to confess your sins."

"And I have no need to. I'm just doing what an agent is paid to do. The film roles are drying up and she's not getting any younger. She just wants to feel loved. They all do."

"Good for her," Jess says, standing. "I gotta go."

"Wait," Barker says, sticking a leg out from under the table to block her exit. He indicates for her to sit back down. "I might have another job for you."

And as tired as she is the thought of returning to her apartment, her bed mockingly tempting her with a sleep she knew wouldn't come, makes her rejoin him.

Barker slips a hand into the inner pocket of his designer suit jacket and removes a Hi-8 tape. He places it upright on the table between them.

"What's on it?" Jess asks.

"It's a sex tape."

"Who?"

"To be honest I'm not sure. This is a favor. For a friend of mine. "

"Which friend?"

Barker's expression remains neutral. "Just a colleague."

"You know how hard these things are to sell nowadays? Nobody gives a shit any more."

"I realize that . . . but if you could at least try I would greatly appreciate it—and of course would recommend you to my colleagues for any future work."

Jess takes the tape, standing again. "No promises," she says then walks out.

In the darkness of her apartment the red light of her answer phone strobes. The digital readout displays the number four.

Without turning on any other lights she hits the PLAY button then crosses to her refrigerator, hunting around for something edible whilst the messages play.

The first is a tip off about some movie directors' drug deal that will be going down the next night, offering her exclusive rights to the bust. The second is her bank reminding her about overdue loan payments, the third Voodoo letting her know that the Bentley footage was now live and had already drawn in 20,000 hits.

The final message plays, nothing more than a background hiss. The hiss continues whilst she pushes aside old jars of mayo and cartons of Chinese food which have developed a thin fur of mold. Then there's a voice.

"*Open the door.*"

Jess stands up. Nothing but hissing again. She hits BACK on the answer phone and listens to the message again.

"*Open the door.*"

Now wishing she'd turned on another light she slowly crosses to the apartment door, described in a fuzzy glowing outline. She listens for the sound of anyone outside then reaches for the handle. Turns it. On the answer phone the static continues, seeming to grow louder, urging her to follow the instruction.

She opens the door. Beyond, the corridor is empty. Halfway up one of the ceiling lights flickers from a faulty connection. Behind her the answer phone beeps then goes silent.

She closes the door, locks it then engages the security chain. Turns on every light she can find including those in the bathroom and finally her bedroom. Staring down at her bed, the sheets still unmade, she again becomes aware of her overwhelming tiredness but resists the urge to lie down. She knows by now that the sensation is a trick, that as soon as she lies down her mind will rouse once more.

Instead she empties her pockets onto the kitchen counter, the money from Voodoo, the money from Barker—and the tape. From in amongst a pile of VHS cassettes she finds a Hi-8 adaptor and clicks Barker's tape into place then slides it into her VCR. Her TV shivers into life with a static drone which echoes that from the answer machine message.

At first there is only darkness and the sound of heavy breathing, sexual groans, then an image blurs into view. A naked couple wrapped around

one another, lying on a bed. The man is on top, pinning the woman by her arms as she bites down on his shoulder, their movements slow and intense. What at first seems like his hair then looks more like a hood of some sort, fastened around his neck. The camera's focus keeps changing as the operator zooms it in and out, the bodies merging and distorting.

Jess sits forward, trying to determine who they are. The man's back arches, the woman's nails digging into him and then he moves his head to one side and as the camera finally steadies the woman's face is revealed.

Barker comes to the door after three solid minutes of her ringing the bell of his compact mansion. He wears an expensive silk robe with a handgun butt sticking out of one pocket.

"What the hell are you . . . ?"

She pushes past him hard enough to knock him to the ground, snatching the weapon as she does so, slams the door shut and locks it. She holds up the Hi-8 tape, still in its adaptor, and aims the gun at his crotch.

"What do you want? Who put you up to this?"

"Put me up to what?"

He's far calmer than he should be. Jess figures this probably isn't the first time he's had a gun pointed at him.

"Get up," she says and forces him through to his living room. She puts the tape into his VCR deck and powers on the enormous TV. She stands next to it, the gun still trained on him, watching his reaction. Sex noises fill the room via expensive surround sound speakers.

"I don't understand," Barker says. "What?"

"That's my bedroom. That's me."

Barker frowns, squinting at the grainy footage. "No it's not."

Jess tightens her grip on the gun. She figures he's just trying to trick her into looking at the screen, distracting her enough to grab the weapon back, but is compelled to look anyway.

And it's not her. Not her bedroom.

"What are you doing?" she asks, the gun shaking in her grasp. The static beneath the sex noises disorients her. "What are you up to?"

"I'm not up to anything," Barker says.

On the TV the woman slides out from under the hooded man, her hair far longer than Jess's. She spreads her legs and pulls him into her desperately.

"Who gave you the tape?"

"I told you already, a colleague."

She cocks the weapon.

"Okay, okay," Barker says, holding up his hands. "I was at a club, *Chiaroscuro*. This guy came up to me in the bathroom. It happens all the time when people figure out who you are. Audition tapes, stolen CCTV tapes, you name it. Normally I pay no attention but this guy . . ."

His words trail.

"Who was he? What did he look like?"

"I don't remember. I was a little high and one of the lights kept flickering. Are you okay? You look . . ."

"Shut up," she says, then ejects the tape. She puts the gun down on a shelf next to the TV and strides past him, needing to get out of there and away from the echo of the static-filtered sex noises which fill the room.

Back at her apartment she switches the lights on one by one before entering the bedroom. She turns on the bedside lamp and looks down at the rumpled sheets, the scene blending with that from the tape and she calculates where the camera would have to have been positioned. She studies the opposing wall, running her finger across each crack, knowing how small covert cameras could be, but finds nothing.

She moves aside a small drawer unit to check behind it though the angle seems too low then stops dead. With the drawer unit gone a set of shoe prints are revealed in the carpet pile. She turns, placing her own feet next to them but not daring to come into contact with the impressions themselves, and when she looks back down at the bed it is framed in exactly the same way as on the footage.

Someone has been in her room.

The realization is quickly shattered by the ringing of her phone and she rushes through, suddenly compelled to be out of that room. She puts the handset to her ear and there's a noise like a de-tuned radio.

"*Open the door,*" a voice says.

The panic which had begun to swell within her in the bedroom now threatens to overwhelm her, the phone shaking in her hands. The message is repeated. *Open the door.* She stares at her front door, wanting to run but unable to move. She can't shake the feeling of there being something else in the apartment with her and then the screaming begins, pouring down the phone and into her head and she drops it, throwing open the door and running out into the corridor beyond.

The screaming follows her all the way out into the parking lot.

"I didn't know where else to go," she says as Voodoo leads her towards the couch. He tries to get her to sit but she resists, too full of nervous energy.

"Jesus, Jess, look at the state of you. What happened?"

"I don't know," she says, pacing back and forth. "I don't fucking know."

She pulls the tape from her jacket and gives it to him, tells him to put it on.

He loads it up and images emerge from the darkness of his TV screen.

"A sex tape?" he says, unimpressed. "And this should interest me why?"

"Do you recognize her?" Jess asks, pointedly not looking at the screen, still pacing.

Voodoo studies it for a few moments, cocking his head from side to side. "I don't think so."

And now she looks at the screen herself and once again it's her in the footage and she's too disorientated to know if she should feel relieved or not.

"That's my bedroom, Voodoo. Someone was in there. Someone filmed me."

"You're saying this is *you?*"

He studies the footage further, the couple writhing sluggishly like drugged murder victims. "It doesn't really look like . . . I mean I guess it could be but . . ."

"I don't know who the guy is. I don't remember any of this, Voodoo."

"You think he slipped you a roofy then filmed himself fucking you?"

"Not him. Someone else was there. You have to tell me, is that really me?"

"I can't really tell, Jess, it looks like you but . . ."

"How would we know?" she asks. "How would we know if that's really me in that tape or if it's really me here with you? Both can't be real."

"Jess what are you talking about? Look, sit down, let me get you . . ."

She snatches her arm away when he tries to take it, stabbing the PAUSE button on his VCR deck. She stares at the screen, the frozen image a zoomed-in frame of the woman clutching the sheets in a fist.

"Jess? What is it? What do you see?" Voodoo asks, his voice full of genuine fear.

"A club stamp," she says, pointing to a blurry mark on the webbing between the woman's thumb and forefinger. "For *Chiaroscuro.*"

"The club over by the river?" Voodoo says, squinting at the screen, the image jittering as the tape head tries to hold onto the frame.

"I remember. I think I remember going there."

"To that dive? What the hell for?"

And she turns to him, her eyes bloodshot and rimmed with dark shadows but alive with the reflection of the video footage. "Because I wanted to feel loved," she says.

Each of those ahead of her hold out their hand to the man and he takes the money they hold in it then presses a small stamp onto their skin before letting them into the building.

When Jess reaches the front he grabs her hand, his eyes hidden behind the dark glasses he wears, then he stops.

"Okay," he says, waving her in without taking her money and when she looks at her hand she sees that there is already a stamp there, just as there had been on the tape, but smudged and faded.

Inside, fast and menacing drum and bass fills the place, the crowd instantly swarming around her, drawing her in so that she quickly loses her bearings. The club lights strobe, turning the people into stuttering multi-coloured creatures which flick in and out of existence until she sees a figure drifting towards her. Lit from behind he is nothing but shadow, slightly stooped. Fear blossoms with her and she has to fight her way clear as consciousness threatens to elude her.

She staggers towards the toilets, the looped sample of a woman groaning in pleasure or agony now playing over the music. Jess bursts into the toilets and dives into a cubicle, pulling the door shut behind her.

Slumped across the seat, her breathing is ragged and she is soaked in sweat. The vomit comes quickly and easily then she closes her eyes, trying to shut everything out until she reorders it all into something which makes sense. The music thrums through the walls like a heartbeat.

A gasp comes from one of the other cubicles. A woman's sigh, a moan, then the soft slap-slapping of sex. Jess breathes deeply, rocking back and forth. She starts to cry. She clutches a hand to her mouth to try and stop herself but the sadness forces it's way out as easily as the vomit had. The fucking sounds grow quicker, more desperate.

Then through the tears she notices words scrawled on the cubicle wall in lipstick.

Open the door.

The bathroom lights flicker, making the words seem alive.

Her breathing slows and she stands up. The other woman's groans continue, deep and shivering, she whimpers. Jess pushes the door open.

Beyond it is dark and quiet, the music gone but the sounds of sex still there. Jess steps out of the cubicle and into the darkness.

Then figures become visible, two people entwined before her on a bed. The woman lies on her stomach, the man on top of her, and she arches her back as he slides in and out. He grips her hair with one hand, pressing his face into the back of her neck.

Jess tries to see his features but they are distorted by the hood he wears and the couple's now-frantic movements. The woman clutches the sheets and then she looks up at Jess and Jess watches herself, watches the woman. Jess adjusts the focus on the camera she holds.

Everything is reaching a crescendo, the sex becoming quicker and louder, Jess crying again, the tears flowing, draining her of everything inside. Jess tries to scream but the only sound that comes out is the thick and growling static of an empty broadcast.

THE DROWSY MAN DREAMS

NICK MAMATAS

The air in the Rucksack Truckstop and Diner is gray, grainy. It sizzles. That's how it looks to Laura. Even Elmer, standing before her on the other side of the Formica countertop, hands at his sides as if waiting for a cue, shimmers as if constructed from extra-large molecules. His nameplate reads ELMER. Between them, a cigarette burns in an ashtray. It is Laura's. It's easy enough for us to imagine her smoking all the time, a pair of giant lips and nothing else. She looks down at the cigarette, then up at Elmer.

"What'll it be?" Elmer says. He swings his hands into the pockets of his apron—they are large hands, small pockets—and then raises his pad and golf pencil to his chest.

"I want a coffee. Black as a moonless midnight." Laura smiles. She has a crooked smile. A faded scar run from the corner of her mouth, up her left cheek. "And I want somebody killed."

"One," Elmer says as he writes, "coffee." When he returns with the coffee, in a white cup, on a white saucer, he looks at Laura expectantly. His eyes are huge. They could fill a wall. The bloodshot streaks pulse as he speaks, his voice lower now. "And who is it?"

Laura flicks her chin, sending the wayward hair of her wet bangs away from her forehead. "There is a man."

A pair of headlamps tear down a highway, burning orange. Either side of the road is desolate, just short of desert. A factory of brick and tombstone windows appears in the reflection of the windshield, crawling over the curve of the glass. There is a driver in the car. He is a young man, who looks even younger than he must be. Like a girl dressed as a boy. He turns to his passenger. Another man. Older. Pock-marked. Teeth wide as fingernails. He is smiling.

"I can smell it, Jim," says the wide-toothed man.

"You can smell *him*, Todd," Jim says. Jim turns to the window, and depresses a button. The window lowers into the well of the driver's side door of the car and Jim inhales richly. "That's him. Flour, and vanilla, and bananas, and pussy. Dried pussy flakes. Out there in the dark."

"You're a dirty-minded son-of-a-gun," Todd says. His voice is like rough pebbles. He grins, jogs his shoulders in a silent cackle.

Jim leans on the steering wheel. The horn blares and doesn't stop blaring. Just one long long blare. Todd howls and raises his arms and clenches his fists and howls again, then his howling collapses into a sputtering cough. Jim lets up on the horn.

There is a shadow in the swirling pool of headlamp light. There is a shadow stepping toward the car. There is a shadow, and it shuffles slowly. Another few, painful steps and the shadow falls away from a man. The man rests his palms on the hood of the car and squints at Jim and Todd inside. He is wearing a blue-collared jumpsuit. He yawns, and puts a fist to his mouth, then puts that hand back on the hood of the car.

"It's the Night Shift!" Todd leans over Jim, his big shoulder jamming the little man into his seat. Jim smacks at Todd ineffectually, then struggles with the seat belt pulled taut against his neck. "Night Shift!" Todd shouts again, his head worming out the window. "Gimme a freebie! Gimme a freebie!" The Night Shift smiles and raises a finger then reaches behind his back and from a rear pocket withdraws a cellophane-wrapped pink snack cake. He throws it underhand, and Todd half-lurches out of the car window to catch it. Jim, crushed against his seat, wriggles around and smacks at Todd's broad back again. Todd slides back into his own seat and struggles with the cellophane. The man fills the open window of the car and peers at Jim as the young man arranges his suit jacket, smoothes his necktie.

"That fellah sure enjoys his riboflavin," the man Todd called the Night Shift says. Todd peeks up from his snack cake. His lips are on the corner of the pink blob. He goes back to nibbling it, daintily.

"He likes to make them last," Jim says to the Night Shift. "But everything goes away in the end."

"That's true," the Night Shift says. He casts a glance over at the factory. "Once upon a time, third shift had two hundred souls, every night, singin' and a dancin', filling cakes with cream filling. Banana filling. Chocolate filling. Raspberry thrilling."

"All things must end," Jim says.

"It's just me now," the Night Shift says. "Just me and the machines. I

pull a lever at 8 pm, and watch the old girl go hog wild, hog wild in her guts, all night long, till 5:55 am."

"Guts," Todd says, his mouth full of cream, his lips flecked with pink. "Cream filling!"

The Night Shift runs his fingers through his hair. He looks at the ground. He sighs, deflating. "Well boys, it was real nice for you to come out all this way and visit with me, but I have to get back to work now. There's a lot of work that needs doing." He takes a step back and stands tall. Without saying goodbye, Jim puts the car in reverse and drives away from Night Shift. Todd reaches over to the steering wheel and honks the horn again, quick bleats. Jim swings the car around, the headlamps huge spotlights throwing spidered shadows across the wasted landscape, then guns the engine and the car roars into the night. The Night Shift turns and walks down the highway, right on the yellow lines.

Jeremy's hands hover above the keyboard. He's in a cubicle, between two other cubicles. The world buzzes fluorescent blue. Someone is snoring loudly. Jeremy stands up and raises himself to his tip-toes. His cubicle is one among many. The large room the cubicles are in looks itself much like a cubicle. It's a roaring snore, thick and buttery, coming from the depths of a face very much unlike Jeremy's. Jeremy's face is narrow, hawklike. His nose is prominent, his brows heavy. He frowns at the snore of a heavy man, somewhere, in some cubicle nearby. Jeremy leaves his cubicle. He plays with the cuffs of his button-down shirt—it's the lightest pink, with white cuffs and collar—as he stalks the aisle between cubicles, poking his head into one after another. He walks down a second aisle and spots something on the floor. His eyes go wide. There's a woman on the floor, curled into a ball and weeping. She's in a business suit. Her legs are huge in her finely creased pink pants. She has a fancy handkerchief to her face. She's leaning against the exterior wall of the cubicle.

Jeremy walks up to her, stares down at her, waits for her to look up at him. She blinks away the tears, looks at him expectantly. "There's a man," she hisses, *sotto voce*, "in my cubicle." The snoring is very loud now. Jeremy strains to hear the woman at his feet, because of the very loud snoring.

"Tell him to leave," Jeremy says.

"I can't. He's asleep."

"You stay here." Jeremy takes a step into the cubicle. There are little toys scattered about, pink picture frames and pictures of smiling black children in the frames. The Night Shift sleeps in the chair, still in his blue jumpsuit, his head resting in his folded-up arms. We notice this last, because it's out of place. Not like the photo of the sobbing woman, and a man, standing

next to one another under the brightest blue sky we ever saw.

Jeremy taps the Night Shift on the shoulder. "Wake up. Wake up, sir. This is not a homeless shelter, this is a place of business." He shakes the Night Shift's shoulder roughly. "Get up!" Jeremy growls when he says those two words. He finds an *r* somewhere in the word *get* and says it again. "Get up!"

The Night Shift stirs. He raises his head, looks up at Jeremy. We can imagine the Night Shift looking at us. The Night Shift looks a little confused, like Jeremy seems familiar.

"What did you say?" the Night Shift says.

"Get out now, please. You have to go."

"Pardon me for asking," the Night Shift says. "You have awoken me from an incomplete nap. My lexical recall and verbal comprehension suffer when I'm newly awake."

"Well . . ." Jeremy pauses for a moment. His eyebrows are practically a V-shape on his face. "I am very sorry to hear that."

"Hear that?"

There's the slightest *twipsp* of a sound. Jeremy inhales sharply. He looks down at his shirt. It's raspberry red with blood, sticking to his belly. He falls against the wall of the woman's cubicle, throws out an arm, knocks a picture from a shelf as he sinks to the floor. The Night Shift groans as he rises from the chair. There's a gun in his hand, a silencer on the gun. He shuffles as he walks his first step, slaps his thigh like his leg has fallen asleep. Jeremy gurgles, and jerks once. The woman is up, her pink pantsuit blocking the cubicle entrance.

"Sorry ma'am," the Night Shift says in the midst of a yawn. He gestures with the gun. There is another *twipsp*. He shoots her in her sizeable bosom. She clutches at her chest, falls to the floor. The Night Shift stumbles a bit as he navigates around her body. There's a general murmur washing over the scene. A head pops out of a cubicle, then back down, as the Night Shift walks toward the exit. The Night Shift stops at the kitchenette, pours himself one third of one second's worth of coffee from the pot into a paper cup. He opens the glass door to the office with his back, gun raised in one hand, coffee cup in the other. He yawns again as he leaves, and walks slowly away.

Laura does that trick with her bangs again. She smiles. She has crow's feet around her eyes. They're beautiful blue eyes. The room she's in now is featureless. It's so dark behind her that, all we can see is those eyes, the white of her nose, a gray finger of smoke from her cigarette. If there's light, it's shining from somewhere behind our own heads. She smiles and begins to speak.

THE DROWSY MAN DREAMS

"When I was a young girl, I had so many dreams. And such a loving family too. My grandpa always used to take me to the little luncheonette by the dog track. We drove past several other diners to get there, because he said this particular luncheonette had the best milkshakes in the tri-state area. I believed it too. Grandpa would tell me that if you have a lot of problems in your life, have yourself a milkshake. If you do, it'll be a respite from the hornets in your mind. If a body is capable of sitting upright and enjoying a milkshake, even if said body spent her last three dollars in the world to get it, things can't be so bad. I believed him. To this day, I believe in my grandpa's wisdom.

"One time, in my hometown, I went to a show in an old movie house. They'd torn out the screen, but kept the stage and the thick red velvet curtains. It was a Punch and Judy show, but with real actors, not puppets. Mr. Punch laid into Judy real hard with a big wax baseball bat, and then when she moved no more, he said 'Get up! Get up I say!' over her body. Then he declared, 'Well then, get down.' And he kicked her into the orchestra pit. Rolled her right in, with a thump. Then all these lights came on, all pink and blue and swirly, beautiful and terrible." And lights she just described come on, just like that, so pink they're white, so blue they're white, then they die down again.

Laura has changed position in her chair. She's older now too. The cigarette in her lips has burned down to the filter. She keeps her lips pursed, speaks around the filter in her mouth. "I had an angel once. A holy guardian angel. It saved me once, in college, from three men with evil on their minds with its great black claws and teeth like knives of ice. Then the angel turned to me, with its one hundred fiery eyes, and told me that everybody gets one. Just one. Since then, I've been on my own. Every time I fuck, I'm on my own. That's how I feel about it, anyways." She flicks the remnant of the cigarette over her shoulder, into the shadows behind her. We sit on the other side of the desk and nod, and reach for our own cigarette pack, our own Zippo lighter. We've been practicing. We flick the Zippo with a practiced *flichyt* and light her another one.

"We all get one," a slight voice says. It sounds like Jim's, but far away. "And we used it," another, rougher voice says. And it sounds like Todd's, but far away.

"Thanks," Laura says—her smile is a thirty-foot wide streak of light, at an aspect ratio of one point eight-five to one.

TEATRO GROTTESCO

THOMAS LIGOTTI

The first thing I learned was that no one *anticipates* the arrival of the Teatro. One would not say, or even think, "The Teatro has never come to this city—it seems we're due for a visit," or perhaps, "Don't be surprised when you-know-what turns up. It's been years since the last time." Even if the city in which one lives is exactly the kind of place favored by the Teatro, there can be no basis for predicting its appearance. No warnings are given, no fanfare to announce that a Teatro season is about to begin, or that *another* season of that sort will soon be upon us. But if a particular city possesses what is sometimes called an "artistic underworld," and if one is in close touch with this society of artists, the chances are optimal for being among those who discover that things have already started. This is the most one can expect.

For a time it was all rumors and lore, hearsay and dreams. Anyone who failed to show up for a few days at the usual club or bookstore or special artistic event was the subject of speculation. But most of the crowd I am referring to led highly unstable, even precarious lives. Any of them might have packed up and disappeared without notifying a single soul. And almost all of the supposedly "missing ones" were, at some point, seen again. One such person was a filmmaker whose short movie *Private Hell* served as the featured subject of a local one-night festival. But he was nowhere to be seen either during the exhibition or at the party afterwards. "Gone with the Teatro," someone said with a blasé knowingness, while others smiled and clinked glasses in a sardonic farewell toast.

Yet only a week later the filmmaker was spotted in one of the back rows of a pornographic theater. He later explained his absence by insisting he had been in the hospital following a thorough beating at the hands of

some people he had been filming but who did not consent or desire to be filmed. This sounded plausible, given the subject matter of the man's work. But for some reason no one believed his hospital story, despite the evidence of bandages he was still required to wear. "It has to be the Teatro," argued a woman who always dressed in shades of purple and who was a good friend of the filmmaker. "*His* stuff and *Teatro* stuff," she said, holding up two crossed fingers for everyone to see.

But what was meant by "Teatro stuff"? This was a phrase I heard spoken by a number of persons, not all of them artists of a pretentious or self-dramatizing type. Certainly there is no shortage of anecdotes that have been passed around which purport to illuminate the nature and workings of this "cruel troupe," an epithet used by those who are too superstitious to invoke the Teatro Grottesco by name. But sorting out these accounts into a coherent *profile*, never mind their truth value, is another thing altogether.

For instance, the purple woman I mentioned earlier held us all spellbound one evening with a story about her cousin's roommate, a self-styled "visceral artist" who worked the night shift as a stock clerk for a supermarket chain in the suburbs. On a December morning, about an hour before sun-up, the artist was released from work and began his walk home through a narrow alley that ran behind several blocks of various stores and businesses along the suburb's main avenue. A light snow had fallen during the night, settling evenly upon the pavement of the alley and glowing in the light of a full moon which seemed to hover just at the alley's end. The artist saw a figure in the distance, and something about this figure, this winter-morning vision, made him pause for a moment and stare. Although he had a trained eye for sizing and perspective, the artist found this silhouette of a person in the distance of the alley intensely problematic. He could not tell if it was short or tall, or even if it was moving—either toward him or away from him—or was standing still. Then, in a moment of hallucinated wonder, the figure stood before him in the middle of the alley.

The moonlight illuminated a little man who was entirely unclothed and who held out both of his hands as if he were grasping at a desired object just out of his reach. But the artist saw that something was wrong with these hands. While the little man's body was pale, his hands were dark and were too large for the tiny arms on which they hung. At first the artist believed the little man to be wearing oversized mittens. His hands seemed to be covered by some kind of fuzz, just as the alley in which he stood was layered with the fuzziness of the snow that had fallen during the night. His hands looked soft and fuzzy like the snow, except that the snow was white and his hands were black.

In the moonlight the artist came to see that the mittens worn by this little man were more like the paws of an animal. It almost made sense to the artist to have thought that the little man's hands were actually paws which had only appeared to be two black mittens. Then each of the paws separated into long thin fingers that wriggled wildly in the moonlight. But they could not have been the fingers of a hand, because there were too many of them. So what appeared to be fingers could not have been fingers, just as the hands were not in fact hands or the paws really paws— no more than they were mittens. And all of this time the little man was becoming smaller and smaller in the moonlight of that alley, as if he were moving into the distance far away from the artist who was hypnotized by this vision. Finally a little voice spoke which the artist could barely hear, and it said to him: "I cannot keep them away from me anymore, I am becoming so small and weak." These words suddenly made this whole winter-morning scenario into something that was too much even for the self-styled "visceral artist."

In the pocket of his coat the artist had a tool which he used for cutting open boxes at the supermarket. He had cut into flesh in the past, and, with the moonlight glaring upon the snow of that alley, the artist made a few strokes which turned that white world red. Under the circumstances what he had done seemed perfectly justified to the artist, even an act of mercy. The man was becoming so small.

Afterward the artist ran through the alley without stopping until he reached the rented house where he lived with his roommate. It was she who telephoned the police, saying there was a body lying in the snow at such and such a place and then hanging up without giving her name. For days, weeks, the artist and his roommate searched the local newspapers for some word of the extraordinary thing the police must have found in that alley. But nothing ever appeared.

"You see how these incidents are hushed up," the purple woman whispered to us. "The police know what is going on. There are even *special police* for dealing with such matters. But nothing is made public, no one is questioned. And yet, after that morning in the alley, my cousin and her roommate came under surveillance and were followed everywhere by unmarked cars. Because these special policemen know that it is artists, or highly artistic persons, who are *approached* by the Teatro. And they know whom to watch after something has happened. It is said that these police may be party to the deeds of that 'company of nightmares.'"

But none of us believed a word of this Teatro anecdote told by the purple woman, just as none of us believed the purple woman's friend,

the filmmaker, when he denied all innuendos that connected him to the Teatro. On the one hand, our imaginations had sided with this woman when she asserted that her friend, the creator of the short movie *Private Hell*, was somehow in league with the Teatro; on the other hand, we were mockingly dubious of the story about her cousin's roommate, the self-styled visceral artist, and his encounter in the snow-covered alley.

This divided reaction was not as natural as it seemed. Never mind that the case of the filmmaker was more credible than that of the visceral artist, if only because the first story was lacking the extravagant details which burdened the second. Until then we had uncritically relished all we had heard about the Teatro, no matter how bizarre these accounts may have been and no matter how much they opposed a verifiable truth or even a coherent portrayal of this phenomenon. As artists we suspected that it was in our interest to have our heads filled with all kinds of Teatro craziness. Even I, a writer of nihilistic prose works, savored the inconsistency and the flamboyant absurdity of what was told to me across a table in a quiet library or a noisy club. In a word, I delighted in the *unreality* of the Teatro stories. The truth they carried, if any, was immaterial. And we never questioned any of them until the purple woman related the episode of the visceral artist and the small man in the alley.

However, this new disbelief was not in the least inspired by our sense of reason or reality. It was in fact based solely on fear; it was driven by the will to negate what one fears. No one gives up on something until it turns on them, whether or not that thing is real or unreal. In some way all of this Teatro business had finally worn upon our nerves; the balance had been tipped between a madness that intoxicated us and one that began to menace our minds. As for the woman who always dressed herself in shades of purple . . . we avoided her. It would have been typical of the Teatro, someone said, to use a person like that for their purposes.

Perhaps our judgment of the purple woman was unfair. No doubt her theories concerning the "approach of the Teatro" made us all uneasy. But was this reason enough to cast her out from that artistic underworld which was the only society available to her? Like many societies, of course, ours was founded on fearful superstition, and this is always reason enough for any kind of behavior. She had been permanently stigmatized by too closely associating herself with something unclean in its essence. Because even after her theories were discredited by a newly circulated Teatro tale, her status did not improve.

I am now referring to a story that was going around in which an artist was not *approached* by the Teatro but rather took the first step *toward* the

Teatro, as if acting under the impulse of a sovereign will. The artist in this case was a photographer of the I-am-a-camera type. He was a studiedly bloodless specimen who quite often, and for no apparent reason, would begin to stare at someone and to continue staring until that person reacted in some manner, usually by fleeing the scene but on occasion by assaulting the photographer, who invariably pressed charges. It was therefore not entirely surprising to learn that he tried to engage the services of the Teatro in the way he did, for it was his belief that this cruel troupe could be hired to, in the photographer's words, "utterly destroy someone." And the person he wished to destroy was his landlord, a small balding man with a mustache who, after the photographer had moved out of his apartment, refused to remit his security deposit, perhaps with good reason but perhaps not.

In any case, the photographer, whose name incidentally was Spence, made inquiries about the Teatro over a period of some months. Following up every scrap of information, no matter how obscure or suspect, the tenacious Spence ultimately arrived in the shopping district of an old suburb where there was a two-story building that rented space to various persons and businesses, including a small video store, a dentist, and, as it was spelled out on the building's directory, the Theatre Grottesco. At the back of the first floor, directly below a studio for dancing instruction, was a small suite of offices whose glass door displayed some stencilled lettering that read: TG VENTURES. Seated at a desk in the reception area behind the glass door was a young woman with long black hair and black-rimmed eyeglasses. She was thoroughly engrossed in writing something on a small blank card, several more of which were spread across her desk. The way Spence told it, he was undeterred by all appearances that seemed to suggest the Teatro, or Theatre, was not what he assumed it was. He entered the reception area of the office, stood before the desk of the young woman, and introduced himself by name and occupation, believing it important to communicate as soon as possible his identity as an artist, or at least imply as best he could that he was a highly artistic photographer, which undoubtedly he was. When the young woman adjusted her eyeglasses and asked, "How can I help you?" the photographer Spence leaned toward her and whispered, "I would like to enlist the services of the Teatro, or Theatre if you like." When the receptionist asked what he was planning, the photographer answered, "To utterly destroy someone." The young woman was absolutely unflustered, according to Spence, by this declaration. She began calmly gathering the small blank cards that were spread across her desk and, while doing this, explained that TG Ventures was, in her words, an "entertainment service." After placing the small blank cards to one side,

she removed from her desk a folded brochure outlining the nature of the business, which provided clowns, magicians, and novelty performances for a variety of occasions, their specialty being children's parties.

As Spence studied the brochure, the receptionist placidly sat with her hands folded and gazed at him from within the black frames of her eyeglasses. The light in that suburban office suite was bright but not harsh; the pale walls were incredibly clean and the carpeting, in Spence's description, was conspicuously new and displayed the exact shade of purple found in turnips. The photographer said that he felt as if he were standing in a mirage. "This is all a front," Spence finally said, throwing the brochure on the receptionist's desk. But the young woman only picked up the brochure and placed it back in the same drawer from which it had come. "What's behind that door?" Spence demanded, pointing across the room. And just as he pointed at that door there was a sound on the other side of it, a brief rumbling as if something heavy had just fallen to the floor. "The dancing classes," said the receptionist, her right index finger pointing up at the floor above. "Perhaps," Spence allowed, but he claimed that this sound that he heard, which he described as having an "abysmal resonance," caused a sudden rise of panic within him. He tried not to move from the place he was standing, but his body was overwhelmed by the impulse to leave that suite of offices. The photographer turned away from the receptionist and saw his reflection in the glass door. She was watching him from behind the lenses of black-framed eyeglasses, and the stenciled lettering on the glass door read backwards, as if in a mirror. A few seconds later Spence was outside the building in the old suburb. All the way home, he asserted, his heart was pounding.

The following day Spence paid a visit to his landlord's place of business, which was a tiny office in a seedy downtown building. Having given up on the Teatro, he would have to deal in his own way with this man who would not return his security deposit. Spence's strategy was to plant himself in his landlord's office and stare him into submission with a photographer's unnerving gaze. After he arrived at his landlord's rented office on the sixth floor of what was a thoroughly depressing downtown building, Spence seated himself in a chair looking across a filthy desk at a small balding man with a mustache. But the man merely looked back at the photographer. To make things worse, the landlord (whose name was Herman Zick) would lean towards Spence every so often and in a quiet voice say, "It's all perfectly legal, you know." Then Spence would continue his staring, which he was frustrated to find ineffective against this man Zick, who of course was not an artist, or even a highly artistic person, as were the usual victims of the

photographer. Thus the battle kept up for almost an hour, the landlord saying, "It's all perfectly legal," and Spence trying to hold a fixed gaze upon the man he wished to utterly destroy.

Ultimately Spence was the first to lose control. He jumped out of the chair in which he was sitting and began to shout incoherently at the landlord. Once Spence was on his feet, Zick swiftly maneuvered around the desk and physically evicted the photographer from the tiny office, locking him out in the hallway. Spence said that he was in the hallway for only a second or two when the doors opened to the elevator that was directly across from Zick's sixth-floor office. Out of the elevator compartment stepped a middle-aged man in a dark suit and black-framed eyeglasses. He wore a full, well-groomed beard which, Spence observed, was slightly streaked with gray. In his left hand the gentleman was clutching a crumpled brown bag, holding it a few inches in front of him. He walked up to the door of the landlord's office and with his right hand grasped the round black doorknob, jiggling it back and forth several times. There was a loud click that echoed down the hallway of that old downtown building. The gentleman turned his head and looked at Spence for the first time, smiling briefly before admitting himself to the office of Herman Zick.

Again the photographer experienced that surge of panic he had felt the day before when he visited the suburban offices of TG Ventures. He pushed the down button for the elevator, and while waiting he listened at the door of the landlord's office. What he heard, Spence claimed, was that terrible sound that had sent him running out in the street from TG Ventures, that "abysmal resonance," as he defined it. Suddenly the gentleman with the well-groomed beard and black-rimmed glasses emerged from the tiny office. The door to the elevator had just opened, and the man walked straight past Spence to board the empty compartment. Spence himself did not get on the elevator but stood outside, helplessly staring at the bearded gentleman, who was still holding that small crumpled bag. A split second before the elevator doors slid closed, the gentleman looked directly at Spence and winked at him. It was the assertion of the photographer that this wink, executed from behind a pair of black-framed eyeglasses, made a mechanical clicking sound which echoed down the dim hallway. Prior to his exit from the old downtown building, leaving by way of the stairs rather than the elevator, Spence tried the door to his landlord's office. He found it unlocked and cautiously stepped inside. But there was no one on the other side of the door.

The conclusion to the photographer's adventure took place a full week later. Delivered by regular post to his mail box was a small square envelope

with no return address. Inside was a photograph. He brought this item to Des Esseintes' Library, a bookstore where several of us were giving a late-night reading of our latest literary efforts. A number of persons belonging to the local artistic underworld, including myself, saw the photograph and heard Spence's rather frantic account of the events surrounding it. The photo was of Spence himself staring stark-eyed into the camera, which apparently had taken the shot from inside an elevator, a panel of numbered buttons being partially visible along the righthand border of the picture. "I could see no camera," Spence kept repeating. "But that wink he gave me ... and what's written on the reverse side of this thing." Turning over the photo Spence read aloud the following handwritten inscription: "The little man is so much littler these days. Soon he will know about the soft black stars. And your payment is past due." Someone then asked Spence what they had to say about all this at the offices of TG Ventures. The photographer's head swivelled slowly in exasperated negation. "Not there anymore," he said over and over. With the single exception of myself, that night at Des Esseintes' Library was the last time anyone would see Spence.

After the photographer ceased to show up at the usual meeting places and special artistic events, there were no cute remarks about his having "gone with the Teatro." We were all of us beyond that stage. I was perversely proud to note that a degree of philosophical maturity had now developed among those in the artistic underworld of which I was a part. There is nothing like fear to complicate one's consciousness, inducing previously unknown levels of reflection. Under such mental stress I began to organize my own thoughts and observations about the Teatro, specifically as this phenomenon related to the artists who seemed to be its sole objects of attention.

Whether or not an artist was approached by the Teatro or took the initiative to approach the Teatro himself, it seemed the effect was the same: the end of an artist's work. I myself verified this fact as thoroughly as I could. The filmmaker whose short movie *Private Hell* so many of us admired had, by all accounts, become a full-time dealer in pornographic videos, none of them his own productions. The self-named visceral artist had publicly called an end to those stunts of his which had gained him a modest underground reputation. According to his roommate, the purple woman's cousin, he was now managing the supermarket where he had formerly labored as a stock clerk. As for the purple woman herself, who was never much praised as an artist and whose renown effectively began and ended with the "cigar box assemblage" phase of her career, she had gone into selling real estate, an occupation in which she became quite a

success. This roster of ex-artists could be extended considerably, I am sure of that. But for the purposes of this report or confession (or whatever else you would like to call it) I must end my list of no-longer-artistic persons with myself, while attempting to offer some insights into the manner in which the Teatro Grottesco could transform a writer of nihilistic prose works into a non-artistic, more specifically a *post-artistic* being.

It was after the disappearance of the photographer Spence that my intuitions concerning the Teatro began to crystalize and become explicit thoughts, a dubious process but one to which I am inescapably subject as a prose writer. Until that point in time, everyone tacitly assumed that there was an intimacy of *kind* between the Teatro and the artists who were either approached by the Teatro or who themselves approached this cruel troupe by means of some overture, as in the case of Spence, or perhaps by gestures more subtle, even purely noetic (I retreat from writing *unconscious*, although others might argue with my intellectual reserve). Many of us even spoke of the Teatro as a manifestation of super-art, a term which we always left conveniently nebulous. However, following the disappearance of the photographer, all knowledge I had acquired about the Teatro, fragmentary as it was, became configured in a completely new pattern. I mean to say that I no longer considered it possible that the Teatro was in any way related to a super-art, or to an art of any kind—quite the opposite in fact. To my mind the Teatro was, and is, a phenomenon intensely destructive of everything that I conceived of as art. Therefore, the Teatro was, and is, intensely destructive of all artists and even of highly artistic persons. Whether this destructive force is a matter of intention or is an epiphenomenon of some unrelated, perhaps greater design, or even if there exists anything like an intention or design on the part of the Teatro, I have no idea (at least none I can elaborate in comprehensible terms). Nonetheless, I feel certain that for an artist to encounter the Teatro there can be only one consequence: the end of that artist's work. Strange, then, that knowing this fact I still acted as I did.

I cannot say if it was I who approached the Teatro or vice versa, as if any of that stupidity made a difference. The important thing is that from the moment I perceived the Teatro to be a profoundly anti-artistic phenomenon I conceived the ambition to make my form of art, by which I mean my nihilistic prose writings, into an *anti-Teatro* phenomenon. In order to do this, of course, I required a penetrating knowledge of the Teatro Grottesco, or of some significant aspect of that cruel troupe, an insight of a deeply subtle, even dreamlike variety into its nature and workings.

The photographer Spence had made a great visionary advance when

he intuited that it was in the nature of the Teatro to act on his request to utterly destroy someone (although the exact meaning of the statement "he will know about the soft black stars," in reference to Spence's landlord, became known to both of us only sometime later). I realized that I would need to make a similar leap of insight in my own mind. While I had already perceived the Teatro to be a profoundly anti-artistic phenomenon, I was not yet sure what in the world would constitute an anti-Teatro phenomenon, as well as how in the world I could turn my own prose writings to such a purpose.

Thus, for several days I meditated on these questions. As usual, the psychic demands of this meditation severely taxed my bodily processes, and in my weakened state I contracted a virus, specifically an *intestinal virus*, which confined me to my small apartment for a period of one week. Nonetheless, it was during this time that things fell into place regarding the Teatro and the insights I required to oppose this company of nightmares in a more or less efficacious manner.

Suffering through the days and nights of an illness, especially an intestinal virus, one becomes highly conscious of certain realities, as well as highly sensitive to the *functions* of these realities, which otherwise are not generally subject to prolonged attention or meditation. Upon recovery from such a virus, the consciousness of these realities and their functions necessarily fades, so that the once-stricken person may resume his life's activities and not be driven to insanity or suicide by the acute awareness of these most unpleasant facts of existence. Through the illumination of analogy, I came to understand that the Teatro operated in much the same manner as the illness from which I recently suffered, with the consequence that the person exposed to the Teatro-disease becomes highly conscious of certain realities and their functions, ones quite different of course from the realities and functions of an intestinal virus. However, an intestinal virus ultimately succumbs, in a reasonably healthy individual, to the formation of antibodies (or something of that sort). But the disease of the Teatro, I now understood, was a disease for which no counteracting agents, or antibodies, had ever been created by the systems of the individuals—that is, the *artists*—it attacked. An encounter with any disease, including an intestinal virus, serves to alter a person's mind, making it intensely aware of certain realities, but this mind cannot remain altered once this encounter has ended or else that person will never be able to go on living in the same way as before. In contrast, an encounter with the Teatro appears to remain within one's system and to alter a person's mind permanently. For the artist the result is not to be driven into insanity or suicide (as might be the case

if one assumed a permanent mindfulness of an intestinal virus) but the absolute termination of that artist's work. The simple reason for this effect is that there are no antibodies for the disease of the Teatro, and therefore no relief from the consciousness of the realities which an encounter with the Teatro has forced upon an artist.

Having progressed this far in my contemplation of the Teatro—so that I might discover its nature or essence and thereby make my prose writings into an anti-Teatro phenomenon—I found that I could go no further. No matter how much thought and meditation I devoted to the subject I did not gain a definite sense of having revealed to myself the true realities and functions that the Teatro communicated to an artist and how this communication put an end to that artist's work. Of course I could vaguely imagine the species of awareness that might render an artist thenceforth incapable of producing any type of artistic efforts. I actually arrived at a fairly detailed and disturbing idea of such an awareness—a *world-awareness*, as I conceived it. Yet I did not feel I had penetrated the mystery of "Teatro-stuff." And the only way to know about the Teatro, it seemed, was to have an encounter with it. Such an encounter between myself and the Teatro would have occurred in any event as a result of the discovery that my prose writings had been turned into an anti-Teatro phenomenon: This would constitute an *approach* of the most outrageous sort to that company of nightmares, forcing an encounter with all its realities and functions. Thus it was not necessary, at this point in my plan, to have actually succeeded in making my prose writings into an anti-Teatro phenomenon. I simply had to make it known, falsely, that I had done so.

As soon as I had sufficiently recovered from my intestinal virus I began to spread the word. Every time I found myself among others who belonged to the so-called artistic underworld of this city I bragged that I had gained the most intense awareness of the Teatro's realities and functions, and that, far from finishing me off as an artist, I had actually used this awareness as inspiration for a series of short prose works. I explained to my colleagues that merely to exist—let alone create artistic works—we had to keep certain things from overwhelming our minds. However, I continued, in order to keep these things, such as the realities of an intestinal virus, from overwhelming our minds we attempted to deny them any voice whatever, neither a voice in our minds and certainly not a precise and clear voice in works of art. The voice of madness, for instance, is barely a whisper in the babbling history of art because its realities are themselves too maddening to speak of for very long . . . and those of the Teatro have no voice at all,

given their imponderably grotesque nature. Furthermore, I said, the Teatro not only propagated an intense awareness of these things, these realities and functionings of realities, it was *identical* with them. And I, I boasted, had allowed my mind to be overwhelmed by all manner of Teatro stuff, while also managing to use this experience as material for my prose writings. "This," I practically shouted one day at Des Esseintes' Library, "is the super-art." Then I promised that in two days time I would give a reading of my series of short prose pieces.

Nevertheless, as we sat around on some old furniture in a corner of Des Esseintes' Library, several of the others challenged my statements and assertions regarding the Teatro. One fellow writer, a poet, spoke hoarsely through a cloud of cigarette smoke, saying to me: "No one knows what this Teatro stuff is all about. I'm not sure I believe it myself." But I answered that Spence knew what it was all about, thinking that very soon I too would know what he knew. "*Spence!*" said a woman in a tone of exaggerated disgust (she once lived with the photographer and was a photographer herself). "He's not telling us about anything these days, never mind the Teatro." But I answered that, like the purple woman and the others, Spence had been overwhelmed by his encounter with the Teatro, and his artistic impulse had been thereby utterly destroyed. "And *your* artistic impulse is still intact," she said snidely. I answered that, yes, it was, and in two days I would prove it by reading a series of prose works that exhibited an intimacy with the most overwhelmingly grotesque experiences and gave voice to them. "That's because you have no idea what you're talking about," said someone else, and almost everyone supported this remark. I told them to be patient, wait and see what my prose writings revealed to them. "Reveal?" asked the poet. "Hell, no one even knows why it's called the Teatro Grottesco." I did not have an answer for that, but I repeated that they would understand much more about the Teatro in a few days, thinking to myself that within this period of time I would have either succeeded or failed in my attempt to provoke an encounter with the Teatro and the matter of my nonexistent anti-Teatro prose writing would be immaterial.

On the very next day, however, I collapsed in Des Esseintes' Library during a conversation with a different congregation of artists and highly artistic persons. Although the symptoms of my intestinal virus had never entirely disappeared, I had not expected to collapse the way I did and ultimately to discover that what I thought was an intestinal virus was in fact something far more serious. As a consequence of my collapse, my unconscious body ended up in the emergency room of a nearby hospital,

the kind of place where borderline indigents like myself always end up—a backstreet hospital with dated fixtures and a staff of sleepwalkers.

When I next opened my eyes it was night. The bed in which they had put my body was beside a tall paned window that reflected the dim fluorescent light fixed to the wall behind me, creating a black glare in the windowpanes that allowed no view of anything beyond them but only a broken image of myself and the room where I had been assigned for treatment. There was a long row of these tall paned windows and several other beds in the ward, each of them supporting a sleeping body that, like mine, was damaged in some way and therefore had been committed to that backstreet hospital.

I felt none of the extraordinary pain that had caused me to collapse in Des Esseintes' Library. At that moment, in fact, I could feel nothing of the experiences of my past life: it seemed I had always been an occupant of that dark hospital ward and always would be. This sense of estrangement from both myself and everything else made it terribly difficult to remain in the hospital bed where I had been placed. At the same time I felt uneasy about any movement *away* from that bed, especially any movement that would cause me to approach the open doorway which led into a half-lighted backstreet hospital corridor. Compromising between my impulse to get out of my bed and my fear of moving away from the bed and approaching that corridor, I positioned myself so that I was sitting on the edge of the mattress with my bare feet grazing the cold linoleum floor. I had been sitting on the edge of that mattress for quite a while before I heard the voice out in the corridor.

The voice came over the public address system, but it was not a particularly loud voice. In fact I had to strain my attention for several minutes simply to discern the peculiar qualities of the voice and to decipher what it said. It sounded like a child's voice, a sing-song voice full of taunts and mischief. Over and over it repeated the same phrase—*paging Dr. Groddeck, paging Dr. Groddeck*. The voice sounded incredibly hollow and distant, garbled by all kinds of interference. *Paging Dr. Groddeck*, it giggled from the other side of the world.

I stood up and slowly approached the doorway leading out into the corridor. But even after I had crossed the room in my bare feet and was standing in the open doorway, that child's voice did not become any louder or any clearer. Even when I actually moved out into that long dim corridor with its dated lighting fixtures, the voice that was calling Dr. Groddeck sounded just as hollow and distant. And now it was as if I were in a dream in which I was walking in my bare feet down a backstreet hospital corridor,

hearing a crazy voice that seemed to be eluding me as I moved past the open doorways of innumerable wards full of damaged bodies. But then the voice died away, calling to Dr. Groddeck one last time before fading like the final echo in a deep well. At the same moment that the voice ended its hollow outcrying, I paused somewhere toward the end of that shadowy corridor. In the absence of the mischievous voice I was able to hear something else, a sound like quiet, wheezing laughter. It was coming from the room just ahead of me along the right hand side of the corridor. As I approached this room I saw a metal plaque mounted at eye-level on the wall, and the words displayed on this plaque were these: Dr. T. Groddeck.

A strangely glowing light emanated from the room where I heard that quiet and continuous wheezing laughter. I peered around the edge of the doorway and saw that the source of the laughter was an old gentleman seated behind a desk, while the strangely glowing light was coming from a large globular object positioned on top of the desk directly in front of him. The light from this object—a globe of solid glass, it seemed—shone on the old gentleman's face, which was a crazy-looking face with a neatly clipped beard that was pure white and a pair of spectacles with slim rectangular lenses resting on a slender nose. When I moved to stand in the doorway of that office, the eyes of Dr. Groddeck did not gaze up at me but continued to stare into the strange, shining globe and at the things that were inside it.

What were these things inside the globe that Dr. Groddeck was looking at? To me they appeared to be tiny star-shaped flowers evenly scattered throughout the glass, just the thing to lend a mock-artistic appearance to a common paperweight. Except that these flowers, these spidery chrysanthemums, were pure black. And they did not seem to be firmly fixed within the shining sphere, as one would expect, but looked as if they were floating in position, their starburst of petals wavering slightly like tentacles. Dr. Groddeck appeared to delight in the subtle movements of those black appendages. Behind rectangular spectacles his eyes rolled about as they tried to take in each of the hovering shapes inside the radiant globe on the desk before him.

Then the doctor slowly reached down into one of the deep pockets of the lab coat he was wearing, and his wheezing laughter grew more intense. From the open doorway I watched as he carefully removed a small paper bag from his pocket, but he never even glanced at me. With one hand he was now holding the crumpled bag directly over the globe. When he gave the bag a little shake, the things inside the globe responded with an increased agitation of their thin black arms. He used both hands to open

the top of the bag and quickly turned it upside down.

From out of the bag something tumbled onto the globe, where it seemed to stick to the surface. It was not actually adhering to the surface of the globe, however, but was sinking into the interior of the glass. It squirmed as those soft black stars inside the globe gathered to pull it down to themselves. Before I could see what it was that they had captured, the show was over. Afterward they returned to their places, floating slightly once again within the glowing sphere.

I looked at Dr. Groddeck and saw that he was finally looking back at me. He had stopped his asthmatic laughter, and his eyes were staring frigidly into mine, completely devoid of any readable meaning. Yet somehow these eyes provoked me. As I stood in the open doorway of that hideous office in a backstreet hospital, Dr. Groddeck's eyes aroused in me an intense outrage, an astronomical resentment of the position I had been placed in. Even as I had consummated my plan to encounter the Teatro and experience its most devastating realities and functions (in order to turn my prose works into an anti-Teatro phenomenon) I was outraged to be standing where I was standing and resentful of the staring eyes of Dr. Groddeck. It no longer mattered if I had approached the Teatro, the Teatro had approached me, or we both approached each other. I realized that there is such a thing as being approached in order to force one's hand into making what only appears to be an approach, which is actually a non-Teatro approach that negates the whole concept of approaching. It was all a fix from the start because I belonged to an artistic underworld, because I was an artist whose work would be brought to an end by an encounter with the Teatro Grottesco. And so I was outraged by the eyes of Dr. Groddeck, which were the eyes of the Teatro, and I was resentful of all the insane realities and the excruciating functions of the Teatro. Although I knew that the persecutions of the Teatro were not exclusively focused on the artists and highly artistic persons of the world, I was nevertheless outraged and resentful to be singled out for *special treatment*. I wanted to punish those persons in this world who are not the object of such special treatment. Thus, at the top of my voice, I called out in the dim corridor—I cried out the summons for others to join me before the stage of the Teatro. Strange that I should think it necessary to compound the nightmare of all those damaged bodies in that backstreet hospital, as well as its staff of sleepwalkers who moved within a world of outdated fixtures. But by the time anyone arrived Dr. Groddeck was gone, and his office became nothing more than a room full of dirty laundry.

My escapade that night notwithstanding, I was soon released from the

hospital, even though the results of several tests I had been administered were still pending. I was feeling as well as ever, and the hospital, like any hospital, always needed bedspace for more damaged bodies. They said I would be contacted in the next few days.

It was in fact the following day that I was informed of the outcome of my stay in the hospital. "Hello again," began the letter, which was typed on a plain, though water-stained sheet of paper. "I was so pleased to finally meet you in person. I thought your performance during our interview at the hospital was really first rate, and I am authorized to offer you a position with us. There is an opening in our organization for someone with your resourcefulness and imagination. I'm afraid things didn't work out with Mr. Spence. But he certainly did have a camera's eye, and we have gotten some wonderful pictures from him. I would especially like to share with you his last shots of the soft black stars, or S.B.S., as we sometimes refer to them. Veritable super-art, if there ever was such a thing!

"By the way, the results of your tests—some of which you have yet to be subjected to—are going to come back positive. If you think an intestinal virus is misery, just wait a few more months. So think fast, sir. We will arrange another meeting with you in any case. And remember—*you* approached *us*. Or was it the other way around?

"As you might have noticed by now, all this artistic business can only keep you going so long before you're left speechlessly gaping at the realities and functions of . . . well, I think you know what I'm trying to say. I was forced into this realization myself, and I'm quite mindful of what a blow this can be. Indeed, it was I who invented the appellative for our organization as it is currently known. Not that I put any stock in names, nor should you. Our company is so much older than its own name, or any other name for that matter. (And how many it's had over the years— The Ten Thousand Things, Anima Mundi, Nethescurial.) You should be proud that we have a special part for you to play, such a talented artist. In time you will forget yourself entirely in your work, as we all do eventually. Myself, I go around with a trunkful of aliases, but do you think I can say who I once was *really*? A man of the theater, that seems plausible. Possibly I was the father of Faust or Hamlet . . . or merely Peter Pan.

"In closing, I do hope you will seriously consider our offer to join us. We can do something about your medical predicament. We can do just about anything. Otherwise, I'm afraid that all I can do is welcome you to your own private hell, which will be as unspeakable as any on earth."

The letter was signed Dr. Theodore Groddeck, and its prognostication of my physical health was accurate: I have taken more tests at the backstreet

hospital and the results are somewhat grim. For several days and sleepless nights I have considered the alternatives the doctor proposed to me, as well as others of my own devising, and have yet to reach a decision on what course to follow. The one conclusion that keeps forcing itself upon me is that it makes no difference what choice I make or do not make. You can never anticipate the Teatro . . . or anything else. You can never know what you are approaching or what is approaching you. Soon enough my thoughts will lose all clarity, and I will no longer be aware that there was ever a decision to be made. The soft black stars have already begun to fill the sky.

HINTERKAIFECK AGAIN

NICK ANTOSCA

Rebecca asks her fiancé, What's the worst thing you've ever done?
They've been engaged two weeks. They met six months ago. He's thirty-three, wry and careful with words, a lawyer for a nonprofit opposed to the death penalty. She's twenty-eight, a first grade teacher, and she's draped on him in bed after making love.
What's the worst thing you've ever done?
He doesn't answer. He seems to be thinking about other things. At certain moments, she's learned, his presence is a kind of absence.
I've been thinking about Hinterkaifeck again.
About what?
She's never heard that word before. The way he says it, as if it's something they've discussed, disturbs her.
Hinterkaifeck is a farm in Germany. Or it was. The family that lived there, the Grubers, were murdered along with their maid. This was in 1922.
Why did you say 'again'?

Andreas Gruber was head of the family, her fiancé says. He was sixty-three years old and his wife Cäzilia was seventy-two. Their daughter Viktoria was widowed and lived on the farm with them, and so did her two-year-old son Josef and seven-year-old daughter, also named Cäzilia.
It was an open secret in town that Andreas was fucking Viktoria. Josef might even have been Andreas's son by incest. But that sort of thing wasn't so uncommon as to be completely beyond the pale. Just . . . unseemly.

One day in March of 1922, Andreas Gruber went out to tend livestock and saw footprints in the snow. The footprints emerged from the forest and went straight to the farm—but there were no footprints going back to the forest.

No one had seen a stranger around the farmstead, though. When Andreas mentioned the footprints to a neighbor, he mentioned something else as well: A house key had gone missing.

Around that time, the family started to hear strange sounds, like footsteps, in the attic. They became convinced some kind of animal was nesting up there, but they were unable to find it.

You're very warm, Rebecca says, touching his chest, feeling heat rise through the nest of soft but wiry hair. Are you getting sick?

Again it seems he doesn't hear.

On the last day of March, a new maid came to Hinterkaifeck. This was a Friday. Her name was Maria Baumgartner, and the Grubers were glad to see her. The last maid had left six months earlier, complaining that the farmstead was haunted.

That night, a few hours after Maria Baumgartner arrived, someone lured the older family members out to the barn one by one and split their skulls with a pickaxe.

Andreas, his wife Cäzilia, his daughter Viktoria, and his granddaughter Cäzilia were each killed with sudden, brutal blows. The killer stacked their bodies and covered them with hay.

Then he went into the farmhouse, killed Maria Baumgartner in her bed, and covered the body with bedsheets. Josef, the two-year-old, was the last to die. The killer draped one of his mother's dresses over his corpse.

During the four days after the murder, neighbors saw smoke coming from the chimney at Hinterkaifeck. The postman delivered the mail. A mechanic came and fixed a motor in the barn, not knowing about the corpses hidden under hay nearby. The mechanic later said that the Grubers' dog was tied up outside the barn, with food and water. He said it barked at him.

When the murders were finally discovered, on Tuesday, it was noticed that the livestock weren't hungry. The killer had remained at Hinterkaifeck

over the weekend, after the murders, and fed and cared for the animals.

The Gruber family had a stash of gold coins, but the killer hadn't touched them.

So what did he want? Rebecca says.

Her fiancé sighs. He absently strokes her hair. His body is strong, warm, capable. It reminds her of armor.

On Wednesday, her fiancé says, a court physician did an autopsy in the barn. He beheaded the corpses and sent their heads to a clairvoyant, but the clairvoyant never returned them. So the Gruber family and their maid were buried headless.

The maid is tragic. She just started working for the wrong family on the wrong day. A week later and she would have lived.

And they never caught the killer?

No, they never caught anyone.

It's a good mystery. The footprints in the snow, the missing key. And how did he lure them out to the barn one by one? And ninety years later, they'll never know who did it.

I did it.

Ha.

I killed the Gruber family and their maid.

Ninety years ago.

I did. I'm absolutely certain of it.

Stop it. That's a weird thing to say.

When I first read about it, I recognized the name. And over the years, memories have risen to the surface. They're vivid, but still hazy. I don't know *why* I did it, but I've come to believe the memories are real.

What memories, exactly?

I remember coming toward the house—the sound of my feet crunching in the snow. I remember stealing the key off the hook in the kitchen. The house is familiar to me. I know the Gruber family somehow. Being in the house brings up strong, complicated emotions.

I remember hiding out in the attic for a day, then climbing out on the roof to hide when they come up after hearing sounds. After that I sneak out to the barn and stay there for another two days, watching them go about their daily business. I've come here to cause some sort of trouble, perhaps to have a confrontation of some kind, but I can't bring myself to do it, or to leave without doing it. I am in a kind of purgatory. This family has some kind of hold on me.

I remember remembering. But memories within memories are indistinct, weird. I believe—I'm not sure, but I *believe*, by which I mean this is the story as I have reconstructed it—that I am in love with Viktoria. I believe we had some sort of affair—after she was widowed, but before she came to live at Hinterkaifeck.

I believe I hate her, as well. She's become her father's mistress, had his child. It nauseates me. Every time I see her, I'm filled with complicated loathsome love. When I see *him*, I feel pure hate.

I wish I could live at Hinterkaifeck in Andreas's place, with Viktoria. I wish these animals were my animals, that these children were my children. I would like to rise in the morning before dawn and tend the livestock and feed the dog, and return to read the newspaper while my wife Viktoria makes breakfast, and my children Cäzilia and Josef scurry about my feet.

On Friday afternoon, Maria Baumgartner arrives. She glimpses me peering out of the barn. I nod at her, hoping she'll think I'm a hired man or something. Hoping she'll have no reason to mention me to the Grubers. And apparently, she doesn't.

Viktoria still knows me. I live in the town. We have remained outwardly friendly. Late on the third evening, Friday evening, I intercept her with little Cäzilia and Josef outside the house, as if I've just arrived. I say I must speak to her privately. She sends Cäzilia in to put Josef to bed and goes with me to the barn. We argue. I'm not sure what about . . . maybe in a kind of delirium I ask her to run away with me. She resists. I tell her how she disgusts me. How the whole town knows about what she's let Andreas turn her into. She tries to leave. I grab the pickaxe. Her skull splits.

Now I'm not sure what to do. The children saw me. I go to the house and find little Cäzilia waiting for her mother in the kitchen. I ask her to go wake Andreas and tell him that her mother needs him in the barn. She must say it's urgent and she must not tell him I'm here. We have a surprise for him.

I split his skull easily. I am heady with it, dizzy. I clean myself off, and go back to the house and tell little Cäzilia to send her grandmother out. Once the grandmother is dead, I go and get little Cäzilia herself. I hold her

hand as I walk her to the barn.

Afterward, I go into the house and kill poor Maria Baumgartner as she sleeps, and finally little Josef in his bed. If they hadn't seen me, I would have left them alive.

But now everyone is dead, and I am alone with the dead.

He's still stroking her hair.

You must think I've lost my mind, he says.

She doesn't reply.

Maybe I have, he says. But I know it was me. In a different life or a different body, I don't know. But I . . . whatever I am, whatever this entity is that's speaking to you out of this body . . . I took those lives. That's the worst thing I've ever done.

She sighs. It's late, she says in a strange voice. It's really late. Let's sleep.

All right.

He rises and leaves the room. She hears him walk down the hall to the bathroom. She sits up in bed. Through the open doorway, she can no longer see her fiancé, but when he opens the bathroom door, she sees his shadow on the hallway wall in a frame of light.

THE IMPLIED HORROR OF DAVID LYNCH

DAVID J

The door is slightly ajar
Nothing is happening

The door is slightly ajar
Nothing is happening

The door is slightly ajar
Nothing is happening

Except. In. Your. Head!

ABOUT THE AUTHORS

ANDREW WAYNE ADAMS is the author of the novella *Janitor of Planet Anilingus*, published as part of the Eraserhead Press New Bizarro Author Series. as well as numerous stories. He was born and raised in rural Ohio. Now he lives in Portland, Oregon, where people call him Andy.

KIRSTEN ALENE is the author of the novels *Japan Conquers the Galaxy* and *Unicorn Battle Squad*, and the novella *Love in the Time of Dinosaurs*. Her fiction has appeared in *Smalldoggies*, *New Dead Families*, *Bust Down the Door and Eat All the Chickens*, and other publications. She lives in Portland, Oregon with her husband.

NICK ANTOSCA was born in New Orleans and currently lives in Los Angeles, California. He is the author of a novel, *Fires*, and two novellas, *Midnight Picnic* and *The Obese*. He also writes for film and television.

LAURA LEE BAHR is the author of the short stories "Happy Hour" and "The Liar" (available in the anthologies *Demons* and *Psychos*, edited by John Skipp and published by Black Dog & Leventhal). She is the award-winning screenwriter of the feature films *Jesus Freak* and *the little Death*. Her first novel, *Haunt*, received the Wonderland Book Award.

GABRIEL BLACKWELL is the author of the books *The Natural Dissolution of Fleeting-Improvised Men*, *Shadow Man*, and *Critique of Pure Reason*. He is an editor for *The Collagist*.

JEFF BURK is the author of *Shatnerquake*, *Super Giant Monster Time*, *Cripple Wolf*, and *Shatnerquest*. He is also the head-editor of Deadite Press. He lives in Portland, OR where he spends his time reenacting scenes from *Wild at Heart* with his morbidly obese cat. You can stalk him online at www.jeffburk.wordpress.com and www.facebook.com/literarystrange.

SUZANNE BURNS's debut short story collection, *Misfits and Other Heroes*, was published by Dzanc Books. She is currently working on a

follow-up collection, *Love and Other Monsters*. Her parents let her watch *The Elephant Man* when she was a child. This is probably why she became a writer instead of a lawyer. Her favorite David Lynch movie is *Blue Velvet*. Sometimes late at night she sings "In Dreams" into her husband's portable shop light. (You know, the one about "the candy colored clown they call the sandman.") Her husband always stares at her with a mixture of wonder and fear. This is probably why they are still married.

BLAKE BUTLER's most recent books are *Sky Saw* (Tyrant Books, 2013) and *Nothing: A Portrait of Insomnia* (Harper Perennial, 2012). His next novel, *300,000,000*, will be released from Harper Perennial in 2014.

MATTY BYLOOS's first collection of short stories, *Don't Smell the Floss*, was published in 2009 by Write Bloody Books. His work has appeared in *Everyday Genius, Matchbook, Bomb, Dark Sky Magazine*, and *The Magazine of Bizarro Fiction*, among others. With Carrie Seitzinger, he runs *Nailed Magazine* from Portland, Oregon, where he lives and works. His first novel, *ROPE*, will be published in the summer of 2013. Learn more about him at his personal blog: www.mattybyloos.com.

GARRETT COOK is the author of *Time Pimp* (forthcoming from Eraserhead Press), *Archelon Ranch*, the *Murderland* series, and *Jimmy Plush, Teddy Bear Detective*. He is also the co-creator of *Imperial Youth Review*. Garrett lives in Boston, MA.

LIAM DAVIES's short fiction has appeared in numerous magazines and anthologies over the last few years and as a playwright he earned a M.E.N. Theatre Award nomination for best new play back in 2000. His absurd intertextual novella Bugger All Backwards and horror novel Sow and the Three Beasts of Brunlea were published by Gallows Press.

CODY GOODFELLOW has written three novels—*Radiant Dawn, Ravenous Dusk*, and *Perfect Union*—and cowrote *Jake's Wake, Spore*, and *The Last Goddam Hollywood Movie* with John Skipp. His short fiction has been collected in *All-Monster Action* and *Silent Weapons for Quiet Wars*. He is powerless to stop living in Los Angeles.

AMELIA GRAY is a writer living in Los Angeles, CA. She is the author of *AM/PM* (Featherproof Books), *Museum of the Weird*, (Fiction Collective

2) and *THREATS* (Farrar, Straus and Giroux). Her writing has appeared in *American Short Fiction*, *McSweeney's*, *DIAGRAM*, and *Caketrain*, among others.

DAVID J was a founding member of Bauhaus, one of the most influential British bands of the 1980's. Following their termination in '83, David J joined up with The Jazz Butcher for a brief stint, producing and playing in the group. Then came Love and Rockets. Another highly successful outfit, scoring a gold record with their first release, *Ball Of Confusion*.

He has collaborated with various other artists, such as celebrated graphic novelist Alan Moore, renowned author Hubert Selby Jr., producer and musician T Bone Burnett, and MC5 founder Wayne Kramer. He also co-wrote "Strays," the title track of the Jane's Addiction album. In 2008 he contributed extensively to the soundtrack of the musical feature film *Repo! The Genetic Opera*.

October 2011 saw the release of his eighth solo album, *Not Long For This World*, on Starry Records. The follow up album, *An Eclipse of Ships*, has just been completed and will be released in 2014. Visit him online at www.davidjonline.com

JEREMY ROBERT JOHNSON is the Wonderland Book Award-winning author of *We Live Inside You*, the cult hit *Angel Dust Apocalypse*, the Stoker Nominated novel *Siren Promised* (w/ Alan M. Clark), and the end-of-the-world freak-out *Extinction Journals*. His fiction has been acclaimed by authors like Chuck Palahniuk and Jack Ketchum and has appeared in numerous anthologies and magazines. In 2008 he worked with The Mars Volta to tell the story behind their Grammy-winning album *The Bedlam in Goliath*. He also runs indie publishing house Swallowdown Press and is at work on a host of new books. For more information you can access his techno-web presence at the cleverly-named www.jeremyrobertjohnson.com.

MP JOHNSON's short stories have appeared in more than twenty-five underground books and magazines, including *Bare Bone* and *Cthulhu Sex*. His debut book, *The After-Life Story of Pork Knuckles Malone*, was recently released by Bizarro Pulp Press. His second book, *Dungeons and Drag Queens*, is due soon from Eraserhead Press. He is the creator of the zine *Freak Tension*, a B-movie extra, and an obsessive music fan currently based in Minneapolis. Learn more at www.freaktension.com.

CHRIS KELSO is an author and illustrator. He is the author of *Schadenfreude* (Dog Horn Publishing), *A Message from the Slave State* (Western Legends Press) and *Charm/Offensive* (Strangehouse Books). Along with Garrett Cook, he is the co-creator of *Imperial Youth Review*.

MIKE KLEINE was born in December of 1988. He graduated from Grinnell College with a B.A. in French Literature. He currently lives somwhere in the Midwest. His first novel, *Mastodon Farm*, was published by Atlatl Press in 2012.

VIOLET LEVOIT is the author of *I Am Genghis Cum*, *Hotel Butterfly*, and many other works of fiction. She lives in Philadelphia.

THOMAS LIGOTTI is a contemporary horror author and reclusive literary cult figure. His books include *Teatro Grottesco*, *My Work Is Not Yet Done*, and *The Conspiracy Against the Human Race*.

SIMON LOGAN is the author of the short story collections *I-O*, *Rohypnol Brides*, and *Nothing is Inflammable* as well as the novel *Pretty Little Things to Fill Up the Void*. He is also the author of the industrial crime thriller *Katja From The Punk Band* which was selected as one of the top 10 crime books of 2010 by *Spinetingler Magazine* and has just been released as an audiobook from Audible.com. *KFTPB 2* is due out from ChiZine Publications in Spring 2014. Visit him online at www.coldandalone.com.

BEN LOORY'S fables and tales have appeared in *The New Yorker*, on NPR's *This American Life*, and live at *Selected Shorts*. His book *Stories for Nighttime and Some for the Day* was published by Penguin in 2011.

NICK MAMATAS is the author of several novels, including *Bullettime* and *Love is the Law*, and dozens of short stories. His work has appeared in *Asimov's Science Fiction*, *New Haven Review*, *subTERRAIN*, and *Best American Mystery Stories* among many other venues. In 2013 he was nominated for the Locus Award for his anthology *The Future Is Japanese*, co-edited with Masumi Washington. A native New Yorker, Nick now lives in California.

JARRET MIDDLETON is the author of *An Dantomine Eerly* and other fiction. He is the editor-in-chief and co-founder of Dark Coast Press and Pharos Editions. His fiction, essays, and reviews have appeared in *The*

Collagist, Smalldoggies, Big Other, HTMLGIANT, *Smoke Long Quarterly* and *Slingshot*. He lives in Seattle, WA. For more visit www.jarretmiddleton.com.

EDWARD MORRIS is a 2011 nominee for the Pushcart Prize in Literature, also nominated for the 2009 Rhysling Award and the 2005 British Science Fiction Association Award. His short fiction has appeared in over a hundred worldwide markets, including *The Lovecraft Ezine*, Robert M. Price's *The Mountains of Madness* and Joseph Pulver's *A Season in Carcosa*.

J. DAVID OSBORNE lives in Norman, OK with his wife and dog. His work has appeared in *Warmed and Bound*, John Skipp's *Demons*, and several other online and print publications. He is the winner of the 2010 Wonderland Book Award for Best Novel for *By The Time We Leave Here, We'll Be Friends*. His second novel, *Low Down Death Right Easy*, was published by Swallowdown Press in 2013. He also runs the rural noir publishing house Broken River Books.

SAM PINK is the author of *Rontel, Person, Hurt Others, I Am Going to Clone Myself Then Kill the Clone and Eat It*, and other books. He lives in Chicago and plays in the band Young Family. Visit him online at www.impersonalelectroniccommunication.com.

JOSEPH S. PULVER, SR., is the author of the novels *The Orphan Palace* (Chomu Press) and *Nightmare's Disciple* (Chaosium), and he has written many short stories that have appeared in magazines and anthologies, including *Weird Fiction Review, Crypt of Cthulhu*, and *The Lovecraft eZine*, Ellen Datlow's *Best Horror of the Year*, S. T. Joshi's *Black Wings* (I and III; PS Publishing) *A Mountain Walked* (Centipede Press 2014), and Ross E. Lockhart's *The Book of Cthulhu* (Night Shade). His collections, *Blood Will Have Its Season, SIN & ashes*, and *Portraits of Ruin*, were published by Hippocampus Press.

He edited *A Season in Carcosa* and *The Grimscribe's Puppets* (Miskatonic River Press), and collections by Ann K. Schwader (*The Worms Remember*) and John B. Ford, and Edward Morris' *A CROOKED MAN* series (Mercury Retrograde Press).

His new collection, *Stained Translations*, edited by Jeffrey Thomas, will appear in 2013.

You can find his blog at: http://thisyellowmadness.blogspot.com.

MATTHEW REVERT is the author of *Basal Ganglia* (Lazy Fascist Press), *How to Avoid Sex* (Copeland Valley/Dark Coast Press), *The Tumours Made Me Interesting* (LegumeMan Books) and *A Million Versions of Right* (LegumeMan Books). Revert has had work published in *Le Zaporogue*, *The Best Bizarro Fiction of the Decade*, *The New Flesh*, and *The Bizarro Starter Kit (Purple)*, among others.

In addition to his writing, Revert has gained recognition for his design work for various highly-regarded presses and record labels.

KRIS SAKNUSSEMM is the author of eleven books that have been translated into twenty-two languages. His second novel, *Private Midnight*, is now under option in Hollywood. His story included here was first selected for publication in *The New England Review* by guest editor Raymond Carver and appears in his collected early works of short fiction, *Sinister Miniatures*, published by Lazy Fascist Press.

KEVIN SAMPSELL lives in Portland, Oregon and has seen the movie *Blue Velvet* about thirty times. His books include the story collections, *Beautiful Blemish* and *Creamy Bullets*, the memoir, *A Common Pornography*, and the novel, *This Is Between Us*. His favorite Lynch actress is Sherilyn Fenn.

BRADLEY SANDS is the author of *Sorry I Ruined Your Orgy*, *Rico Slade Will Fucking Kill You*, *TV Snorted My Brain*, and others. Visit him at bradleysands.com.

MICHAEL J SEIDLINGER is the author of *My Pet Serial Killer* and *The Laughter of Strangers*, forthcoming from Lazy Fascist in November 2013. He owns and operates the small press Civil Coping Mechanisms.

JEREMY C. SHIPP is the author of *Cursed*, *Vacation*, and *Attic Clowns*. His short fiction has appeared in over sixty publications, including *Cemetery Dance*, *ChiZine*, *Apex Magazine*, and *Shroud Magazine*. Jeremy lives in southern California in a moderately haunted Victorian farmhouse. Visit him online at www.jeremycshipp.com.

JOHN SKIPP is a *New York Times* bestselling author and editor, whose twenty-three books have sold millions of copies in a dozen languages worldwide. His first anthology, *Book of the Dead*, laid the foundation in

1989 for modern zombie literature. He has edited four anthologies for Black Dog & Leventhal, *Zombies*, *Werewolves*, *Psychos*, and *Demons*, which won a Bram Stoker Award. From splatterpunk founding father to hilarious elder statesman, Skipp's legendary horror works include *The Light At The End*, *The Scream*, *The Long Last Call*, and *The Last Goddam Hollywood Movie* (with Cody Goodfellow).

JODY SOLLAZZO grew up in the suburbs of Westchester County. While the other girls were going to see *Pretty Woman* again she was begging for bootlegs of *Eraserhead* and *MST3K*. She always looked to artists like David Lynch, Joyce Carol Oates, George Carlin, Ani Difranco and Joss Whedon to explore the darkness. She lives in Northern California with her wonderful partner, their perfect daughter, and pets. She works in mental health, disability rights, and anti-bullying. Always a fan of bad timing, she is now also trying to achieve her lifelong dream of becoming a writer. "Outlier" is her first published story. You can also check out her blog at: http://thatdisabledmom.blogspot.com.

JEFFREY THOMAS is the author of such novels as *Deadstock* (finalist for the John W. Campbell Award), *Blue War*, *Monstrocity* (finalist for the Bram Stoker Award), *Letters from Hades*, *The Fall of Hades*, and *A Nightmare on Elm Street: The Dream Dealers*. His short story collections include *Punktown*, *Nocturnal Emissions*, *Thirteen Specimens*, *Voices from Punktown*, *Voices from Hades*, and (with W. H. Pugmire) *Encounters With Enoch Coffin*. Several of his books have been translated into German, Russian, Greek, Polish, and Taiwanese editions. His stories have appeared in the anthologies *The Year's Best Fantasy and Horror*, *The Year's Best Horror Stories*, *Leviathan 3*, *The Thackery T. Lambshead Pocket Guide to Eccentric & Discredited Diseases*, and *The Solaris Book of New Science Fiction*. Jeffrey Thomas lives in Massachusetts. His blog can be found at http://punktalk.punktowner.com.

ZACK WENTZ'S work has appeared in many places. He runs *New Dead Families* [http://newdeadfamilies.com/], and is a part of (Charles) Book&Record.

ACKNOWLEDGMENTS

Special thanks to all the editors who originally published the following stories:

"Hinterkaifeck Again" by Nick Antosca first published in *Black Candies*. © 2012 by Nick Antosca. Reprinted by permission of the author.

"A Model Made Out of Card Or, The Elephant Man and Other Reminiscences" by Gabriel Blackwell first published in *Unstuck #2*. © 2012 by Gabriel Blackwell. Reprinted by permission of the author.

"Twin Peaks" by Blake Butler first published in *Titular Journal*. © 2009 by Blake Butler. Reprinted by permission of the author.

"Where Walls Would Have" by Blake Butler first published in *New Dead Families*. © 2010 by Blake Butler. Reprinted by permission of the author.

"These Are the Fables" by Amelia Gray first published in *Hobart*, and subsequently as part of Electric Literature's *Recommended Reading*. © 2012 by Amelia Gray. Reprinted by permission of the author.

"Persistence Hunting" by Jeremy Robert Johnson first published in *We Live Inside You* (Swallowdown Press). © 2011 by Jeremy Robert Johnson. Reprinted by permission of the author.

"Teatro Grottesco" by Thomas Ligotti first published in *The Nightmare Factory* (Carroll and Graf) and subsequently in *Teatro Grottesco* (Durtro, Virgin). © 1996 by Thomas Ligotti. Reprinted by permission of the author.

"Hadley" by Ben Loory first published in *Stories for Nighttime and Some for the Day* (Penguin). © 2011 by Ben Loory. Reprinted by permission of the author.

"Friendship is Niceness And Is" by Sam Pink first published in *The Self-Esteem Holocaust Comes Home* (Lazy Fascist Press). © 2010 by Sam Pink.

Reprinted by permission of the author.

"The Garage Door" by Kris Saknussemm first published in *The New England Review* and subsequently in *Sinister Miniatures* (Lazy Fascist Press). © 2011 by Kris Saknussemm. Reprinted by permission of the author.

"Hot Dog (Bring Protection)" by Kevin Sampsell first published in *How To Lose Your Mind With the Lights On* (Future Tense). © 1994 by Kevin Sampsell. Reprinted by permission of the author.

"Trembler" by Kevin Sampsell is a chapter from the novel *This Is Between Us* (Tin House). Chapter first published in *Pageboy*. © 2012 by Kevin Sampsell. Reprinted by permission of the author.

ABOUT THE EDITOR

CAMERON PIERCE lives in Portland, Oregon. He is the author of eight books, including the Wonderland Book Award-winning collection *Lost in Cat Brain Land*, the controversial cult hit *Ass Goblins of Auschwitz*, and most recently, *Die You Doughnut Bastards*. His fully illustrated novel *Fantastic Earth Destroyer Ultra Plus* (w/ Jim Agpalza) is forthcoming in hardcover in November 2013. In 2012, he edited the anthology *The Best Bizarro Fiction of the Decade*. Cameron is also the head editor of Lazy Fascist Press and writes for *ManArchy Magazine*.

He's currently hard at work on *Our Love Will Go the Way of the Salmon*, a collection of Lynchian fishing stories set in the Pacific Northwest.

His favorite David Lynch film is *Blue Velvet*.

Bizarro Books

CATALOG SPRING 2013

ERASERHEAD PRESS

Swallowdown Press

FunGasm

LAZY FASCIST

Your major resource for the bizarro fiction genre:

WWW.BIZARROCENTRAL.COM

Introduce yourselves to the bizarro fiction genre and all of its authors with the Bizarro Starter Kit series. Each volume features short novels and short stories by ten of the leading bizarro authors, designed to give you a perfect sampling of the genre for only $10.

BB-0X1
"The Bizarro Starter Kit"
(Orange)
Featuring D. Harlan Wilson, Carlton Mellick III, Jeremy Robert Johnson, Kevin L Donihe, Gina Ranalli, Andre Duza, Vincent W. Sakowski, Steve Beard, John Edward Lawson, and Bruce Taylor.
236 pages $10

BB-0X2
"The Bizarro Starter Kit"
(Blue)
Featuring Ray Fracalossy, Jeremy C. Shipp, Jordan Krall, Mykle Hansen, Andersen Prunty, Eckhard Gerdes, Bradley Sands, Steve Aylett, Christian TeBordo, and Tony Rauch. **244 pages $10**

BB-0X2
"The Bizarro Starter Kit"
(Purple)
Featuring Russell Edson, Athena Villaverde, David Agranoff, Matthew Revert, Andrew Goldfarb, Jeff Burk, Garrett Cook, Kris Saknussemm, Cody Goodfellow, and Cameron Pierce **264 pages $10**

BB-001 "The Kafka Effekt" D. Harlan Wilson — A collection of forty-four irreal short stories loosely written in the vein of Franz Kafka, with more than a pinch of William S. Burroughs sprinkled on top. **211 pages $14**

BB-002 "Satan Burger" Carlton Mellick III — The cult novel that put Carlton Mellick III on the map ... Six punks get jobs at a fast food restaurant owned by the devil in a city violently overpopulated by surreal alien cultures. **236 pages $14**

BB-003 "Some Things Are Better Left Unplugged" Vincent Sakwoski — Join The Man and his Nemesis, the obese tabby, for a nightmare roller coaster ride into this postmodern fantasy. **152 pages $10**

BB-005 "Razor Wire Pubic Hair" Carlton Mellick III — A genderless humandildo is purchased by a razor dominatrix and brought into her nightmarish world of bizarre sex and mutilation. **176 pages $11**

BB-007 "The Baby Jesus Butt Plug" Carlton Mellick III — Using clones of the Baby Jesus for anal sex will be the hip sex fetish of the future. **92 pages $10**

BB-010 "The Menstruating Mall" Carlton Mellick III — "The Breakfast Club meets Chopping Mall as directed by David Lynch." - Brian Keene **212 pages $12**

BB-011 "Angel Dust Apocalypse" Jeremy Robert Johnson — Meth-heads, man-made monsters, and murderous Neo-Nazis. "Seriously amazing short stories..." - Chuck Palahniuk, author of Fight Club **184 pages $11**

BB-015 "Foop!" Chris Genoa — Strange happenings are going on at Dactyl, Inc, the world's first and only time travel tourism company.
"A surreal pie in the face!" - Christopher Moore **300 pages $14**

BB-032 "**Extinction Journals**" **Jeremy Robert Johnson** — An uncanny voyage across a newly nuclear America where one man must confront the problems associated with loneliness, insane dieties, radiation, love, and an ever-evolving cockroach suit with a mind of its own. **104 pages $10**

BB-037 "**The Haunted Vagina**" **Carlton Mellick III** — It's difficult to love a woman whose vagina is a gateway to the world of the dead. **132 pages $10**

BB-043 "**War Slut**" **Carlton Mellick III** — Part "1984," part "Waiting for Godot," and part action horror video game adaptation of John Carpenter's "The Thing." **116 pages $10**

BB-047 "**Sausagey Santa**" **Carlton Mellick III** — A bizarro Christmas tale featuring Santa as a piratey mutant with a body made of sausages. 124 pages $10

BB-048 "**Misadventures in a Thumbnail Universe**" **Vincent Sakowski** — Dive deep into the surreal and satirical realms of neo-classical Blender Fiction, filled with television shoes and flesh-filled skies. **120 pages $10**

BB-053 "**Ballad of a Slow Poisoner**" **Andrew Goldfarb** — Millford Mutterwurst sat down on a Tuesday to take his afternoon tea, and made the unpleasant discovery that his elbows were becoming flatter. **128 pages $10**

BB-055 "**Help! A Bear is Eating Me**" **Mykle Hansen** — The bizarro, heartwarming, magical tale of poor planning, hubris and severe blood loss...
150 pages $11

BB-056 "**Piecemeal June**" **Jordan Krall** — A man falls in love with a living sex doll, but with love comes danger when her creator comes after her with crab-squid assassins. **90 pages $9**

BB-058 "The Overwhelming Urge" Andersen Prunty — A collection of bizarro tales by Andersen Prunty. **150 pages $11**

BB-059 "Adolf in Wonderland" Carlton Mellick III — A dreamlike adventure that takes a young descendant of Adolf Hitler's design and sends him down the rabbit hole into a world of imperfection and disorder. **180 pages $11**

BB-061 "Ultra Fuckers" Carlton Mellick III — Absurdist suburban horror about a couple who enter an upper middle class gated community but can't find their way out. **108 pages $9**

BB-062 "House of Houses" Kevin L. Donihe — An odd man wants to marry his house. Unfortunately, all of the houses in the world collapse at the same time in the Great House Holocaust. Now he must travel to House Heaven to find his departed fiancee. **172 pages $11**

BB-064 "Squid Pulp Blues" Jordan Krall — In these three bizarro-noir novellas, the reader is thrown into a world of murderers, drugs made from squid parts, deformed gun-toting veterans, and a mischievous apocalyptic donkey. **204 pages $12**

BB-065 "Jack and Mr. Grin" Andersen Prunty — "When Mr. Grin calls you can hear a smile in his voice. Not a warm and friendly smile, but the kind that seizes your spine in fear. You don't need to pay your phone bill to hear it. That smile is in every line of Prunty's prose." - Tom Bradley. **208 pages $12**

BB-066 "Cybernetrix" Carlton Mellick III — What would you do if your normal everyday world was slowly mutating into the video game world from Tron? **212 pages $12**

BB-072 "Zerostrata" Andersen Prunty — Hansel Nothing lives in a tree house, suffers from memory loss, has a very eccentric family, and falls in love with a woman who runs naked through the woods every night. **144 pages $11**

BB-073 "The Egg Man" Carlton Mellick III — It is a world where humans reproduce like insects. Children are the property of corporations, and having an enormous ten-foot brain implanted into your skull is a grotesque sexual fetish. Mellick's industrial urban dystopia is one of his darkest and grittiest to date. **184 pages $11**

BB-074 "Shark Hunting in Paradise Garden" Cameron Pierce — A group of strange humanoid religious fanatics travel back in time to the Garden of Eden to discover it is invested with hundreds of giant flying maneating sharks. **150 pages $10**

BB-075 "Apeshit" Carlton Mellick III - Friday the 13th meets Visitor Q. Six hipster teens go to a cabin in the woods inhabited by a deformed killer. An incredibly fucked-up parody of B-horror movies with a bizarro slant. **192 pages $12**

BB-076 "Fuckers of Everything on the Crazy Shitting Planet of the Vomit At smosphere" Mykle Hansen - Three bizarro satires. Monster Cocks, Journey to the Center of Agnes Cuddlebottom, and Crazy Shitting Planet. **228 pages $12**

BB-077 "The Kissing Bug" Daniel Scott Buck — In the tradition of Roald Dahl, Tim Burton, and Edward Gorey, comes this bizarro anti-war children's story about a bohemian conenose kissing bug who falls in love with a human woman. **116 pages $10**

BB-078 "MachoPoni" Lotus Rose — It's My Little Pony... *Bizarro* style! A long time ago Poniworld was split in two. On one side of the Jagged Line is the Pastel Kingdom, a magical land of music, parties, and positivity. On the other side of the Jagged Line is Dark Kingdom inhabited by an army of undead ponies. **148 pages $11**

BB-079 "The Faggiest Vampire" Carlton Mellick III — A Roald Dahl-esque children's story about two faggy vampires who partake in a mustache competition to find out which one is truly the faggiest. **104 pages $10**

BB-080 "Sky Tongues" Gina Ranalli — The autobiography of Sky Tongues, the biracial hermaphrodite actress with tongues for fingers. Follow her strange life story as she rises from freak to fame. **204 pages $12**

BB-081 "Washer Mouth" Kevin L. Donihe - A washing machine becomes human and pursues his dream of meeting his favorite soap opera star. **244 pages $11**

BB-082 "Shatnerquake" Jeff Burk - All of the characters ever played by William Shatner are suddenly sucked into our world. Their mission: hunt down and destroy the real William Shatner. **100 pages $10**

BB-083 "The Cannibals of Candyland" Carlton Mellick III - There exists a race of cannibals that are made of candy. They live in an underground world made out of candy. One man has dedicated his life to killing them all. **170 pages $11**

BB-084 "Slub Glub in the Weird World of the Weeping Willows" Andrew Goldfarb - The charming tale of a blue glob named Slub Glub who helps the weeping willows whose tears are flooding the earth. There are also hyenas, ghosts, and a voodoo priest **100 pages $10**

BB-085 "Super Fetus" Adam Pepper - Try to abort this fetus and he'll kick your ass! **104 pages $10**

BB-086 "Fistful of Feet" Jordan Krall - A bizarro tribute to spaghetti westerns, featuring Cthulhu-worshipping Indians, a woman with four feet, a crazed gunman who is obsessed with sucking on candy, Syphilis-ridden mutants, sexually transmitted tattoos, and a house devoted to the freakiest fetishes. **228 pages $12**

BB-087 "Ass Goblins of Auschwitz" Cameron Pierce - It's Monty Python meets Nazi exploitation in a surreal nightmare as can only be imagined by Bizarro author Cameron Pierce. **104 pages $10**

BB-088 "Silent Weapons for Quiet Wars" Cody Goodfellow - "This is high-end psychological surrealist horror meets bottom-feeding low-life crime in a techno-thrilling science fiction world full of Lovecraft and magic..." -John Skipp **212 pages $12**

BB-089 "Warrior Wolf Women of the Wasteland" Carlton Mellick III — Road Warrior Werewolves versus McDonaldland Mutants...post-apocalyptic fiction has never been quite like this. **316 pages $13**

BB-091 "Super Giant Monster Time" Jeff Burk — A tribute to choose your own adventures and Godzilla movies. Will you escape the giant monsters that are rampaging the fuck out of your city and shit? Or will you join the mob of alien-controlled punk rockers causing chaos in the streets? What happens next depends on you. **188 pages $12**

BB-092 "Perfect Union" Cody Goodfellow — "Cronenberg's THE FLY on a grand scale: human/insect gene-spliced body horror, where the human hive politics are as shocking as the gore." -John Skipp. **272 pages $13**

BB-093 "Sunset with a Beard" Carlton Mellick III — 14 stories of surreal science fiction. **200 pages $12**

BB-094 "My Fake War" Andersen Prunty — The absurd tale of an unlikely soldier forced to fight a war that, quite possibly, does not exist. It's Rambo meets Waiting for Godot in this subversive satire of American values and the scope of the human imagination. **128 pages $11**

BB-095 "Lost in Cat Brain Land" Cameron Pierce — Sad stories from a surreal world. A fascist mustache, the ghost of Franz Kafka, a desert inside a dead cat. Primordial entities mourn the death of their child. The desperate serve tea to mysterious creatures. A hopeless romantic falls in love with a pterodactyl. And much more. **152 pages $11**

BB-096 "The Kobold Wizard's Dildo of Enlightenment +2" Carlton Mellick III — A Dungeons and Dragons parody about a group of people who learn they are only made up characters in an AD&D campaign and must find a way to resist their nerdy teenaged players and retarded dungeon master in order to survive. **232 pages $12**

BB-098 "A Hundred Horrible Sorrows of Ogner Stump" Andrew Goldfarb — Goldfarb's acclaimed comic series. A magical and weird journey into the horrors of everyday life. **164 pages $11**

BB-099 "Pickled Apocalypse of Pancake Island" Cameron Pierce—A demented fairy tale about a pickle, a pancake, and the apocalypse. **102 pages $8**

BB-100 "Slag Attack" Andersen Prunty— Slag Attack features four visceral, noir stories about the living, crawling apocalypse. A slag is what survivors are calling the slug-like maggots raining from the sky, burrowing inside people, and hollowing out their flesh and their sanity. **148 pages $11**

BB-101 "Slaughterhouse High" Robert Devereaux—A place where schools are built with secret passageways, rebellious teens get zippers installed in their mouths and genitals, and once a year, on that special night, one couple is slaughtered and the bits of their bodies are kept as souvenirs. **304 pages $13**

BB-102 "The Emerald Burrito of Oz" John Skipp & Marc Levinthal—OZ IS REAL! Magic is real! The gate is really in Kansas! And America is finally allowing Earth tourists to visit this weird-ass, mysterious land. But when Gene of Los Angeles heads off for summer vacation in the Emerald City, little does he know that a war is brewing...a war that could destroy both worlds. **280 pages $13**

BB-103 "The Vegan Revolution... with Zombies" David Agranoff— When there's no more meat in hell, the vegans will walk the earth. **160 pages $11**

BB-104 "The Flappy Parts" Kevin L Donihe—Poems about bunnies, LSD, and police abuse. You know, things that matter. **132 pages $11**

BB-105 "Sorry I Ruined Your Orgy" Bradley Sands—Bizarro humorist Bradley Sands returns with one of the strangest, most hilarious collections of the year. **130 pages $11**

BB-106 "Mr. Magic Realism" Bruce Taylor—Like Golden Age science fiction comics written by Freud, *Mr. Magic Realism* is a strange, insightful adventure that spans the furthest reaches of the galaxy, exploring the hidden caverns in the hearts and minds of men, women, aliens, and biomechanical cats. **152 pages $11**

BB-107 **"Zombies and Shit" Carlton Mellick III**—"Battle Royale" meets "Return of the Living Dead." Mellick's bizarro tribute to the zombie genre. **308 pages $13**

BB-108 **"The Cannibal's Guide to Ethical Living" Mykle Hansen**— Over a five star French meal of fine wine, organic vegetables and human flesh, a lunatic delivers a witty, chilling, disturbingly sane argument in favor of eating the rich.. **184 pages $11**

BB-109 **"Starfish Girl" Athena Villaverde**—In a post-apocalyptic underwater dome society, a girl with a starfish growing from her head and an assassin with sea anenome hair are on the run from a gang of mutant fish men. **160 pages $11**

BB-110 **"Lick Your Neighbor" Chris Genoa**—Mutant ninjas, a talking whale, kung fu masters, maniacal pilgrims, and an alcoholic clown populate Chris Genoa's surreal, darkly comical and unnerving reimagining of the first Thanksgiving. **303 pages $13**

BB-111 **"Night of the Assholes" Kevin L. Donihe**—A plague of assholes is infecting the countryside. Normal everyday people are transforming into jerks, snobs, dicks, and douchebags. And they all have only one purpose: to make your life a living hell.. **192 pages $11**

BB-112 **"Jimmy Plush, Teddy Bear Detective" Garrett Cook**—Hard-boiled cases of a private detective trapped within a teddy bear body. **180 pages $11**

BB-113 **"The Deadheart Shelters" Forrest Armstrong**—The hip hop lovechild of William Burroughs and Dali... **144 pages $11**

BB-114 **"Eyeballs Growing All Over Me... Again" Tony Raugh**— Absurd, surreal, playful, dream-like, whimsical, and a lot of fun to read. **144 pages $11**

BB-115 **"Whargoul" Dave Brockie** — From the killing grounds of Stalingrad to the death camps of the holocaust. From torture chambers in Iraq to race riots in the United States, the Whargoul was there, killing and raping. **244 pages $12**

BB-116 **"By the Time We Leave Here, We'll Be Friends" J. David Osborne** — A David Lynchian nightmare set in a Russian gulag, where its prisoners, guards, traitors, soldiers, lovers, and demons fight for survival and their own rapidly deteriorating humanity. **168 pages $11**

BB-117 **"Christmas on Crack" edited by Carlton Mellick III** — Perverted Christmas Tales for the whole family! . . . as long as every member of your family is over the age of 18. **168 pages $11**

BB-118 **"Crab Town" Carlton Mellick III** — Radiation fetishists, balloon people, mutant crabs, sail-bike road warriors, and a love affair between a woman and an H-Bomb. This is one mean asshole of a city. Welcome to Crab Town. **100 pages $8**

BB-119 **"Rico Slade Will Fucking Kill You" Bradley Sands** — Rico Slade is an action hero. Rico Slade can rip out a throat with his bare hands. Rico Slade's favorite food is the honey-roasted peanut. Rico Slade will fucking kill everyone. A novel. **122 pages $8**

BB-120 **"Sinister Miniatures" Kris Saknussemm** — The definitive collection of short fiction by Kris Saknussemm, confirming that he is one of the best, most daring writers of the weird to emerge in the twenty-first century. **180 pages $11**

BB-121 **"Baby's First Book of Seriously Fucked up Shit" Robert Devereaux** — Ten stories of the strange, the gross, and the just plain fucked up from one of the most original voices in horror. **176 pages $11**

BB-122 **"The Morbidly Obese Ninja" Carlton Mellick III** — These days, if you want to run a successful company . . . you're going to need a lot of ninjas. **92 pages $8**

BB-123 **"Abortion Arcade" Cameron Pierce** — An intoxicating blend of body horror and midnight movie madness, reminiscent of early David Lynch and the splatterpunks at their most sublime. **172 pages $11**

BB-124 **"Black Hole Blues" Patrick Wensink** — A hilarious double helix of country music and physics. **196 pages $11**

BB-125 **"Barbarian Beast Bitches of the Badlands" Carlton Mellick III** — Three prequels and sequels to *Warrior Wolf Women of the Wasteland*. **284 pages $13**

BB-126 **"The Traveling Dildo Salesman" Kevin L. Donihe** — A nightmare comedy about destiny, faith, and sex toys. Also featuring Donihe's most lurid and infamous short stories: *Milky Agitation, Two-Way Santa, The Helen Mower, Living Room Zombies,* and *Revenge of the Living Masturbation Rag.* **108 pages $8**

BB-127 **"Metamorphosis Blues" Bruce Taylor** — Enter a land of love beasts, intergalactic cowboys, and rock 'n roll. A land where Sears Catalogs are doorways to insanity and men keep mysterious black boxes. Welcome to the monstrous mind of Mr. Magic Realism. **136 pages $11**

BB-128 **"The Driver's Guide to Hitting Pedestrians" Andersen Prunty** — A pocket guide to the twenty-three most painful things in life, written by the most well-adjusted man in the universe. **108 pages $8**

BB-129 **"Island of the Super People" Kevin Shamel** — Four students and their anthropology professor journey to a remote island to study its indigenous population. But this is no ordinary native culture. They're super heroes and villains with flesh costumes and outlandish abilities like self-detonation, musical eyelashes, and microwave hands. **194 pages $11**

BB-130 **"Fantastic Orgy" Carlton Mellick III** — Shark Sex, mutant cats, and strange sexually transmitted diseases. Featuring the stories: *Candy-coated, Ear Cat, Fantastic Orgy, City Hobgoblins,* and *Porno in August.* **136 pages $9**

BB-131 "**Cripple Wolf**" **Jeff Burk** — Part man. Part wolf. 100% crippled. Also including *Punk Rock Nursing Home, Adrift with Space Badgers, Cook for Your Life, Just Another Day in the Park, Frosty and the Full Monty*, and *House of Cats*. **152 pages $10**

BB-132 "**I Knocked Up Satan's Daughter**" **Carlton Mellick III** — An adorable, violent, fantastical love story. A romantic comedy for the bizarro fiction reader. **152 pages $10**

BB-133 "**A Town Called Suckhole**" **David W. Barbee** — Far into the future, in the nuclear bowels of post-apocalyptic Dixie, there is a town. A town of derelict mobile homes, ancient junk, and mutant wildlife. A town of slack jawed rednecks who bask in the splendors of moonshine and mud boggin'. A town dedicated to the bloody and demented legacy of the Old South. A town called Suckhole. **144 pages $10**

BB-134 "**Cthulhu Comes to the Vampire Kingdom**" **Cameron Pierce** — What you'd get if H. P. Lovecraft wrote a Tim Burton animated film. **148 pages $11**

BB-135 "**I am Genghis Cum**" **Violet LeVoit** — From the savage Arctic tundra to post-partum mutations to your missing daughter's unmarked grave, join visionary madwoman Violet LeVoit in this non-stop eight-story onslaught of full-tilt Bizarro punk lit thrills. **124 pages $9**

BB-136 "**Haunt**" **Laura Lee Bahr** — A tripping-balls Los Angeles noir, where a mysterious dame drags you through a time-warping Bizarro hall of mirrors. **316 pages $13**

BB-137 "**Amazing Stories of the Flying Spaghetti Monster**" **edited by Cameron Pierce** — Like an all-spaghetti evening of Adult Swim, the Flying Spaghetti Monster will show you the many realms of His Noodly Appendage. Learn of those who worship him and the lives he touches in distant, mysterious ways. **228 pages $12**

BB-138 "**Wave of Mutilation**" **Douglas Lain** — A dream-pop exploration of modern architecture and the American identity, *Wave of Mutilation* is a Zen finger trap for the 21st century. **100 pages $8**

BB-139 "Hooray for Death!" Mykle Hansen — Famous Author Mykle Hansen draws unconventional humor from deaths tiny and large, and invites you to laugh while you can. **128 pages $10**

BB-140 "Hypno-hog's Moonshine Monster Jamboree" Andrew Goldfarb — Hicks, Hogs, Horror! Goldfarb is back with another strange illustrated tale of backwoods weirdness. **120 pages $9**

BB-141 "Broken Piano For President" Patrick Wensink — A comic masterpiece about the fast food industry, booze, and the necessity to choose happiness over work and security. **372 pages $15**

BB-142 "Please Do Not Shoot Me in the Face" Bradley Sands — A novel in three parts, *Please Do Not Shoot Me in the Face: A Novel*, is the story of one boy detective, the worst ninja in the world, and the great American fast food wars. It is a novel of loss, destruction, and--incredibly--genuine hope. **224 pages $12**

BB-143 "Santa Steps Out" Robert Devereaux — Sex, Death, and Santa Claus ... The ultimate erotic Christmas story is back. **294 pages $13**

BB-144 "Santa Conquers the Homophobes" Robert Devereaux — "I wish I could hope to ever attain one-thousandth the perversity of Robert Devereaux's toenail clippings." - Poppy Z. Brite **316 pages $13**

BB-145 "We Live Inside You" Jeremy Robert Johnson — "Jeremy Robert Johnson is dancing to a way different drummer. He loves language, he loves the edge, and he loves us people. These stories have range and style and wit. This is entertainment... and literature."- Jack Ketchum **188 pages $11**

BB-146 "Clockwork Girl" Athena Villaverde — Urban fairy tales for the weird girl in all of us. Like a combination of Francesca Lia Block, Charles de Lint, Kathe Koja, Tim Burton, and Hayao Miyazaki, her stories are cute, kinky, edgy, magical, provocative, and strange, full of poetic imagery and vicious sexuality. **160 pages $10**

BB-147 "Armadillo Fists" Carlton Mellick III — A weird-as-hell gangster story set in a world where people drive giant mechanical dinosaurs instead of cars. **168 pages $11**

BB-148 "Gargoyle Girls of Spider Island" Cameron Pierce — Four college seniors venture out into open waters for the tropical party weekend of a lifetime. Instead of a teenage sex fantasy, they find themselves in a nightmare of pirates, sharks, and sex-crazed monsters. **100 pages $8**

BB-149 "The Handsome Squirm" by Carlton Mellick III — Like Franz Kafka's *The Trial* meets an erotic body horror version of *The Blob*. **158 pages $11**

BB-150 "Tentacle Death Trip" Jordan Krall — It's *Death Race 2000* meets H. P. Lovecraft in bizarro author Jordan Krall's best and most suspenseful work to date. **224 pages $12**

BB-151 "The Obese" Nick Antosca — Like Alfred Hitchcock's *The Birds*... but with obese people. **108 pages $10**

BB-152 "All-Monster Action!" Cody Goodfellow — The world gave him a blank check and a demand: Create giant monsters to fight our wars. But Dr. Otaku was not satisfied with mere chaos and mass destruction.... **216 pages $12**

BB-153 "Ugly Heaven" Carlton Mellick III — Heaven is no longer a paradise. It was once a blissful utopia full of wonders far beyond human comprehension. But the afterlife is now in ruins. It has become an ugly, lonely wasteland populated by strange monstrous beasts, masturbating angels, and sad man-like beings wallowing in the remains of the once-great Kingdom of God. **106 pages $8**

BB-154 "Space Walrus" Kevin L. Donihe — Walter is supposed to go where no walrus has ever gone before, but all this astronaut walrus really wants is to take it easy on the intense training, escape the chimpanzee bullies, and win the love of his human trainer Dr. Stephanie. **160 pages $11**

BB-155 "Unicorn Battle Squad" Kirsten Alene — Mutant unicorns. A palace with a thousand human legs. The most powerful army on the planet. **192 pages $11**

BB-156 "Kill Ball" Carlton Mellick III — In a city where all humans live inside of plastic bubbles, exotic dancers are being murdered in the rubbery streets by a mysterious stalker known only as Kill Ball. **134 pages $10**

BB-157 "Die You Doughnut Bastards" Cameron Pierce — The bacon storm is rolling in. We hear the grease and sugar beat against the roof and windows. The doughnut people are attacking. We press close together, forgetting for a moment that we hate each other. **196 pages $11**

BB-158 "Tumor Fruit" Carlton Mellick III — Eight desperate castaways find themselves stranded on a mysterious deserted island. They are surrounded by poisonous blue plants and an ocean made of acid. Ravenous creatures lurk in the toxic jungle. The ghostly sound of crying babies can be heard on the wind. **310 pages $13**

BB-159 "Thunderpussy" David W. Barbee — When it comes to high-tech global espionage, only one man has the balls to save humanity from the world's most powerful bastards. He's Declan Magpie Bruce, Agent 00X. **136 pages $11**

BB-160 "Papier Mâché Jesus" Kevin L. Donihe — Donihe's surreal wit and beautiful mind-bending imagination is on full display with stories such as All Children Go to Hell, Happiness is a Warm Gun, and Swimming in Endless Night. **154 pages $11**

BB-161 "Cuddly Holocaust" Carlton Mellick III — The war between humans and toys has come to an end. The toys won. **172 pages $11**

BB-162 "Hammer Wives" Carlton Mellick III — Fish-eyed mutants, oceans of insects, and flesh-eating women with hammers for heads. Hammer Wives collects six of his most popular novelettes and short stories. **152 pages $10**

CPSIA information can be obtained at www.ICGtesting.com
Printed in the USA
BVOW01s0256040614

355172BV00020B/32/P